ARMOUR AND MASCULINITY IN TH

During the Italian Wars of 1494–1559, with innovations in military technology and tactics, armour began to disappear from the battlefield. Yet as field armour was retired, recycled, and discarded, parade and ceremonial armour took on greater importance and grew increasingly flamboyant. Removed from its utilitarian function of defence but retained for symbolic uses, armour evolved in a new direction as a medium of artistic expression. Working with this vestigial cultural form, armourers became artists, free to experiment with elaborate embossed ornament and three-dimensional modelling more appropriate to sculpture.

Drawing on theoretical perspectives from anthropology, literary studies, art history, and gender studies, *Armour and Masculinity in the Italian Renaissance* explores the significance of armour as a cultural artifact and symbolic form. As real warfare diverged more decisively from the symbolic, armour – encoded with messages regarding the owner's social status – became a chief accessory of elite male identity. Luxury armour was explicitly customized with reference to the owner's genealogy and political alliances just as it was modelled on his unique physical form. It was, in effect, a three-dimensional portrait of the individual, a map of his place in the world, and a mirror of his masculinity.

In this book Carolyn Springer examines the significance of early modern armour and the implications of its circulation in culture through case studies of three patrons of luxury armour studios: Guidobaldo II della Rovere (1514–75), Charles V Habsburg (1500–58, Holy Roman Emperor 1519–56), and Cosimo I de' Medici (1519–74). By examining an array of objects and images from Cinquecento court culture, Springer demonstrates that Renaissance armour is not just a background to literary texts but a vibrant representational practice in its own right.

(Toronto Italian Studies)

CAROLYN SPRINGER is a professor in the Department of French and Italian at Stanford University.

CAROLYN SPRINGER

Armour and Masculinity in the Italian Renaissance

UNIVERSITY OF TORONTO PRESS
Toronto Buffalo London

© University of Toronto Press 2010
Toronto Buffalo London
www.utppublishing.com
Printed in the U.S.A.

Reprinted in paperback 2013

ISBN 978-1-4426-4055-9 (cloth)
ISBN 978-1-4426-2617-1 (paper)

Printed on acid-free paper.

Toronto Italian Studies

Library and Archives Canada Cataloguing in Publication

Springer, Carolyn
Armour and masculinity in the Italian Renaissance / Carolyn Springer.

Includes bibliographical references and index.
ISBN 978-1-4426-4055-9 (bound). – ISBN 978-1-4426-2617-1 (pbk.)

1. Armor, Renaissance – Social aspects – Italy. 2. Italy – Civilization –
1268–1559. 3. Italy – Intellectual life – 1268–1559. 4. Masculinity –
Italy – History. 5. Armor in art. I. Title.

NK6652.A1S67 2010 739.7'5094509031 C2010-900370-5

This book was published with the aid of a grant from the Division of
Literatures, Cultures and Languages at Stanford University.

University of Toronto Press acknowledges the financial assistance to its
publishing program of the Canada Council for the Arts and the Ontario
Arts Council.

Canada Council **Conseil des Arts**
for the Arts **du Canada**

University of Toronto Press acknowledges the financial support for its
publishing activities of the Government of Canada through the Book
Publishing Industry Development Program (BPIDP).

Contents

Illustrations

Photograph Credits

References are to figure numbers.

For help with illustrations, thanks to Carlo Biancalani, Antonio Fazzini, Marta Fodor (Art Resource), Aden Hayes, Ilse Jung (Kunsthistorisches Museum, Vienna), Allison Levy, Stephanie Marsh (akg-images), Elena Obuhovich (State Hermitage Museum, Saint Petersburg), Patricia Simons, Alvaro Soler del Campo and Silvia Rueda (Patrimonio Nacional), and Jeri Wagner (Metropolitan Museum of Art).

Acknowledgments

I am grateful to the many friends and colleagues who have taken an interest in this project along the way. At Stanford I have especially appreciated the warm encouragement of Robert Harrison and Roland Greene. Many thanks also to Remo Ceserani, Paula Findlen, Sepp Gumbrecht, Stephen Orgel, and Patricia Parker for their advice and support.

Other friends and colleagues have generously read and commented on previous drafts: Albert Ascoli, Stephen Bann, Louise Clubb, Valeria Finucci, John Freccero, Giuseppe Mazzotta, Courtney Quaintance, Eileen Reeves, and Deanna Shemek. I am deeply indebted to them for their insight and guidance.

For advice and help with illustrations, I wish especially to thank Allison Levy and Patricia Simons.

Audiences in a number of settings helped me to refine and develop my ideas: the Modern Language Association of America, the Renaissance Society of America, Brown University, the University of Chicago, New York University, the University of Massachusetts at Amherst, Wesleyan University, and Yale University.

I owe special thanks to my editor, Ron Schoeffel, of the University of Toronto Press, for overseeing this project with calm efficiency and care. My two anonymous readers contributed valuable suggestions and helped me to improve the book substantially. I am grateful to Maureen Epp for her meticulous copyediting and to Anne Laughlin for guiding the work through the Press.

Thanks as ever to Linda Bernard and Katie Mangan for their patience and good humour.

This book is dedicated, with love, to Leighton.

ARMOUR AND MASCULINITY IN THE ITALIAN RENAISSANCE

Introduction

The purpose of this book is to explore the significance of armour in early modern Italy as a cultural artifact and symbolic form. During the early stages of this project, my intent was to examine the historical phenomenon of sixteenth-century armour to better understand its representation in literary texts of the period (particularly in Ariosto's epic poem *Orlando furioso*). As my work progressed, I found my attention increasingly drawn to the objects themselves: not as raw data subject to literary elaboration, but as artifacts that were themselves the site and residue of complicated stories. My move toward the semiotics of culture was a methodological experiment: I wanted to use my training as a literary critic to examine one manifestation of material culture that fascinated me and seemed to require different forms and strategies of explanation than those strictly deriving from the disciplines that had claimed it.[1] I borrowed theoretical perspectives from anthropology, sociology, psychoanalysis, and gender studies in an effort to situate these artifacts among the larger repertory of objects that we associate with the Renaissance. In the process I began to address a series of apparently prosaic questions that turned out to be infinitely more complex than I had imagined. How did these objects come into being? How were they produced, used, and exchanged? What kinds of cultural work did they do?

As I studied early modern armour, I began to appreciate its structural complexity. These works are indeed texts to be read: overdetermined objects traversed by multiple formal and figurative codes.[2] Armour is always embedded in culture; it is inscribed with markers of political and social identity. This is especially true of luxury armours: unlike munitions-grade equipment mass-produced for infantry, prestige

armour was created for an individual patron and customized by specific references to his position in the social hierarchy. Its design maps the genealogy of his privilege. More discreetly, it also names the armourer who produced the work and the guild that regulated his activity. In this way armour evokes a network of social and economic relations that contributed to its production.

Armour is further complicated by its diachronic dimension. Works of armour are not inert objects, but dynamic fields of force continually transformed by their shifting historical contexts. They do not stand still, but exist in time. Even the most personalized armour is transferable; invested with aesthetic as well as symbolic value, it is born with the potential to circulate. In this respect, real armour resembles its literary equivalent: the armour that moves through epic poetry is notoriously unstable, a highly contended object of desire and exchange.[3] Armour is especially vulnerable to such reappropriation because of its fragmentary nature: unlike sculpture, it is easily disassembled and scattered because it is not fused into a single form. Armour may constitute identity, but it is never a secure possession.[4] Like many charismatic objects, it invites theft. Hence, Renaissance armours tend to have complicated histories.

Such stories appealed to me as a student of literature. Each one was a chapter in what anthropologists call the social life of things.[5] The historical texture of these artifacts makes them objects of resonance and wonder.[6] These are relics that radiate a cultural charge in excess of any measurable aesthetic value or antiquarian interest. To view an empty armour in a museum is an ambiguous encounter, because the *cavaliere inesistente* is both a phantasm and a formidable presence, uncannily remote and irresistibly human. I was drawn to these objects by their contradictory nature: they were imaginatively accessible but infinitely strange.[7]

Precisely because armour is so easily dismembered, a complex terminology governs its conventions of display. I avoid the English term 'suit' of armour in this study because it is misleading. In popular usage it implies the assumption that each armour displayed on a museum mannequin was created and transferred as a coherent ensemble. Actually such cases are extremely rare. The number of surviving fifteenth-century Italian armours in completely original (or at least 'essentially primal') assemblage has been estimated at thirteen. Instead, most armours mounted in museums combine pieces from several different

(but roughly contemporaneous) sources. Curators refer to these display sets as compositions or associations.

The terminology can be confusing and is not always consistent. Ideally, the components displayed on a single mannequin are as similar as possible in style and historical period. But because of the distinctive production method of Italian armour in the fifteenth century (in which individual components were subcontracted to different workshops by a single producer), *all* pre-1500 Italian armours must be considered assemblages by definition. These assemblages may be classified as original, essentially primal, or composite, depending on their degree of historical and stylistic integrity. An original assemblage is a set constructed initially from components produced by various shops or craftsmen, but all destined to be united in the armour at hand. An essentially primal assemblage includes some replacement pieces from the early working life of the armour that do not substantially alter its character, while a composite assemblage is not a working armour at all but intended purely for display.[8]

It is important to clarify one further point. Most of the historical armour we imagine to be 'medieval' is really the product of the sixteenth century (and hence 'early modern,' if we find the term preferable to 'Renaissance').[9] Throughout Europe, knights wore helmets and mail shirts well into the fourteenth century. These mail garments were fashioned from a network of interlocking metal rings and had the advantage of being flexible. With the development of new metallurgical techniques, plate armour gradually evolved into a carapace covering the entire body. This gave superior protection (especially from missile weapons such as the crossbow and longbow) but remained extremely expensive. Few of these early armours survive because they were routinely melted down for reuse. Therefore, the vast majority of specimens displayed in modern museums date from no earlier than the sixteenth century; some (including the *faux* medieval artifacts of the romantic period) are much more recent.[10]

All armour is simultaneously an affirmation of power and an admission of vulnerability. In presenting an idealized double to the world, the armoured knight admits his own insufficiency; by publicly displaying this prosthesis he expresses his need for physical protection. In this sense armour is inevitably paradoxical. But Renaissance armour embodies a further contradiction: with the historical transition to firearms, it was 'always already belated.'[11] No matter how modern its engi-

neering and sophisticated its design, after the introduction of artillery, armour became increasingly impractical on the battlefield. Advances in metallurgy could not compensate for the force of the new projectiles, and metal plate proofed against artillery became too heavy to allow freedom of movement in battle.[12] Made by prestigious workshops at prodigious expense, these Renaissance inventions were born obsolete.

Yet armour did not disappear: instead it was displaced. Once disassociated from its utilitarian function of defence, it assumed even greater importance and prestige as a symbolic form. It is at this precise juncture (when it is least functional) that armour becomes most significant as a medium of social display. The parade and costume armour of the sixteenth century, no longer proofed for battle but established as the highest form of male ceremonial dress, was increasingly ornate and frequently enriched with encomiastic imagery illustrating the deeds of the owner and his (often legendary) ancestors. Freed from practical constraints, master armourers like the Negroli dynasty in Milan embossed metal surfaces in high relief to obtain dazzling decorative effects. By weakening the tensile strength of the steel such ornament compromised the objects as literal protection, but it greatly enhanced their value as instruments of rhetoric.

Machiavelli was famously mistaken in judging the future of artillery, but he fully understood and lucidly theorized the semiotics of war in ways that help to illuminate the evolving function of armour in sixteenth-century Italy.[13] Fundamental to Machiavelli's theory of power relations was his insight into the politics of deterrence: the notion that it was easier to conquer through the appearance of strength than through direct recourse to force. It is not only more efficient to display force than to use it; it is more necessary to project an appearance of power than it is to possess that power. This principle helps to explain why armour remains part of the discourse of war long after it has been abandoned in combat. At this point its potential is fully realized as a medium of symbolic action and rhetorical performance. In this sense armour does not just represent or imply a threat but actually produces and constitutes it.

Suleiman I, Sultan of the Ottoman Empire (1520–66), was perfectly Machiavellian in his dialogue with Western enemies and rivals during the early decades of the Cinquecento. The sultan's confrontation with emperor and pope was willfully rhetorical. On the eve of his planned invasion of Italy in 1532, Suleiman sought to intimidate both Charles V and Pope Clement VII, who had gathered against him in Bologna. On this occasion he deliberately adopted a Western imperial vocabulary to

address his European adversaries on their own terms in a visual language they would easily understand. With the help of his two closest advisors, the Ottoman ruler devised an eclectic suite of artifacts with which to represent his power to the West. Along with traditional motifs (such as the sword, dagger, and crescent), this regalia included European emblems of sovereignty – crown, sceptre, baldachin, orb, and chain – that were foreign to the Islamic tradition.

The focus of this regalia was a fantastical gold helmet (Fig. 1) made by jewellers in Venice and publicly displayed there before its shipment to the Ottoman court.[14] Largely responsible for this *invenzione* was the jewel merchant Alvise Gritti.[15] The illegitimate son of the Venetian doge and a Greek concubine, Gritti (now living in Istanbul) was fluent in all three cultures and fully understood the material dimension of diplomacy. The towering helmet he conceived for the sultan consisted of four superimposed crowns studded with twelve-carat pearls, diamonds, rubies, emeralds, and a large (and evidently eponymous) turquoise. At the cusp of the helmet was a plumed aigrette set in a crescent moon–shaped mount. (Appropriately, the feathers were said to be those of the Indian chameleon or 'bird of paradise,' which adapted its colours to its setting). The syncretistic extravaganza combined elements from the papal tiara and Habsburg parade helmets but by implication surpassed them all: it represented a transparent challenge to both authorities and announced the sultan's imperial designs on all of Europe.

The gold tiara was featured in a series of parades and receptions choreographed by the sultan's grand vizier Ibrahim Pasha during his advance toward Vienna. On all these occasions it was used transparently as a stage prop.[16] The sultan, who wore a turban and gold brocade caftan in deference to Ottoman custom, exhibited the crown for its pure semiotic value, both in his triumphal entries into the cities along his route and at the diplomatic receptions held in his lavishly appointed tent. In parades it preceded him, borne by a favourite page (the last of a hundred pages bearing military accoutrements). In his tent it rested beside him on a golden throne. The helmet was part of the *mise-en-scène* of Ottoman power and played a critical role in the sultan's self-staging. It conveyed two messages about its owner: first, his staggering wealth (and willingness to spend it); and second, the scale of his imperial ambitions. Just a few years after the Holy Roman Emperor's 1529 entry into Bologna and subsequent coronation by the pope, the crown was an explicit reprise and dilation of papal and Habsburg regalia. Its opulence represented the ideal of *magnificentia*, which Suleiman and his

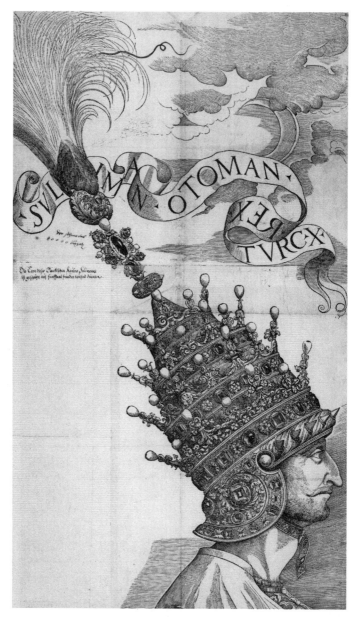

Fig. 1. Sultan Suleiman the Magnificent wearing the jewel-studded helmet. Anonymous woodcut, Venice, ca 1532.

advisors understood to be an essential attribute of sovereignty in Western courts. In Europe such conspicuous display would in fact earn him the title of 'Suleiman the Magnificent.'

The theatre of power was (and remains today) an ongoing competitive performance, an exchange of images. The Venetian diarist Marino Sanuto claims that the sight of the golden helmet turned Habsburg ambassadors into 'speechless corpses.'[17] Hyperbole aside, the object's implications were clearly legible to his contemporaries. Rapidly publicized by the new printing industry, the helmet was familiar enough in Cinquecento Italy to be mentioned in a number of popular plays, including Pietro Aretino's *Il marescalco* (1533) and Francesco Negri's *Libero arbitrio* (1550).[18] In a Turkish context, however, it attracted small notice; descriptions and illustrations of the event that circulated within the Ottoman empire made no reference to this fantastical tiara.[19]

Suleiman's helmet was a particularly celebrated example of the luxury armours that circulated in the Cinquecento. Devised for a specific political encounter, the object did not outlive the occasion for which it was produced: it was stripped and its parts ingloriously recycled.[20] Though we can reconstruct it only from textual and iconographic evidence, many other examples of sixteenth-century armour are extant, intact, and available for analysis. Such objects belonged to the material landscape of the Renaissance. If considered at all, they have traditionally been viewed as backdrop to its 'human' drama, as if the same events could have unfolded in their absence, in some unfurnished realm. My goal in these pages is to give sustained attention to a series of such artifacts (with particular focus on parade and ceremonial armour of the early Cinquecento) and to suggest ways of situating them in historical context. By exploring the rhetorical and symbolic transactions in which they were involved, I mean to illustrate their dynamic participation in human events. Like the armour that circulates in epic poetry – with narrative trajectories independent of any of the characters – these objects acquire a kind of agency and themselves become the protagonists of political encounters.

This interpretive mode, entailing the conceptualization of artifacts as agencies or quasi-agencies, has been called the socio-semiotics of objects.[21] Its practitioners examine the behaviour of objects as 'social others' rather than the passive embodiment of human intentions. By blurring the subject–object distinction they suggest new ways of animating the study of material culture, particularly with regard to its transformation through time – since objects continue to develop new

meanings in shifting contexts while retaining the same physical form. It is a perspective that I have found congenial as I tried to articulate the significance of armour in early modern Italy.

This book examines the specific circumstances of armour's production and transmission and considers more broadly the implications of its circulation in culture. Complementing the philological study of individual specimens is the more speculative task of reconstructing the cultural work they perform. By considering a range of early modern figural and discursive practices, I have tried to reimagine the semiotic density of armour in the Italian Renaissance. Ironically, this often returned me to the literary sources where I began. Ultimately, I found, there is no stable boundary between the specimens of Renaissance armour and the texts that describe or imagine them. The objects are 'caught in a semiotic web with which they become consubstantial.'[22] All such artifacts are 'intertextual' – both conditioned and transformed by the texts that arise to explain and interpret them. Though I have tried to sustain a focus on the objects, I have found they interact with texts in a variety of genres – including poetry, theatre, conduct books, and political treatises – all implicated in the rhetoric of masculinity.[23]

The time frame on which I focus is the first half of the sixteenth century. Many of my examples are works produced by the Negroli workshop in Milan, and in particular by Filippo Negroli (1510–79).[24] My discussion does not, of course, pretend to be comprehensive. In identifying this time frame I mean only to indicate the period from which I gather most of my examples. It was at this point that armour was first recognized as a medium of artistic expression; a sign of its new status was Vasari's reference to Filippo Negroli in his *Vite* (*Lives of the Artists*) of 1550.[25] By 1595, Paolo Morigi included a number of armourers among the *Nobiltà di Milano,* noting that they had succeeded in gaining social advancement and intermarriage with noble families through their control of the international luxury trade.[26] Technocouture was an immensely profitable business – a vehicle for social promotion on the part of both artist and patron.

Apart from its utilitarian function, clothing is always an expressive medium. In everyday life as in the overtly political arena, clothes play an essential role in the presentation of self – indeed, to put it more emphatically, in the performance of self.[27] Clothing is an embodied sign that conveys information about an individual's social attributes and perceptions of self and others.[28] In fact, clothing is one of the fundamental components of social solidarity because it helps to orient strangers

toward each other, since the vestimentary codes built into everyday perception provide a critical set of social cues.[29]

Although armour would seem to figure the autonomy of the individual – self-contained, closed, impermeable – I have found that instead it documents a network of social relationships. The elegant planes and sleek surfaces of armour obscure its many interfaces with external structures. There are no free-standing armours, just as there are no free-standing individuals; as Victor Turner writes, human beings are 'peculiarly festooned with prepositions ... we are for, against, with, towards, above, below, within, outside, or without one another.' Every human subject is modified by such relational and functional connectives: 'If we could make a psychosomatigram of a member of our species, it would not be smoothly nude, but, as it were, sprouting with prepositional lines and plugs, and pitted with prepositional plug-holes.'[30] Similarly, armour – the most anthropomorphic of objects – is never 'smoothly nude.' Its polished surfaces are bristling with complications.

Luxury armour in particular is 'festooned with prepositions.' As a heightened form of costume, it is overcoded with messages regarding the owner's social status (achieved or desired).[31] This ensures the maximum return for the patron's considerable investment. Sometimes, like other forms of aristocratic finery, armour is aspirational – borrowed or rented for portraits or ceremonial occasions.[32] But the most valuable armour is explicitly customized by references to the owner's genealogy and political alliances, just as it is modelled on his unique physical form. It is a three-dimensional portrait of the individual and a map of his place in the world.

It is also, by definition, a mirror of his masculinity. In this respect, body armour might be viewed as a metonymic expansion of the codpiece – an object that aestheticizes masculine power and actively produces an idealized somatic form.[33] It erases the infinite morphological variations of individual bodies by substituting a normative ideal. Armour constructs the elite male body through the process of prosthetic addition. This process illustrates the variability of the physical silhouette identified with masculinity. Fashions in armour closely mirrored the development of male civilian dress; the formal evolution of armour reflected the changing canons of elegance in the male body. The history of the breastplate shows a continual migration of the waistline and reinvention of the shape of the torso, from the attenuated forms and vertical fluting of Maximilian armour to the tonlet skirt and peascod belly and the ungainly 'lobster' tassets of seventeenth-century cuirassiers (Fig. 2).[34]

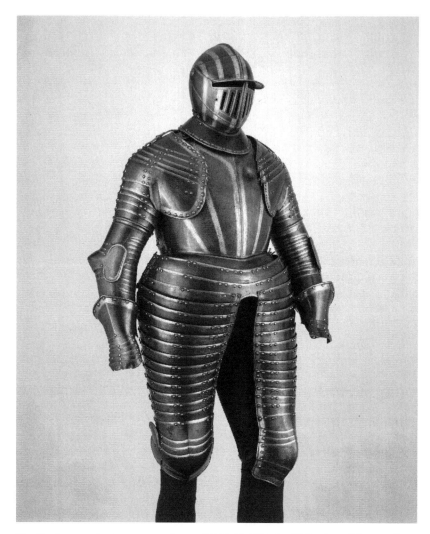

Fig. 2. Armour for heavy cavalry, ca 1610–20. Weight 86 lbs 8 oz. Metropolitan Museum of Art.

A number of recent critics have associated Renaissance armour with Lacan's description of the mirror stage.[35] Like the prosthetic body of Lacan's mirror stage, body armour represents an integrated version of the self that serves the individual as an enabling fiction in his psychic development. According to Lacan, the mirror stage 'manufactures a

succession of phantasies that extends from a fragmented body-image to a form of its totality that I shall call orthopaedic – and lastly, to the assumption of an alienating identity.'[36] Armour monumentalizes the body and displays it in heroic and aggrandized form; it literally confers *gravitas*. It is a portrait of the self – but more importantly, of the Father who is the source of the individual's identity and authority.[37] It embodies the principle of patrilineal succession and the very nature of aristocratic privilege: the fantasy of access to a second, incorruptible body, the preservation and extension of identity through property.

If armour is inevitably complicit with power, it is also by definition gendered male.[38] The only women routinely equipped with armour in early modern Europe were fictional (Bradamante, Britomart, and the other warrior women of epic poetry) or allegorical (abstract nouns figured as feminine in both iconographic and grammatical terms).[39] Except in the rarest of cases, access to armour has been historically defined as a male privilege. Queen Elizabeth I would be the exception that proves the rule, if she had indeed worn armour to rally the troops at Tilbury as her legend holds. Instead, historians find no evidence that she ever wore armour; this, like the stirring speech she was said to have delivered there, was a Jacobean fantasy.[40] The legend itself, however, demonstrates the force of the assumption that armour belonged to men. Precisely because it was identified as masculine, armour could in exceptional cases be used as a mode of female idealization.[41] Alternately (in cases where it was not justified by her exceptional status), the wearing of armour by a woman could be associated with subversion. By wearing armour, Joan of Arc was understood to be willfully cross-dressing as male. This was the theological (and cultural) heresy for which she was tried and condemned.[42]

Given the importance of armour in the performance of gender, we can imagine the relevance of such imagery to sixteenth-century anxieties regarding Italy's political victimization. During the period of the Italian wars (1494–1559), warfare was more or less constant as Habsburg–Valois dynastic rivalries were played out over the body of Italy.[43] The shock of the French invasion in 1494 was repeatedly figured as a rape. Successive invasions by the Spanish and French, accompanied by unprecedented violence and cruelty toward civilians, contributed to a political climate in which Italy was perceived as being feminized in its vulnerability.[44] Despite their differences, Machiavelli and Guicciardini concurred in invoking this vulnerability as an urgent theme.

Two of the most arresting images in Machiavelli's *Principe (The Prince)* suggest the relationship between armour and the gendering of the body politic. The personification of Italy as a vilified and fragmented female body derives from a long tradition in Italian political rhetoric, beginning with Dante.[45] In this climactic passage from *The Prince*, Machiavelli describes Italy's degradation:

> più stiava che li Ebrei, più serva ch'e' Persi … sanza capo, sanza ordine, battuta, spogliata, lacera, corsa, et avessi sopportato d'ogni sorte ruina. Rimasa sanza vita, aspetta qual possa esser quello che sani le sua ferite … e la guarisca di quelle sue piaghe già per lungo tempo infistolite. Vedesi come la prega Dio che le mandi qualcuno che la redima da queste crudeltà et insolenzie barbare. Vedesi ancora tutta pronta e disposta a seguire una bandiera, pur che ci sia uno che la pigli.

> [more enslaved than the Hebrews, more abject than the Persians … headless, orderless, beaten, stripped, scarred, overrun, and plagued by every sort of disaster. Left almost lifeless, [she] waits for a leader who will heal her wounds … and minister to those sores of hers that have been festering so long. Behold how she prays God to send someone to free her from the cruel insolence of the barbarians; see how ready and eager she is to follow a banner joyously, if only someone will raise it up.][46]

What distinguishes Machiavelli's use of the familiar trope is the way it reverberates against his image of Fortune in the previous chapter:

> Io iudico bene questo, che sia meglio essere impetuoso che respettivo, perché la fortuna è donna; et è necessario, volendola tenere sotto, batterla et urtarla. E si vede che la si lascia più vincere da questi, che da quelli che freddamente procedano. E però sempre, come donna, è amica de' giovani, perché sono meno respettivi, più feroci, e con più audacia la comandano.

> [But I do feel this: that is better to be rash than timid, for Fortune is a woman and the man who wishes to hold her down must beat and bully her. We see that she yields more often to men of this stripe than to those who come coldly toward her. Like a woman too, she is always a friend of the young, because they are less timid, more brutal, and take charge of her more recklessly.][47]

The most striking implication of these two images of violence against women is their cumulative logic. Machiavelli objects not to the brutal-

ity of the scenario, but to the shame of being cast in the submissive role. Convinced that violence is inevitable in human relations, he calls for a revitalization of masculine *virtù* that would enable Italy to reclaim its position of military dominance and political autonomy. Unlike the ancient Gauls, judged by Titus Livius to be 'more than men' at the beginning of a fight but as it progresses becoming 'less than women,' Italians must recover that combination of ardour and discipline achieved by the Romans.[48] Most of all, they must assume responsibility for defending their own borders through a citizen militia instead of delegating their defence to foreign mercenaries. In this scheme the core of masculine identity resides in physical integrity, while femininity bears the stigma of vulnerability to attack.

To be open, permeable, and accessible is the nature of femininity; virility instead is closed, secure, and (literally) impregnable. The imagery associated with armour easily absorbs and accommodates such notions of gender inherited from the Aristotelian tradition.[49] Machiavelli's exhortation to defend Italy's borders is also an invitation to reinstate the boundaries that define masculine identity. Again in *L'arte della guerra* (*The Art of War*) he proclaims that Italy has become *il vituperio del mondo* (the scorn of the world) because of the weakness and effeminacy of its princes, who did not foresee that their passivity would make them easy prey:

> Credevano i nostri principi italiani, prima ch'egli assaggiassero i colpi delle oltramontane guerre, che ad uno principe bastasse sapere negli scrittoi pensare una acuta risposta, scrivere una bella lettera, mostrare ne' detti e nelle parole arguzia e prontezza, sapere tessere una fraude, ornarsi di gemme e d'oro, dormire e mangiare con maggiore splendore che gli altri, tenere assai lascivie intorno … né si accorgevano, i meschini, che si preparavano ad essere preda di qualunque gli assaltava.[50]

> [Before they tasted the blows of the ultramontane wars, our Italian princes thought it sufficient for a prince to know how to fashion a clever response at his desk, write an elegant letter, show wit and acuity in his deeds and conversation, know how to weave a fraud, dress in jewels and gold, sleep and eat in greater splendour than anyone else, and surround themselves with lascivious pleasures … Nor did these wretches realize that they were preparing themselves to be the prey of whoever assaulted them.]

By contrast, the Romans hardened their bodies and spirits in preparation for battle:

[E] se in loro, o in parte di loro, si poteva dannare troppa ambizione di
regnare, mai non si troverrà che in loro si danni alcuna mollizia o alcuna
cosa che faccia gli uomini delicati e imbelli.[51]

[And if in any of them one could blame too much ambition to rule, one
can never blame them for softness or anything that makes men delicate
and unwarlike.]

An unmanly soldier would be a monstrosity, a crime against nature:
'uno abortivo, e non una figura perfetta' (an abortion, and not a per-
fect figure). But if Machiavelli deplores the impotence of Italian troops,
he insists that it is not too late to reform them. Regretting his own
advanced age, he appeals to Lorenzo di Filippo Strozzi (to whom *L'arte
della guerra* is dedicated) to look toward the future:

E io mi dolgo della natura, la quale o ella non mi doveva fare conosci-
tore di questo, o ella mi doveva dare facultà a poterlo esseguire. Né penso
oggimai, essendo vecchio, potere averne alcuna occasione; e per questo io
ne sono stato con voi liberale, che essendo giovani e qualificati potrete ...
a' debiti tempi in favore de' vostri principi aiutarle e consigliarle ... Ma
quanto a me si aspetta, per essere in là con gli anni me ne diffido.[52]

[I find fault with nature, which either should not have given me this
knowledge or should have given me the ability to carry it out. Now that
I am old, I do not think I will have any such opportunity. So I have been
liberal toward you, who are young and qualified ... so that you might at
the appropriate time help and counsel your princes to their benefit ... But
I doubt that much can be expected of me, as I am getting on in years.]

The midlife lament that closes *L'arte della guerra* recalls the elegiac
opening of the treatise, which noted the premature death of Cosimo
Rucellai. Born in the year of the first French invasion, Cosimo died at
twenty-five without a chance to fulfil his adult promise, emasculated
because he was denied public achievement. 'Nato per morire giovane
dentro alle sue case e inonorato,' Rucellai is a symbol of the generation
of men humiliated by the Italian wars.[53]

How thoroughly the polemic against 'effeminacy' was integrated into
the official rhetoric of the Florentine republic is clear from the series of
public harangues delivered to its citizen troops during the following

years. In one such oration, Bartolommeo Cavalcanti urged Florentine soldiers to overcome their 'effeminate habits' and regain their masculine *virtù*:

> Scacciamo da noi ogni molle pensiero, spogliamoci d'ogni effeminato habito; non le donnesche delicatezze, ma più tosto la militare antica rozzezza a noi giudichiamo convenirsi.

> [Let us ban every weak thought, let us renounce all effeminate habits; the times require not womanly delicacy, but the military roughness of our forefathers.][54]

The last word of Machiavelli's treatise on war – *vergogna* – attests to an anxiety also expressed by Guicciardini. If Boiardo's *Orlando innamorato* was cut short by the onset of war, Guicciardini's *Storia d'Italia* begins with an account of the disastrous French invasion of 1494. Guicciardini writes of the feeble Italian resistance to Charles VIII that his compatriots showed 'neither virtue nor courage nor good judgement, neither desire for honor nor power nor faith' ('né virtù né animo né consiglio, non cupidità d'onore non potenza non fede'). The episode concluded, he says, 'to the greatest shame and derision of Italian arms, and at the gravest peril and ignominy of all' ('con sommo vituperio e derisione della milizia italiana e con gravissimo pericolo e ignominia di tutti'). Guicciardini describes the calamity of the French invasion in the following terms:

> [Carlo] entrò in Asti il dí nono di settembre dell'anno mille quattrocento novantaquattro, conducendo seco in Italia i semi di innumerabili calamità, di orribilissimi accidenti, e variazione di quasi tutte le cose: perché dalla passata sua non solo ebbono principio mutazioni di stati, sovversionii di regni, desolazioni di paesi, eccidi di città, crudelissime uccisioni, ma eziandio nuovi abiti, nuovi costumi, nuovi e sanguinosi modi di guerreggiare, infermità insino a quel dí non conosciute; e si disordinorono di maniera gli instrumenti della quiete e concordia italiana che, non si essendo mai poi potuta riordinare, hanno avuto facuoltà altre nazioni straniere e eserciti barbari di conculcarla miserabilmente e devastarla.

> [[Charles] entered Asti on the ninth day of September of the year 1494, bringing with him into Italy the seeds of innumerable calamities, of most horrible events and changes in almost the entire state of affairs. For his

passage into Italy not only gave rise to changes of dominions, subversion of kingdoms, desolation of countries, destruction of cities and the cruelest massacres, but also new fashions, new customs, new and bloody ways of waging warfare, and diseases which had been unknown up to that time. Furthermore, his incursion introduced so much disorder into Italian ways of governing and maintaining harmony, that we have never since been able to re-establish order, thus opening the possibility to other foreign nations and barbarous armies to trample upon our institutions and miserably oppress us.][55]

Compounding the shame of military defeat, Guicciardini suggests, is the humiliation of submitting to an unworthy adversary – an opponent who was himself less than a man:

> Perché certo è che Carlo, insino da puerizia, fu di complessione molto debole e di corpo non sano, di statura piccolo, di aspetto ... bruttissimo, e l'altre membra proporzionate in modo che e' pareva quasi più simile a mostro che a uomo.

> [For it is certain that Charles, from boyhood on, was of very feeble constitution and unhealthy body, short in stature, very ugly ... and his limbs so ill-proportioned that he seemed more like a monster than a man.][56]

The ultimate proof of Charles's inferiority is his reliance on artillery, a coward's weapon.[57] This was the first plague he brought to Italy; the second was, of course, syphilis.[58] Both introduced a dimension of bodily vulnerability that was previously unknown. If Italy was feminized by its subjugation to France, its rape was all the more traumatic because it brought sterility and disease. In this context, armour nostalgically figured a virility that was lost.

Castiglione is particularly sensitive to the importance of armour in the male masquerade. If for Goffman all social action is staged, Castiglione describes a society in which this fundamental rule is perversely dramatized. The Cinquecento court is a display culture deeply invested in surfaces. With Machiavelli, Castiglione shares a thoroughly pragmatic focus on the issue of visibility. Like the prince, the courtier must be adept at manipulating appearances to his advantage. These semiotic skills are essential to his political survival.

Italian courtiers of the Cinquecento actually did very little fighting (indeed, this was left to the mercenary troops employed by the prince).[59]

But their identity was nonetheless constructed on the nostalgic principle of the primacy of arms (versus letters) and the fiction that as a social elite they retained this role.[60] A courtier's lack of military experience in the field could be disguised by proficiency in the tournaments and exercises that substituted for actual combat among members of his class. Whatever his actual capability or inclination, he is advised to make the most of the skills he does possess by ensuring that he shows them to best advantage. They must be visible to the prince and to the court at large. This will guarantee that his gestures earn maximum political capital. In Book II of Castiglione's *Il cortegiano*, Federico Fregoso elaborates on the way in which the courtier should practise the profession of arms:

> [P]rocurerà esser nell'arme non meno attillato e leggiadro che sicuro, *e pascer gli occhi dei spettatori* di tutte le cose che gli parrà che possano aggiungergli grazia; e porrà cura d'aver cavallo con vaghi guarnimenti, abiti ben intesi, motti appropriati, invenzioni ingeniose, che *a sé tirino gli occhi dei circonstanti*, come calamita il ferro. (emphasis mine)

> [[He] will strive to be as elegant and attractive in the exercise of arms as he is skillful, and *to feed his spectators' eyes* with all those things that he thinks may give him added grace; and he will be careful to have a horse gaily caparisoned, to wear becoming attire, to have appropriate mottoes and ingenious devices that will feed the *eyes of the spectators* even as the loadstone attracts iron.][61]

Fregoso recommends the cultivation of strategic visibility as a vehicle for social and political advancement:

> Ritrovandosi il cortegiano nella scaramuzza o fatto d'arme o battaglia di terra … dee discretamente procurar di appartarsi dalla moltitudine e quelle cose segnalate ed ardite che ha da fare, farle con minor compagnia che può ed *al conspetto de* tutti i più nobili ed estimati omini che siano nell'esercito, e massimamente alla presenzia e, se possibile è, *inanzi agli occhi proprii* del suo re o di quel signore a cui serve. (emphasis mine)

> [Whenever the Courtier chances to be engaged in a skirmish or an action or a battle in the field … he should discreetly withdraw from the crowd, and do the outstanding and daring things that he has to do in as small a company as possible *and in the sight of* all the noblest and most respected men in the army, and especially in the presence of and, if possible, *before the very eyes of* his king or the prince he is serving.][62]

So familiar was the principle of staged inauthenticity – an art we might now call impression management – that it became fully naturalized as *dissimulazione onesta*. In the Seicento Torquato Accetto wrote a treatise with this very title.[63] *Dissimulazione onesta* was viewed as a practical necessity – a pragmatic response to the political pressures of the Renaissance court.[64] It was legitimated by its specular nature: all parties were engaged in the same practice, mirroring each other in the strategic dance of deception.[65]

A successful social performance depends on moderation in all things. Predictably, then, the theorist of *sprezzatura* suggests that courtiers wear their armour lightly. As Count Canossa remarks, 'We don't wish the courtier to make a show of being so fierce that he is always blustering and bragging, *declaring that he is married to his cuirass*' ('il quale [cortegiano] non volemo però che si mostri tanto fiero, che sempre stia in su le brave parole *e dica aver tolto la corazza per moglie*,' I.17; emphasis mine). A lady replies to a gentleman who has turned down her invitation to dance: 'I should think that since you aren't at war at the moment and you're not engaged in fighting, it would be a good thing if you were to have yourself well greased and stowed away in a cupboard [*armadio*] with all your fighting equipment, so that you avoid getting rustier than you are already'('"Crederei," disse, "che or che non siete alla guerra, né in termine de combattere, fosse bona cosa che vi faceste molto ben untare ed insieme con tutti i vostri arnesi da battaglia riporre in un armario finché bisognasse, per non ruginire più di quello che siate"').

The remark casts a new light on the armour pictured in the intarsia panels of the duke of Urbino's studiolo (Fig. 26).[66] Armour was implicated in an erotics of masculinity that was inevitably linked to political power. It was the vehicle not only for fantasies of mastery and aggression but also for specific territorial and dynastic claims. In a period of extreme political instability and disruption, armour was a site for the inscription of ideology. In particular, it served during crises of succession as a prime vehicle for representing and asserting legitimacy. The most dramatic example, which I will discuss in a later chapter, is that of Philip of Spain, resplendent in armour at the Diet of Augsburg in his bid for the succession to the Holy Roman Empire. But the process was mirrored in many smaller Italian courts, where genealogical claims and political alliances were emblazoned on shields, breastplates, and helmets. These sumptuous objects were luxury commodities, but also part of the symbolic inventory of the court. These works were produced by and emblematic of the ruling elite; their purpose was to reaffirm the

social and political hierarchy. They embodied hereditary privilege and literally magnified invented authority. Parade armour was a forceful symbolic assertion of legitimacy, but also signalled anxiety over maintaining that position of dominance. Like all armour, it simultaneously conveyed strength and vulnerability.

I have used two very different but complementary approaches in this book. Both are provisional and entirely pragmatic. By configuring the material in this way I mean to create not a definitive taxonomy, but a set of working categories that enable me to map certain morphological variations in Renaissance armour. Chapters 1 through 3 develop a typology of armour based on the manner in which it stylizes the body. Reclaiming Bakhtin's opposition between the classical and grotesque body – but complicating it by the addition of a third term – I classify Italian Renaissance armour into three types.[67] The 'classical body' refers to the archaizing costume armour of the Cinquecento, in particular to the muscle cuirass or thorax derived from Roman sculptural prototypes. This armour represents an idealized nude torso and head and is anatomically explicit in every detail (including musculature, ears, lips, hair, and beard). Apart from any vestigial defensive function, it signifies the perfection and completion of the body, and by simulating an unarmed nude paradoxically imitates its own absence.

Chapter 2, 'The Sacred Body: The Armour of Sacrifice,' discusses a second type of armour whose iconography establishes an identification with Christ that implies not the completion but the transcendence of the body. The inscriptions and devotional imagery found on specimens of this type allude not only to biblical accounts of the Incarnation and Resurrection of Christ but also to episodes in the lives of the saints that illustrate the theme of the miraculous body.

Chapter 3, 'The Grotesque Body: Tropes and Apotropes,' analyses a third type of armour which represents a distortion or mutilation of the human body. This armour assumes the form of a demonic mask and uses zoomorphic, abstract, or other apotropaic imagery to intimidate the enemy. It is the oldest of the three types, found in most traditional cultures and closely related to the practice of body painting and scarring. Demonic female imagery also appears on this type of armour, with Medusa the most common shield motif.

Chapters 4 through 6 follow with a three-part study of individual patrons: Guidobaldo II della Rovere (1514–74), Charles V Habsburg (1500–58, HRE 1519–58), and Cosimo I de' Medici (1519–74). Adept at

the material project of self-fashioning, the Holy Roman Emperor was by far the greatest celebrity client of the Negroli dynasty of Milan. I frame his story with profiles of two Italian figures in the orbit of the empire – Italian princes who (with varying degrees of success) sought to ally themselves with power and made deliberate use of armour to cultivate these alliances. The symmetries are striking: Guidobaldo and Cosimo were almost exact contemporaries, with parallel careers. Both came from a secondary (cadet) line of the family and hence were anxious to prove themselves and preoccupied with the question of legitimacy. As I will show, armour proves a sensitive register of such political anxieties.

The choice of patrons should help to clarify the geographical scope of this study. In specifying that I deal with armour in early modern Italy, I mean to identify the provenance of the works, but not necessarily the identity of the patron, as Italian. Given their prestige as luxury objects, parade and ceremonial armours were the focus of a lively international trade. Their nature was to cross boundaries of space, if not of class. The products of an elite culture, they were coveted and collected by the wealthiest and most ambitious individuals in Europe. The finest armourers' own ambitions mirrored those of their clients, ensuring the broadest possible circulation of their works.

This project was undertaken in the spirit of the new historicism, to the extent we can define it; in my view, it has come to describe not a method or procedure but (however uneasily) a style of inquiry.[68] As Greenblatt has suggested, a better term might be the poetics of culture.[69] As I have tried to demonstrate, Renaissance armour is not just a background to literary texts but a vibrant representational practice in its own right.

This study is grounded in the close reading of objects. Since many will not be familiar and only a few can be illustrated here, my topic requires frequent and sometimes lengthy descriptions of individual artifacts. Writing these passages was an important part of the process of learning to look at the works; acquiring the vocabulary itself enabled me to distinguish the relevant features of armour and its iconography. Such direct observation of the physical world was refreshing and is surely indispensable to the work of material culture studies. Consider these passages an homage to the ekphrastic tradition associated with armour from the beginnings of the epic genre. The descriptive mode is more than a rhetorical expedient; it provides access to the material horizons of the Renaissance.

PART ONE

Armoured Bodies

1 The Classical Body: The Poetics of the *Bella Figura*

In a footnote to his discussion of the grotesque image of the body in the Renaissance, Mikhail Bakhtin suggests that for a more thorough understanding of this phenomenon it would be important to 'trace the struggle of the grotesque and classical concept in the history of dress and fashion.'[1] The following three chapters examine the relevance of Bakhtin's categories to the history of armour, which closely parallels the development of male civilian dress and provides a particularly striking illustration of the images of the classical and grotesque body that Bakhtin observed in Rabelais' work.

This chapter will be concerned with what is perhaps the most distinctive type of Italian armour developed in the Renaissance, the classicizing armour *alla romana* exemplified by the 'Medici fragments' in the Museo Nazionale del Bargello in Florence (Fig. 3).[2] The muscle cuirass or thorax reinvented in the Renaissance was of ancient origin, first appearing in Greek tombs of the fifth century BC but not usual until the fourth. The standard schematization of the torso reflected in these fragments of Greek armour, usually made of metal or leather covered with metal plates, seems to have been derived from the sculpture of Polykleitos. As a cultural form, it codified an interpretation of the male anatomy that remained immensely influential into the early modern era. The powerfully articulated musculature, formalized stomach, and rectangular chest reflected a physical ideal that was associated metaphorically with the highest military and moral virtue. The thorax was reserved throughout the ancient world to the highest ranks, and only later in Christian Rome extended to centurions and finally to ordinary soldiers. Its frequent appearance in Roman relief sculpture (most notably in Trajan's Column) testifies to its propagation and prestige in the

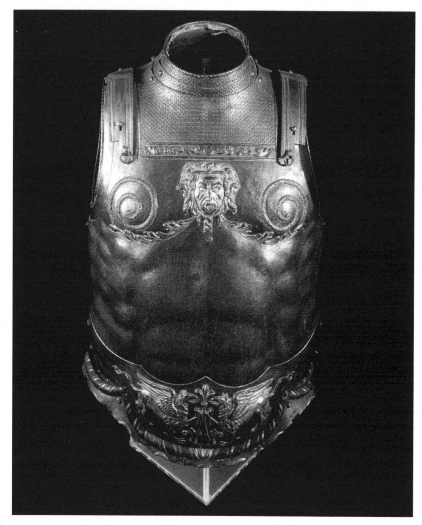

Fig. 3. Roman-style cuirass ('Medici fragments'). Milan, 1545–50. Museo Nazionale del Bargello, Florence.

classical world, and was at the same time a vehicle for its rediscovery in the Renaissance.

Gothic plate armour of the fifteenth century, designed for use on the battlefield, only rarely alluded to Roman forms. It was not until the

independent development of armour for Renaissance pageantry that the muscle cuirass type was revived, first in ephemeral materials (textiles, cardboard, plaster, and wood) and later in the specimens in steel, silver, and bronze that survive in contemporary collections.

Such versions of Roman or pseudo-Roman armour were initially worn only by the attendants in court pageants and processions and not by the princes themselves, who preferred to wear the latest versions of plate armour.[3] Archaizing costume was reserved for the minor players in such tableaux, while the protagonists wore contemporary military dress. This seems to have remained the case throughout the Renaissance in the north of Europe. Despite the high degree of technical skill and ingenuity in the development of field and tournament armour, particularly in such important centres of arms production as Nuremberg, Innsbruck, and Augsburg, interest in classical costume was limited.

In Italy, however, armour *alla romana* was rapidly elevated to the highest form of ceremonial dress. Cosimo I, Grand Duke of Tuscany, was among the first political leaders to be portrayed in classical armour during his lifetime. In Cellini's bronze bust (Fig. 4; completed in 1557, now in the Bargello), he wears a muscle cuirass clearly modelled on Roman sculptural prototypes, embossed with a Medusa mask and confronted griffins similar to those on a third-century bronze statue of the Emperor Lucius Severus in the National Museum in Naples. (The lion-mask pauldrons, although typically a feature of sixteenth-century pseudo-Roman armour, do not appear frequently in classical precedent.) Numerous contemporary portraits of Cosimo depict him in similar versions of archaizing armour.[4]

Among Cosimo's successors, heroic armour continued to be an integral part of both portraiture and pageantry in the Medici court. Although jousts, tournaments, and other war games required specific armour and accessories designed for each event, the processions and entertainments that preceded them made extensive use of Roman costume in increasingly theatrical display. In the public celebration of his marriage to his mistress Bianca Cappello in 1579 (whom he had married secretly a year earlier, less than two months after the death of his first wife in childbirth), Francesco I rode an elaborate chariot and was dressed as Mars. Another chariot displayed a group of sea gods astride dolphins, dressed in ingenious fish-shaped helmets and classical cuirasses painted with scales.[5] Such allegorical processions had traditionally served a propagandistic function in the Renaissance court, but the extravagance of this display (the festivities cost 300,000 *ducati*)

Fig. 4. Benvenuto Cellini, *Cosimo I*, 1557. Museo Nazionale del Bargello, Florence.

suggests that Francesco I felt a particular need to legitimate not only the already consolidated Medici dynasty but more importantly, his new marriage to Bianca Cappello, whose unpopularity among the Florentines had reached a critical point.[6]

The conceit of dressing as Mars served a twofold purpose in Francesco's project of self-legitimation. First, it enabled him to pose as the ancient patron of Florence and hence to identify himself with the city's political foundations and most venerable traditions.[7] More importantly, it enabled Francesco to dramatize his own figurative rehabilitation as an 'epic' hero. If his critics had compared his mistress to Ariosto's Alcina and ridiculed his subjection to the Venetian courtesan, the grand duke now sought publicly to retrieve his abandoned armour and reassert his masculine authority in contemporary Florence. Not by renouncing his lover but by marrying her, Francesco chose to resume his role in the imperial politics of the Medici succession; and like Ruggiero he was lured by the prospect of a male heir (Francesco's first wife, Giovanna d'Austria, had borne him six daughters and one son who died in infancy; Bianca Cappello had simulated several pregnancies and even the birth of a son, who nonetheless had no hope of being recognized as legitimate).[8]

Upon his death eight years later, in the absence of an heir, Francesco was succeeded by his brother Ferdinando. Classical armour continued to play an important role in Medici games and pageants at the weddings of Ferdinando I and Cristina di Lorena (1589), Cosimo (nephew of the Duke Alessandro) and Lucrezia Catani (1603), and Cosimo II and Maria Maddalena d'Austria (1608). On the latter occasion, pseudo-Roman helmets and cuirasses were used in abundance, essential parts of the visual vocabulary of court spectacles and certain of obtaining the desired theatrical effect.[9]

The use of *all'antica* armour persisted despite its increasingly anachronistic effect. At the marriage of Ferdinando II and Vittoria della Rovere in 1637, firearms were introduced in the mock military manoeuvres of a *ballo equestre* (Scalini describes it as 'una sorta di *Gerusalemme liberata* da circo'), and by 1697 pyrotechnic pistol displays were an established component of such entertainments.[10] Armour survived in these contexts, but purely as a theatrical prop, while the firearms cursed by Ariosto had become fully legitimized and embraced by the vestiges of the Renaissance court.

Bakhtin describes the classical body as an image of 'finished, completed man; it is shown from the outside as something individual ... The basis of the image is the strictly limited mass, the impenetrable façade.'[11] Unlike the grotesque body, which is 'unfinished, outgrows itself, transgresses its own limits,' the classical body is autonomous and self-contained; its opaque surface represents 'the border of a closed individuality that does not merge with other bodies and with the world.'[12]

Specimens of the classical thorax type clearly echo this description. This armour, with its careful delineation of a stylized anatomy, represents the perfection and completion of the elite male subject. It monumentalizes the body and enacts a prosthetic fantasy that is essentially sculptural. Armour *alla romana* enables the wearer to disguise the imperfections of his own body and at the same time to project an idealized persona that corresponds to his culture's highest model of proportion and physical beauty. It is a privileged form of male masquerade, simultaneously concealing the contingent identity of the subject and representing him in a heroic and aggrandized mode that reflects the diffused cultural memory of the schematized torsos of Greek sculpture. Dressed in classical thorax, the Renaissance prince recalls Leonardo's drawing of Vitruvian man, that universal model of proportion inscribed in the perfect geometrical forms of the square and the circle; the armour is a cultural catachresis of the image of the 'body enclosed.'[13]

Apart from its primary defensive function, armour has always served to compensate at a symbolic level for human vulnerability – our nakedness among the animals, our lack of claws, fur, scales, and fangs. As armour evolved during the fourteenth and fifteenth centuries into a steel carapace that eventually covered the entire body, it became a metallic alter ego that promised spiritual as well as physical protection. Armour conferred psychological power because it was an expression not merely of physical force but, more importantly, of the technological imagination that is uniquely human. Like the doppelgänger of medieval and romantic legend, a knight's armour accompanied him through life, closely modelled against his form, and promised to take his place in battle, to transform him into an invincible hero.[14]

Classical armour complicates the paradoxes associated with armour by imitating its own absence. By simulating an unarmed nude, the thorax implicitly denies the protection it affords, creating a freestanding monument to the autonomy of the individual. The bronze casques frequently worn with such cuirasses enhance this effect; two extant examples in Vienna (Fig. 5) and Madrid (Fig. 6) represent a young boy and a mature man and are anatomically explicit in every detail (curly hair, smoothly planed cheeks, ears, lips, beard, and moustache). In view of Bakhtin's observations on the classical body, it is significant that bodily orifices, when represented, are closed; the lips on the Negroli casque in Madrid are tightly shut.[15] While the grotesque canon emphasizes those parts of the body that are open to the world, 'the open mouth, the genital organs, the breasts, the phallus, the potbelly, the nose,'[16] the classical

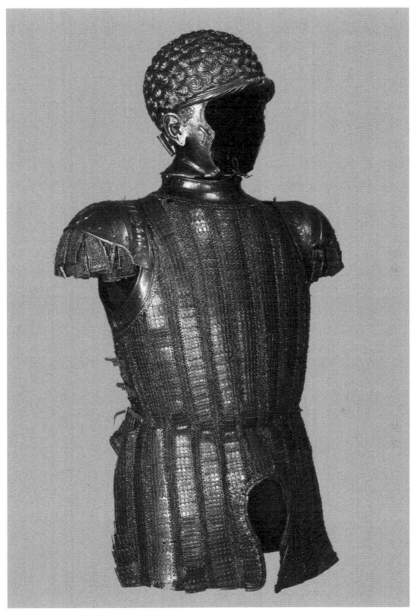

Fig. 5. Burgonet of Francesco Maria I della Rovere, Duke of Urbino. Filippo Negroli, 1532. Rüstkammer des Kunsthistorischen Museums, Vienna.

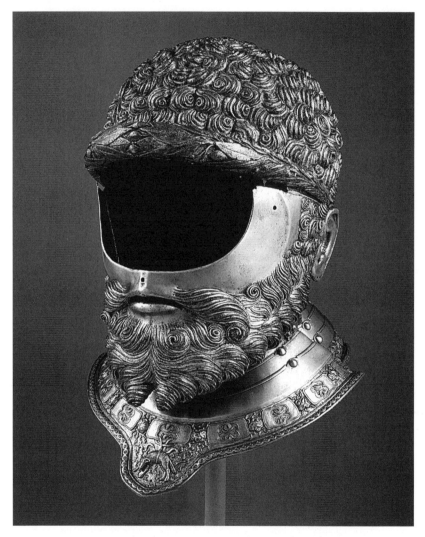

Fig. 6. Helmet of Charles V. Filippo Negroli, 1533. Real Armería, Madrid.

body emphasizes the head as the seat of reason and attributes a leading role to the 'individually characteristic and expressive parts of the body: the head, face, eyes, lips, to the muscular system, and to the place of the body in the external world.'[17] The canon of the grotesque body finds expression in other types of armour, with distended bellies, over-

sized codpieces, and enormous phallic noses, whereas classical armour represents a masculine ideal of stability and decorum, an impenetrable facade, an autonomous form.

The opposition between the classical and grotesque defines two canons 'in their pure, one might say extreme form,' according to Bakhtin.[18] But historically they did not appear in such strict isolation; representations of the body often invoked both conceptions simultaneously. Thus, even the Renaissance thorax – which represents the purest manifestation of the classical body – was enriched (or contaminated) by references to the grotesque. We can examine these by looking at the 'Medici fragments' in closer detail (Fig. 3).

The cuirass consists of an anatomically modelled breastplate and backplate, originally blued and gilt. On each piece a false gorget is incised to represent mail and terminates in a high neck of two plates finished in a twisted rope design. This design is repeated in the right shoulder guard (the left is missing). The breastplate is embossed and gilt with an image of Medusa; two acanthus leaves issue from the central mascaron and terminate in spiralled garlands that accentuate the nipples. The base of the breastplate is embossed and gilt with two confronted griffins bearing a lily. The remaining plate of the fauld repeats the twisted rope design as well as a lily and crescent. The crescent appears again at the centre of the band marking the base of the rectangular gorget, flanked front and back by scrolled foliage designs. The pendant tab attached to the base of the backplate is a later addition; it is decorated with the Medici *palle* and the cross of the Order of Santo Stefano, founded by Cosimo I in 1561 to commemorate the Florentine victory over Siena at Marciano that unified Tuscany under Medici rule.[19]

The classical body articulated in this thorax is thus overlaid with two varieties of iconographic detail: the first heraldic (with reference to the family of the patron), and the second more properly grotesque (Medusa). Scalini has argued that the heraldic emblems on the cuirass itself (but not on the pendant, which he says was added after the armour came into the possession of the Medici) help to prove that the armour was commissioned for a member of the Valois dynasty, and most probably for Henry II on his accession to the throne. While Boccia grants that the lily does not conform to the standard schematization of the Florentine *ireos*, he argues that it is not therefore to be interpreted as a French *fleur-de-lis*. The crescent, he maintains, alludes to the rising fortunes of the Medici after the critical half-century that followed the

death of Lorenzo the Magnificent. The confronted griffins, as previously noted, are Caesarian emblems frequent in Roman Imperial sculpture.

What interests me about such iconographic detail is the way in which it both complements and subverts the representation of the classical body. Heraldic imagery situates the stylized male subject in a network of political relationships and alliances. The monstrous face of Medusa, on the other hand, evokes a broader system of popular and carnivalesque imagery that Bakhtin has characterized as grotesque: the visual language of festive obscenity and abuse that subverts the decorum of the classical body. Like the fantastic helmets sometimes worn with the classical thorax in Renaissance pageantry – shaped like serpents and dolphins and dragons with open jaws – Medusa alludes to the world of fabulous beings and dismembered bodies that merge in the cosmic anarchy of the grotesque. These exuberant inventions can look strangely out of place on the measured planes and modelled surfaces of the classical thorax. While imitating antique prototypes, Renaissance artists were recalling an apotropaic and propitiatory function of grotesque imagery that is virtually universal. Even the most sharply idealized representation of the classical body could not fail to incorporate its opposing conception. The sign of the grotesque was a talisman to ward off precisely the disorder it represented.

Grotesque imagery engulfed armour of the mannerist period, and by the end of the sixteenth century the classical thorax had passed out of fashion. Armour retained its ties to the antique, but its relationship to that example had shifted. Artists no longer fashioned armour in an anatomical mould, as the replica of a monumental classical nude; instead they treated the armour as a surface on which to inscribe multiple classical figures and motifs. Roman soldiers in muscle cuirass reappear in miniature in the embossed medallions and incised borders of breastplates and morions, along with sphinxes and sea horses and clusters of fruit; their arms are dismantled in ingenious geometrical trophies. Classical horsemen join combat in curling acanthus while musical *putti* scramble through ribbons of foliage.

In such designs the classical *exemplum virtutis*, previously imitated on human scale in the form of an anthropomorphic sculpture, is miniaturized and inscribed in a pictorial fashion. The Roman soldier becomes just one of many decorative motifs distributed over the exquisitely worked surface of the armour. The image of the classical body is subsumed into the anarchic play of mannerist ornament, with its free anatomical fantasies and tangle of intertwining forms. If the thorax

simulates the impenetrable facade of the elite male subject, the 'border of a closed individuality that does not merge with other bodies and with the world,'[20] mannerist armour portrays the continuous metamorphosis of a corporate body that forever outgrows itself and transgresses its own boundaries, merging human and animal and vegetable forms, masks and dismembered bodies and fabulous beasts in the endless improvisation of its narrative.

The vogue of mannerist ornament throughout Europe was certainly promoted by the invention of printing; mannerist style flourished in all the decorative arts of the period, and it is ironic that many of the motifs found in armour were borrowed from printed manuals of textile design. An armour by Niccolo Silva, for example, is decorated with a motif of musical instruments derived from Cesare Vecellio's manual of designs for embroidery and lace – women's work, the 'lavori di fuso e ago' scorned by Tasso's Clorinda.[21]

The classical thorax represents a fantasy of stability and closure suitable to the epic hero, while mannerist ornament enacts an open-ended, comic narrative of the grotesque body through the ceaseless, exuberant metamorphosis of its forms. The theme of metamorphosis recurs in another type of armour that can be usefully contrasted to the classical thorax. Tournament armour, developed largely in the sixteenth century, was by its very nature in continual metamorphosis, since it relied on the substitution of individual plates and accessories created for each specific event. The very concept of the garniture – an ensemble of interchangeable prostheses, both offensive and defensive – was antithetical to that of the classical thorax, which was complete unto itself and not subject to further modification. The knight arming for a sequence of *giochi guerreschi* had no stable boundaries; he continually transformed his bodily image by adding and subtracting individual components of his harness. In equestrian games such as the joust or *carriera*, whose object was to thrust the opponent from his horse, the player wore a rigid torso and heavily reinforced arm and shoulder plates that protected the left side of his body and provided a target for the opponent's wooden lance. The weight of his own lance was supported by a reinforced rest fixed to the right side of his breastplate. His saddle had a flat seat to allow movement to the rear, and in games where opponents were not separated by a barrier their horses required blinders to prevent collisions. The knight's own vision was restricted by an enormous helmet that had no visor or other movable parts and only a narrow horizontal

sight. A complete suit of armour for such jousts was extremely heavy and could weigh as much as one hundred pounds. The tilt, whose object was to shatter the adversary's lance, required a different set of equipment, including a special tilting saddle with support at the rear. Foot combat such as the *barriera* called for much lighter armour, with half leg-harness or none at all. Mobility and visibility were of primary importance for such contests on foot, and required accessories of a very different design from those used on horseback.[22]

The asymmetry of armour created for such tournaments is in fundamental contrast with the classical thorax, which represents an ideal of stasis, closure, and symmetry. In this respect the costume thorax contrasts with most field armour as well. Even before the development of the cap-a-pie harness, the knight had always presented an asymmetrical image, since he held his offensive arms in his right hand and used a large shield to protect the left side of his body. When full body armour rendered the shield obsolete, armour still tended to reinforce the left side of the body and allow greater mobility to the right. In fact, there seems to have been no place for the left-handed in combat; although left-handed work and agricultural tools can be found from this period, without exception field and tournament armour was built for the right-handed.[23] Only parade armour such as the muscle cuirass could preserve the illusion that the human body was perfectly symmetrical – a fiction easily disproved by empirical observation.

The classical thorax was a disguise that masked the irregularities of human anatomy and produced an idealized somatic form. It was an image of bodily control and discipline that emphasized not only the athletic prowess of the aristocratic male subject (and by extension, his prowess in war), but also his impenetrability. More than any other kind of armour, it thus embodied an ideal of masculinity inherited from the Roman world – that of corporeal inviolability.[24] If politics was a homosocial spectacle, anatomical armour deflected any suggestion of sexual ambiguity. In a regime of masculinity where sexual penetration was considered demeaning and inherently emasculating, *all'antica* armour reinscribed the boundaries of the elite male body – and betrayed a classic anxiety to defend them.

All'antica armour materializes an ideology of masculinity based on a normative ideal of symmetry, autonomy, and closure. But this fantasy of the paradigmatic male subject is only one of the cultural narratives concretized in armour; other specimens tell a different story, of the body's violation, disfigurement, and sacrifice. Through its inscriptions and iconography this armour invokes the image of the sacred body and expresses an identification with Christ that implies not the completion and perfection of the human form but the prospect of its sacrifice and ultimate transcendence. By wearing this mask and assuming this persona, the subject expresses a will to imitate Christ, to accept and even welcome the violation of the body as the price of its redemption. In this armour, the icon of the classical body is broken; the athlete-hero becomes a passionate victim who aspires not to mastery but to martyrdom.

I will begin to examine this category of armour by considering the range of its inscriptions. On the general matter of armorial inscriptions, it is important to note that written texts as well as images were traditionally an important component in the ornamentation of armour, not only in Europe but also in eastern cultures. As plate armour developed in fourteenth-century Italy, all but the cheapest field armour bore at least the mark of the artisan or workshop that had produced it; the industrialized Milanese armour shops of the fifteenth century employed many specialists, each of whom made only one component of an ensemble and struck his mark on it as a guarantee. Thus it was not unusual to find a single set of Milanese armour that displayed half a dozen different artisan's marks in addition to its primary workshop mark; and inevitably, these signatures contributed to the overall deco-

rative scheme. Another common motif in expensive armours was the name of the patron, rendered as a monogram or heraldic device and occasionally spelled out in full. But apart from such monograms and artisans' marks, it was not uncommon to inscribe longer and more ambitious texts on early modern armour – a matter that should interest the literary critic, accustomed to focusing on ekphrastic descriptions (or 'inscriptions') of armour in poetry but perhaps unaware of the material inversion of this metaphorical practice in the armour of the period.

Most frequently, such inscriptions were derived from the Gospels, and express the ideal of *imitatio* to be enacted by the soldier of Christ. A prime example (Fig. 7) is a late-fourteenth-century composite armour with ornamental brass borders engraved with a verse from Luke (4:30), describing Jesus's departure from the synagogue: IESUS TRANSIENS PER MEDIUM ILORUM IBEAD ('Jesus, passing through the midst of them, went away').[1] On the borders of the basinet, breastplate, gauntlet, and other components of the assemblage, the Gothic script recurs, variously corrupted (IESUM, TRANSIEM, PER M.TE.DIUM.E ILLORUM, ILLORIUM, etc.). Boccia confirms that this verse was frequently inscribed on armour of the period and remained a popular motto for several decades.[2] Occasionally, he notes, the implication was blasphemous, as when the verse appeared on the blade of a sword, to be thrust 'per medium illorum.' From a philological standpoint, Boccia is most concerned with the problems of attribution that result from the frequency of the motif; as he points out, it is impossible to be certain which elements bearing the script originally belonged to a single armour. But from a symbolic perspective, the currency of the inscription suggests its importance as a contemporary gloss on the cultural ideal of the sacred body. Apart from its more cynical applications, the text clearly invokes the protection of Christ for the wearer of the armour and expresses an identification with his sacred body – miraculously resistant to historical vicissitudes yet certain of sacrifice, capable only of deferring death until the appointed time. Like Jesus, driven out of the temple and threatened by an angry mob, the wearer of this armour hopes to pass through the dangers of battle unharmed.

Since the pragmatic purpose of armour was to protect the body, it is not surprising to find this kind of text on actual specimens. It may seem obvious, and even inevitable, that armorial symbolism would incorporate such references to Christ's divinity in order to invoke divine protection for the human body. What is more surprising, at least initially, is the frequency of inscriptions that invoke the opposite principle of

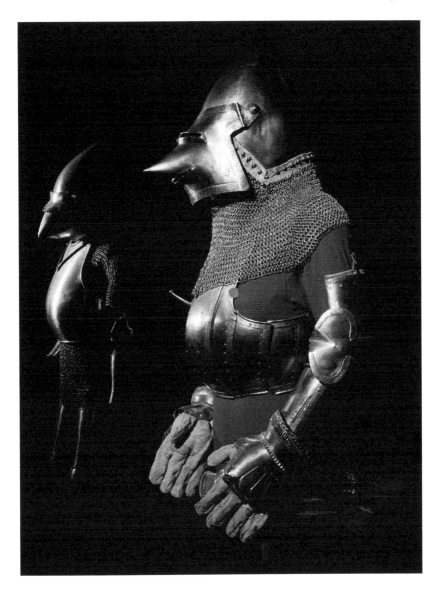

Fig. 7. North Italian composite armour, ca 1390. Schloss Churburg, South Tyrol (Italy).

Christ's *humanity* – his vulnerability to bodily pain, his eventual sur-render to the Crucifixion. Such texts underscore the paradoxical nature of armour itself: simultaneously an expression of power and an admission of vulnerability, an aggressive display of the body and its anxious displacement, both exhibition and masquerade.

Of all the types of armour surviving from the Renaissance, the category I have associated with the sacred body most freely admits and explores this essential paradox. For the double nature of the armoured knight is analogous to the double nature of Christ, both master and victim, divine and human. The centuries of imaginative elaboration accorded to the very concept of the Incarnation – the central mystery of the Christian faith – clearly contribute to the extraordinarily sophisticated play on its metaphorical implications in the ornamentation of early modern armour. And certainly the new emphasis in the Quattrocento on the concept of the Incarnation – what some historians have called a Renaissance incarnational theology – is consistent with the elaboration of this principle in armour.[3]

As a corollary to the citation from Luke, then, we would need to consider the citation from John 19:36, inscribed on a breastplate dated 1510: OS NON CHOMINUETIS EX EO (Not a bone of him shall be broken) (Fig. 8). The text refers to the injunction to the soldiers attending the Crucifixion not to break Jesus's legs as they took him down from the cross. This plea to spare the body is of a very different order from the one considered above. It takes for granted the prospect of sacrifice, asking only that the corpse finally be treated without contempt. Any bravado that might be read into the verse as it appears, out of context, on the polished steel breastplate is quickly undermined by the memory of its scriptural source. In taking up the cross and the example of Christ, the subject is inviting the violation of the body. His armour tells the story of that wilful exposure.

Devotional images as well as inscriptions contribute to the representation of the sacred body. Among the most frequent ornamental motifs on armour are the medallions of saints – etched, incised, or embossed, often on a horizontal band across the breastplate in a *sacra conversazione* format, framing a medallion of Virgin and Child (as in Fig. 8). A light-cavalry armour of Milanese manufacture (ca 1510), now in the Metropolitan Museum in New York, features such an etched band across the breastplate, with the Virgin and Child flanked by Saint Paul and Saint George (Fig. 9). The inscription below reads, CRISTUS RES VENIT IN PACE ET DEUS HOMO FACTUS EST (Christ the King came in peace and God was

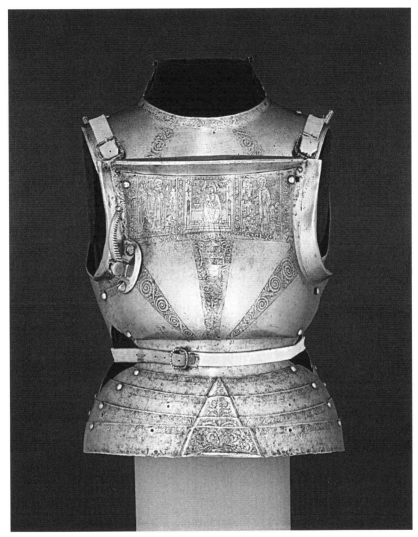

Fig. 8. Portions of a north Italian field armour, ca 1510. Philadelphia Museum of Art.

made man). On the backplate appears the now-familiar legend, IESUS AUTEM TRANSIENS PERMEDIUM ILORUM EST.

Like the texts cited above, these images invoke divine protection and patronage; yet they also allude, often in graphic detail, to the scene of

Fig. 9. Elements of a light-cavalry armour, ca 1510. Metropolitan Museum of Art, New York.

martyrdom. If heroic armour portrayed an invulnerable torso as a sign of moral and military virtue, sacred armour inverts that symbolism in an obsessive display of the *wound* that is proof of the individual's passionate imitation of Christ.

The Christian knight bears these wounds on his breastplate like the wounds he metaphorically inscribes on his body in making the sign of the cross – as a symbol of piety, humility, and reverence. These modelled medallions are his stigmata – overdetermined, always, by the miniature scenes of martyrdom that they illustrate: Sebastian pierced by arrows, Jerome in the desert, Francis of Assisi receiving the wounds of Christ.[4] Paradoxically, the power of the body consists in its disfigurement, and the *ostentatio vulnerum* is a manifestation of strength.

The practice of inscribing armour with the images of martyrs is clearly just one expression of the cult of saints that occupied so much of the imaginative energy of the medieval world and persisted into the Renaissance despite the efforts of reformers. Without attempting to consider the broader implications of this phenomenon, I will discuss a few of the saints and martyrs most commonly represented on armour and suggest why they were specifically invoked in this context.

Patron saints of both cities and individual families are prominent in armour for obvious reasons: they form part of the heraldic hieroglyph that distinguishes an armour as the portrait of a patron. The warrior saints Michael and George are conspicuous both for their specific political connotations and for their more general role as traditional exempla of Christian military virtue.[5] Furthermore, as armoured figures they are logical candidates for illustration on armour; they serve the game of *mise-en-abîme* often evident in the genre.

More directly relevant to the question of the body are a number of other saints typically portrayed on the horizontal band of the breastplate. I will consider them individually, in the context of Jacobus of Voragine's *Golden Legend* (*Legenda aurea*, ca 1270). Whatever its relation to historical fact, this work was central to the hagiographical tradition. Throughout Europe it was the most influential medieval anthology of saints' lives, directly informing subsequent medieval and Renaissance iconography.[6]

Saint Christopher appears frequently on armour, in the episode from which his name supposedly derives (Christo-phorus, Christ-bearer).[7] According to the *Golden Legend*, Christopher (then called Reprobus) was a Canaanite of prodigious size who wished to serve the most powerful king on earth. Having been disappointed by the king of the Canaanites and by Satan himself, Reprobus sought Christ. At the suggestion of a pious hermit who instructed him in the faith, he decided to live alone by a ford where many travellers passed, and to carry over all those who wished to cross. When one day a child appeared on the river bank, the

giant agreed to take him too; but the child grew heavier and heavier, and Reprobus feared they would both drown. At last they reached the other side, where the child revealed that he was Christ; 'Christopher' had thus borne on his shoulders the sins of the whole world.

Saint Christopher was a natural exemplum for the Christian knight, being of superhuman size and strength and devoted to the service of the weak and the poor. He has always been a patron saint of travellers (and more recently of motorists); traditionally his image was made very large on buildings, to be visible at a distance, for it was believed to instill courage and physical strength in the fainthearted. But it is likely that his image was also associated with armour because of its encoded reference to the physical burden, the sheer weight of the armour, which was frequently allegorized as a penance of the Christian knight.[8]

Even the manner of Christopher's martyrdom suggests a peculiar relevance to armour. Again according to the *Golden Legend*, in the course of his persecution by the king of Lycia, Christopher was at one point beaten with iron rods; the king ordered an iron casque to be heated in the fire and placed upon his head, an iron seat made and the saint bound onto it, and a fire lighted underneath. Yet the seat fell to pieces like wax, and Christopher arose unharmed. This elaboration of the legend precedes the development of full plate armour by a hundred years, but in retrospect the story may have proved particularly appropriate to the armoured knight, for it served as a projection of the very natural fear that he might remain trapped by his armour in the heat and chaos of battle, immobilized by the very harness he depended on for protection.[9]

A similar expression of this fear is the fifteenth-century legend of the Devil's Mask armour preserved in Santa Maria delle Grazie in Udine.[10] According to the story a young nobleman, possessed by the Devil, became imprisoned in his armour and was unable to remove it until he made a vow to the Virgin. When at last she released him, the knight donated the armour to the church as a pious atonement. This full-body ex-voto is actually an inversion of the traditional ex-voto, which represents a diseased body part miraculously restored to health. It is an image not of metonymy (the dismembered body) but of synecdoche, in which the integral body of the armour is associated first with possession (a doubling *in malo*, a demonic displacement of the knight's natural virtue) and then with redemption (the recovery of his integrity and identity through the mediation of the Virgin).

It is clear that one function of saints' images on armour is to signify – like the armour itself – the 'doubling' of the individual Christian,

a possession *in bono* by the patron saint who is at once his guardian, guarantor, invisible companion, and higher self.[11] In fact the saints' own extraordinary resistance to pain, their indifference to torture (both physical and psychological) was explained in theological terms as a form of possession.[12] Their impassibility at the time of martyrdom was a case of prolepsis; it anticipated the condition of the glorified body, to which they were already assimilated through the experience of sacrifice.[13] This prolepsis was more than a pictorial convention; it illustrated a serious theological argument. Late medieval and Renaissance paintings of Christian martyrs, serenely withstanding unspeakable torments, can be profoundly shocking to modern viewers. But as Caroline Bynum has argued, like the hagiographical and theological texts that they glossed, these images asserted the literal simultaneity of sacrifice and salvation, and sought to deny the ontological possibility of pain.[14]

The implications of the display of the wound on Renaissance armour are therefore more complex than we might have suspected. In addition to invoking the example of Christ's Passion, this armour invoked the counter-example of the martyrs' impassibility. Armour did not guarantee an exemption from suffering, but at its most replendent it was a *hysteron proteron* that prefigured the condition of the glorified body. It represented a surrogate body onto which the subject's human pain might be miraculously displaced.

The martyrs' virtual anaesthesia was a topos developed in hagiographical narrative as well as the visual arts. To return to Christopher's story in the *Golden Legend*: undeterred (or further provoked) by the failure of his sadistic inventions, the king of Lycia next had Christopher tied to a pillar and ordered four thousand soldiers to shoot arrows at him; but the arrows hung in mid-air, and not a single one touched him. Indeed the king himself was blinded by one of the falling arrows. At last Christopher was beheaded, but not before offering a cure for the king's blindness: he was to make a paste of the martyr's blood and rub it into his eyes. The king recovered his sight, was converted, and resolved that whoever should blaspheme against God or Saint Christopher should at once be beheaded.

Sebastian, another saint frequently represented on armour, survived an equally lengthy and hideous martyrdom. Transfixed with arrows and left for dead by the soldiers of Diocletian, Sebastian was nursed back to health and returned to confront the emperor with a fresh avowal of his faith. Enraged by his 'resurrection,' Diocletian finally ordered him beaten to death.[15]

There is something anticlimactic about the moment of death in these narratives of martyrdom. In view of the martyrs' miraculous resilience, there seems to be no intrinsic reason why any one of these tortures should at last cause their death – except perhaps in the extreme case of James the Dismembered, who after losing all his limbs in ecstatic succession ultimately had little else to lose but his head. Nonetheless, as Bynum insists, the point of these stories is to deny the possibility of bodily partition through the very act of describing it; however horribly they are mutilated, the bodies of the blessed will rise intact. Grotesque as it seems when considered out of context, the tale of James the Dismembered is in this respect prototypical, for severed fingers and toes are the seeds from which glorified bodies will spring.[16]

The very redundancy of the hagiographers' tireless descriptions of dismemberment betrays their anxiety to deny the physical horror of death (and most of all the *summum malum* of death preceded by suffering) through the promise of bodily resurrection. All such torment is meaningless precisely because the body will rise intact at the Last Judgment; it is already redeemed and undone through Christ. Every part of the body is already the whole; the disfigured body remains unblemished. Only the damned will suffer everlasting pain, while the blessed will rise uncorrupt and impassible.

Female saints are rarely depicted on armour, with the significant exception of Saint Barbara. As the patron saint of armourers and makers of firearms, her figure often ornaments armour and guns.[17] Her patronage of firearms is associated with the idea of sudden and violent death, since her father was said to have been struck dead by lightning and his body consumed by fire at the moment when he executed her. More speculatively, we might suggest that Barbara's emblem, the tower in which her father imprisoned her to preserve her chastity, also figures the armour in which the male knight is imprisoned. Although her body (with all its desires) was confined, Barbara's spirit was freed – for she succeeded in admitting a priest, who baptized her a Christian. During her father's absence, she even persuaded the workmen to add a third window to the two in her tower, announcing to her father upon his return that the three windows symbolized the Trinity that had enlightened her soul. Like Tasso's Clorinda (herself cross-dressing in armour), Barbara retains the association with the tower that is simultaneously an emblem of masculine power and feminine enclosure, a sign of both her desire for autonomy and her effective subjection.[18]

The biblical gloss that would seem to account most directly for the use of Christological imagery on armour is the letter of St Paul to the Ephesians 6:11–17:

> Put on the whole armour of God, that ye may be able to stand against the wiles of the devil. For we wrestle not against flesh and blood, but against principalities, against the powers, against the rulers of the darkness of this world, against spiritual wickedness in high places. Wherefore take unto you the whole armour of God, that ye may be able to withstand in the evil day, and having done all, to stand. Stand therefore, having your loins girt about with truth, and having on the breastplate of righteousness; And your feet shod with the equipment of the gospel of peace: Above all, taking the shield of faith, wherewith ye shall be able to quench all the fiery darts of the wicked. And take the helmet of salvation, and the sword of the Spirit, which is the word of God.

This passage was the primary source for the edifying descriptions of armour in medieval manuals of chivalry, in which the various components of the knight's armour were individually allegorized. Paul's text of course refers not to secular warfare, but to the spiritual *psychomachia* of the individual Christian. But as has often been observed, the Pauline allegory was interpreted in an increasingly literal way during the historical evolution of the idea of crusade.[19] As the church grew to sanction and eventually to promote the idea of a holy war, it reinterpreted the spiritual notion of the *militia Christi* and came to identify this force with its own crusading armies. Thus the armour of Christ underwent a radical redefinition through the course of the Middle Ages. Already at the outset of the First Crusade, the allegory was translated into the actual design of military costume: the crusaders emblazoned a red cross on their surcoats and battle standards. As they left for the Holy Land, they were literally signed by the cross.

But the armour of Christ is a conceit that has a less linear development than this set of phenomena would alone seem to indicate. In fact we must trace the origin of Christological imagery in armour not only to the church's political appropriation of Paul, but (at least as importantly) to the network of more purely literary medievalizations of the motif.[20] The textual tradition presents a broad range of treatments of the topos of Christ as knight. The theme appeared in a variety of genres and registers throughout late medieval Europe, both in Latin and in the

emerging vernaculars, and may have had an impact on the iconography of armour itself.

Many early treatments of the topos portray the Harrowing of Hell as a tournament with Satan. Disarmed at the Crucifixion, Christ the knight enters hell fully armed to joust with the enemy who had humiliated him on the cross. Later and more sophisticated versions, including the familiar passage from the *Vision of Piers Plowman* (Passus 18–19) represent Calvary itself as the site of the joust.[21] Here the image of Christ the knight is displaced onto the scene of the Crucifixion. Because it openly exploits the discrepancy between the two iconographical traditions associated with the portrayal of Christ (the older, Byzantine *Christus triumphans* and the new Gothic *Christus patiens*), this variant of the topos is particularly rich in paradoxes and conceits. In its dramatic form, it may also be subtler in tracing the psychological development of the other actors in the Crucifixion; in the York cycle of the Corpus Christi plays, for example, the executioners spontaneously take up the theme of Christ's knighthood as a game. As they mount Jesus on the cross, they imagine themselves in the role of squires arming their lord for the joust.[22]

Most suggestive of all in the context of this discussion is a fourteenth-century poem in Old French by the English friar Nicolas Bozon. Here the Incarnation itself is represented as an *armouring*; it is not the *tortores* who arm Christ for battle on the cross, but Mary who 'arms' him from birth in human flesh. Since this extraordinary text is also relatively little known, I will summarize its argument at some length, in the paraphrase provided by its nineteenth-century English editor:

> A certain king had a lady whom he loved more than life itself, which was shown when he, for jealousy, accepted death at a foredoomed time. He had enclosed her within a strong castle, where she had quite enough to content her. But there came a traitor, who by promises induced her to come away with him, thus sorely wronging the king. The king, who was jealous of her, knew well that through ignorance she had committed this folly. He wished revenge on the deceiver, and to bring back her who had fled. He could have had his army do this, without even coming to battle. But to win back the heart of this eloper, he wished to prove his right claim in her. But his name was so renowned for prowess that the tyrant feared him, wherefore he would never have met him on the field, had the king displayed his own arms.
>
> But the brave knight managed cunningly, taking the arms of one of his

bachelors, who was named Adam, and caused them to be furbished, and caused himself to be armed with them by a maiden. He entered the chamber of this damsel, who was most beautiful, so softly that no one knew it, save the maiden herself.

The damsel clad him in curious armor; for acketon she gave him very white and pure flesh; for worsted and cotton, she put blood in layers; for cuisses and mustiliers, she gave him the fourchure; for iron chausses, the juncture of the nerves. His plates were of bone, which fitted him perfectly; the silken gambeson, the skin over them. On all sides she laid the veins for hemming. For bassinet, she gave him a skull, and for the round of the bassinet, she put the brain within; the ventaile of the hauberk was the fair face, which privately in the chamber the maiden laced.[23]

It is precisely the detail of the anatomical armour that is most arresting. This image of Christ crucified is a chiastic inversion of the classical body: armour and body remain the terms of the comparison, but the vehicle and tenor of the metaphor have been reversed. In other words, both the Renaissance prince in anatomical cuirass and Christ on the cross appear to be stripped – but the prince's nudity is stylized, an elegant fiction, while Christ's nakedness is real and tragic and ineluctable. Christ is armed in human flesh; this negative armour is the sign of his perfect vulnerability.

A final point of interest in Bozon's treatment of the theme, however, is his emphasis that even Christ's human armour is a disguise. He describes the Crucifixion itself in the following terms:

To the king was brought a war-horse, mottled with four sorts of hair: Of cypress the body, the foot of cedar, the back of olive, and high-maned with palm. The king mounted of his own free will, to show his right in the thing claimed. His saddle was hard, and hurt him excessively, but for love of his lady he ignored the pain. The tyrant surrounded the king with his army: the king well saw their lofty pride. He displayed against them the banner of his arms, and thrust toward them the shield which they all hated. It was white, stencilled with gules; in chief his crown of thorny rods; blue the border, with four costly signs. He wore a helmet of red hairs; a hauberk on his back enamelled with scourges; a sword forged from an iron nail, in his hand; and a lance of patience strong and iron-tipped. The tyrant looked at him in great disdain, and the King allowed him to waste his labors … When they came together the battle was hard, so that the earth shook, and the rocks were broken.

Christ's body itself is the despised shield – charged with the instruments of his humiliation and suffering, the *arma Christi* (the crown of thorns, lance, nails, etc.). But Christ's outward 'armour,' stencilled with blood and enamelled with scourges, is only a disguise, as the Devil discovers when he strips the fallen knight:

> When the foreign coat of the disguised king was thus torn, then was the king beneath well armed in his own armor, which was thus devised: Entirely quartered with joy and with life; fretted with power and knowledge and righteousness; in chief a fillet of high dignity; a bend in belief of immortality. When the tyrant saw that it was the king, his courage was much abated, for he had seen him before in his great palace, and knew his power and his just laws. The wretch fled in confusion, and the king descended to a dungeon, where he found his love a captive, who sought his pardon.

By drawing on the language of both armour and armory, Bozon's allegory of Christ as knight raises the question of the iconography of the *arma Christi* in the visual arts. In devotional illustration of the late medieval period, the armour of Christ referred specifically to a repertoire of visual motifs associated with the Passion.[24] The development and codification of this iconography closely paralleled the development of defensive armour itself. It is worth looking at this imagery in the context of the present discussion, if only as a photographic negative of the body of Christ – for as aids to meditation on the Passion, the *arma* designate with increasing precision the space around the absent body of the resurrected Christ.

The essential paradox of the *arma Christi* tradition is the same principle of *ostentatio vulnerum* that we have seen in working armours of the period. More specifically, the paradox of the *arma Christi* motif is implicit in the ambiguity between the subjective and objective genitive in the Latin phrase: because of his role in the Redemption, Christ is both the agent and victim of the Passion, and the weapons used against him become the emblems of his sovereignty. Foremost among these *arma* is of course the cross;[25] but the vocabulary of the *arma Christi* was enriched and extended throughout the thirteenth century to include all the primary and secondary instruments of the Passion (lance, crown of thorns, rod with sponge, nails, scourges, bucket of vinegar, column of the flagellation, robe, pincers, hammer, ladder, and dice).

Subsequent amplifications of this established list of topoi swelled the

catalogue of *arma Christi*. During the fourteenth century such inventions were added as the bandage for Christ's eyes, his loincloth, the pieces of silver, the cord that tied him to the column of the flagellation, the column on which Peter wept after the denial, the curtain of the Temple, the lanterns of the seizure, and the sword with which Peter cut off Malchus's ear.

The rhetorical invention of *arma Christi* parallels the physical 'invention' of a host of Passion relics and their translation to the West, particularly due to the Crusades.[26] As each relic was (more or less officially) recognized, it joined the ranks of the instruments to be represented in the genre of the *arma Christi*. This field of visual motifs was increasingly overdetermined; it was dazzlingly redundant, a colossal synecdoche of the scene of the Passion. In fact the only element missing was, necessarily, the body of Christ, for no part of Christ's body could logically be found or 'invented' on earth, since (like the body of the Virgin) it was already fully risen. In the genre of the *arma Christi* (as opposed to the more straightforward narrative illustrations of the Crucifixion that it both complemented and displaced), Christ's body could only be rendered as an absence. Playing (like the poet Bozon) on the ambiguity of the word *arma* (which referred to armory as well as armour, coats-of-arms as well as weapons), visual artists increasingly portrayed that absence as the blank ground of a shield, charged with the mock-heraldic devices of Christ.

The majority of those devices, as I have shown, represented contact relics ostensibly retrieved from Calvary; bodily relics of Christ were considered heretical.[27] But it may be objected that parts of Christ's body were indeed included among the *arma*: most conspicuously, the wound in his right side. In early illustrations of the *arma Christi* this appears in flamboyant isolation, as a disproportionately large, stylized lozenge.[28] The four wounds on Christ's hands and feet also occur among the *arma*; they are usually pictured as nails or bleeding roses. But Christ's wounds are by definition the only parts of his body that can be displayed in the genre, for they signify, precisely, the absence of body, and therefore must be represented not naturalistically but iconically (the lozenge), metonymically (the nails), or metaphorically (the four roses).

A rhetorical analysis of the *arma Christi* genre would proceed from the level of invention (its vocabulary of topoi) to that of disposition (the principles governing their combination and distribution in the visual field). Early versions of the *arma Christi* are essentially paratactic in structure (characterized by a random array or succession of motifs,

with no discernible order or consistent scale), while later versions are rhetorically more sophisticated, with a higher degree of logical and figural subordination. We can easily see that the static hieroglyphs or pictograms of the thirteenth century, where the isolated emblems float freely in space, are very different in spirit from the bundled trophies of arms in later versions or extreme examples like the Buxheim Altar (ca 1500).[29]

As the genre develops historically, artists attempt to compensate for the high degree of disorder inherent in its subject (literally, the absence of body) by introducing new principles of visual organization. I have argued that the *arma* are not reassembled in any overtly naturalistic fashion, and that the principles of heraldry more often dictate their design; the surrogate body of the shield replaces the absent body of Christ. Thus the *arma Christi* image is simultaneously a figure of metonymy and synecdoche. It both celebrates and denies the fact of bodily division and fragmentation that it illustrates.

Relics themselves were of course caught up in the same contradictions; as Bynum has shown, they were used to signify a variety of 'truths' about the body that were mutually exclusive.[30] The relevance of relics to armour will become clearer when we consider their essentially rhetorical nature. Like *arma Christi* pictures, they were elaborately coded representations of the body and fundamentally ambivalent artifacts.

From a secular viewpoint, relics might seem to represent the inverse of armour: bits of gristle and bone, inert fragments of matter that absurdly belie the integrity of the body. But whatever their mode of display (ironic or celebratory) and whatever their artistic, political, or liturgical treatment, relics were always rhetorically charged and constructed. The practice of wearing holy bones as talismans, for example (fashionable among the pious rich in the fourteenth century) made the highly political point that such objects could legitimately be held (and indeed handled) as private property.

In the course of the fourteenth century a new type of reliquary evolved in Western Europe which imitated the specific shape of the body part it contained. Previous artistic treatments of relics had been considerably more generic and literally opaque; they hid the relic from view and did not allude through their form to the nature of their contents. In contrast, the new style of reliquary was both figuratively and materially transparent; panes of glass revealed the body parts inside. One gold reliquary of the late Middle Ages is not only shaped like a hand, but appears to be wearing extravagant rings: the 'jewels' are actually

glass windows exposing the finger bones. This reliquary is like an iron gauntlet gone mad; it is the precise inversion of a human hand. Yet each type of reliquary (opaque or transparent) is an emblem of the glorified body; both artifacts recast the body in incorruptible metal, and both allude in different ways to the possibility of its resurrection. Armour, built to be reassembled, is an ideal working model of the resurrected body, while the reliquary compensates for its inherently fragmentary nature by pointing to the precious bones that it preserves.

I have suggested a homology between armour and relics as cultural constructions of the body, a complicity also apparent in legend and literature. Both Durendal and Joiuse, the swords of Roland and Charlemagne, were said to have sacred relics embedded in their hilt. The poet of the *Chanson de Roland* says that Durendal enclosed a tooth of Saint Peter, the blood of Saint Basil, the hair of Saint Denis, and a scrap of clothing from the Virgin, while Charlemagne had the metal point of the centurion's lance set in the golden pommel of his sword. The political importance of such sacred relics cannot be underestimated. In fact the turning point of the First Crusade was said to be the discovery at Antioch of a relic of the Holy Lance.

In exploring the relationship between armour and the sacred body, I have focused primarily on defensive armour. It is significant, however, that a last avatar of the armour of Christ is an overtly offensive weapon. As body armour disappears in the late Renaissance, firearms inherit its Christological imagery. A most eloquent instance is the seventeenth-century cannon in the courtyard of Florence's Museo Nazionale del Bargello, created for Ferdinand II de' Medici by Cosimo Cenni: the breech of the massive weapon is adorned with a mask of Saint Paul. At a time when Catholic missions were rapidly expanding, this was a dramatic metamorphosis of the sacred body and an aggressive reinterpretation of the Pauline injunction to put on the armour of Christ. The Catholic arsenal was not limited to defensive armour now; artillery itself was enriched with sacred ornament, suggesting the divine sanction of its its imperial designs.

3 The Grotesque Body:
Tropes and Apotropes

In one of the most memorable scenes in the *Iliad*, Priam's infant son Astyanax is terrified by the sight of his father dressed for battle in a helmet with a horsehaired crest:

> Hektor held out his arms to his baby,
> who shrank back to his fair-girdled nurse's bosom
> screaming, and frightened at the aspect of his own father,
> terrified as he saw the bronze and the crest with its horse-hair,
> nodding dreadfully, as he thought, from the peak of the helmet.[1]

The scene dramatizes armour's apotropaic function: the warrior's armour is so fearsome that he becomes unrecognizable, even inhuman.

The armour I associate with the grotesque body employs a defining strategy of distortion or mutilation of the human form. This armour frequently assumes the form of a demonic mask and uses zoomorphic, abstract, or other apotropaic imagery to intimidate the enemy (Fig. 10). It is the oldest of the three types of armour that I have described, found in most traditional cultures and closely related to the practice of body painting and scarring. Demonic female imagery also appears on this type of armour, with Medusa the most common shield motif. Clearly there are many intersections between this category of armour and carnival costume. In a world turned upside down, the warrior arms himself not with an idealized but a deformed image of self.

My use of the term grotesque in this historical context also implies a specific association with the design vocabulary inspired by the sixteenth-century rediscovery of the frescoes in Nero's Domus Aurea.[2] In fact, parade and festival armour is an important vehicle for mannerist

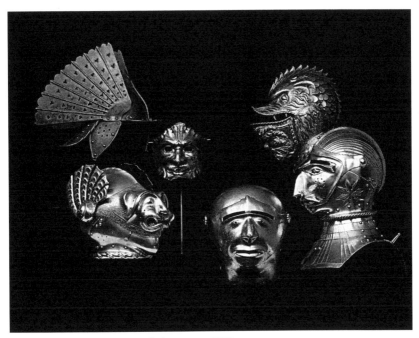

Fig. 10. Multiple grotesque helmets, ca 1550.

imagery and a rich field in which to observe its many variations.[3] Mannerist design was a festival of hybridities – a world of fabulous beings and dismembered bodies, a tangle of intertwining forms. In this sense it enacts in miniature the subversion of classical decorum that is characteristic of the broader category of grotesque armour that I will address in this chapter.

Medusa, the epitome of the apotropaic object, was the most ancient blazon on warriors' shields.[4] In a phase of exuberant iconographic invention, it remained the most frequent image on Italian parade armour of the Cinquecento.[5] Because it unites the logic of apotropea with the paradox of gender play, this visual motif is especially well suited to illustrate the relationship of grotesque armour to the cultural performance of masculinity. The image that Freud associated with male fear of castration was endowed with undeniable power.[6]

Medusa's homeopathic magic is described in countless texts in the Western tradition. The essential story of her rape, monstrous transformation, and decapitation was familiar long before its many variants

were moralized by medieval and Renaissance mythographers.[7] Versions of her story concur in describing her power to petrify the beholder – a power appropriated by Perseus, who used her severed head as a shield. The *Iliad* tells how Perseus gave the relic to his protectress Athena to wear on her aegis.[8] Agamemnon is one of many warriors in epic who wore her image on their armour.[9]

Renaissance armourers honoured this paradoxical tradition by emblazoning shields, breastplates, and helmets with the mask of Medusa. This ornamental motif did not feminize a prince or *condottiere*: on the contrary, it played a central role in constituting his masculinity.[10] The perfect *vir* augments the classical body (mimed in anthropomorphic armour) by carrying a woman's face into a battle (or its fantasy equivalent). This feminine image is an uncanny double that symbolically precedes and conceals him, deflecting the enemy. In parade armour, Medusa becomes a political apotropaion, a symbol of the power of the state.

Ovid's tale of the wedding of Perseus and Andromeda further illustrates Medusa's role in the mythic construction of masculinity. Boasting at his wedding banquet of how he slew the Gorgon, Perseus is confronted by a rival suitor. It is only by raising the Gorgon's head that he defends his prize, turning his enemies to stone.[11] Perseus is helpless without his miraculous trophy. Indeed, his power resides in the mask of the woman he has mastered through a ruse; he is condemned to wear her image as a mark of humility, to show that his faculties derive from a surrogate. In this sense, the Perseus role play implicit in Medusa-blazoned armour entails a curious admission of vulnerability. The valiant hero described in the myth needs considerable apparatus – a veritable trousseau of equipment, apparel, and devices designed to approach and circumvent his adversary. Not only does he steal the single shared eye of the Graeae to extort the magic helmet, winged sandals, and satchel in which to hide his dangerous trophy; he also requires Athena's shield, Hermes' sword, and the ultimate trick of averting his gaze. Perseus accomplishes his task only by indirection and multiple forms of mediation, and throughout the process of his heroic performance, like the armoured knight he is hiding. Reflecting on the ironies implicit in the Perseus myth, Cixous laughs at this convergence of heroism and cowardice: 'Look at the trembling Perseuses moving backward toward us, clad in apotropes. What lovely backs! Not another minute to lose. Let's get out of here.'[12]

No doubt oblivious to such implications, Renaissance armourers returned frequently to the Medusa motif. An especially opulent Medusa armour of the Cinquecento is the parade shield made by Filippo and

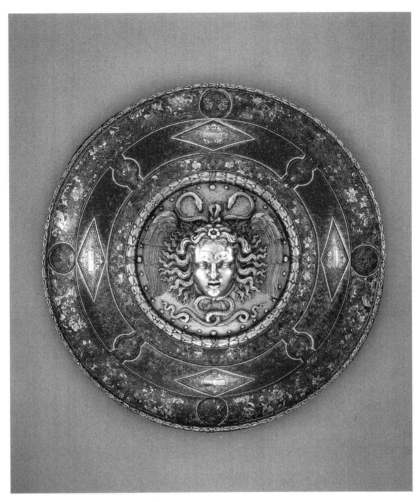

Fig. 11. Medusa Shield of Charles V. Filippo and Francesco Negroli. Real Armería, Madrid, 1541.

Francesco Negroli for Charles V in 1541 (Madrid, Real Armería, inv. D 64) and presented to him personally during his second visit to Milan (Fig. 11).[13] Like a protuberant evil eye, the silver umbo embossed with Medusa's head projects in high relief from the darker plate to which it is riveted. To suit an emperor the armourers designed an unusually precious portrait of the severed head: framed by wings like a Renaissance *putto*, she wears a flower on her forehead while two confronted snakes

ring her face, their tails tied by a ribbon under her chin. Her wavy hair floats around her face in overlapping locks; her pupils are rolled back in the head and her brows are furrowed; her full lips are parted above a cleft chin.

The surrounding shield is articulated by a complex array of geometric motifs bordered by laurel wreaths embossed in silver. Three concentric bands are ornamented with damascened foliate scrolls, recessed medallions, and raised panels. Set within the panels are cartouches with the Latin inscription: IS TERROR/QUOD VIRTUS/ANIMO ET FOR/TUNA PARET (This object inspires terror, for worth is shown through courage and fortune). The uncanny residue of heraldic motifs specifically identified with the Holy Roman Emperor is legible in the medallions distributed on the perimeter of the shield: the outlines and attachment points of the bicephalate eagles and columns of Hercules remain, although the gold appliqués themselves have been lost or removed (there are other signs of vandalism on the shield).

The artists' pride in this extravagant confection is clear from the gold damascened signature and date on the inside of the shield.[14] Pyhrr and Godoy point out that the signature is positioned to confront the bearer of the shield and served to proclaim the paternity of an especially valuable work.[15] They note too that the eight axes described by the shield's ornament ingeniously converge between Medusa's brows, at the bridge of her nose: creased with wrath, it is in flagrant contrast with the smooth planes of the face (and for that matter, with the Botox-immobilized brows to which we have become accustomed). This icon of femininity is treasured (and feared) precisely because of its capacity to express emotion – a quality that the male appropriates and mimics by holding this image in front of him as he advances (in this case, in a purely ritualistic act of display).

Another Medusa shield that has been much admired (and until recently associated with Charles V) is the one acquired by the Archduke Ferdinand II for his armoury in Ambras (Fig. 12), now located in Vienna (Kunsthistoriches Museum, inv. A 69a).[16] What distinguishes this specimen is the lavish use of gold against a blue-black field (especially to frame the central Medusa head) and the dense play of ornament in the surrounding bands, incorporating multifigured scenes copied from Quattrocento engravings of classical reliefs. The frieze of musical instruments and military trophies is conspicuously updated by the inclusion of a cannon – a reminder of the technological advances that had begun to render armour functionally obsolete, displacing it into an aesthetic and symbolic mode. Although iconographically com-

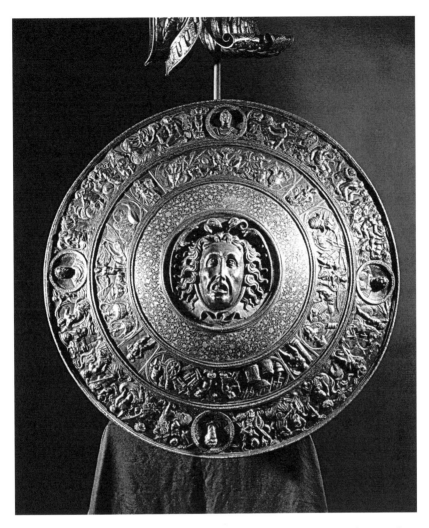

Fig. 12. Medusa Shield. Milan, ca 1550–5. Rüstkammer des Kunsthistorischen Museums, Vienna.

plex and ambitious, the unsigned shield is no longer attributed to Filippo Negroli; certainly it was made by an artist aware of his example.

A number of other specimens (including an exquisite Medici parade shield in the Museo Nazionale del Bargello in Florence, inv. M 956) show the popularity of the Medusa motif in armour design of the early Cinquecento (Fig. 13). Later examples demonstrate the persistence of the

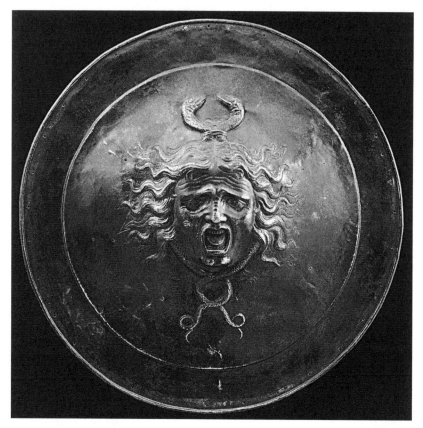

Fig. 13. Medusa Shield. Filippo Negroli. Museo Nazionale del Bargello, Florence.

theme. The Milanese parade shield ca 1570–80 in the Musée de l'Armée in Paris (inv. I 75) is notable for the contrast between the Gorgon's grimace and the jewel on her forehead.[17] Cellini's embossed oval silver shield for Francesco de' Medici features a glittering Medusa between the portrait medallions of the grand duke and Bianca Cappello.[18]

A different way to incorporate the Medusa motif into armour was to embed the image in a narrative scene portraying the achievements of Perseus. An exquisite mannerist parade shield in the Bargello (inv. M 757) features a tiny gorgon embedded on the hero's shield in the depiction of his rescue of Andromeda.[19] Such treatment of the Medusa theme was not uncommon in parade shields; at least four others are known, including two at the Metropolitan Museum in New York (inv. 14.25.780

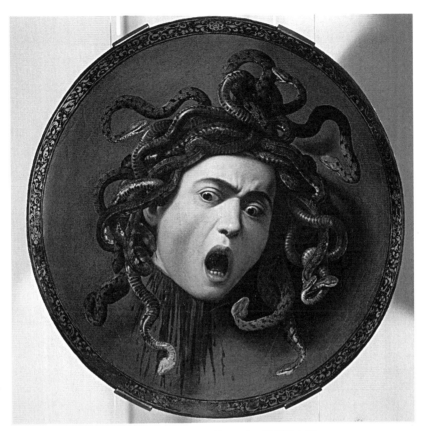

Fig. 14. Caravaggio, Medusa Shield. Galleria degli Uffizi, Florence.

and 04.3.261) and two at the State Hermitage Museum in Saint Peters-burg (inv. 3511 and 6154). The Bargello shield is notable, however, for its sophisticated self-reflexive play with armour as a narrative subject; the reverse is worked with scenes from *Iliad* 18 and 19 portraying the gift of Achilles' shield (first as Vulcan delivers it to the nymph Thetis, and then as she presents it to Achilles). If this Renaissance shield was itself a gift, it reflects on the epic tradition of bestowing armour in an especially ingenious way, reminding its owner of his debt to both the donor and the artist every time he lifted the shield onto his forearm and assumed the heroic persona that it illustrated.[20]

Of all Medusa images of the Renaissance, perhaps the most familiar is Caravaggio's *rotella* in the Galleria degli Uffizi (inv. 1352) (Fig. 14).

Now extensively restored, it was the subject of a recent exhibition.[21] To contemporary readers this work may be best known as the focus of Louis Marin's reflections on the art of visual representation in his 1977 study, *Détruire la peinture*.[22] To vie with a (now lost) Medusa shield by Leonardo, Caravaggio devised a virtuoso treatment of the subject, mounting his illusionistic canvas on a circular wooden shield. Blood spurts from the severed head, which is writhing with snakes. Shadows make the convex surface of the shield appear concave, like a tray at the executioner's side (Caravaggio attended public executions to study the physiology of decapitation; crowds were transfixed by the spectacle and the alleged Medusa effect of the dying man's gaze).[23]

The spectacular work was given by Caravaggio's patron, the Cardinal Francesco Maria del Monte, to Ferdinando I soon after its completion in 1598 and displayed in the grand-ducal armoury. At some point (the chronology is still disputed) the shield was incorporated into a theatrical *mise-en-scène* at the heart of that collection, held by the mannequin of a Persian warrior shown jousting with another armoured knight.[24] These life-sized figures were surrounded by over sixty parade armours, artillery, and assorted weapons from around the world – Europe, the Orient, Africa, and India. The arsenal was pure theatre, a *Wunderkammer* of weapons (including the alleged sword of Charlemagne) designed to impress visitors to the Medici court. The mannequins themselves were apparently gifts from Abbas the Great, the Shah of Persia (r. 1596–1628), who had hoped to win an alliance with Tuscany against the Turks.[25] Caravaggio's Medusa was thus given pride of place in a striking narrative ensemble reflecting European curiosity, fear, and admiration of the Islamic world. With other prodigies of art and nature (a giant magnet, a bird of paradise with jewelled collar, Indian feathers, coral, and sea horse tails), the shield reflected the exotic beauty and danger of all that is excessive and unknown. The shah's diplomatic mission was partly aborted and ultimately unsuccessful, but his armoured mannequin continued to brandish Caravaggio's shield until the dispersal of the Medici armoury in the eighteenth century.

Both Giambattista Marino and Gaspare Murtola wrote poems describing Caravaggio's parade shield. Marino includes an ekphrasis of the object in his virtual museum, *La galeria*, praising the shield as an apotropaion with the power to petrify Cosimo's enemies.[26] Even today the work retains its apotropaic power, seducing and confounding theorists of representation.[27] Both a pictorial image and a sculptural object, it mesmerizes the viewer with its many contradictions – not least its

double trick of casting the beholder simultaneously as Medusa (mirrored in the moment of her decapitation) and the warrior Perseus (foolishly contemplating the severed – but still deadly – head of his victim). The final irony, of course, is that Caravaggio's Medusa has the painter's own features: this classic image of the infernal feminine is the self-portrait of a man.

Apart from the Medusa theme, apotropaic imagery in armour was often zoomorphic. Such armour reverses the valence of the classical thorax by implying a descent in the chain of being – not transcendence of one's physical nature but a willed identification with lower animal forms. Again, we might associate grotesque armour with an Ovidian concept of the body (based on continual metamorphosis and improvisation) intrinsically opposed to the Virgilian norm of piety, stoicism, and stability. If classical armour represents an image of normativity – a reification of the civilized *habitus* – grotesque armour is inherently subversive. In these objects, ideology is undermined by play. Monstrous images disrupt the performance of epic masculinity by their ludic, even magical associations. But they also express mockery, contempt, and aggression. The phallic insult of the laughing codpiece in Schloss Churburg (South Tyrol, Italy) could not be more apparent (Fig. 15).

With a handful of exceptions (associated mostly with heraldic imagery), the animals portrayed on grotesque armour exist only in the imagination. As Roger Caillois observed in his study of the evolutionary adaptations of insects, throughout the natural world the most effective disguise is to resemble nothing at all. Certain insects engage in cross-species mimicry to terrify and fascinate both predators and prey; by changing their appearance they provoke 'an imaginary terror not corresponding to any real danger, a threat pure and simple, working through the strange and fantastic.'[28] In armour, too, the most sinister appearance is often the most fanciful. Mannerist armour stages a pageant of zoomorphic inventions: hybrid creatures composed of horns, fins, scales, and wings – an assortment of appendages and excrescences that combine to menacing effect. Italian Cinquecento armour is filled with such boundary creatures, apparently bred from a promiscuous company of reptiles, fish, mammals, and birds.

Leonardo created the prototype of such grotesque armour in the *animalaccio* described in Vasari's tale of the artist's life.[29] Given a crude wooden shield to decorate, Leonardo decided to invent an image that would terrify anyone who saw it, producing the same effect as the head

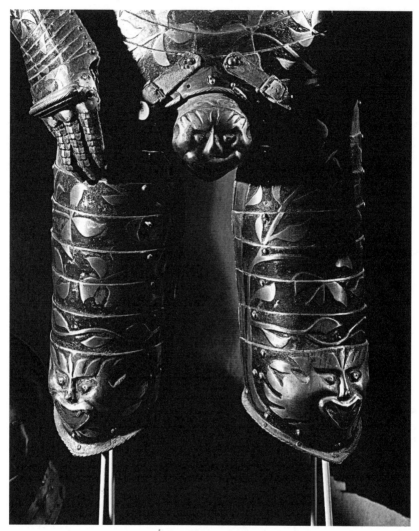

Fig. 15. Detail of armour with grotesque codpiece and poleyns, 1550–60. Chur-burg, South Tyrol (Italy).

of Medusa. The painter retreated into his study, surrounded by lizards, serpents, butterflies, locusts, bats, and other creatures, where he set to work: '[F]rom all these he took and assembled different parts to create a fearsome and horrible monster which emitted a poisonous breath and

turned the air to fire. He depicted the creature emerging from the dark cleft of a rock, belching forth venom from its open throat, fire from its eyes and smoke from its nostrils in so macabre a fashion that the effect was altogether monstrous and horrible.' In fact, Vasari tells us, 'Leonardo took so long over the work that the stench of the dead animals in his room became unbearable, although he himself failed to notice because of his great love of painting.' The finished work was so lifelike that it terrified his father, who had come to claim it on behalf of the original client. In a typically Vasarian twist, Piero substituted an ordinary painted shield bought from a pedlar and sold his son's marvellous painting at a healthy profit; these merchants resold it to the duke of Milan for three times the sum.

Many grotesque armours were complemented by crests in perishable materials that enhanced their monstrous effect. Although few of these crests have survived, written and iconographic records show that they were composed of lightweight materials like textiles and leather and adorned with horns, bones, antlers, and feathers. These metonymic allusions to real and mythical beasts comprised an improvisational and entirely unregulated outgrowth of heraldry. Apart from their decorative and totemic value, these crests served the rhetorical purpose of aggrandizing the individual by exaggerating his stature.[30] Lucio Piccinino's helmet for Alessandro Farnese precariously supports such a crest, depicting a harpy sculpted in bluesteel, gold, and silver (Fig. 16).

Visual artists associated such fantastic costumes with the ancient world. A Salviati drawing of 1550 portrays a helmet of pseudo-Roman inspiration, combining Medusa masks on the cheekpieces with a dolphin brim and ostrich plumes.[31] Another drawing from the same period imagines a towering helmet in the form of a dragon worn astride the head.[32]

Medusa, of course, had a family relationship with monsters and chimeras. Born of sea gods, the Gorgon sisters had scales, tusks, and wings before Athena endowed Medusa with a headdress of serpents. Medusa's own offspring – born from her blood at the moment of her decapitation – were chimeras as well: the winged horse Pegasus and the giant Chrysaor, who would sire triple-headed Geryon.

In the carnival of animals portrayed in grotesque armour, even horses masquerade as other species. The Milanese-produced chanfron of the Dauphin Henry II of France (Metropolitan Museum, inv. 04.3.253)

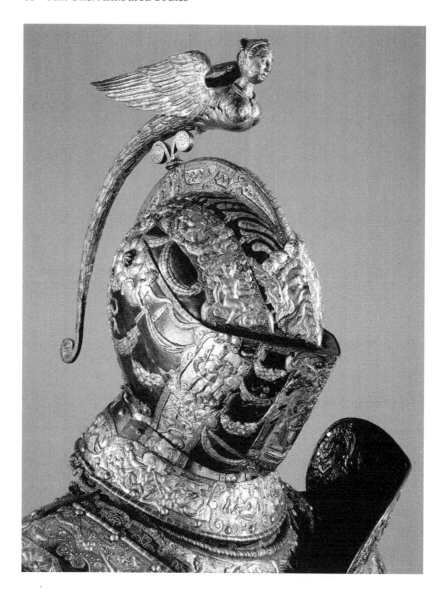

Fig. 16. Helmet with harpy, from the armour of Alessandro Farnese, by Lucio Piccinino. Rüstkammer des Kunsthistorischen Museums, Vienna.

transforms the horse into a dragon, with a rippling snout and embossed teeth.[33] Further complicating the hybrid animal imagery are the multiple dolphins on the eye flanges and at the base of the main plate; these allude, of course, to the owner's status as heir to the French throne. (The chanfron was probably worn during the visit of Emperor Charles V to France in 1539.) Contemporary drawings illustrate the effect of such armours when worn with full pageant costume: Jacopo Bellini's drawing of a mounted knight shows the animal at full gallop, with a bat-winged peytral, curly tail, and plumed crest.

Because the warrior and his mount embodied a continuous being, a single 'identity machine,' they often wore a coordinated ensemble with matching motifs.[34] In such costumes, *cavallo* and *cavaliere* engage in synchronized shape-shifting. The royal armoury in Madrid is an especially rich collection of parade armours with matching bards reflecting complementary mechanisms of masquerade.

Armour, like all forms of technology, illustrates the evolutionary desire to exceed the limits of the species. Caillois has pointed out intriguing parallels between the behaviour of humans and insects – particularly caterpillars, butterflies, and moths, which use Medusa-like *ocelli* to fascinate and repel predators. He notes, however, that 'the insect … acquires [eyes, circles, and masks] as part of the morphology of the species and carries them as an indelible part of its organism,' while humans develop prostheses that can be taken up and removed at will.[35] Armour is one such prosthesis, with both a defensive and aggressive function – used for disguise, mimicry, and intimidation as well as for bodily protection. As it evolves into a carapace covering the entire body, armour mimes the development of certain species of mollusks and insects, acquiring an ornamental surplus that exceeds its original purpose and retains the value of a mask – sinister, predatory, and disturbing. As in the insect world, this mask is an attribute reserved to males.

I have shown that classical armour is often anthropomorphic, projecting an anatomical ideal of symmetry and proportion. But there are also examples of anthropomorphic armour in a grotesque mode, portraying an individual who looks menacing or abusive. An anthropomorphic burgonet of particular interest as an example of this type is the steel and gold helmet by Filippo Negroli and his brothers, dated 1538, now divided among collections in Florence, London, and Leeds (Fig. 17).[36] This helmet offers two costume options: the buffe is fixed in an expression of contempt, with wrinkled nose and pursed lips. On the peak a

Fig. 17. Buffe of grotesque burgonet. Filippo Negroli and brothers, 1538. Museo Nazionale del Bargello, Florence.

bloated satyr-like face sticks out its tongue while the eyes roll upward in a lewd grimace. The teeth are exposed and the bushy twirled moustache and large ears are encrusted with leaves. The cheekpieces are decorated with lions, scrolls, masks, and dragons. Both faces (on the upper and lower plates) are edged with gilt leaves; apparently there was also a gold comb embossed with scales. This double mask, with its coarse, goat-like features and mocking leer, is the Dionysian counterpart of the bearded buffe made for Charles V (also by Filippo Negroli) which projected such statesmanlike calm and authority (Fig. 6).[37] The circumstances of this strange commission are not clear, but one theory is that it was part of a costume made for Francesco Maria della Rovere on his appointment as captain of a Holy League against the Turks. The grotesque mask would express derision and defiance of the infidel. Ironically, its only public appearance was on the duke's catafalque; he died before the campaign began. It was natural that the *condottiere* would be dressed in his finest armour (and most recent commission) for the occasion, but it is hard to imagine a more incongruous funeral costume.

The resemblance between such anatomical buffes and Japanese

mempo is striking, especially to modern observers who have seen them together in collections such as the Museo Stibbert in Florence.[38] It is tempting to imagine a connection, but we have no evidence of direct influence. As Pyhrr and Godoy point out, there is no record of Japanese objects in European collections before the 1580s, when the first Japanese visitors arrived in Europe.[39] Though it may be coincidental, the similarity between the two traditions has continued to intrigue collectors.

An especially rich collection of grotesque visors and helmets is in the Kunsthistorisches Museum in Vienna. Many were collected by Ferdinand II for his Armoury of Heroes at the Castle of Ambras.[40] Worn in carnival parades, pageants, and costume tournaments, they embody Machiavelli's hybrid political ideal in material form, combining sinister and terrifying features with harmless, even endearing ones. These helmets literally embody the rhetorical ingenuity – the range of disguises – required of the ideal prince. They represent not just the classic tropes of the lion and fox, but a rhetorical menagerie armed with apotropaic power.

One fox helmet (inv. A 461) has exposed teeth, an elongated snout, and engraved fur. Made in 1529, the year of the first Turkish siege of Vienna, for Ferdinand I, King of Bohemia (the brother of Charles V, who would succeed him in 1558 as Holy Roman Emperor), the armour appears to be an emblem of Western *astuzia* in the face of the Turkish threat.

The costume ensemble of Albert, the first Duke of Prussia, is an especially odd invention (inv. 78). Its bird's-beak visor with huge sawtoothed plates and embossed cranial ridge were completed by bearpaw sabatons, mitten gauntlets, and a broad pleated skirt threaded with ornamental ribbons. The long, smooth *schiniere* (greaves) worn with the skirt simulate bare legs. Iconographical details indicate that the armour was probably made for the occasion of the duke's wedding in 1526: a barely visible bridal couple, surrounded by pomegranates (symbolizing fertility) is engraved on the backplate, complemented by votive images of Santa Barbara and Santa Caterina (also with pomegranates) on the breastplate. This warrior android must have been a bizarre apparition on his wedding day.

A grotesque mask (1525–9) with bulbous nose, straight slit mouth, and shifty eyes was owned by Wolf Dietrich von Hohenmens, who served Charles V as head of the *Landsknechte* (inv. A 342). Another mask (inv. A 188) has a swollen hooked nose and a ruined mouth, its decorative lozenge motif simulating broken teeth. A clown-faced helmet (ca

1525, inv. A 237) with a comical frown, skewed eyes, moustache, and flat, triangular nose belonged to Duke Ulrich of Wurttemberg. This disfigured mask was worn with an elegant ribbed cuirass that imitated high-fashion civilian dress.

Normally staid military historians have enjoyed describing these curious armours. Ewart Oakeshott remembers a number of grotesque visors: one, he notes, has 'a kind of half-man's, half-lion's face, but with an entirely human mouth stretched in a huge, toothy grin, suggesting infinite *bonhomie.*'[41] One of the oddest examples is a helmet in the Tower of London made in apparent self-parody by Maximilian as a gift for Henry VIII. The emperor's twisted face, with a 'long hooked nose and wolfish smile,' has an additional touch of realism: a steel drop of mucus hanging from the tip of his nose. The armour is an exuberant phallic insult, an assertion of physical licence and personal exemption from *politesse.* In extreme form, it illustrates the rich expressive range of Renaisssance armour.

PART TWO

Studies in Self-Fashioning

4 Guidobaldo II della Rovere (1514–74)

One of the most avid collectors of Italian Renaissance armour was Guidobaldo II della Rovere (1514–74, Duke of Urbino from 1538). As the primary patron of Filippo Negroli, he owned some of the most flamboyant, distinctive, and original armours ever created. The evidence of these armours and of their representation in portraiture suggests that Guidobaldo considered these costumes central to his project of self-fashioning. In this chapter I will begin by reviewing a series of portraits of Guidobaldo and his father, Francesco Maria della Rovere (1490–1538), which clearly exploit the rhetoric of costume to negotiate the relationship between father and son. I will go on to examine a series of armours commissioned by Guidobaldo and show how they serve to articulate claims regarding his identity, autonomy, and masculinity.

Konrad Eisenbichler has persuasively argued that Bronzino's portrait of Guidobaldo II (1531–2, Uffizi) (Fig. 18) must be read in the context of a specific dilemma: the decision regarding the eighteen-year-old man's marriage.[1] For five years he had been betrothed to Giulia Varano (1523–47), heiress to the adjacent duchy of Camerino. When the portrait was created, she was still only nine years old – hardly ready for marriage. Guidobaldo, on the other hand, was sexually mature and in love with the daughter of a rival family, Clarice Orsini.

Guidobaldo's engagement was a purely political alliance, negotiated by his father to consolidate the family claim to the duchy of Urbino. This was a sensitive matter because Francesco Maria himself had been adopted by the sterile Guidobaldo I da Montefeltro (his maternal uncle) and designated as his heir, creating the new line of della Rovere dukes. The succession was legitimate but vulnerable; it was both recent and tainted by nepotism (Francesco Maria owed his position in large part to pressure from his fraternal uncle, then Pope Julius II).

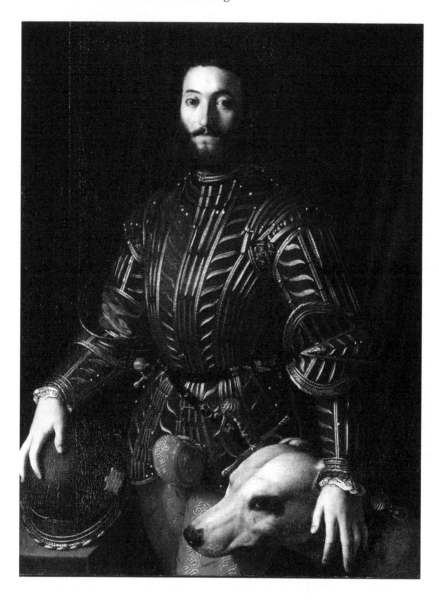

Fig. 18. Agnolo Bronzino, *Portrait of Guidobaldo II della Rovere*, 1531–2. Galleria degli Uffizi, Florence.

From the father's perspective, it was essential that Guidobaldo II make a favourable political marriage and get down to the business of producing an heir. From birth he had been destined to this future; his dynastic responsibilities were inscribed in his name, which paid filial homage to the first Guidobaldo. When he commissioned the Bronzino portrait the eighteen-year-old was acting as regent, home alone for the first time during his parents' absence from Urbino.[2] In view of these specific circumstances, the portrait seems a deliberate challenge to his father's authority and an assertion of his independent identity and erotic choice.

Eisenbichler was surely right to focus on the protruding red codpiece at the base of the painting, which earlier criticism had contrived not to see.[3] The codpiece is clearly the crux of the composition, and must be interpreted in the most literal way as an assertion of the young man's sexual maturity and prowess.

The painting shows Guidobaldo in three-quarter length against a green velvet curtain, dressed in a sumptuous dark green armour decorated with gold. Beneath the armour we glimpse a red silk doublet that reflects the red damask of the embroidered codpiece and hose. The youth looks forward with a bold expression and caresses the head of a large white mastiff that stands at his side. On the left is a helmet in symmetrical position, forming a clearly legible pyramid with the codpiece at its base, protruding into the picture plane toward the viewer. The codpiece is further emphasized by the glittering sword hilt at its side.

The Greek motto on the helmet ('It will certainly be as I have decided') makes the portrait's message explicit: it is an open provocation and almost certainly refers to his impending marriage choice.[4] Guidobaldo, with his bold gaze and sexually assertive stance, implies that he is in control of the dynastic succession and will have no difficulty in producing an heir. The young man may indeed have wished to distinguish himself from his namesake Guidobaldo I da Montefeltro, the famously absent host of the conversations imagined in Castiglione's *Cortegiano*. That figure is an inept and submissive husband who retires early every night, leaving his spirited wife in the company of other men. He is chronically ill and physically deformed (crippled by gout in 'tutti i membri'); we are told that he cannot even stand erect ('né stare in piedi né moversi potea'). All in all he is frustrated in every desire: '[L]a fortuna tanto gli fu contraria, ch'egli rare volte trasse ad effetto cosa che desiderasse' ('Fortune opposed him so in his every undertaking that he rarely brought to a successful issue anything he tried to do').[5]

Due to his infirmity (and perhaps more generally to his nature) Guidobaldo I was no soldier; and even though he nominally served as captain of the papal army (for which Castiglione praises his 'indomitable spirit') he was largely bedridden throughout its campaigns. In a text dedicated to theorizing a certain model of masculinity, it is no secret that in Urbino there is no 'man' in charge.

Guidobaldo I was notoriously ineffective as a ruler and a soldier. But Castiglione implies that the greatest political embarrassment was his sexual impotence. So inadequate was he as a husband that members of the court pronounced his wife a virtual widow. In a court culture shaped by the law of gracious dissimulation, this marks an uncharacteristically blunt moment in *Il cortegiano*. Cesare Gonzaga praises the duchess's fortitude for her brave resignation to a sexless marriage:

'Non posso pur tacere una parola della signora Duchessa nostra, la quale, essendo vivuta quindeci anni in compagnia del marito come vidua, non solamente è stata costante di non palesar mai questo a persona del mondo, ma essendo dai suoi proprii stimulata ad uscir di questa viduità, elesse più presto patir esilio, povertà ed ogni'altra sorte d'infelicità, che accettar quello che a tutti gli altri parea gran grazia e prosperità di fortuna; – e seguitando pur messer Cesare circa questo, disse la signora Duchessa: – Parlate d'altro e non intrate più in tal proposito.'

['Nor can I keep from mentioning our Duchess who has lived with her husband for fifteen years like a widow, and has not only been steadfast in not manifesting this to anyone in the world, but, when urged by her own people to leave such widowhood, she chose to suffer exile, poverty, and all kinds of hardships rather than accept what seemed to all others the great favor and bounty of Fortune'; and as messer Cesare was going on to say more of this, the Duchess said: 'Speak of something else, and do not persist in this subject.']⁶

Clearly, in Bronzino's portrait the second Guidobaldo intends to project the opposite image – that of a strong and virile young man whose sexual prowess figures an independent political will. Indeed, the choice of this armour (among many in his *armadio*) itself appears significant. Vasari reports that Guidobaldo insisted on wearing this armour, even though it caused an inconvenient delay.⁷ It was newly made in Milan and clearly one of his most stylish, but I suspect that it was more than a fashion statement and could be read as a specific political

reference. The puffed-and-slashed style derived from the costume of the *Landsknechte*, the German mercenary soldiers who were the chief protagonists of the Italian wars and had carried out the Sack of Rome just a few years earlier (1527). These soldiers had an unsavoury reputation and were conspicuous due to their elaborate dress; their doublets were deliberately slashed in the front, back, and sleeves, with shirts in contrasting colours pulled through the rents in the fabric. Their particoloured hose and huge feathered hats completed a costume that challenged all conventions of civilian dress. The slashes seem to have been intended to represent the battle scars that these mercenaries had earned in the field; they are an ironic and improvised variation on the insignia of regular troops, a brash display of that particular style of machismo which their contemporaries found both fascinating and repellent.

When Guidobaldo della Rovere, son of the papal *condottiere*, adopts the persona of a freelance mercenary and soldier of fortune, it is clearly a transgressive form of role play. Potentially it encodes the son's resistance to both levels of patriarchal authority – that of the biological father and the papacy he represented. To Francesco Maria, whose identity was grounded in his relationship of service to the pope, such a reference could only have been offensive.[8]

Landsknecht costume remained in vogue for several decades following the Sack; Bronzino's *Portrait of a Young Man with a Book* (1535–40; Metropolitan Museum of Art, New York) is a familiar illustration. As is often the case, the style was eventually emptied of political content. But when Guidobaldo's portrait was commissioned in 1531, the memory of the specific referent was still fresh. Particularly in the context of the power struggle between this father and son, it cannot have failed to evoke that humiliating defeat.

Adolescent costume choices have limited oppositional power. In any case, Guidobaldo had no cosmic quarrel with the social order of which he was the beneficiary, and no desire to relinquish its privileges. His only intent was to disrupt the succession established by his father. Yet the young prince's insistence on being portrayed in this armour can in no way be viewed as politically neutral. This case illustrates the need for close attention to the literal surfaces of visual culture, which may be inscribed with references to a society's deepest concerns.

Still, the pseudo-*Landsknecht* costume embodies an array of contradictions. To replicate a ragged textile doublet in precious metals borders on self-parody. Guidobaldo's luxury armour is an early form of street chic, like deconstructed couture. If he resisted his dynastic responsi-

bilities, Guidobaldo nevertheless very much depended on the family fortune to acquire the costume.[9]

Guidobaldo's luxury armour (and the portrait that memorialized it) represents a young man's ambivalent attempt to position himself within a social order that works very much to his advantage. The armour might be said to perform quite literally a containment function for his disruptive adolescent energies, a theatrical release for his resentment toward the hereditary system that inhibited his erotic choice.

Guidobaldo's challenge infuriated the young duke's father. The correspondence between father and son during the following months entails a lengthy exchange of innuendos and insults.[10] In one letter, Francesco Maria declares that the Orsini have no place in the della Rovere succession because they are socially inferior; they should be content to marry della Rovere bastards and not the legitimate heir. Furthermore, he claims that Clarice Orsini's father, Gian Giordano, is insane: how dare Guidobaldo taint the blood of his family by such an alliance?

Responding in kind to his son's phallic posturing, the elder della Rovere boasts of his own virility. Although at forty-two he is well into middle age, Francesco Maria declares that he is sexually potent enough to father another large family. In fact, he announces, his wife is now pregnant. The firstborn son and heir could easily be displaced by a brace of younger brothers: '[P]ensa, pensa al debito tuo prima che a tor moglie: massimamente avendo madre che ha pieno il corpo, e che ne può far dieci benissimo' (Think hard about your mother, who is pregnant and can very well produce ten more).[11]

When Guidobaldo replies maliciously by questioning the pedigree of his fiancée's mother, Francesco Maria issues the ultimate threat: 'E quando sentirò il contrario di quel ch'io comando, farò contro di te, prima, quello che uomo non penseria che forsi mai padre facesse a figliuolo' (If I hear that you disobey me, I will first of all do to you what no one ever imagined a father might do to a son).

Eisenbichler's chronology suggests that Duchess Eleanora did in fact conceive her second son Giulio at the height of this dispute.[12] In any case, shortly after that son's birth, Guidobaldo abandoned his liaison with Clarice Orsini and married Giulia Varano in accordance with his father's plan.

Although Giulia died without bearing a son, Guidobaldo finally produced an heir by his second wife, Vittoria Farnese. It is this son, Francesco Maria II, who appears in the double portrait by Titian (1552–3, private collection) that concludes Eisenbichler's analysis (Fig. 19). The adult Guidobaldo (now thirty-nine) no longer wears armour, and only a

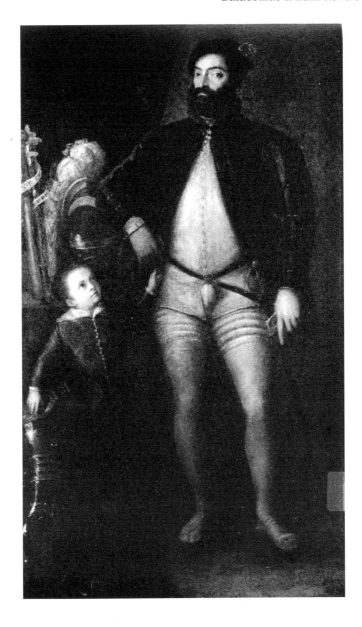

Fig. 19. Titian, *Portrait of Guidobaldo II della Rovere with His Son Francesco II*, 1552–3. Private collection.

discreetly attenuated codpiece. Fragments of armour, a plumed helmet, and military batons are clustered around the child, who will inherit the father's office. This intergenerational portrait celebrates the dynastic future of the della Rovere that the first Francesco Maria had hoped to secure. Ironically, the young boy tugging at his father's cloak in this portrait (and evidently failing to get his attention) would die without an heir and abdicate the duchy of Urbino.[13]

Patricia Simons has developed Eisenbichler's argument by extending it to a broader set of images from the Urbino court.[14] She argues that all of these images document the larger dynamic of intergenerational rivalry and competition among men that we have seen in the struggle between Guidobaldo and his father.

First in the series is Carpaccio's *Young Knight* of 1510 (Thyssen-Bornemisza Collection, Madrid) – another 'aggressively posed man with a prominent red codpiece.'[15] On the theory that this represents Francesco Maria della Rovere himself as a youth, she suggests that the son may have deliberately appropriated the father's example in his own 1531 portrait by Bronzino. The very act of portraying himself in similar guise would have been an act of hubris and a polemical assertion of self. It is equally plausible, in my view, that the son was unaware of this precedent; one might argue that the irony was inadvertent and that Guidobaldo unintentionally doubled his father in the very act of attempting to express his autonomy.

Another painting clearly relevant to the construction of masculinity at the Urbino court is Titian's portrait of Francesco Maria della Rovere of 1536–8 (Galleria degli Uffizi, Florence). This painting (Fig. 20), which represents the duke in armour with a helmet, sword, and baton, seems a direct response to the son's portrait in armour and indeed 'a kind of subliminal retaliation for the Bronzino image.'[16] In fact, the contrast between the apparel of father and son could not be more evident. The father wears not a stylish costume cuirass but a functional field armour complete with steel vambraces and gauntlets.[17] The codpiece is replaced by a mail shield that would more plausibly be worn into battle than the son's impressive prosthesis.[18] The father's armoured fist and baton, thrust sharply into the picture plane, contrast with the son's elegantly elongated hands and lace cuffs. Again, the choice of the sitter's armour is deliberate, and Titian took pains to render it in every detail; we know that the painter kept it in his studio in Venice in 1536 to assure its accurate transcription.[19] Beside the duke stand several more batons and emblems of office, including the live heraldic oak rod of the

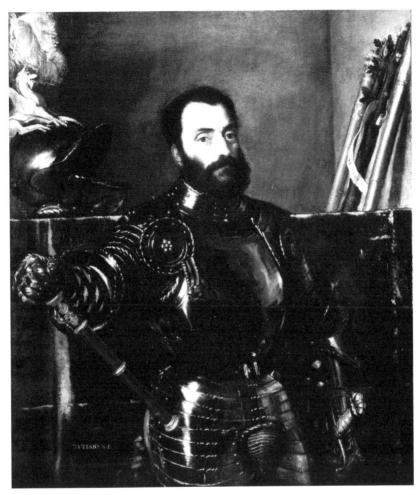

Fig. 20. Titian, *Portrait of Francesco Maria della Rovere*, 1536–8. Galleria degli Uffizi, Florence.

della Rovere family – decorated with a scroll that reads, pointedly, SE SIBI (For himself alone).

In both portraits the face is the same, except for a tired expression and a deep furrow in the father's brow. It may be, as Harry Berger has speculated, that Francesco Maria was a reluctant poseur; perhaps what the picture most accurately records is the inevitable difficulty of fashioning a public persona, the pathos of attempted conformity to an imagined

ideal. Berger cites the 'faintly hilarious' implications of Lorne Campbell's observation on the probable consequences of the public circulation of such images: '[P]rinces would have been to some degree obliged to conduct themselves as they appeared to behave in their portraits.'[20] The obligation to be 'pictogenic' – to behave like one's portrait – would result in a semiotic reversal whereby 'the portrait becomes the original rather than the copy.' Official images intended to portray dominance would actually register the sitter's submission to the independent logic of the production of images.

As a symbol of masculinity, the codpiece is at any rate problematic. '[It is] itself, bizarrely, a sign of gender undecidability,' points out Marjorie Garber, 'since it is the quintessential gender mark of "seeming," Lacan's third term interposed between "having" and "being" the phallus … The codpiece is the thinking man's (or woman's) bauble, the ultimate detachable part.'[21] The codpiece indicates only a space that may or may not be filled; it veils that genital endowment that it seeks to imply and paradoxically confounds the question of gender. In this respect, body armour could more generally be viewed as a metonymic expansion of the codpiece, since its relationship with the underlying anatomy is equally ambiguous.

As if to short-circuit such theories, Pietro Aretino offers the following straightforward ekphrasis of Titian's painting:

Se il chiaro Apelle con la man de l'arte
rasemplò d'Alessandro il volto e il petto
non finse già del peregrin suggetto
l'alto vigor che l'anima comparte.

Ma Tizian che dal cielo ha maggior parte
fuor mostra ogni invisibile concetto,
Tal che il gran duca nel dipinto aspetto
scopre le palme entro al suo cuor sparte.

Egli ha il terror fra l'uno e l'altro ciglio
l'animo in gli occhi, e l'altezza in fronte,
nel cui spazio l'onor siede, e 'l consiglio.

Nel busto armato e ne le braccia pronte
arde il valor, che guarda dal periglio
Italia sacra e sue virtuti conte.[22]

[If famed Apelles with the hand of art portrayed the face and breast of Alexander, he did not capture the lofty vigour that the soul bestows on his unique subject.

But Titian, better endowed by Heaven, shows forth every invisible quality, so that the great duke in his painted image reveals the victories held in his heart.

He has terror between his brows, courage in his eyes, and pride on his forehead, where honour and wisdom reside.

In his armoured breast and in his ready arms burns valour, which protects sacred Italy and her renowned virtues from danger.]

Aretino's sonnet is a conventional lyric encomium celebrating the painter's technical mastery and ability to convey both the outward traits and inner virtues of his subject.[23] The poet's reading of the work underscores its idealizing function within the visual regime of state portraiture. At the same time it uses the language of Cinquecento aesthetic theory to formulate the same claims we have made regarding the semiotics of armour during this period: the duke's armour does not conceal his valour but makes it visible.

Both Eisenbichler and Simons agree that the intergenerational portraits in this system derive at least in part from an image going back one generation further, the 1477 portrait of *Federigo da Montefeltro with His Son Guidobaldo I* (Galleria Nazionale, Urbino), alternately attributed to Pedro Berruguete and Joos van Ghent (Fig. 21).[24] This painting established the Renaissance prototype of the state portrait in armour. The improbable image of a fully armed man silently reading in his study illustrates the maxim that a prince must be equally proficient in arms and letters. The armour is the crux of Federigo's detailed regalia: the ermine-lined mantle, golden chain, garter, pearl tiara, and ducal sceptre establish the duke's authority and commemorate the relationships with other powerful men (popes, cardinals, kings, and even the shah of Persia) that have reinforced his rule.

But the duke's most valued possession (and chief political accessory) is his son. This hieratic painting obscures the drama and difficulty with which Federigo had finally produced an heir. (His first wife was infertile, while the second died at the birth of this son after eight daughters). He presents himself in this portrait secure in his dynastic identity,

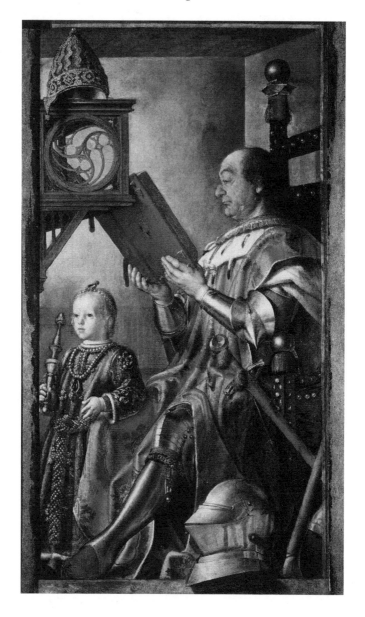

Fig. 21. Pedro Berruguete(?), *Federigo da Montefeltro with His Son Guidobaldo I,* 1477. Galleria Nazionale, Urbino.

armed with proof of his sexual potency and reproductive power. The armour both represents and constitutes the persona of the legitimate prince. This was particularly necessary to Federigo's construction of identity, since he was himself illegitimate.

The role of portraiture in the presentation of self has been widely documented and discussed in studies of the Renaissance court.[25] In particular, Eisenbichler and Simons have focused on the relevance of armour to the rhetoric of costume in portraiture. What has not been explored in a systematic way is the role of armour as a primary artifact in Renaissance visual culture. This has tended to obscure its independent semiotic dimension; armour in portraiture has been treated in a generic sense as an emblem of masculinity, without attention to its specific formal and expressive attributes. For this reason it seems important to consider an array of armours that are not known to have been illustrated in painting but nonetheless provide significant insights into the court and festival culture for which they were created. Guidobaldo II's collection presents an opportunity to examine this issue in some detail. In the following pages I will discuss a series of individual harnesses owned by Guidobaldo that convey distinct messages regarding his construction of identity at the Urbino court.

One of the most prized armours ever commissioned by Guidobaldo II is the parade harness by Bartolomeo Campi now in Madrid's Real Armeria. This is the only complete *all'antica* ensemble known from Renaissance Europe (Fig. 22).[26] As noted in my earlier chapter on the classical body, many individual pieces in the Roman style survive – helmets, breastplates, greaves, gauntlets, and other body parts. But Campi's work is particularly valuable because it enables us to imagine the achieved effect of an entire costume. In material terms, this is a rare opportunity; it is precisely the difficulty of reassembling dismembered armours that have found their way into disparate collections that made the 1998 exhibition at the Metropolitan Museum such an important initiative.

This armour is unusually well documented, in part due to the artist's pride in his achievement. Perhaps imitating the style of his more famous contemporary Filippo Negroli, the armourer signed and dated his work in a Latin inscription around the base of the breastplate and on the left gusset lame: BARTHOLOMEUS CAMPI AURIFEX TOTIUS OPERIS ARTIFEX QUOD ANNO INTEGRO INDIGEBAT PRINCIPIS SUI NUTUI OBTEMPERANS GEMINATO MENSE PERFECIT. PISAURI ANNO MCXLVI (Bartolomeo

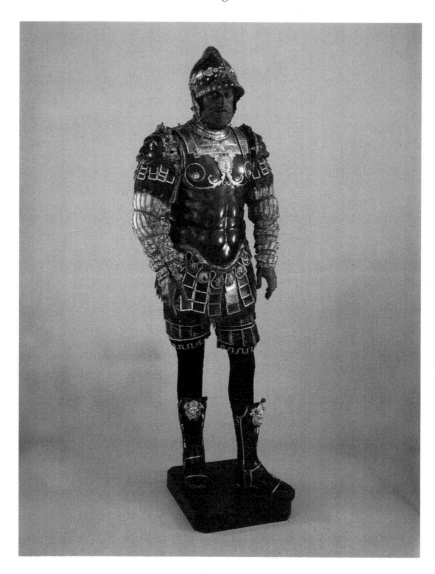

Fig. 22. Roman-style armour of Guidobaldo II della Rovere. Bartolomeo Campi. Real Armería, Madrid.

Campi, goldsmith, author of the entire work, finished it in two months in order to obey the wish of his prince, even though it needed a full year. Pesaro 1546). Another designer logo, BCF (Bartolomeus Campi Fecit), appears on the shoulder blades.

Again Guidobaldo proves to have been a difficult patron; the artist wants it known that this magnificent work was completed under unusual (and perhaps unreasonable) pressure. This suggests that it was created for a specific occasion, possibly related to Guidobaldo's career as a *condottiere*. He was appointed governor of the Venetian armies in 1546 and invested with that office in a lavish ceremony in Venice; the occasion was certainly celebrated in Urbino.

In any case this sumptuous costume armour implies a very different form of role play from the *lanzichenecco* armour in the Bronzino portrait. At thirty-two, Guidobaldo II is all grown up – a Roman athlete and hero, imposing, muscular, and very married (as noted by the GG double monogram front and centre on the breastplate). The two addorsed and entwined Gs mark his unlucky marriage to Giulia Varano; she died in the following year. Only six months later he negotiated his second marriage, to Vittoria Farnese; most probably he did not wear the armour again.[27]

Bartolomeo Campi was a man of many talents and is known to have organized the festivities for Guidobaldo's second wedding, as well as those for the birth of his son Francesco Maria II the following year. Although there is no record of a costume produced for the duke's second marriage, the artist seems to have served for a number of years as the duke's event planner. An expert military engineer as well as sculptor and goldsmith, evidently he had a genius for many dimensions of image management. As Guidobaldo succinctly put it in a letter to Ercole II, Duke of Ferrara, 'Mi servo de lui, de continuo et in molte cose' (I use him continually and in many things).[28]

The choice of a Roman military persona reflects its familiarity as a form of symbolic currency. Many paintings of historical and allegorical subjects appear to be modelled on specific armours that the painters knew directly or even kept in their studios. An example is Primaticcio's heroic portrait of the French general Jean de Dinteville (ca 1550, private collection), whose armour is rendered in such detail that it suggests an actual prototype.[29] Ironically, the classical armour is inflected in a very different way in this portrait; the sixteenth-century general in Roman armour is further coded as a Christian saint (Michael) by the addition of the lance and dragon at his feet. It is an opportunistic pastiche of

references that simultaneously enlists an array of conflicting codes to portray its patron and subject. The fact that such a painting appears at the distant court of Fontainebleau indicates the broad familiarity of *all'antica* armour and suggests it may have circulated in material as well as iconographic form.

A primary characteristic of classical armour, as I have noted, is that by simulating an unarmed nude it imitates its own absence. Campi's ensemble plays a more complicated game, representing not nudity itself but the simulation of nudity. The cuirass in fact models four layers of illusion: the outer anatomical plate, a trompe-l'œil mail shirt glimpsed at the neck (to be distinguished from the actual mail shirt and under-sleeves), a damascened gorget (ostensibly worn underneath the mail), and underneath it all, the apparent play of muscles of the collarbone and shoulders. The steel boots simulate leather sandals that strap across the calves; the openwork feet terminate in detailed trompe-l'œil toecaps. Overlapping waistplates accent the abdominal muscles and gilt brass scrolls outline the chest; a silver rosette punctuates each nipple. The genital area is accentuated but elaborately veiled by a flat skirt of pseu-do-Roman pteruges riveted to leather straps; these dangle from sepa-rately hinged scalloped tabs ornamented with gilt brass appliqués.

The smoothly modelled anatomical plates are bordered by foliate scrolls damascened in silver and gold. A heraldic triple-oak wreath in alternating textures of gilt brass is applied to the bowl of the helmet. Acanthus leaves issue from a Medusa head on the breastplate; the paul-drons are embossed with grotesque moustachioed masks. Every inch of the armour is ornamented in some fashion; even the rivets are shaped like exquisite rosettes. This feverishly overdetermined object, with its redundant panoply of references (heraldic, mythological, and allegori-cal), is a vivid icon of the sixteenth-century male masquerade.

Because of the novelty of its *concetto* and the sheer difficulty of its material execution, this armour presents itself as the highest level of parade couture. Although the monogrammed harness was quickly out-dated by the death of Guidobaldo's first wife, we know that the duke preserved it carefully and can well imagine that he intended it to be associated with his own memory.

But the armour did not remain in the ducal collection. For whatever reason, it found its way to the Real Armeria in Madrid, where it can still be viewed today. Historically it has been associated with Charles V; scholars have even imagined that it was created for the emperor's 1530 coronation in Bologna.[30] Since the work is conspicuously dated 1546, this seems safe to exclude.

Before the double G monogram was definitively linked to Giulia Varano, the date did suggest to other scholars that the armour was associated with Guidobaldo's 1547 marriage to Vittoria Farnese. Some theorized that it had been created expressly for the emperor as a gift from the bridegroom, to honour their new relationship (the marriage to Vittoria Farnese brought Guidobaldo into the emperor's extended family, since her brother Ottavio was the emperor's son-in-law). But there is no precedent and no explanation for the prominence of Guidobaldo's own monogram on a harness intended for the emperor's use. The long shelf life of such dubious theories shows the charisma of the object; it was assumed that only a person of the highest rank could possess such an impressive costume.

How exactly did the armour make its way to Madrid? The apparent consensus is that it was actually a gift to the emperor's son Philip II (1527–98), King of Spain. Either Guidobaldo or his son may have given it to the king to mark their investiture (in 1561 and 1585, respectively) with the Order of the Golden Fleece. More intriguingly, Francesco Maria II may have offered it to Philip II during his three-year residence at the Spanish court (1565–8). The young prince of Urbino, who had been sent to Spain to complete his education, watched the installation of the Real Armeria and may have offered (with or without his father's permission) to contribute a family heirloom to display in this splendid setting.

In any case, the coveted armour soon entered into the Spanish royal collection, where it was absorbed and mistakenly catalogued among the armours of Charles V. Not surprisingly, the Holy Roman Emperor had no difficulty upstaging a della Rovere duke. The ghost of Charles V effectively appropriated Guidobaldo's prized armour, displacing the original owner. So thoroughly is it associated with the emperor's memory that it is still displayed on a mannequin that is a portrait of Charles V.[31]

Although the 1546 Campi ensemble is the only surviving example of a complete Renaissance armour *alla romana*, it was almost certainly not the first. Scholars have suggested that Titian's painting of the Emperor Caligula for the Gabinetto dei Cesari in Mantua illustrates a lost classical parade harness by Filippo Negroli that would have been created some time before 1540 (the year when Titian delivered the completed set of paintings to Federico II Gonzaga). Although Titian's paintings were destroyed in a fire in 1734, they had been widely admired and recorded in a number of copies, including the five sets painted by Bernardino Campi (no relation to the armourer Bartolomeo).[32] Caligula's costume is rendered with such specificity that it seems to have por-

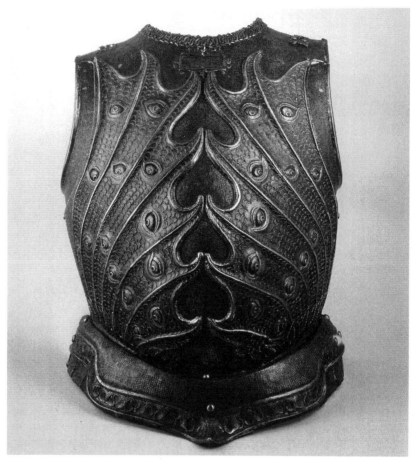

Fig. 23. Batwing breastplate of Guidobaldo II della Rovere, Duke of Urbino. Filippo Negroli, ca 1532–5. Museo Nazionale del Bargello, Florence.

trayed an actual armour that no longer exists. It is not known who would have possessed such an armour, although it must have been a wealthy patron who was well known by Titian. It is logical to suspect either a della Rovere duke or Federico II Gonzaga, but there is no evidence of the harness in the inventories of either family's armoury.[33]

One priceless armour that did remain in della Rovere custody is the 'batwing' armour similarly illustrated in Titian's famous series as the costume of the Emperor Claudius (Figs. 23, 24).[34] This ensemble is one of the most dazzling, enigmatic, and bizarre inventions in the his-

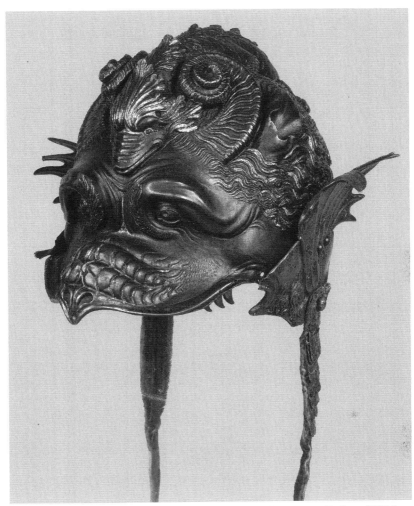

Fig. 24. Grotesque burgonet of Guidobaldo II della Rovere, Duke of Urbino. Filippo Negroli, ca 1532–5. The State Hermitage Museum, Saint Petersburg.

tory of Renaissance armour. The long-dismembered armour, reunited for the Metropolitan exhibition of 1998–9, is considered one of Filippo Negroli's masterpieces. Seven pieces were reunited for the exhibit: a breastplate (from the Museo Nazionale del Bargello in Florence), a burgonet (from the State Hermitage in Saint Petersburg), two pauldrons (from the Bargello and the Metropolitan Museum in New York), and

a set of three lames for the left pauldron (from the Museo Stibbert in Florence).[35] This armour is labelled with some confidence as having belonged to Guidobaldo II della Rovere.

Historically there has been much disagreement on the issue of the armour's original owner. Clearly it must have existed before Titian incorporated it into his cycle of Roman emperors as the costume of Claudius (1538). Scholars as reputable as Boccia and Coelho have retrodated the work to 1529 and argued that it was created for Francesco Maria I della Rovere.[36] Nevertheless, the fact that it is so prominently featured in a late portrait of Guidobaldo II suggests that he himself had commissioned it and hence considered it a brand or trademark image to be permanently linked to his identity.[37]

Further complicating the issue, Mario Scalini has theorized that the batwing armour was of such exceptional quality that it could only have belonged to one of the period's most powerful rulers rather than the prince of a minor Italian state.[38] Having ruled out both Charles V and Henry VIII, he argues that it must have been commissioned by the French king Francis I (1494–1547; r. 1515–47) during the period when he was recruiting some of the most talented Italian artists to decorate his castle at Fontainebleau. Indeed, from an engraving by Marten van Heemskerk, Scalini concludes that the French king wore this armour on the very day of his disastrous defeat at the Battle of Pavia (1525).

The theory is unsupported by any physical evidence. Scalini admits that the armour pictured in Heemskerk's engraving differs in many ways from the batwing garniture, but attributes this to the fact that the artist himself was not present at the battle and had to reconstruct the details of the king's costume from eyewitness accounts. But the engraving shows a savage melee with the emperor's horse rearing over a field of fallen knights; even if this image were intended to be a 'realistic' transcription of the event (already a problematic assumption), presumably anyone present at the battle would not have been in a position to examine the king's armour in any detail.

In any case, how would it be possible to reconcile the theory of the French king's original ownership with the evidence of Guidobaldo's portrait? Scalini offers a truly ingenious explanation ('ovvia deduzione, ed unica spiegazione'): the armour (or whatever remained of it) must have been given after the battle of Pavia to Francesco Maria della Rovere as a reward for having contributed ('evidentemente in maniera essenziale') to the capture of the French king.[39] The della Rovere duke would then have bequeathed the armour to his son. This wonderful-

ly circular argument illustrates the degree to which even experts will inflate the associations of such a superb artifact, straining to invent a plausible biography of the object.

Not accidentally, Scalini's theory of the Valois origins of the batwing armour conforms to his hypothesis (now equally discredited) of French ownership of the important *all'antica* anatomical cuirass in the Bargello. Scalini argues that the cuirass was created in 1547 for the ascent of Henry II to the throne upon the death of his father Francis I. It is indeed the case that both Henry II and his father admired the work of the Negroli family and that they frequently held tournaments in classical costume, as illustrated in the Valois tapestries. The French court undoubtedly owned a number of *all'antica* armours of Italian manufacture which found their way to Florence either as diplomatic gifts or through the bequest of Catherine de' Medici to Christine of Lorraine, who married Ferdinando I de' Medici (1549–1609) in 1589.[40] But there is no evidence that the batwing armour was among them, and many indications that it could not have been.

Why have scholars quarrelled to this extent on this armour's attribution? What is, after all, so unique about the batwing armour? The answer lies in both the novelty of its conception and the technical quality of its execution. Although, as noted in chapter 4, there are many examples of grotesque armour from the Italian Renaisssance, this is by far the most complicated and puzzling one. No textual source has been found to explain its iconography, and no contemporary interpretation has proved entirely convincing.

The ensemble is known as the batwing garniture only for the sake of convenience; in fact the armour portrays a monster that is an exuberant hybrid of many creatures, both observed and imagined, in nature, poetry, and legend. The steel burgonet is embossed with a grotesque mask that has a pointed snout and eight sharp projecting teeth (Fig. 24). The monster has wavy hair, protruding pig's ears, and coiled ram's horns. Another creature, which seems to be a dragon or crocodile, crouches on the monster's head on four webbed feet. Two cheekpieces are shaped like bat wings, their ribs and membranes articulated and fanning out to display almond-shaped eyes like those of a peacock. Red velvet chin straps riveted to the cheekpieces are covered with metal scales. Another scowling face, its lower part now missing, appears at the back of the helmet.

The breastplate is embossed with confronted bat wings that meet at the centre in a multiple inverted heart-like motif (Fig. 23). Each wing

consists of seven membranes covered with overlapping fish scales and studded with the same open eyes pictured on the helmet. At the neck is a chain that appears to be made of bent and woven branches (this echoes the stylized leaves found elsewhere on the waist and breastplate). Suspended from the chain is a cartouche picturing a river and bulrushes beneath the inscription NULLA BIBAM LAETHES OBLIVIA FULMINE IN IPSO. Finally, each of the pauldrons portrays a fantastic creature with pointed ears and snout, sharp teeth, and stiff, spiky hair. This has been referred to in the literature as a dolphin, but clearly it is a free adaptation on the theme.

If grotesque armour is by definition a portrait of the 'Other' which confronts the idealized nude of the classical hero, this harness represents an amalgam of Others, all fused in a single hybrid body. In slightly different terms, it might be imagined as a portrait of the Ovidian body that counters the normative Vesalian body in the Renaissance.[41] It is a hallucinatory composite creature, evidently the product of many metamorphoses. It does not conform to any precedent and resists the very notion of normativity. Unlike the canonical Renaissance images of the human body whose perfect proportions reflected the divinity immanent in man, this armour is a ludic object that subverts humanist pieties and seduces with its unorthodox appeal.

Part of the armour's charisma is undoubtedly due to its tactile quality. The artist manages to convey a range of textures and surfaces not usually represented in armour or indeed in any form of metal sculpture: the bulging liquid eyes and spiky wings, the rubbery cartilage of the ears and wet slippery snout are all rendered with exceptional realism. One detail that seems an extreme bid for attention is the ribbon from which the inscribed tablet at the neck is suspended: one loop, in high relief, stands entirely free from the surface.[42] The armourer implies that his own fame 'hangs' on such artistry. The trompe l'œil is so effective that a number of scholars, seeing parallels with the anatomical cuirass in Madrid, once attributed the work to Bartolomeo Campi, but the current consensus is that it is the work of the even greater master, Filippo Negroli.

It is not known when or how the batwing armour would have been worn in the della Rovere court. Although the design is without precedent in Renaissance arms manufacture, it recalls the theatrical costume tradition of the Quattrocento. The phantasmagorical armours created for fifteenth-century ceremonies and civic pageants were made from perishable materials such as papier mâché, textiles, and feathers and there-

fore have not survived, but the costume tradition is widely illustrated in Quattrocento painting and was certainly known to the Negroli. Artists who had studied ancient works to learn the vocabulary of Roman military dress freely modified these forms to create increasingly elaborate designs, incorporating exotic plumes, scales, beaks, and masks. Roman coins and medals, which included motifs such as the winged helmet, were a frequent source of imagery for such pageant armours.

Playful and bizarre as these inventions might be, none precisely anticipated the Negroli batwing armour. Its iconography is so complex and unusual that it seems to refer to a specific literary source. The timing and context suggest that that source was most probably Ariosto's *Orlando furioso*. First published in 1516, with subsequent editions appearing in 1521 and 1532, the poem was an immediate bestseller and was soon surpassed by only the Bible in popularity.[43]

Given its almost certain attribution to Filippo Negroli (b. 1510) and comparison with his securely dated works, the batwing armour was most likely made in 1532–5. Ariosto himself died a relative celebrity in 1533. Although there is no record of the armour's use in any specific festival or performance, the armour's chronology, along with the close ties between the courts of Ferrara and Urbino, suggests a link between the two works. If its program is derived from a contemporary literary source, there is no more likely candidate than Ariosto's epic.

One of the most appealing suggestions is that it refers to the armour of Rodomonte,[44] the pagan warrior who emerges as one of the primary figures in Ariosto's epic and is killed by Ruggiero in its last lines. Rodomonte was famed for his magical armour, inherited from Nimrod. Among the many splendid armours displayed in the epic, his alone is made of dragon's skin:

> Armato era d'un forte e duro usbergo,
> che fu di drago una scagliosa pelle.
> Di questo già si cinse il petto e 'l tergo
> quello avol suo ch'edificò Babelle,
> e si pensò cacciar de l'aureo albergo,
> e torre a Dio il governo de le stelle:
> l'elmo e lo scudo fece far perfetto,
> e il brando insieme; e solo a questo effetto. (*Orlando furioso*, Canto 14.118)

[He was armed with a strong and hard breastplate made from the scaly hide of a dragon. It once covered the chest and back of his ancestor who

built Babel, thinking he might drive God from his golden palace and wrest from him the control of the stars. For this reason he had a perfect helmet and shield made, and a sword as well.][45]

In describing Rodomonte's armour, the poet focuses in an unprecedented way on its material dimension, particularly as it contrasts with the arms of his adversaries (which seem reduced from iron to soft pewter or even to bark):

Il re di Sarza (come avesse un'ala
per ciascun de' suoi membri) levò il pondo
di sí gran corpo e con tant'arme indosso,
e netto si lanciò di là dal fosso.

Poco era men di trenta piedi, o tanto,
et egli il passò destro come un veltro,
e fece nel cader strepito, quanto
avesse avuto sotto i piedi il feltro:
et a questo et a quello affrappa il manto,
come sien l'arme di tenero peltro,
e non di ferro, anzi pur sien di scorza:
tal la sua spada, e tanta é la sua forza! (14.129–30)

[Rodomonte, as though he had wings for limbs, lifted the weight of his great body and all that armour, and leaped clear across the trench. It was a good thirty feet across, and he jumped across with the agility of a greyhound, hitting the ground as if he had landed on felt. Now he shreds everyone's armour, as if it were made of soft pewter, or even of bark, instead of iron: such was his sword and the force behind it.]

How is it that such a great warrior can be defeated by Ruggiero? At the level of plot, Ariosto supplies a simple and incontrovertible answer: on that day, the pagan wasn't wearing his own armour:

Non si trovò lo scoglio del serpente,
che fu sí duro, al petto Rodomonte,
né di Nembrotte la spada tagliente,
né 'l solito elmo ebbe quel dí alla fronte;
ché l'usate arme, quando fu perdente
contro la donna di Dordona al ponte,

lasciato avea sospese ai sacri marmi,
come di sopra avervi detto parmi.

Egli avea un'altra assai buona armatura,
non come era la prima già perfetta ... (46.119–20)

[That day he didn't have the hard dragon's hide on his chest, nor did he
have Nembrot's sharp sword, nor his usual helmet; when he lost to Brada-
mante at the bridge, he left his usual arms hung on the shrine, as I believe
I told you earlier. He had another armour that was fairly good, but not
perfect like the other one ...]

A second-rate armour is worthless against an enemy like Ruggiero
(himself armed with the enchanted sword Balisarda). Ariosto's narrator
makes it clear that the duel between the two knights is a test not only of
courage, strength, and cunning, but also – more mundanely – of their
equipment. Midway through the battle the two knights take up their
swords, testing each other's armour for flaws ('con le pungenti spade
incominciaro / a tentar dove il ferro era più raro,' 46.118). Ruggiero
succeeds in piercing the pagan's armour in a number of places, and the
sight of the bloodied metal further enrages Rodomonte. As the struggle
continues, Rodomonte gradually weakens from the loss of blood and is
finally overcome.

The spectacle of Rodomonte's pierced and bloodied armour reminds
the reader of his preoccupation with the issue of bodily integrity
throughout the epic. Rodomonte is consumed by the desire for an
invulnerable body like that of the Christian champion Orlando (whose
armour is of great symbolic importance but unnecessary for his literal
protection).[46] This transgressive desire is clearly related to his ances-
tor's sin of pride in building the Tower of Babel; recklessly, Rodomonte
wishes to exceed the bounds of the human condition by rendering his
body impenetrable. He is not satisfied with the enchanted prosthe-
sis, the magical supplement that was granted to him by Nembrot, but
instead wants his own body transformed into the 'real thing.' Ironi-
cally, it is this very desire that renders him vulnerable to Isabella's trick:
when she offers him a magic potion that would proof his body against
fire and sword ('dal ferro e dal fuoco'), he agrees to test it first on her
body and thus, inadvertently, kills the woman he loves.

It is intriguing to imagine that the Negroli pageant armour might rep-
resent the dragon-skin armour of Rodomonte. But other theories have

been proposed: one critic finds it reminiscent of the enchanted armour of Marfisa (19.84).[47] Others have compared the Negroli armour to the Orc that Ruggiero battles in Canto 10.100–12. In fact, there is a family resemblance: that 'brutto mostro' also has a horned head, pointed wings, protruding eyes, and porcine snout bristling with teeth. When Ruggiero strikes at the monster, he finds it harder than iron or stone ('par che un ferro o un duro sasso tocchi,' 10.101). Whatever the angle of his approach, he finds it impermeable as a rock ('come sempre giunga in un diaspro, /non può tagliar lo scoglio duro et aspro,' 10.104). When at last he lifts the covering from his magic shield, the monster is immobilized, rising to the surface on its belly like a stunned fish – but even now Ruggiero cannot penetrate its hide ('Di qua di là Ruggier percuote assai, / ma di ferirlo via non truova mai,' 10.110).

The episode of Ruggiero's battle with the Orc is an extended play on the metaphor of armour. Unable to pierce its tough scales, the knight finally abandons his onslaught on the beast and agrees to unchain Angelica before the Orc revives. But as soon as he frees her and carries her off on the hippogriff, he is again overwhelmed by the instinct for penetration and tries to rape the virgin princess. At this test of his manhood he is equally unsuccessful; undeterred by his knightly vow of chastity or his recent pledge of love to Bradamante, Ruggiero is restrained by the practical impediment of his armour. Before he can undress ('non gli parve altra volta mai star tanto; / che s'un laccio sciogliea, dui s'annodava'), Angelica has vanished. The frustrated assault on the Orc and thwarted rape of Angelica mirror each other, foregrounding the issue of armour and its relationship to masculinity with the comic irony characteristic of Ariosto.

Some commentators have suggested a parallel between the batwing armour and the creature that Rinaldo encounters in the Ardennes forest:[48]

> un strano mostro in feminil figura.
> Mill'occhi in capo avea senza palpebre;
> non può serrarli, e non credo che dorma;
> non men che gli occhi, avea l'orecchie crebre;
> avea in loco de crin serpi a gran torma.
> Fuor de le diaboliche tenebre
> nel mondo uscì la spaventevol forma.
> Un fiero e maggior serpe ha per la coda,
> che pel petto si gira e che l'annoda. (42.46)

[a strange monster in the shape of a woman. Her head had a thousand lidless eyes that she could never shut (I believe she never slept) and just as many ears. Instead of hair she had a great mass of snakes. This frightful shape emerged from the shadows of hell. Her tail was a large, fierce snake coiled and knotted around her torso.]

Finally, critics have proposed that the Negroli armour be interpreted as an allegory of Fame. In some respects it does resemble the figure of Fame from the iconographic tradition, a frightening creature whose wings are covered with open eyes. This image derived from Virgil's description of Fama in Book 4 of the *Aeneid*: 'monstrum horrendum, ingens, cui, quot sunt corpore plumae, tot vigiles oculi subter (mirabile dictu)' (4.181–2); (a huge, fearful monster, with a watchful eye miraculously set under every feather on her body).

The Negroli armour not only resembles Virgil's description of Fame but also appears to allude to Ariosto's treatment of the theme in *Orlando furioso*. In particular, the Latin inscription applied to the breastplate recalls the laborious lunar allegory of Canto 35. Ariosto's readers would remember Saint John's explanation to Astolfo of the pageant they witness on the moon: the old man dropping name plates into the river Lethe, the black crows and vultures that carry some away (but soon drop them), the pair of white swans that recover a few treasured names and safely convey them to the shrine of Immortality. The wearer of the batwing armour would appear to boast that he is among those virtuous men whose fame is forever secure.

To interpret the batwing armour as an allegory of Fame has the advantage of seeming straightforward, but a moment's reflection complicates the matter. Consider the context of the two episodes in Virgil and Ariosto: in the *Aeneid*, Fama (often rendered in English as Rumour) is a destructive force, recklessly spreading both true and false information ('pariter facta atque infecta canebat,' 4.190). She is a 'foul goddess' ('dea foeda') who destroys reputations and lives. Specifically, she spreads malicious word of the 'filthy passion' ('turpique cupidine') of Dido and Aeneas, inflaming the Carthaginians against their queen and provoking Jupiter's rebuke to Aeneas and Dido's ruin.

Ariosto's allegory of Fame is also famously ironic. In one of the most frequently cited passages in the poem, Saint John reveals that fame depends not on a man's intrinsic virtue, but on his ability to influence poets (who guarantee his celebrity). The 'great men' of history were actually those with the sense to befriend good writers; one's reputation

depends entirely on the quality of one's advertising. Indeed, the truth of history is the reverse of the historical record:

> E se tu vuoi che 'l ver non ti sia ascoso,
> tutta al contrario l'istoria converti:
> che i Greci rotti, e che Troia vittrice,
> e che Penelopea fu meretrice. (35.27)

[And if you don't want the truth hidden from you, invert history; Greece lost the war, Troy won, and Penelope was a harlot.]

Saint John concludes by noting sweetly that he was a writer too, and can well understand how to manufacture a legend for a patron. The statement goes far beyond subverting the Este myth by suggesting that the Evangelist himself was just another spin doctor. It is one of the most memorable and outrageous moments in the poem.

If the batwing harness indeed alludes to this episode in Ariosto, Guidobaldo II appears untroubled by any of its more ambiguous implications in the portrait he commissioned featuring the armour (Fig. 25).[49] The portly gentleman with the receding hairline who poses in front of this armour evidently intends it to symbolize his fame in a wholly complimentary sense. The portrait candidly shows that the armour is outgrown (in fact it would have been been made to measure for an eighteen-year-old). But evidently the duke keeps it in his *armadio* and continues to enjoy its glamour and drama. Here he props the cuirass erect against a velvet curtain with batons of office. Around his neck hangs the emblem of the Order of the Golden Fleece (to which the adult Guidobaldo had been admitted in 1561). As a visual statement of pride in his autonomous identity and achievement, the picture contrasts with the Titian portrait discussed earlier in this chapter, which had showcased the son and the dynastic future he represented.

A final irony complicates the interpretation of the batwing harness as an allegory of Fame: it was itself unsigned. Although most scholars have settled on the attribution to Filippo Negroli, there is no signature anywhere on the armour. This is especially puzzling because Negroli usually signed his works. He was an ambitious artist intent on establishing his reputation and winning the most prestigious commissions in Europe. Vasari himself acknowledged that Negroli achieved 'fama grandissima.'[50] By the late Cinquecento Paolo Morigi could use only

Fig. 25. *Portrait of Guidobaldo II della Rovere, Duke of Urbino*, ca 1580 [copy of a lost painting]. Gemäldegalerie, Kunsthistorisches Museum, Vienna.

superlatives when describing the artist in his *La nobiltà di Milano*: 'Filippo Negroli merita lodi immortali, perché è stato il principale intagliatore nel ferro di rilievo, e di basso rilievo ... Questo virtuoso spirito ha fatto stupire il re di Francia, & Carlo Quinto Imperatore ne' suoi veramente meravigliosi lavori in armature, celate, e rottelle miracolose' (Filippo Negroli deserves immortal praise, for he was the principal chiseller of steel in high and low relief ... This virtuoso spirit astounded the king of France and Emperor Charles V with his truly marvellous work on armours, helmets, and miraculous shields).[51] We would expect Negroli to be particularly proud of such an unusual ensemble as the batwing armour and sign it in a conspicuous fashion. Why then would he erase his own name from a work representing the fame he so avidly sought?

Such contradictions emerge whenever we try to isolate a definitive source in the *Furioso* for the iconography of the batwing armour. Perhaps less important than to establish a link between this armour and any single character in the *Furioso* is to identify the text as a field of allusion in a broader sense. The hybrid, shape-shifting armour playfully traverses the text, evoking multiple resonances. In my view there is no literal correspondence with any single passage in the poem: instead the armour is (iconically, mischievously) a hybrid of all these textual loci – a composite creature even at the level of its textual allusions, which overlap like the scales on the monster's wings.

Although this armour, along with the entire della Rovere collection, was transferred to Florence in 1631, the duke might have been gratified by one of the legends that later arose in its regard. In his inventory of 1639–40, Giuseppe Petrini, Custodian of the Medici Guardaroba, maintained that it had belonged to Hannibal of Carthage. His nephew Antonio, author of an important treatise on metallurgy, further embroidered this legend by identifying Hannibal's artist as one Pifanio Tacito ('scultore valentissimo').[52] Pyhrr and Godoy speculate that Petrini may have emphasized this unlikely theory in order to impress the many distinguished visitors to the Medici court.[53]

Petrini created buzz for the collection by claiming a number of celebrity relics. He identified an unusual grotesque burgonet (now attributed to the Negroli workshop) as the helmet of Aeneas: admitting that it had been acquired from Guidobaldo II della Rovere, he invented a wondrous backstory that traced the work to 'Ripa, son of Numa Babilonico,' the alleged armourer of Aeneas.[54] Only the armour of Hector, the ultimate Trojan hero, could be a more prestigious artifact to acquire for the museum. Perhaps because that was known to be circulating still in the *Furioso*, Petrini settled on the arms of Aeneas instead.[55]

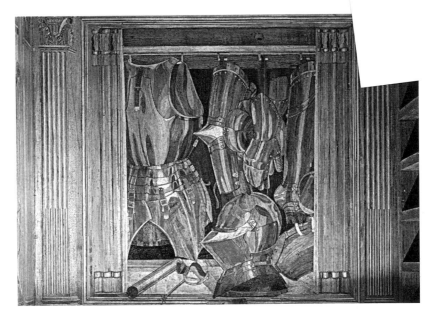

Fig. 26. Palazzo Ducale, Urbino. Intarsia panel of door with armour.

To capture the *arma* from the first line of the *Aeneid* would have indeed been a coup. As it turned out, the della Rovere collection bequeathed to the Medici was priceless already. These emblems of ideal masculinity were the incongruous gift of the infant Vittoria della Rovere, betrothed to Ferdinando II de' Medici, on her family's extinction. The only traces of armour left in Urbino were the trompe-l'œil images in the *studiolo* (Fig. 26).

5 Charles V Habsburg (1500–58)

The greatest celebrity patron of the sixteenth-century arms industry was without question the Holy Roman Emperor himself, Charles V (1500–58; HRE 1519–58). Endowed with four distinct inheritances from his maternal grandparents (Ferdinand and Isabella of Spain) and his paternal grandparents (the Emperor Maximilian I and Mary of Burgundy), Charles V emerged unexpectedly in the early Cinquecento as heir to an empire infinitely larger than the original Roman empire, including newly discovered lands beyond the Atlantic. Once he had subdued his main rival, the French king Francis I (whose claim to the office rested on his alleged descent from Charlemagne), the Habsburg emperor briefly embodied an ideal of world monarchy that had survived the Middle Ages. By his Christianizing mission in the New World as well as his victories over the Turks in the Mediterranean, Charles V seemed to promise the unification of all Christendom and the peaceful resolution of the schism within the Catholic Church.

The story of this anachronistic revival of the 'phantom' of empire has been told many times, most memorably by Frances Yates.[1] It is not my purpose in this chapter to examine either the sixteenth-century Habsburg empire or the historiographical traditions that arose to explain it. Instead, I wish to focus on a series of armours commissioned by Charles V and consider the ways in which they embody his distinctive (and in many respects contradictory) political persona, particularly through their creative negotiation of classical and Christian imagery.

Charles V is remembered as singular connoisseur of armour, both for ceremonial and functional field use. It has been observed that during the early years of his reign Charles V favoured German armours, particularly those from the prestigious Helmschmid workshop in Augsburg.[2]

Certainly the most important workshops throughout Europe competed for his patronage, and his taste in armour was widely emulated in the European courts. However, his enthusiasm for Italian luxury armours has not been sufficiently stressed: after receiving his first commission from the Negroli in Milan, he focused almost exclusively on their work and began to build the impressive Italian collection that is still the centrepiece of the Real Armería in Madrid.

We know of the emperor's growing interest in the work of the Negroli from a number of anecdotes. A seventeenth-century inventory of the della Rovere armoury (made as it was being packed for shipment to Florence) claims that Charles V had so admired the 'batwing' armour that he asked to have a similar one made.[3] Although there is no further record of such a copy, it does seem clear that Charles commissioned an *all'antica* helmet from the Milanese workshop on the example of one created for Francesco Maria I della Rovere. A letter from the duke of Mantua to Francesco Maria reports the emperor's interest in the helmet and urges him to send it directly to the emperor for his inspection.[4] The duke of Urbino was flattered to comply. Apparently the emperor then requested a copy, which was quickly made and presented on his official visit to Milan in March 1533. The occasion brought the Negroli considerable publicity and apparently prompted a fashion for anthropomorphic helmets.[5] Everyone, it seemed, admired the emperor's new clothes.

What interests me in this series of transactions, apart from the role of mimetic desire in generating a demand for such artifacts, is the symbolic escalation implicit in the production of the emperor's armour. Francesco Maria's original helmet (Vienna, Kunsthistorisches Museum, inv. A 498), consisting of an embossed bowl and hinged cheekpieces, had pictured a young boy with smooth cheeks, curly hair, and naturalistically modelled ears (surprisingly, pierced with holes for earrings) (Fig. 5). The 'replica' received by Charles V is similarly constructed, but also features a detachable buffe (or lower face defence) which ages the armour's 'face' by at least twenty years and represents a grown man with gilt hair and full beard (Madrid, Real Armería, inv. D 1) (Fig. 6).[6] This miniature ensemble offered the Habsburg emperor two different costume options: he could either wear it without the buffe, leaving his face free and exposing his own beard, or with the buffe, covering his beard with a stylized gilt one and smoothly modelled lips. Clearly the emperor's helmet is crafted to project an image of *auctoritas* not found in the earlier work. It does not seem too fanciful to suggest that the detachable chinplate tactfully corrects his most striking facial anomaly,

the protruding jaw that is recorded in state portraits and came to be known as the Habsburg jaw (mandibular prognathism).[7] The armour would also have masked his thickened lower lip and enabled him to give the appearance of closing his mouth; this was actually difficult due to the malocclusion caused by his overgrown jaw.[8]

It has been suggested that there originally existed an additional plate that would have covered the rest of the emperor's face (with openings for the eyes). Such a plate would have resulted in a complete transfiguration, masking all traces of the facial irregularities associated with mandibular prognathism. But such a visor has never been found and none is listed or illustrated in any of the inventories of the Habsburg collection.[9] In any event, the Negroli parade helmet idealized the emperor's features much more freely than most contemporary dynastic portraiture. It was his most flattering mask and clearly the actual model for the 'portrait mannequin' later created to display his armours in the Real Armería.[10]

The progression from the della Rovere to the Habsburg helmet implies a shrewd and deliberate rhetorical *amplificatio* on the part of the artist (we have no evidence to assume the emperor's own participation or intervention in the process). If the ducal burgonet represented an anonymous ephebe or athlete, the second helmet portrays an adult commander and hero whose individual identity is clearly legible in a rich overlay of personal insignia. While the Urbino helmet bore only the name of the artist,[11] the Madrid burgonet is emblazoned with a full array of references to its far more important patron.

Of these, the most riveting is the emblem of the pendant ram centred beneath the gilt spiral points of the beard. Its head and feet dangling from an exquisitely worked ribbon, this is immediately recognizable as the Golden Fleece. The Golden Fleece was, of course, a motif derived from classical antiquity; the story of Jason and his Argonauts was known from the celebrated epic poem by Apollonius of Rhodes.[12] But its use on the emperor's armour is more than an antiquarian allusion. Framed by the embossed firestones and flints associated with the House of Burgundy, it is also, and more importantly, a contemporary political reference.

For over a hundred years, the Order of the Golden Fleece had been a badge of Burgundian dynastic identity. Charles's great-grandfather, Philip the Good, founded the chivalric Order of the Golden Fleece in 1429 with the goal of renewing a crusade against the Turks and recapturing Jerusalem; in a deliberate revival of Argonautic imagery, he identified that crusade with Jason's quest for the Golden Fleece. The Fleece

was understood to be a sign of Christ, the Lamb of God; in Habsburg imagery and pageantry the two icons were inevitably associated.

Since infancy, Charles had worn the insignia of the pendant ram. At the age of eighteen he was proclaimed Grand Master of the Order, with the power to confer membership on individuals most committed to the defence and propagation of the faith. By the time of his first visit as emperor to northern Italy in 1529, his role as defender of the church had taken on a new urgency; his crusading mission was directed against both Turks and Protestants. In view of the imminent threat to the unity of the Christian church, the pendant ram represented the emperor's primary identity as *miles christianus*.

In his costume helmet, encircled with a gilt laurel wreath, Charles V looked the part of a Roman emperor, but the Collar of the Order of the Golden Fleece also marked him as a Christian and chivalric ruler whose origins were in northern Europe. In similar fashion, the accompanying shield (Madrid, Real Armería, inv. D 2) incorporates a range of icono-graphical references to both the antiquity and modernity of his office (Fig. 27). The burgonet and shield complement each other and should be read as elements of a single system. Thus the lion's head at the cen-tre of the shield (which would have been emphasized by the black-ened steel that surrounded it)[13] marks the bearer in allegorical fashion as a new Hercules, while the gilt border affirms his individual iden-tity. The device repeatedly inscribed around the border of the shield was not a shared totemic image but proprietary and deeply personal. The emblem consists of twin columns with the motto PLUS OUTRE fram-ing the bicephalate imperial eagle. Created for Charles V by the Italian humanist Luigi Marliano, this *impresa* asserts the emperor's privilege as Christian emperor to extend his rule beyond the columns of Hercules to lands unknown to the Romans.[14] The shield simultaneously acknowl-edges Hercules as a moral exemplum and proclaims the limits of the cult of antiquity; it is a superlative vehicle for Habsburg propaganda.

The image of the lion's head functions at several different levels in the ornamentation of weapons. It was one of the most popular motifs in the decoration of *all'antica* armour, appearing not only on shields and breastplates but often in highly ornamental pauldrons and poleyns (plates to reinforce the shoulder and knee joints).[15] As an antiquar-ian reference it clearly alludes to the costume worn by the Praetorian standard-bearers (*signifers*) in the Roman army. Sixteenth-century art-ists would have been familiar with such costumes from their illustration on the Arch of Constantine, Trajan's Column, and other monuments of

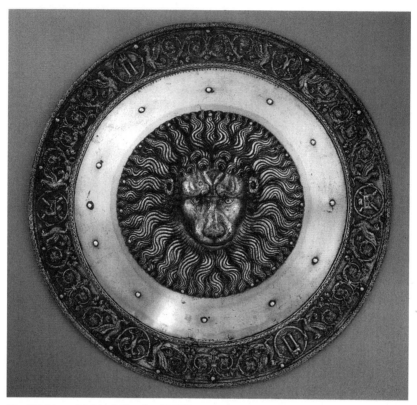

Fig. 27. Lion shield of Charles V. Filippo Negroli, 1533. Real Armería, Madrid.

imperial Rome. They would also have realized that these lion head-dresses were believed to have an apotropaic function; one Renaissance scholar cites the fourth-century writer Vegetius's explanation that the image of the severed lion's head serves 'to render the standard-bearer more ferocious and terrible to the enemy.'[16]

More specifically, its association with the story of Hercules made the lion a popular image in the decoration of armour. The Nemean lion, killed by Hercules in one of the Twelve Labours imposed on him by Juno, was said to have impenetrable skin. When Hercules at last succeeded in strangling the lion, he wore its pelt as a trophy. To use a lion's head in the decoration of armour would thus appear to signify the appropriation of its magical impenetrability to weapons.[17]

The Negroli parade shield invokes all these associations, positioning

Charles V as a Herculean figure whose virtue, wisdom, and ingenuity will serve him as a military commander. But the concentric circles that frame the lion's image update the mythological reference through their repeated inscription of the modern, original, highly personal columnar device: a trademark that visually alludes to the novelty and specificity of Charles's destiny as emperor of a New World.

Ariosto, skilled in the pursuit of patronage, understood the ambitions of Charles V. In a passage added to the third edition of the *Orlando furioso*, Andronica celebrates the 'new Charlemagne' and praises his 'new Argonauts' for their discovery of new lands beyond the straits of Gibraltar.[18] She explains that God willed these lands to be hidden until the emergence of a providential leader who would unite the world under his dominion:

> Dio vuol ch'ascosa antiquamente questa
> strada sia stata, e ancor gran tempo stia;
> né che prima si sappia, che la sesta
> e la settima età passata sia:
> e serba a farla al tempo manifesta,
> che vorrà porre il mondo a monarchia,
> sotto il più saggio imperatore e giusto,
> che sia stato o sarà mai dopo Augusto.
>
> Del sangue d'Austria e d'Aragon io veggio
> nascer sul Reno alla sinistra riva
> un principe, al valor del qual pareggio
> nessun valor, di cui si parli o scriva.
> Astrea veggio per lui riposta in seggio,
> anzi di morta ritornata viva;
> e le virtù che cacciò il mondo, quando
> lei cacciò ancora, uscir per lui di bando.
>
> Per questi merti la Bontà suprema
> non solamente di quel grande impero
> ha disegnato ch'abbia diadema
> ch'ebbe Augusto, Traian, Marco e Severo;
> ma d'ogni terra e quinci e quindi estrema,
> che mai né al sol né all'anno apre il sentiero:
> e vuol che sotto a questo imperatore
> solo un ovile sia, solo un pastore. (*Orlando furioso*, Canto 15.23–6)

[God willed this route to be hidden in the past, and so shall it continue for a long time; it shall not be discovered until the sixth and seventh age have passed, for he has chosen to reveal it when he places the world under the rule of the wisest and most just emperor who ever lived or shall live after Augustus.

I see the birth of a prince on the left bank of the Rhine of Austrian and Aragonese blood; a prince whose valour is unequalled by any that has been spoken or written about. I see Astraea restored to her throne by him, indeed returned from death to life; and the virtues which the world banished with her will also return from exile.

Because of such merits the Supreme Good has given him not only the crown of the great empire that once belonged to Augustus, Trajan, Marcus [Aurelius], and [Septimius] Severus, but also rule over every land under the sun: and he wills that under this emperor there shall be only one shepherd and one fold.]

The last line alludes to the Gospel of St John (10:16): 'And there shall be one flock and one shepherd.' Commentators as astute as Frances Yates have tended to accept this hyperbolic praise of Charles V at face value, greatly underestimating Ariosto's potential for irony. We have already seen the extent to which he undermines the Evangelist's word in Canto 34, where John questions the veracity of all texts (particularly his own).[19] Even if this passage were read as an acclamation of the 'new Charlemagne,' we would have to admit that Ariosto's portrait of the original Charlemagne is less than flattering: the structure of deferral that drives his romance plot is based on the emperor's fundamental inability to rally his troops. It would be misleading to present any passage from the *Orlando furioso* as an unmediated illustration of historical events, but the poem does engage in an imaginative way with such issues of particular concern in the Cinquecento.

Evidently the emperor's public image, particularly with regard to his relationships with subject states in Italy, was the result of a complicated negotiation between classical and Christian codes.[20] It appears that the Negroli were not only superb craftsmen, but also sensitive to such layers of political nuance in the emperor's public positioning. In the panoply we have been examining, presented on the emperor's 1533 Milan visit, the tension between humanist and chivalric visual vocabularies illustrates the delicate balancing act that often characterized Renaissance Habsburg pageantry and propaganda.[21]

For the Holy Roman Emperor it must have been a real question of how far to go in appropriating the language and imagery of *romanitas*. Clearly the emperor's decision to be crowned by the pope in Bologna rather than in Rome in 1530 was a conciliatory move.[22] Particularly after the Sack of 1527, Bologna was more neutral territory on which to perform this curious charade of submission to the authority of the pope, who had been his prisoner in the Castel Sant'Angelo. On this occasion the Holy Roman Emperor relinquished the pageant of *romanitas* to which he might have been entitled both by the nature of his office and his military dominance in the Italian peninsula. Kneeling before the pope (and manifestly not in armour), Charles V formalized his apology to the church for the inadvertent horrors of the Sack while staging the pope's effective sanction of his political hegemony.

Along with all the imagery of triumph, armour was part of the symbolic currency exchanged between the emperor and his subject states. This was particularly true with regard to Milan, due to its position as the centre of the Italian arms industry. Local officials were eager to oblige the emperor and to mark diplomatic occasions of particular importance with especially sumptuous gifts. We have already seen the involvement of several individuals in the emperor's acquisition of the Negroli panoply of helmet and shield. The duke of Mantua first learned of the emperor's interest in the armour and relayed this information to Francesco Maria della Rovere. The duke of Urbino then had it sent to the emperor, who requested a copy – apparently through Francesco II Sforza, Duke of Milan, who in turn charged Massimiliano Stampa, the commander of the Milanese Castello, to arrange its commission and assume responsibility for its formal presentation to the emperor. It seems the transaction was even more complicated, because the duke's specific motive in arranging the gift was to celebrate his engagement to the emperor's niece, Christina of Denmark, which Charles had come to Milan expressly to negotiate.

The armour offered to Charles V commemorated the new level of alliance between the emperor and the Sforza duke – an alliance which amounted to the duke's physical assimilation into the dynastic corporate body of the Habsburgs. The emperor's policy of endogamy – of systematic and strategic intermarriage – was a curiously literal 'politics of the body' that for a time was his most effective strategy to extend and consolidate his power within Europe. In addition to constructing his own individual persona, Charles V was actively creating a dynastic body through the practice of matrimonial imperialism that would steadily multiply his political powers. It is appropriate that gifts of

armour – so deeply implicated with issues of sexuality and masculinity – entered into the process of building that larger corporate persona that reflected his attempt to control his biological legacy. It is, however, ironic that the genetic consequences of the practice of intermarriage contrasted so sharply with the idealized bodies portrayed in armour.

Another gift of armour marked the emperor's second visit to Milan, in 1539. The elaborate harness by Filippo Negroli and his brothers known as the Masks Garniture (Real Armería, inv. A 139) was most probably a gift from Alfonso d'Avalos.[23] At the level of connoisseurship this armour is of exceptional interest for a variety of reasons, not least because it is the largest surviving armour ensemble of the first half of the Cinquecento. In the context of the current argument, however, what concerns me most are the circumstances of its transmission. Like the earlier panoply, the Masks Garniture marked the donor's entry into the corporate body of the Habsburgs, but in a different sense: it acknowledged his admission to the fraternity of the Order of the Golden Fleece, that elite group which functioned as a virtual extension of the dynasty. The armour commemorated not only D'Avalos's entrance into the Order but also his appointments as captain of the imperial army in Italy and governor of Milan. The line of Sforza dukes had in fact ended on the death of Francesco II in 1535, opening up the position for a candidate entirely under the control of the emperor and with no independent title to the duchy. Through its alliance with the Habsburgs, the Sforza line was not only absorbed into the dynasty but essentially eliminated.

From an iconographic perspective, the Masks Garniture is also significant for the evidence it provides of the importance of sacred imagery in the armour of Charles V. In addition to the multiple grotesque masks that give the armour its name, the cuirass (A 142) originally featured two gold appliqués: an imperial eagle on the breastplate and an image of Santa Barbara on the backplate. Apparently a Virgin and Child were also damascened on the breastplate beneath the imperial eagle. Since the formation of the Schmalkaldic League of Protestant princes in 1531, Charles had ordered that all his breastplates bear an image of the Virgin Mary and all backplates an image of Santa Barbara.[24] The figures have now disappeared, but their silhouettes are still visible on the steel.[25] These traces provide valuable context for the surviving ornament on the garniture, which otherwise appears to be wholly secular in nature: a mannerist extravaganza of squirrels, cherubs, insects, arabesques, and trophies swirling round the grotesque masks, which flaunt a variety of grimaces – rolling eyes, protruding tongues, and bared teeth.

There were two models for the state entries on the emperor's Ital-

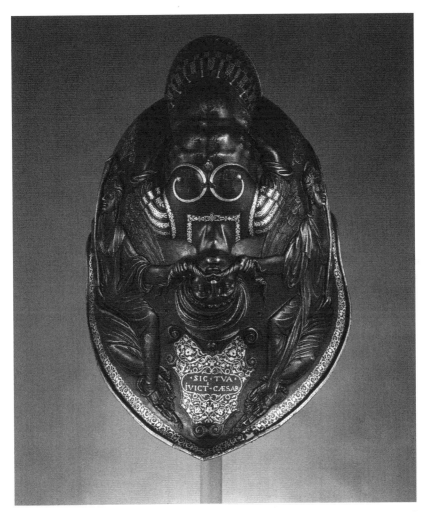

Fig. 28. Burgonet of Charles V. Filippo and Francesco Negroli, 1545. Real Armería, Madrid.

ian tours: the secular tradition of the *trionfo all'antica* and the Christian prototype of Jesus's entry into the New Jerusalem. These two models coexisted and were emphasized in different circumstances to varying degrees. The syncretism is well illustrated by the example of another parade helmet by Filippo and Francesco Negroli, dated 1545 (Real Armería, inv. D 30) (Fig. 28).[26] Its vocabulary at first appears entirely classical, like the gold damascened inscription on the cartouche above

the brim: SIC TUA IVICT CAESAR (Thus is Caesar invincible). But the profile of the helmet would reveal an embossed figure on the crest that could eventually be identified when the helmet was removed: a Turkish prisoner in a turban, held firmly by the figures of Victory and Fame. As if his hands were bound behind his back, the Turk is modelled as a half-bodied herm resting on a fluted column; bending over backwards, he is held in place (upside down) by his long curling moustaches. The *all'antica* helmet thus is updated by its reference to the emperor's war against Islam. Charles is both Caesar and the servant of Christ.[27]

An aphorism attributed to Charles V after his victory over the duke of Saxony puts the matter most succinctly: 'Io non posso dire come Cesare, veni, vidi, vici, ma posso ben dire veni, vidi, et Christus vicit' (I cannot say like Caesar, I came, I saw, I conquered; but I can indeed say I came, I saw, and Christ conquered).[28] In fact the emperor never went into battle without an image of the cross affixed to his arms: to this he attributed his victories against both Protestants and Turks.[29] He actively propagated the legacy of Constantine and incorporated it into his triumphal imagery. A mass in Messina after the emperor's African victories featured an elaborate mute tableau of the cross, which miraculously appeared to cast out the Turkish arms on the model of Constantinople suspended over the nave of the cathedral.[30]

In a portrait that would become the canonical image of Charles V, Titian clearly articulates the emperor's dual nature (Fig. 29). This portrait, commemorating Charles's victory over the German Protestant princes at the Battle of Mühlberg (1547), is considered the first painted or sculpted equestrian monument since antiquity dedicated to a living individual.[31] Clearly the emperor is Romanized by the painting's implied reference to the statue of Marcus Aurelius, one of the classical personae whom Charles often incorporated in his imagery.[32] Central to the project of promoting this association was the widely read imitation of that Roman emperor's *Meditations*, the *Relox de principes* written by the Habsburg royal historiographer Antonio Guevara.[33]

But Titian also makes it clear that Charles V is a *miles christianus*. With his lance in hand, Charles faces the prospect of battle in the armour that he actually wore that day at the Battle of Mühlberg. This is not a theatrical *all'antica* costume but a contemporary German working armour. This relic, still preserved in the Real Armería (inv. A 164–87), was portrayed in a number of state images commissioned to celebrate the battle, including two by the sculptor Leone Leoni.[34]

In red accents that contrast with the glittering steel, Titian further

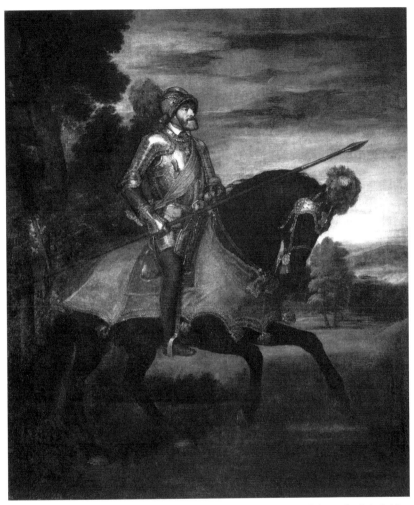

Fig. 29. Titian, *Charles V at Battle of Mühlberg*. 1548. Museo del Prado, Madrid.

emphasizes the emperor's Christian attributes: both the collar of the Golden Fleece and his ceremonial red sash. Through the rhetoric of portraiture Titian articulates the tension between the two primary traditions that shaped the emperor's education: the Stoic classicism of Marcus Aurelius and the Christian humanism of Erasmus. Like Guevara, Erasmus had dedicated a didactic treatise to Charles, *The Education of a Christian Prince* (1516), and the emperor was deeply influenced

by its austerity.[35] In this tract and in the earlier *Enchiridion militis christiani* (1503), Erasmus warned against ostentation and advised the Christian prince to behave with humility (echoing Saint Paul's injunction to put on the 'invisible armour of God').[36] Charles had heard a similar message from his childhood tutor, Adrian of Utrecht, who (however disastrously) went on to become pope.

Given the importance of armour in the emperor's self-definition, it is fitting that the most memorable image associated with Charles V showcases the matter of armour in a spectacular way. The sculpture by Leone Leoni, known as *Charles V and Fury Restrained* (Prado, inv. E 273) was both ingenious and unique – a monumental nude statue equipped with a suit of addable armour (Figs. 30, 31). As a tribute to the victory at Mühlberg, it is the sculptural counterpart to Titian's equestrian portrait. Even more dramatically than the painting, it articulates the emperor's dual nature. Depending on whether the statue is viewed nude or clothed, it can be seen to emphasize his imagined identity as either a classical hero or a contemporary Christian warrior.[37]

The sculptural group of *Fury Restrained* portrays Charles V standing over a chained and struggling figure on a pile of armour and weapons. On this trophy is the inscription: CAESARIS VIRTUTE DOMITUS FUROR (Fury vanquished by the virtue of Caesar). As Leoni explained in his correspondence, the program derives from Jupiter's prophecy of a future golden age in the *Aeneid*.[38]

The struggle between Virtue and Fury was a familiar literary topos, memorably invoked by Petrarch in his Canzone 128 ('Ai signori d'Italia').[39] Machiavelli himself cites these lines in the conclusion of *Il principe*.[40] Ironically, by deriving the program of his sculpture from these familiar lines, Leoni appropriates the climax of Machiavelli's argument into a state image celebrating the very authority he despised. In Leoni's version of the allegory, the roles are reversed: Virtue is identified with the Habsburg empire, and Fury with all those who would subvert or resist its authority. In this reading of Virgil, the true descendant of Aeneas and ultimate heir to the promised *imperium sine fine* is Charles V.[41]

Like his contemporary and rival Benvenuto Cellini, Leoni began as a goldsmith and medallist but was eager to move to larger commissions as his reputation became known. Leoni's early years in Rome were marked by tumult and scandal; he was arrested for numerous crimes and even accused by Cellini of attempted murder.[42] Condemned to have his right hand cut off for a vicious assault on the papal jeweller, he

was able to negotiate an alternate punishment: an indefinite period as a galley slave in the papal fleet. Leoni's colourful career and improbable promotion from galley slave to imperial knight are a separate story. What interests me here, apart from his roots in a culture of male violence, is his fundamental contribution to the project of constructing the public image of Charles V.

There is some evidence that Leoni was himself an armourer.[43] Certainly his detailed knowledge of armour is reflected in this sculpture. With even greater specificity than Titian, Leoni portrays the armour that Charles wore during the Battle of Mühlberg, although he strategically modifies it in significant ways. The cuirass and cuisses are modelled on the actual German armour preserved in the Real Armería, but to these Leoni adds Roman boots and lion-head pauldrons that derive from the costume tradition. The extravagant sandals remain on the figure when it is otherwise disrobed, as if to emphasize its classical associations and facilitate its metamorphosis into a hero of antiquity.

The lion-head pauldrons were also, inevitably, a covert signature of the artist – a way of writing himself into the commission (not surprisingly, Leone Leoni had adopted the lion as his personal emblem). But they were already fully justified by the Renaissance Habsburgs' free use of Herculean imagery in their own genealogical fantasies. As we have seen, references to Hercules in Habsburg iconography were not a generic instance of allegory. Charles V literally claimed Hercules as an ancestor, tracing his descent from Hercules through three family lines: the Austrian, the Burgundian, and the Castilian.

Leoni's *capriccio* of the addable armour was a startling novelty and seems to have derived in part from his rivalry with Cellini. One of Cellini's most ambitious projects had been a colossal statue of his patron Francis I for a fountain at Fontainebleau. Although the statue was never completed, the sculptor did erect an enormous plaster model forty *braccia* high (over twenty-three metres) in the courtyard of his Paris residence. Cellini boasted that it was so high above the roofline that it was visible to half of Paris.[44]

Unable to surpass the grandiose scale of this project, Leoni devised a *concetto* that might exceed it in ingenuity. In a letter of 1551 he requests permission to modify his original project (a standing nude portrait statue) by adding what he calls 'il mio nuovo capriccio' – a removable suit of armour. 'Per ciò ch'io lo desidero assai, assai,' he urges, 'prego [Sua Maestà] di darmene aviso.'[45]

The novelty of this feature is clear from Vasari's comment in his biography of Leoni:

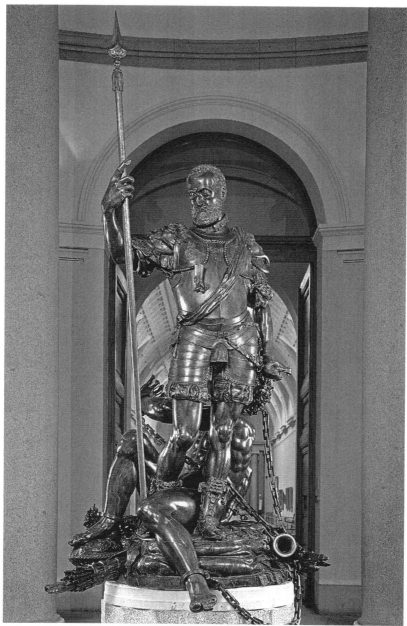

Fig. 30. Leone Leoni, *Charles V and Fury Restrained*. Museo del Prado, Madrid. .

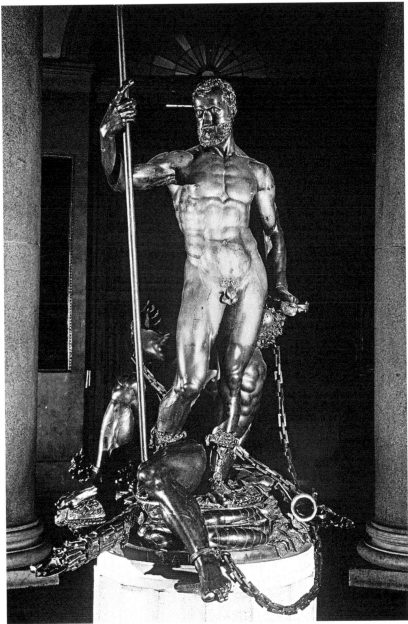

Fig. 31. Leone Leoni, *Charles V and Fury Restrained*. Museo del Prado, Madrid.

Thus not long after he met His Majesty, he made a free-standing bronze statue of the emperor, larger than life-sized, and then clothed it in two light shells with an elegant armour that can be taken off and put on so easily, and with such grace, that whoever saw it clothed would not realize and would almost not believe that it was nude; and whoever saw it nude would not believe that it could be so easily armed.[46]

Leoni's completed work testifies not only to his technical mastery of the bronze medium, but also to his grasp of the essential ambiguity in the emperor's persona. The statue enables us to visualize simultaneously both components of the emperor's identity; the clothing gives it an implied narrative dimension that complicates our reading of the image and reflects the emperor's dual nature. Although the figure is animated by the tension between these two states, classical and Christian, the emperor stands in a stable *contrapposto* that contrasts with the grotesque struggles of the prisoner at his feet: deliberately cast in the rhetorical mode of *asprezza*, Fury is contorted in an expressionistic spiral, his teeth bared and sweat beading on his brow.

It has been suggested that one inspiration for Leoni's idea of the armable statue may have been a recent trip to the monastery of Santa Maria delle Grazie at Curtatone. There he would have seen an enigmatic installation of ex-votos, including mannequins dressed in real (but not removable) armour.[47] The arresting imagery of Curtatone would have been familiar to the emperor, who himself visited the chapel in the 1530s on a state visit to Mantua. Although we have no evidence of the way in which Leoni intended the emperor's statue to be used (was it meant to be armed or disarmed in a public ceremony?), the parallel with the effigies in Santa Maria delle Grazie remains suggestive.[48]

Titian's equestrian portrait and Leoni's armable statue are the most memorable state images designed to commemorate the imperial victory at Mülhberg. Both use armour to articulate the contradictions between the sacred and secular dimensions of the emperor's office. A third work, the portrait bust by Leone Leoni (Prado, inv. E 271) foregrounds the issue of armour in similar fashion, using it as a vehicle to allude simultaneously to the emperor's genealogical romance with antiquity and his direct engagement in one of the most divisive religious controversies of his day (Fig. 32).

As he had in his statue of Charles V with Fury, Leoni modifies the Mülhberg armour in a conspicuous way. We have seen that after the formation of the Schmalkaldic League of Protestant princes in 1531,

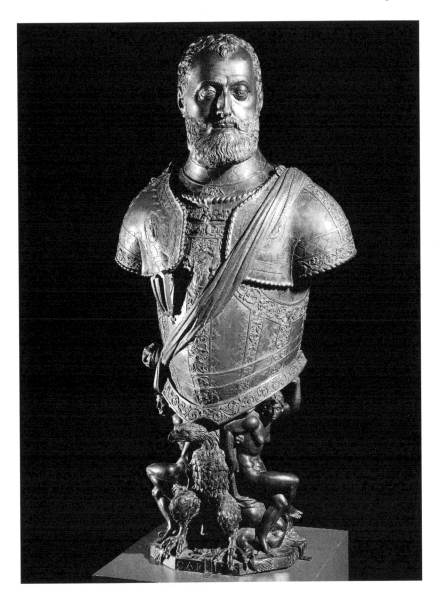

Fig. 32. Leone Leoni, portrait bust of Charles V. Museo del Prado, Madrid.

Charles V had mandated that images of the Virgin and Santa Barbara appear on the front and back of his armours. In crafting an image to celebrate the victory at Mühlberg, Leoni has taken the liberty of substituting for the Virgin in the central medallion an image of Michelangelo's Resurrected Christ (installed in 1521 in the Roman Church of Santa Maria sopra Minerva).[49] Christ is not suffering on the cross but resurrected, holding the cross at his side.

This detail underscores Leoni's sophisticated understanding of the language of armour and the political implications of its iconography. The garniture the emperor wore at Mühlberg had actually been created three years earlier and already worn on a number of occasions. In retrospect, given the surpassing importance of the victory at Mühlberg, Leoni embellishes the breastplate in this fashion, converting the central medallion to a triumphal image. Even more pointedly, by invoking the Church of Santa Maria sopra Minerva, Leoni explicitly alludes to the cult of the Eucharist and its association with the Habsburg dynasty. The church was the centre of eucharistic devotion in Rome and directly affiliated with the Brussels Cathedral of St Gudule, where Charles had dedicated a chapel celebrating the Holy Sacrament. The Christ image on the cuirass thus works as a polemical reference to that tenet of the faith most openly challenged by the Protestant heresy – the belief in the literal presence of the body of Christ in the consecrated Host.[50]

If the central medallion of the Resurrected Christ alludes to Santa Maria sopra Minerva, there is a further irony in its literal placement above the figure of Minerva that, with Mars and the imperial eagle, constitutes the base of the bust. The eighth-century Roman church had been founded on the remains of a temple to Minerva. Thus the syncretism that is written into the topography of Rome is appropriately mirrored in the iconography of this portrait of the Holy Roman Emperor.

A final detail regarding Leoni's treatment of armour in this bust confirms his intention to foreground the issue of armour in an unprecedented way. Instead of arbitrarily truncating the torso and arms as was customary in the portrait bust genre, the artist presents the breastplate and pauldrons intact. This creates the illusion of a freestanding empty cuirass and complicates the imaginative impact of the sculpture; the work not only alludes metonymically to the whole figure of the sitter but appears to function as a self-contained object.[51]

As a primary surface on which dynastic claims were inscribed, armour is a particularly sensitive register of the tensions and anxieties relat-

ing to the issue of dynastic succession in the Cinquecento. Ultimately, there was no matter more critical to Charles's political vision than to ensure the succession by his son Philip to the title of Holy Roman Emperor. Certainly there was no succession among the ruling houses of Europe where so much was at stake. The Holy Roman Emperor was not a hereditary office; in theory, at least, it was an elective title. Despite much opposition, Charles V was determined to convince the electors at the Diet of Augsburg that the office should pass to his eldest son.

The most troublesome opposition came from within the emperor's own family. In presenting Philip's candidacy, Charles V found himself in direct competition with his younger brother Ferdinand of Austria. Already heir to the ambiguous title of King of the Romans, Ferdinand intended to succeed Charles as Holy Roman Emperor and ultimately to pass that office to his own son Maximilian.

Philip's Grand Tour of 1548–51 was a carefully planned public relations exercise designed to introduce the young prince to his potential subjects and the electors at Augsburg.[52] The event took the form of a ceremonial progress through Italy, Austria, Germany, and Flanders, culminating in the prince's presentation to the imperial conclave. By escorting Philip to Augsburg and sending Maximilian to Spain as regent in his absence, Charles V sought to double his tactical advantage in the debate over the succession; it was critical to ensure his own son's visibility (both literal and figurative) throughout the ongoing discussions. In triumphal entries at each of the cities on his route, Philip was presented as heir apparent to the imperial office. Rhetorically, the tour functioned as an elaborate *hysteron proteron* celebrating the prince's election as a *fait accompli*. Precisely because the event consisted of such a self-conscious manipulation of appearances, armour was an important expressive medium and prop to identity. The prince's armour was an essential component of his political image and a conspicuous vehicle to advance his claim to legitimacy.

From his own experience the emperor evidently understood the importance of costume in the construction of identity. This helped to justify the extraordinary expense of the young prince's armour for the tour. We know that Philip acquired four of his finest and most elaborate armours for the occasion. Some were prodigiously expensive; his account books show that Philip paid for these costly armours in installments. One parade harness cost the dizzying sum of 3,690 gold *escudos*.[53]

Both at the meetings of the Diet itself – which the young prince attended in full regalia – and in the ceremonial entries and tournaments

performed in each of the cities on his route, Philip's armour displayed his ancestry and unique claim to the imperial office. That claim was grounded in the principle of primogeniture, which guaranteed direct inheritance by the eldest son. Ferdinand's claim, by contrast, was based on the model of patrilineal seniority, which prescribed that the throne should pass to the monarch's next eldest brother before reverting to the monarch's own children. The fact that neither principle of hereditary succession technically applied to an elective office was irrelevant to the rhetorical promotion of either candidate, and Philip's festival imagery was consistent in its focus on the privileged relationship between fathers and sons.

Predictably, the iconography of the prince's tour was saturated with emblems of the House of Habsburg. Court mythographers devising programs for the ephemeral architecture and decor manipulated the traditional vocabulary of encomium, reiterating the dynasty's most fabulous genealogical claims and invoking its alleged ancestors from Jupiter to Aeneas. But again and again they chose to focus specifically on images that illustrate the transmission of power from father to son. Examples, both biblical and classical, included Jupiter and Hercules, Aeneas and Ascanius, David and Solomon, and Philip of Macedon and Alexander the Great.[54] As a recent study has shown, the prince's tournament and parade armours created for the tour shared this iconographical emphasis.[55] Armour was an integral part of the festivities and an essential platform for Philip's dynastic claims.

The very fact that his entries often culminated in a tournament shows the importance of chivalric role play in his political advancement. Philip's public image depended on his willingness to participate in these ritual tests of his manhood; from childhood he had been trained in such martial exercises and displays.[56] Although official accounts claim that he enjoyed these immensely, we know that he was uneasy after suffering a head injury in a joust on his father's birthday and requested additional reinforcement pieces in the next harness he commissioned.[57] This, the *Ondas* or Cloud Bands Garniture (created for his second marriage) was in fact the last tournament armour that Philip ever ordered.

The simple fact that masculinity in this context implied the public assumption of physical risk further explains the centrality of armour in rituals associated with the drama of succession. The tournaments in which Philip participated during his tour were, of course, stacked in his favour; their outcome was a foregone conclusion. Occasionally that advantage was inscribed in the armours themselves; the *Lacerias*

or Strapwork Garniture has a locking gauntlet, which ensures that the contestant can never drop his weapon.[58] More commonly his advantage was written into the 'plot' of the encounter, most spectacularly in the tournament at Binche. Here the games amounted to a kind of interactive theatre enacting familiar literary scenarios from chivalric romance, with the (disguised) prince in the starring role of the mysterious stranger with miraculous powers. These scenarios, often based on the prince's beloved *Amadis of Gaul*, provided a series of opportunities for the prince to simulate acts of heroism; each time he succeeded at a seemingly impossible task and then revealed his identity, the audience recognized his 'election' as providentially ordained. By appropriating the pleasures associated with familiar romance texts, the games actively engaged spectators (as well as other designated participants) in the symbolic process of acclaiming Philip's presumed destiny and anticipating his succession to the imperial title.

Any young man would have appreciated the chance to wear the glamorous costumes created for the prince's Grand Tour. But Philip in particular benefited from such prostheses: his slight build, evident from the dimensions of the armour, was a disadvantage on the public stage. Contemporaries complained that he was not only slight but also lacked energy, vitality, presence; in the judgment of one Venetian ambassador, 'He is small of stature and his limbs are mean ... His disposition is phlegmatic and melancholic ... Just as his disposition is feeble, his is a somewhat timid spirit.'[59] 'Even his two widowed aunts,' notes Grierson, 'found him disappointingly "small of body compared with the Germans" and by inference only half a man.'[60] Philip's splendid armour represented, pragmatically, a way to enhance his stature. It monumentalized the uncertain young prince and gave him – literally – a new *gravitas*.

The most impressive armour created for his tour – and one of the most dazzling pageant armours ever made – was the embossed gold and steel garniture by Desiderius Colman (Helmschmid) of Augsburg, now displayed in the Real Armería (inv. A 239–42). This was most probably the costume that the prince wore when accompanying his father to meetings of the Imperial Diet.[61] It was of course no accident that the prince had commissioned the armour from a local workshop: as one of the most important centres of arms production in Europe, Augsburg was renowned for its distinctive style and level of craftsmanship, and the Helmschmid were without question its most prestigious *atelier*. Whatever the emperor's interest in Milanese pageant armours (which,

as we have seen, he had begun to collect as early as 1533), he knew that it would have been impolitic to commission an Italian armour for this delicate occasion.[62] It is ironic that of all German armours of this period, this one is the most atypical – in a word, the most Italianate – due to its elaborate figurative composition and the technique with which this decoration was achieved. Embossed in relief rather than etched on the surface of the metal, the armour was necessarily suitable only for costume wear; the embossed ornament weakened the steel plate and made it useless in the field.

Surviving elements of the armour include a breast- and backplate of articulated horizontal lames, gorget, symmetrical pauldrons and besagues or roundels at the armpits, arm and leg defences, poleyns, and a codpiece. A second gorget, as well as the buffe, gauntlets, and toe-caps are missing. The garniture features a matching shield and – most dramatically – a partial horse armour consisting of chanfron (head defence) and ornate embossed saddle. This rare case of a horse armour preserved together with a costume garniture illustrates the close relationship between a *cavaliere* and his *cavallo*; perceived as an organic unity, they were arrayed in a single ensemble.[63]

The armour is signed by both Desiderius Colman (Helmschmid) and the goldsmith Jörg Sigman. Godoy notes that the armour in fact displays a number of signatures: on the helmet, the armourer's name and the date (DESIDERIO COLMAN IN AUGUSO 1550), along with the monogram and initials of Jörg Sigman; on the saddle, the mark of Augsburg (a pine cone) and that of the armourer (a helm surmounted by a five-pointed star); and on the shield, a longer inscription (DESIDERIO COLMAN CAYS MAY HARNASCHMACHER AUSGEMACHT IN AUGUSTA DEN 15 APRILIS IM 1552 IAR (Desiderius Colman, armourer to His Imperial Majesty, completed this in Augsburg on the 15th of April in the year 1552).[64] 'The presence of so many signatures, apparently unique in the history of armor-making,' Godoy adds, 'no doubt reflects the pride of the armorer and the goldsmith in their work.' He interprets this, generously, as evidence of a 'felicitous collaboration.'[65] A more antagonistic reference is embedded in one of the hunting scenes on the shield, which depicts a bull goring a warrior whose shield is inscribed NEGROL. Clearly the armourer believed his work to be superior even to that of the Milanese master Negroli, and he took this discreet opportunity to skewer his rival.

It is fitting that a costume devised for the debate on the imperial succession should so explicitly thematize male rivalries. Luxury goods

such as armour – produced at prodigious expense and conceived as virtuoso performances – offered a natural platform to both artists and patrons for the expression of such rivalries. The battle between Negroli and Helmschmid recalls the contest between Leoni and Cellini, which itself mirrored the struggle between Charles V and Francis I. The Diet at Augsburg was a theatre of similarly fraught relationships – both fraternal and filial – in which two brothers negotiated the future of their sons and of the empire.

The ornamental vocabulary of the Helmschmid armour is typically mannerist, framing figural motifs such as putti, masks, nymphs, and satyrs in a complex field of strapwork, garlands, scrolls, and cartouches. The intricate design is unified by vertical bands lined in gold damascened foliage. Ornament was applied by a variety of techniques: embossed, chiselled, damascened, and engraved. Heraldic motifs referring to the owner include the bicephalate Habsburg eagle (on the burgonet), the coat of arms of the crown prince (on a plate attached to chanfron), the flint and firesteel of the House of Burgundy (in a gold ring around the gorget), and several images of the Golden Fleece on the breastplate, gorget, and couters (on the latter it is displaced onto a nude female half-herm, who herself wears a tiny gold collar with the pendant ram). Important areas (elbows, knees, and skull) are emphasized by a particularly dense array of figural motifs. In a functional field armour, these areas would have been physically reinforced to cover the most vulnerable parts of the body; here the ornament itself serves as a symbolic defence. On the helmet and shield the shapes are configured in more complex narrative scenes: *all'antica* battles appear on each side of the burgonet, hunting scenes (including the Negroli joke) rim the outside of the shield, and medallions depicting the allegorical triumphs of War, Peace, Strength, and Wisdom are framed in elaborate foliage, embossed and damascened to resemble laurel wreaths wrapped in a spiralling ribbon.[66]

On this rich field of ornament, certain details are especially curious. The helmet (traditionally allegorized in didactic fashion as the seat of reason) features an array of bizarre creatures, including horned females splayed uncomfortably on pilasters, drunken satyrs, and lurching putti. In one scene a satyr is about to overturn a vase on the head of a sleeping boy; in another a naked youth tries to shield his genitals from a menacing bird of prey.

The pommel of the saddle depicts a nude female figure in a helmet (possibly Venus Armata). 'Significantly (perhaps), the figure of Love

Armed on Philip's imperial saddle is placed directly in front of the prince's groin,' Frieder ventures. Was this another of the armourer's private jokes, a physical caveat to the newly eligible bachelor being paraded around his future estates?[67] It is easy to be tempted by such readings and virtually impossible to know when to stop. It does, however, seem plausible that a number of images on this armour are meant to allude (however playfully) to the prince's sexuality, and specifically to the need for defence from an erotic threat. In the political context of Philip's journey, we can imagine a reference to his responsibility (as the emperor's heir apparent) to marry again, and to marry well.

The iconographic complexity and ambiguity of this harness contrast with the simplicity and restraint (both formal and thematic) of earlier armours commissioned for the prince. A small shield by Mattheus Frauenpreis of Augsburg (1543) portrays the figure of Fortitude rowing the ship of Humanity, guided by a compass and protected by the shield of Faith. The allegory is straightforward and suitably edifying for a sixteen-year-old prince. It is further clarified by inscriptions identifying all the elements of the scene. The ship's mast – a column topped by a capital – alludes both to the classical virtue of Fortitude and the Christian virtue of Chastity. Possibly a gift on Philip's first marriage (1543), the shield invoked a theme of both private and public importance; the ideal of marital chastity was particularly stressed during the Counter-Reformation. The single column may have also been intended to contrast with the double columns of his father's personal device.

The *Lacerias* or Strapwork Garniture by Desiderius Colman was commissioned in the same year; early pieces of this jousting harness may have been made for the prince's first marriage. The 1594 inventory of the royal armoury by Valencia de San Juan describes it as the first complete suit owned by Philip. Its light weight and slender proportions were appropriate for a debut armour. The simple ornament included a frieze of tiny pine cones and vertical fluting (a vestige of the earlier Maximilian style).

Charles V's campaign to invest his son with the imperial title proved a failure. Although the *Felicisimo Viaje* did enhance Philip's visibility, Maximilian eventually insisted on returning to Augsburg, the scene of the family debate on the succession, and did his best to subvert the emperor's plan. The dispute was eventually resolved by the 'Family Compact' of March 1551 – an agreement brokered by the resourceful Mary, regent of the Netherlands, who was as anxious to restore peace to the family as she was to be relieved of her responsibilities as regent. The

agreement prescribed an alternating pattern of succession between the Spanish and Austrian branches of the family: Ferdinand would inherit the imperial title, to be followed by Philip and then by Maximilian. It was a fragile contract, never actually signed. Historians speculate that Ferdinand never intended to honour the agreement; in any case it did not survive the political crises of the years that followed.[68]

Traces of the disappointment at Augsburg are legible in the shield eventually completed for the parade armour by Desiderius Colman. Finished eight months after Philip returned to Spain, the shield was never fitted with a lining or carrying straps; at that point, apparently, it was simply displayed on a wall.[69] However impressive, the pageant shield arrived too late to be used as a prop in the drama of Philip's bid for the imperial title.

Similarly belated was the lifesized portrait statue in armour completed by Leone Leoni in 1553. Commissioned to celebrate Philip's imminent succession, the statue was soon retired; in the words of one historian, 'iconographically, [it] had become an embarrassment.'[70] The statue, which in many respects paralleled the allegorical portrait statue of Philip's father with Fury, featured an elaborate armour that was largely the product of the artist's imagination. The costume combines pseudo-classical and contemporary elements in a fearless pastiche: the cuirass and leg defences, which conformed to the silhouette of a sixteenth-century parade armour, were incised with overlapping scales and adorned with a double row of exotic pteruges. Other all'antica motifs include the lion-headed boots, imperial sword, fringed pauldrons and chlamys fastened at the shoulder. In deference to his father's figural code, Philip's breastplate bears a conspicuous image of the Virgin; discreetly tucked away and partially obscured by the chlamys is the face of Medusa.[71] The artist freely indulges in such juxtapositions; under his steel gorget, the prince (whose expression and hairstyle recall Marcus Aurelius) wears a starched linen ruff.

Like the armable statue of Charles V, this statue of Philip permits a dual reading (depending on whether it is viewed alone or in the context of its companion figure of Mary of Hungary). Mary is dressed in her state regalia – the floor-length *ciuffa* that is the feminine equivalent of armour – and holds an unidentified book that can be read either as a missal (hence a sign of her piety) or as a reference to her love of humanistic learning.[72] A primary purpose of the sculptural group was to commemorate the prince's coming of age, to be marked by his succession and Mary's welcome release from her regency. What is most striking

about the pair is the artist's ironic manipulation of iconographic prec-
edent: this 'dynastic couple' are not husband and wife, but presump-
tive heir and regent.[73] As previously noted, Philip was unmarried at the
time of his *Felicisimo Viaje* and did not himself have a secure heir; his
son by Maria of Portugal, Don Carlos, was of delicate health and would
die at a young age.[74] The double portrait of Philip and Mary proved an
embarrassment not only because Philip was excluded from the impe-
rial succession, but because it drew attention to the ongoing problem of
his bachelorhood and his protracted reluctance to make another politi-
cal marriage.

After the death of his first wife, Philip spent ten contented years in
the company of his mistress, Dona Ana de Osorio. This was unaccept-
able only because he was essentially monogamous and refused to take
another wife. When rumours began to circulate that he hoped to marry
his mistress, Charles was seriously alarmed.[75] The succession of Mary
Tudor to the throne of England presented an unexpected opportunity to
settle Philip in a strategic position: if he married Mary Tudor (to whom,
confusingly, Charles himself had once been engaged), their son would
become king of England. Charles eventually convinced both reluctant
parties to the match. The courtship and marriage are marked by two
opulent armours: the *Flores* Garniture, which Philip wore in a favourite
portrait by Titian that was copied and sent to the queen (as a visual
introduction to her suitor), and the *Ondas* or Cloud Bands Garniture in
which he was married.[76] To celebrate their union, the wedding armour
bears an image of the arms of England.

It was a brief, unhappy marriage – and there was no son. Mary's
pregnancy, announced almost immediately, proved to be an ovarian
tumour that soon caused her death. In this test of his masculinity, Philip
had again failed. The false pregnancy was cruelly ridiculed by his ene-
mies as further proof of his impotence. Philip would remarry twice
more in the quest for a son, first to Elizabeth of Valois (who gave him
two daughters before dying while giving birth to a third) and finally to
his own niece, Anne of Austria. Of their children only one survived, the
future Philip III.

Unlike his father, Philip II was neither a sportsman nor a warrior.
His state portraits in armour misleadingly imply a military vocation;
the famous portrait by Antonio Moro (1557) portrays him as a victori-
ous general at St Quentin, although we know that Philip was not even
present at the battle. (He appeared a day later in cap-a-pie silver armour
to inspect the outcome). As king, Philip grew to rely on a strategy of

deliberate withdrawal and concealment from his subjects; he believed this to enhance his royal mystique.[77]

Charles V and Philip II both used armour as an essential prop to identity, but in radically different ways. For the emperor – a charismatic public performer – armour was an idealized extension of self and a dramatic vehicle for political advancement. For his son, it was increasingly a place to hide.

6 Cosimo I de' Medici (1519–74)

One of the most ambitious individuals manoeuvring in the orbit of the empire was Cosimo I de' Medici (1519–74; Duke of Florence 1537–69 and Grand Duke of Tuscany 1569–74). After decades of political upheaval in the Italian peninsula he emerged a clear winner in its reconfiguration and succeeded in asserting his dominance throughout Tuscany – in part by exploiting his Habsburg alliances, first with Charles V and then with Philip II.

There was nothing obvious about the choice of the seventeen-year-old Cosimo to succeed Duke Alessandro de' Medici on his assassination in 1537. It has often been observed that the Florentine Senate ratified Cosimo's election chiefly because they believed him to be weak and easily manipulated.[1] Cosimo's title to the succession was indirect: he was a fourth cousin of the assassinated duke, whose death had extinguished the male line of descent from Cosimo il Vecchio. As the only son of the *condottiere* Giovanni delle Bande Nere, Cosimo was a fifth-generation descendant of Lorenzo, the brother of Cosimo *Pater Patriae* – hence a distant representative of a lateral branch of the family with no experience and apparently little interest in politics.[2]

From the Medici perspective, it was essential to find a blood relative to succeed the murdered duke and sustain the hereditary title recently conferred by the emperor.[3] Alessandro left no legitimate heir; he and his wife, Margherita of Austria, had been married less than a year and had no children.[4] Of the secondary branch of the family (descended from Lorenzo, brother of Cosimo il Vecchio), Cosimo appeared to be the last resort: both Lorenzino (Alessandro's assassin) and his brother Giuliano were obviously excluded from the succession. In his favour, it could be argued that Cosimo descended from *both* branches of the Medici, since

his mother, Maria Salviati, was the granddaughter of Lorenzo il Magnifico; this was used to substantiate the claim that he was predestined to rule.

Precisely because his election was so unexpected, Cosimo learned to focus the resources of his court on establishing his legitimacy. With the help of Giorgio Vasari as media strategist, Cosimo consolidated his authority by propagating idealized images of himself that obscured the precarious nature of the transition and dramatized the counter-myth of Medici continuity. It was a sophisticated and self-conscious image industry, a bureaucracy that was both efficient and distinctly modern in its use of media as a means of political control.

One of the most pervasive images of the new Medici duke was his portrait in armour. Portraits of *Cosimo armato* were ubiquitous in Florence and were disseminated in a variety of media – in painting, portrait busts, and medals. Starn and Partridge have argued that Cosimo deployed a 'high triumphalist code' in a calculated and programmatic way, both in the ephemeral art of festival and the more permanent artistic commissions that commemorated and reinforced them; I would add that portraits of Cosimo as *perfetto capitano* were integral to this code.[5] Building on Starn and Partridge's analysis, this chapter will focus on the semiotics of armour in the imagery generated by Cosimo's court and attempt to situate it in the broader context of the political appropriations of armour in the Italian Cinquecento.

Almost all of the many paintings of Cosimo in armour derive from a single prototype: Bronzino's portrait (ca 1543) now in the Uffizi (Fig. 33).[6] In his biography of the artist, Vasari describes the commission in the following terms:

> Having seen this painter's excellence, and especially the fact that he created portraits from life with the greatest diligence imaginable, the young duke ordered a portrait of himself entirely dressed in steel armour, with a hand on his helmet.[7]

Without substantial change, Bronzino's painting was replicated in a variety of formats (bust, half-length, and three-quarter length) and sizes (from miniature to larger than life). The copies range widely in quality; many were the product of the artist's workshop, some with his direct collaboration. Each of these works has followed a complicated itinerary to its present location and bears a genealogical relationship to the other copies that can in part be reconstructed. What interests me most about

Fig. 33. Agnolo Bronzino, *Portrait of Cosimo I de' Medici in Armour*, ca 1543. Galleria degli Uffizi, Florence.

this series, however, is the treatment of armour and its implications for the political iconography of Cosimo's regime.

The armour worn by Cosimo in the Bronzino portrait has been attributed to the Innsbruck armourer Jörg Seusenhofer (with etched

decoration by Leonhard Meurl).[8] Scholars agree that it was probably a diplomatic gift from Ferdinand of Austria, the younger brother of Charles V, to mark Cosimo's accession to the dukedom in 1537.[9] Apparently Cosimo commissioned the portrait to commemorate both his rise to power and the Habsburg inaugural gift that served as material sanction of that authority. In a recent work (ca 1530), Titian had painted the emperor in a nearly identical armour, also the work of Seusenhofer. The painting is now lost, but was presumably known to both Bronzino and his patron.[10] Cosimo could engage in no more explicit form of imperial role play than to model his own armour in a similar portrait. In deference to the emperor's status Bronzino appears to have deliberately attenuated the duke's pose, but the reference is clear and would probably have been recognized by recipients of the Medici portrait. When Cosimo distributed the countless replicas as diplomatic gifts, he simultaneously conferred a favour, acknowledged a debt, and advertised an alliance that remained critical to his advancement.[11]

Each portrait functioned as a surrogate of its subject and served as a metonymic embodiment of the duke's authority, an emanation of his power. More bluntly, the logic of advertising required the multiplication of such images to create and promote his unique visual brand. The scale of the decorative programs undertaken by Cosimo's regime shows that he aimed by sheer force of repetition to saturate the media with signs of Medici sovereignty. In a way that we can recognize as quite modern, Cosimo engineered an explosion of images unlike any the Florentine republic had ever produced. The imagery generated by his court was wilfully redundant; more important than any individual reference was the fact of its repetition. In this sense, Cosimo's regime preferred banality to ingenuity, imitation to *invenzione*.

As important as the principle of repetition was that of exclusivity. Control of the media signified both the multiplication of official images and the prohibition or displacement of alternative imagery. In fact, Cosimo dictated and disseminated a precise series of portrait types reflecting the desired evolution of his political persona. One could even argue that he established a single portrait type that was twice adapted through costume changes but maintained a single recognizable pose.

Bronzino's *Cosimo armato* remained the active prototype until ca 1560, when a second model was introduced, the *Portrait of Cosimo I at the Age of Forty*. This has been described as a less militant and more conciliatory image, since the duke appears in courtly costume (velvet doublet, lace collar, gloves, and handkerchief) rather than armour. Officially

the duke remained forty for at least a decade, until his final costume change into the ceremonial robes that mark his accession to the coveted title of Grand Duke of Tuscany.[12] In these portraits he wears full regalia: an ermine cloak, brocade gown, crown, and sceptre. Since many of the versions of this portrait type were posthumous (and hence conceived in the absence of a model), they display an increasing preoccupation with the costume itself. The court painter Ludovico Cigoli, who in 1602 was the first to paint a full-length portrait of the duke in *abito reale*, borrowed the grand-ducal robes to study for the occasion.[13]

What makes the entire series work as propaganda is its increasing abstraction. As the historical subject was transformed into an icon, the portrait series came to resemble only itself; copies generated other copies without reference to the source. In the process of replication, irregularities and nuances captured in the first portrait were gradually eliminated; as in the process of manuscript transcription, once a detail was erased from the sequence, it was irrevocably lost to the text.[14] Unlike the miniatures exchanged with family and close friends – which more accurately reflect both Cosimo's private nature and the aging process – the duke's public image became increasingly fixed and impersonal. In the series of miniatures, each painted from life, the features coarsen and settle as the duke grows into his face, but in the posthumous grand-ducal portraits the face is evacuated of all expression, as rigid as a mask.

Michelangelo would not have objected to such a process of depersonalization; indeed, he had little interest in naturalistic portraiture and bypassed it entirely in his representation of historical subjects. As he explained of the generically idealized features of the two earlier Medici dukes he sculpted for the New Sacristy of San Lorenzo, 'di qui a mille anni nessuno non ne potea dar cognitione che fossero altrimenti' (in a thousand years no one could know that they once looked different).[15]

Once his portrait type was fixed, Cosimo refused to sit for other artists. Titian himself was turned down when he offered to paint a portrait, and even Bronzino was given no more sittings and was reduced to copying his earlier paintings.[16] Cosimo was not as difficult to please as Isabella d'Este, who rejected countless versions of her portrait in the process of crafting her public image, but he was equally determined to construct an identity through portraiture by retaining control of the dissemination of his image.

A corollary of the systematic replication of approved portrait types was the prompt disposal of eccentric variants. Those who recognize

Pontormo's so-called *Halberdier* as a portrait of Cosimo agree that as an official image it found no following.[17] The same is true (unsurprisingly) of the suave and peculiar *Cosimo as Orpheus* (also by Bronzino) now in Philadelphia; this was sufficiently bizarre to be ruled out as a portrait type.[18]

Throughout this discussion I have presumed Cosimo's direct involvement in the process of constructing his political identity through portraiture. There can be no doubt of his continuous intervention in the artistic process, which is thoroughly documented in Vasari's accounts. Although he delegated willingly, employing a vast bureaucracy of scholars and artists to implement his vision, Cosimo alone dictated the outcome of the artistic ventures produced by his court. From the conception of a work to its execution he maintained the last word; as Vasari famously said of the duke's controlling will, he favoured 'di tanti voleri un solo, che è appunto il suo' (of all wishes one alone, his own).[19]

The frank control of the media practised by the Medici is illustrated by an episode relating to a later stage of the ducal succession. Cosimo I was succeeded by his eldest son, who ruled as Francesco I until his death in 1587. His younger brother Ferdinando's subsequent decision to destroy the existing portraits of his sole rival to the succession shows that he believed that painted images were not just a passive record of events but had an active, transitive influence on their outcome. As the (newly legitimized) son of Francesco I, Antonio de' Medici might have pursued a claim to the grand-ducal title; the existence of an imposing state portrait of Antonio with his parents by the court painter Allori certainly implied that Antonio's mother, Bianca Cappello, had such ambitions for her son. Determined to exclude Antonio from the succession, Ferdinando ordered this painting and all its copies destroyed, literally erasing the image of the pretender from public memory (and quickly substituting a portrait of his own). He followed this act of metaphorical castration by a more literal one, forcing his nephew into the celibate Order of the Knights of Jerusalem.[20] By agreeing to marriage Ferdinando sacrificed his own status as a cardinal, trading his release from the vow of celibacy for the obligation to continue the family name. He would go on to demonstrate his reproductive power by fathering nine children with his wife, Christine of Lorraine.

Given the surpassing importance of Bronzino's *Portrait of Cosimo I in Armour* not just as an isolated work but as the prototype of a series that would be replicated beyond his death, it is critical to examine the portrait more closely and describe it in some detail. The young duke

is portrayed at half-length, with a bare head, light moustache, and faint beard. He wears a highly decorative steel harness studded with gold rivets and hinges and rests his bare hand on a matching helmet. The armour is engraved with a variety of foliate and figural ornament (including scrolls, swags, a sphinx, and *putti*); the central device of the Medici *palle* appears on the breastplate. The gorget has a distinctive rope-like turned edge that is repeated in the shoulder, upper arm, and elbow defences. The most conspicuous visual and formal element of the armour is the pair of besagues or roundels protecting the underarm area; these circular plates have sharp spikes that point to the viewer's right and catch the light in a dramatic way.

One of the elements of the portrait to have attracted most attention is the sitter's pose. Although the sharp points of the besagues emphasize the figure's partial rotation to the left, the duke's eyes face obliquely in the opposite direction and do not engage the viewer. This *contrapposto* has a genealogy all its own; in homage to the sculptor as well as reference to the duke's ancestry, it derives from Michelangelo's portrait of Giuliano de' Medici in the New Sacristy at San Lorenzo.[21]

Perhaps more striking at the time of the portrait's execution would have been the parallel with another Titian portrait of Charles V.[22] The psychological and political nuances conveyed by Bronzino's image become more clear when we compare the stance of the two figures. In a nearly identical armour (spiky besagues and all), the emperor appears in a three-quarter profile accentuated by his familiar prominent chin and pointed beard. Over his right shoulder he raises an unsheathed sword. He faces forward as if marching in a military parade and swivels his head slightly to look straight at the viewer. Though not a full frontal image of the emperor, it is spatially unambiguous and a model of direct address.

In his portrait of Cosimo, Bronzino introduces an element of torsion that alters his sitter's physical stance and also implies a psychological shift. Bronzino's image of the duke has been variously described as cold, arrogant, or even repellent – his stern yet unreadable expression deflects the viewer like the hard, glancing surfaces of the armour he wears. And his contrived indifference to our curiosity is especially annoying because we realize that it is the result of a conscious pose. Particularly in contrast with the Titian model, even as he solicits our gaze Cosimo seems to be advertising his unavailability, his absorption in something 'off-camera' that we will never be privileged to see. The portrait might be imagined as the residue of a passive-aggressive game

intended to situate the subject beyond our grasp. It would seem to be a textbook illustration of Berger's 'fiction of the pose' – an elaborately staged artifact that records the patron's wish to be portrayed in the act of soliciting our attention while simultaneously refusing eye contact.[23]

But a sixteenth-century reading – at least that of a professional panegyricist – ventures an entirely different interpretation of the ducal portrait. Paolo Giovio the Younger, the nephew of the scholar Paolo Giovio who was Cosimo's friend and a Medici partisan, provides the following Latin gloss on the portrait, reproduced in his edition of the *Elogia virorum bellica*:

> Qualis Hyperboreo laetus Gradivus in orbe
> fumantes quum solvit equuos, sudantiaque ora
> Strymonis in ripa victricibus abluit undis;
> Iam furor, & rabies armorum, iraeque, minaeque
> Belligero cecidere Deo, tranquillus inerrans
> Ore rubor placido signat sua lumina vultu;
> Ille sedet lustrans oculis, & mente benigna
> Armiferam Thracen, defensumque hostibus Hebrum
> Prospicit, & Geticae secura mapalia terrae;
> *Tum Veneris blandum pertentant gaudia pectus,*
> Talis magnanimi divino lumine COSMI
> Ante alias longe radians effulget imago,
> Ingentesque gerens humeros augustaque membra
> Effigies ullum nunquam peritura per aevum,
> Vertice nudato celsum caput exerit armis;
> Sidereosque oculos, regalia lumina vibrans
> Pacatam se se populis spectantibus offert.
> *Ceu quum deposito magnarum pondere reum*
> *Olli tranquillam demulcente gaudia mentem,*
> Ingenti quum iam ceciderunt monstra ruina
> Qua se devicto mons Murlius erigit hoste;
> Quum iam laeta suo felix Duce Flora quiescit,
> Atque Etrusca salus tanto sub Principe tuta est.

[Like Mars Gradivus rejoicing in his northern sphere when he has freed his smoking steeds, and cleansed their foaming mouths with conqueror waves along the banks of the river Strymon; now passion and the madness of war, and rages and threats fall from the warlike god, (and) calm, unerring strength in his peaceful visage distinguishes the eyes in his face;

he sits surveying armed Thrace with his eyes and his favoring mind, and he looks on Hebrus safe from the enemy and on the Thracian land's huts free from danger; *now the delights of Venus fill his agreeable heart.* Just so the radiant portrait of Cosimo, great-spirited with divine light, shines forth far and wide, and his likeness, never to perish in any age, with its broad shoulders and its lordly (Augustan) limbs, thrusts forth its lofty head from its armor with bared crown; and shining their regal lights, his starry eyes, it proffers the peaceful man himself to the people who behold him. *As when with the weight of great affairs set aside, pleasures caress his tranquil mind,* when monstrous things have fallen into ruin where Montemurlo rises over the conquered enemy; when fortunate Florence lies peaceful, rejoicing in her Duke, and Etruscan welfare is safe under so great a prince.][24]

Giovio reads the work unproblematically as a triumphal image, the portrait of a mighty hero and *perfetto capitano*. Cosimo is the victorious general returning from Montemurlo and resuming the pleasures of peacetime. In fact, the doffed helmet is an indication that he is *removing* his armour in anticipation of the *gaudia veneris* that await him after the battle. The offstage gaze (or leer) is one of erotic desire rather than arrogance or evasion; such desire is of course further proof of his manhood. Cosimo is Mars himself, about to celebrate his military victory with a sexual conquest. The duke's political triumph prefigures an erotic triumph in which, discarding his armour, he will claim his prize and once again cuckold the blacksmith god. (It would disrupt the poet's optimistic scenario to recall that this actually got Mars into a good deal of trouble.)[25]

A shorter poem by Antonio Rinieri, also published in the illustrated Giovio volume, continues in the same mode, acclaiming Cosimo as the hero who has brought peace to the 'Etruscan fatherland,' closing the gates of war and melting swords and helmets into scythes.[26] Both texts disarm the image with an energy that may appear startling, until we consider that perhaps these commentaries were intended precisely to stabilize an ambiguous image and square it more firmly with its public purpose. In fact, the senior Giovio who founded the famous portrait 'museum' on Lake Como seems to have intervened in similar fashion when requesting a portrait of Cosimo to add to his collection. For the *Cosimo armato* owned (and apparently solicited) by Giovio was slightly different from the Uffizi version we have described.[27] It is iconographically enhanced by the addition of the Medici *broncone* – the broken-

off branch with a green shoot that was one of the founding conceits of Cosimo's regime.[28]

It is plausible that the elder Giovio, who knew the emblem well and had explained it at length in his *Dialogo dell'imprese*,[29] advised the duke to insert the device in the armoured portrait to clarify the painting's political message. In the finished work the *broncone* is a discreet addition (thematically motivated by the use of the tree trunk as a base for Cosimo's helmet), but it serves nonetheless to bring the political function of the portrait into focus. As a symbol of the legitimate Medici succession, it literally foregrounds the issue of genealogy and reinstates a device that Cosimo had left behind when he believed his regime was securely established.[30]

The fact that both Paolo Giovio and his nephew (to whom the portrait collection had been entrusted) felt the need to intervene in the ways I have described suggests a certain anxiety with the ambiguous quality of Bronzino's portrait. In particular, the younger Giovio's poem seems an ingenious (and less than persuasive) textual response to an unorthodox image – an attempt to concoct a triumphalist reading for an artifact that is more problematic, contradictory, and original.

Despite its idiosyncrasies, Bronzino's painting won the duke's approval and became his official state portrait, thus destined to endless replication. As an aspiring court artist Cellini was less fortunate; his bronze bust of Cosimo in *all'antica* armour was rejected by the duke and relegated to an inconspicuous site on the island of Elba.[31] Cosimo apparently objected not to the classicizing armour (which he went on to adopt extensively in the iconography of his regime) but to the excessive drama of Cellini's characterization. This alarming bronze head, torqued abruptly to the right on its straining neck, must have appeared a caricature to the patron. Although he may have recognized its hauteur and even cruelty, this *trux frons* was not the image Cosimo wished to project, and he learned to rely on the infinitely less talented Bandinelli for his many sculptural commissions.[32]

Cosimo sought not only the dissemination of his own image but also ordered countless portraits of his ancestors. Pope-Hennessy observes that in the sixteenth century 'the Medici showed an almost morbid interest in self-perpetuation,' but they had excellent reason to pursue the project of ancestral portraiture.[33] In shaping a dynastic narrative, Cosimo was emulating the royal houses of Europe and attempting to suppress his own family's bourgeois origins. Where no established iconography of an individual was available, his artists invented one. Less

important than the accuracy of the likeness was the continuity of the dynastic series.

Throughout his reign Cosimo continued to commission family portraits, even of his most obscure *antenati*. In Monte Cassino and Prato as well as Florence and Rome he ordered a multitude of commemorative images of his ancestors.[34] Some of these portraits were even executed in porphyry, the element traditionally reserved for royalty. The ongoing Medici fascination with *pietre dure* was politically as well as formally motivated and perhaps related less to the technical challenge of carving and assembling these precious *intarsie* than to a sense of the metaphorical capital inherent in these nearly indestructible materials.[35]

The project of dynastic portraiture was by definition self-serving; its implication was teleological and represented Cosimo himself as the fulfilment of the historical promise of the Medici and the true prince who would restore Tuscan supremacy. In an effort to demonstrate that genealogy was destiny, Cosimo rewrote the history of the Medici rise to power with all the rhetorical resources of his regime.

Cosimo was especially careful to integrate his father, the renowned *condottiere* Giovanni delle Bande Nere, into this commemorative project. Giovanni, who did not descend from the primary branch of the Medici but had married into it, was thus retroactively assimilated into its principal bloodline. The desired effect was the definitive effacement of the dynastic crisis that had resulted in Cosimo's rise to power.

Giovanni delle Bande Nere was given pride of place in the decorative program of the Palazzo Vecchio (where an entire room was dedicated to the celebration of his exploits) and in multiple sculptural commissions throughout Florence. Of these, the most important was his monumental tomb at San Lorenzo, based like all these posthumous images on Giovanni's death mask (guarded with reverence by Pietro Aretino).[36] The result was disappointing; the ungainly figure had to wait three hundred years for a pediment. According to a satirical verse written when it was finally unveiled in 1850, the statue eventually gave up and just sat down.[37]

The many commemorative images of this Medici *condottiere* remind us of an essential contrast between father and son. Like Philip II, Cosimo did not seek a military career and fought most of his battles by proxy, but as the son of a legendary soldier he inherited a martial image that he was bound to uphold. In a curious reversal of the usual dynamics of filial devotion, Cosimo lends his *own* armour to his father in one

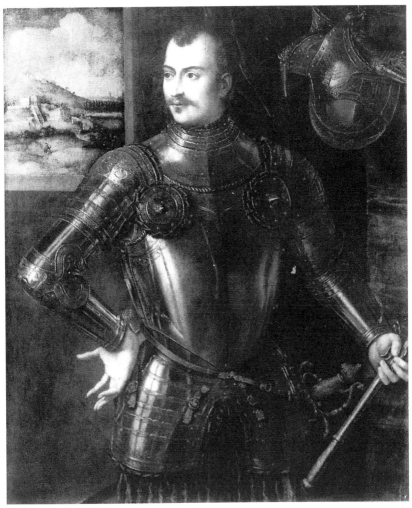

Fig. 34. Anonymous, *Portrait of Giovanni delle Bande Nere*, ca 1545. Galleria Sabauda, Turin.

posthumous portrait – the same armour, in fact, that he himself wears in the Bronzino series (Fig. 34).[38] It is a revealing moment in the process of Medici myth-making – a gesture of homage that is complicated by an irrepressible instinct for self-promotion. The result is almost comical; Giovanni's head appears superimposed on the familiar armour in a

way that is less than convincing. The irony of the image is compounded by its clumsy execution: Giovanni looks like a prankster posing behind a carnival cut-out. 'For Giovanni's portrait, it would seem, Cosimo's armor was summoned up from the *guardaroba* and drawn uninhabited,' observes one critic; hence the impossible anatomy and thorough disconnect between the armour and the figure that pretends to inhabit it.[39]

It was an act of particular hubris on Cosimo's part to clothe the *condottiere* in this armour, because Giovanni delle Bande Nere was so closely identified with his own armour that it had become a material part of his legend. After his death in Mantua at the age of just twenty-eight, Giovanni's armour was indissolubly linked with his memory. A classic biography relates that the *condottiere* was buried in his armour and that his funeral featured an armoured effigy that perfectly resembled him: 'né più né meno come era solito di andare a combattere, talmente che a ciascuno che lo vedeva pareva vivo, avendo l'immagine nel viso e negli occhi, e la stessa terribilità e alterezza che in vita aveva' (neither more nor less than he seemed when he used to go into battle, so that everyone who saw him thought he was alive, since he had the same expression in his face and eyes and the same proud and terrifying quality he had during his life).[40] When his body was moved from Mantua to Florence in 1685, the funerary armour was repatriated with his remains and treated with reverence, like a dynastic relic. Although scholars who examined the armour insisted that it was not his personal armour but just an assortment of pieces from the Gonzaga storerooms, the legend of Giovanni's funerary armour survived and (interestingly) is borne out by Scalini in a recent publication after its *restauro*.[41]

Cosimo's armour from the Bronzino portrait series remained in the Medici collections until the early twentieth century. The fact that it survived the wholesale dispersal of the collections implies that curators recognized its value (either historical or sentimental). The armour was finally appropriated by Mussolini himself, who in 1927 required armour for his collections in Rome. Authorities at the Bargello complied, notes Boccia with evident indignation, 'con ben scarsa responsabilità … in piatta obbedienza a un invito ministeriale che chiedeva armi per il nascente Museo che Mussolini voleva nella capitale' (in less than responsible fashion … in flat obedience to an administrative order for armour to display in the new museum that Mussolini wished to build in the capital).[42] Only a few fragments of the armour survive; they can still be found in the museum of the Castel S. Angelo.[43]

Cosimo did not often presume to dress his father in his own armour.

A less transparent way to reinvent his ancestors in his own image was to clothe them in *all'antica* armour. This appears an archaizing gesture but is of course another case of retrofitting, since these fantasy armours did not exist in classical antiquity but reflected a vogue from the mid-sixteenth century. Both in the Salone and individual rooms, Vasari used *all'antica* armour extensively in his decorative program for the Palazzo Vecchio. The effect is to project onto the generations of Medici a shared identity derived from Cosimo's example. Flanking his throne and arranged round the central fresco of Cosimo's apotheosis, his assembled ancestors are costumed like generals in his army.

The redecoration of the Palazzo Vecchio was not Vasari's first use of armour in articulating the myth of Medici supremacy. In one of his earliest Florentine commissions he had experimented with such iconography in the now-famous 1534 portrait of Alessandro de' Medici (Fig. 35).[44] The armour occupies three-quarters of the picture's surface and is rendered in painstaking detail. Never at a loss for words, Vasari recalls that it was a singular technical challenge:

> Then, in a picture three braccia high, I painted Duke Alessandro in armour, with new invention, on a seat made of prisoners bound together, and other imaginative things. And I remember that besides the portrait, which was a good likeness, I almost went out of my mind trying to make the burnished surface of the armour look shining, bright, and natural; that is how hard I tried to portray every detail. But, despairing of making an accurate portrayal, I brought Jacopo da Pontormo, whom I revered because of his great skill, to look at the work and advise me; and when he had seen the painting and realized how deeply I cared about it, he said to me affectionately: My son, as long as this real, shining armour is next to this picture, the armour you have painted will always look like a painting; for even though lead-white is the finest pigment an artist can use, iron is still finer and more lustrous. Remove the real armour, and you'll see that your imitation armour isn't as bad as you think.[45]

Vasari's pride in his achievement is transparent in this anecdote, which serves as a pretext to mention the older artist's endorsement of his work.[46] In fact, the painting has been admired for its technical virtuosity and in particular for the painter's skill in rendering the illusion of the armour. The young Duke Alessandro, seated in profile looking out at panorama of Florence, wears a polished steel armour of contemporary design, presumably based on one in the Medici collection. Vasari

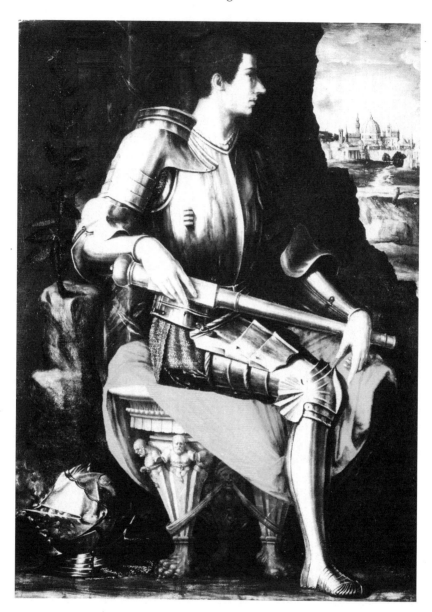

Fig. 35. Giorgio Vasari, *Portrait of Alessandro de' Medici*, 1534. Galleria degli Uffizi, Florence.

pays scrupulous attention to its range of surfaces and textures – the smooth steel plates, silver buckles, and rough chain mail edged in gold. Especially self-conscious lighting effects include the faint reflection of a window in the visor of the helmet. This not only projects the mirror image of an object located (by implication) in the viewer's space, but suggests a fundamental disjunction between the spaces of the viewer and the subject of the painting, since the viewer must occupy an interior distinct from the outdoor setting where the figure is posed.[47]

If Vasari viewed the armour as the supreme test of his mimetic skill, it is ironic that he overlooked a fundamental error in its transcription. The prominent shoulder plate thrust into the picture plane is on the wrong side.[48] As we have mentioned earlier, sixteenth-century garnitures frequently included asymmetrical components adapted to specific uses in sport and combat. But in such cases, the left side was always the side with more prominent reinforcement. Apparently in deference to the numismatic tradition, Vasari shows the right profile of his sitter;[49] this requires him to shift the extra shoulder plate to the right. Projecting dramatically into the picture plane, this formal element accentuates the metaphorical significance of the armour, which Vasari is anxious to explain in his letter to Ottaviano de' Medici (the painting's intended recipient):

> Now I will explain the meaning of the painting. His shining, polished armour is identical to the prince's function as mirror of the people, so that they can see their own reflection in him as they go through life. I have armed the entire figure, apart from the head and hands, to show that he is prepared to defend every public and private interest for love of his country.[50]

This is just the beginning of a lengthy explanation of the painting's iconography.[51] The duke is seated (to show that he is already ruling) on a round chair (representing his perpetual sovereignty). The chair legs, adorned with human figures without arms or legs, represent the people who lack a will of their own. There are three such figures on each chair leg because three is a perfect number. The lion paws on the chair legs allude to the Florentine Marzocco. The duke holds a commander's baton to show that he is the prince and captain of his people. Behind him are the smoking ruins caused by the siege of 1529; he gazes forward at a peaceful view of Florence under his own rule. The mask represents Volubility tethered by strong government. The red

cloth draped over his chair signifies the blood spilled by the Medici in defence of their country. The *broncone* represents the renewed vigour of the dynasty due to Alessandro's succession. Most importantly, the smoking helmet on the ground ('lo elmetto che non tiene in capo, ma in terra abbrucciando') signifies the eternal peace that he will bring to Florence and to Tuscany.

As this letter shows, the portrait suffers from iconographic overload. The chief problem with Vasari's painting was not the quality of its execution but the excessive complexity (and novelty) of its *invenzione*. Critics found the program too difficult and the composition too cluttered; as Vasari had guessed, it required a lengthy explanatory key. The effect of this paint-by-numbers allegory was mechanical; in fact, once the script was provided the image itself seemed secondary – just the illustration of a preexisting text.[52]

Langedijk has speculated that the complex array of emblematic objects in the painting suggests the influence of the scholar Pierio Valeriano, a colleague in the immediate circle of the Medici.[53] Valeriano was deeply involved in the study of hieroglyphs, at the time known only through Horapollo's *Hieroglyphica*, a fourth-century text printed in Venice in 1505. Dürer had already based his woodcut portraits of the Emperor Maximilian on imagery borrowed from this text. Certain elements in Vasari's Alessandro portrait echo the Dürer woodcut (which Vasari may have known) as well as images described in the *Hieroglyphica*. Apart from such literal correspondences, it is likely that Valeriano's passion for hieroglyphs was a catalyst for Vasari's iconographical experiments in his armoured portrait of Alessandro. Valeriano was also quite probably the author of the Latin epigram intended for Vasari's (now lost) picture frame. The script was meant to supplement the image and provide a synthesis of its program for the general viewer, who would not have had access to its specific delineation in Vasari's letter to Ottaviano.[54]

In constructing an identity for the first duke of Florence, Vasari faced the difficulty of working without an established tradition. The imagery appropriate to a Medici duke would bear little relation to the imagery cultivated by the family during its careful rise to power.[55] In this important and sensitive commission, the twenty-four-year-old Vasari seems to have drawn on a range of sources – Domenico di Polo, Valeriano, and possibly Giovio as well – for ideas to pitch to the new regime. That the work found no direct following as a portrait type might not have surprised the artist; perhaps he frankly intended it as a montage of visual

options for his patron to consider. In any case, the attempt to rehabilitate a figure so widely hated was unlikely to succeed; shining armour and an edifying allegory were hardly sufficient at this point to redeem Alessandro in the eyes of Florentines. In fact, the portrait betrays the duke's anxiety and vulnerability as he surveys the panorama of the city from his niche in the newly built Fortezza da Basso.[56] Armed in full panoply with his right hand poised on the hilt of his sword, Alessandro sits ensconced within the massive walls of the fortress – which, like the other defensive configurations that he fashioned in his brief years as duke (including the dynastic strategy of his marriage to Margaret of Austria) failed to protect him from assassination. Nonetheless, in his portrait of the ill-starred duke, Vasari succeeded in establishing his influence with the rising Medici. He went on to become the virtual public relations director for Alessandro's successor, Cosimo I. The most entrepreneurial artist could not have anticipated how profitable this contract would become.

Malcolm Campbell proposes an intriguing parallel between Vasari's Alessandro and one last artwork: Giovanni Montorsoli's portrait statue of the Duke Alessandro in armour.[57] This life-sized figure intended for the Church of SS. Annunziata was exactly contemporary with Vasari's painting and seems to have resembled it in the most literal way: it was a wax effigy dressed in real armour, quite possibly the same armour that Vasari copied in his painting. Since such ex-votos were used to celebrate important military and political victories, this would most logically have been the armour that Alessandro wore for his triumphal entrance into Florence in 1531 at the end of the siege.

We can only guess at its relationship with Vasari's painting, since Montorsoli's statue (with the armour it wore) disappeared centuries ago from the Church of SS. Annunziata. Almost all such ex-voto effigies have been destroyed; the figures in the sanctuary of Santa Maria delle Grazie, described in the previous chapter, are among the very few to have survived. But particularly within a culture that prized the ephemeral art of festival, such works had considerable impact. In his life of Verrocchio, Vasari describes these wax figures with real fascination: they were made with 'l'ossatura di legname ... ed intessuta di canne spaccate, ricoperte poi di panno incerato, con bellissime pieghe e tanto acconciamente ... simile al naturale. Le teste poi, mani e piedi fece di cera più grossa, ma vote dentro, e ritratte dal vivo e dipinte a olio con quelli ornamenti di capelli ed altre cose ... che rappresentano non più uomini di cera, ma vivissimi' (a wooden skeleton, and woven with split

reeds, covered with waxed cloth, with beautiful folds ... just like the real thing. The heads, hands, and feet were made with a thicker wax, but they were hollow, and they were painted from life and decorated with human hair and other ornaments ... so they no longer seemed wax figures, but truly alive).[58]

These ex-votos were paraded in elaborate *cavalcate* that led to the most precious ex-voto image in Florence, the Madonna dell'Annunziata. Such processions were lavish performances staged before large crowds of spectators. Montorsoli's effigy of Alessandro would therefore have attracted considerable public notice, and should be considered a significant part of the context of Vasari's painting.

Certainly by portraying the duke in armour rather than civilian dress, both artists document the transformation of the Medici into a hereditary regime. Previous images (including Vasari's own portrait of Lorenzo) had represented members of the family in *abito civile*.[59] By fashioning portraits in armour, both Vasari and Montorsoli reveal the new face of the Medici – no longer posing as merchants but vested with absolute power.

Alessandro's armour outlived him – returning as late as 1628 in a painting by Francesco Furini known as the *Allegoria di Casa Salviati* (Fig. 36).[60] The painting shows two parallel scenes of investiture relating to the Salviati sisters, Maria and Francesca. In the left panel, Francesca (wife of Ottaviano de' Medici) presents her son (the future Leone XI) to the figure of Rome; he would survive only twenty-nine days as pope. On the right, Maria (wife of Giovanni delle Bande Nere) presents her son Cosimo to Toscana. None of the four historical characters is a portrait: the boys are idealized and identical and the mothers' faces are obscured. But there *is* one portrait in the painting: the *cavaliere inesistente* who stands at the right margin. The empty armour impaled on a sword is clearly recognizable from Vasari's portrait as the ghost of the assassinated Alessandro de' Medici.

Vasari's grandest commission for Cosimo I was the redecoration of the Palazzo della Signoria. In his *Ragionamenti* the artist praises Cosimo for having chosen to rehabilitate this space instead of levelling the building; it was a unique opportunity to transform the chief symbol of the Florentine republic into a monument to the House of Medici. Given Cosimo's political vision, it is not surprising that images of armour are ubiquitous in both the Sala Grande and Appartamenti.

The Sala Grande is a phantasmagoria of battle scenes produced with

Fig. 36. Francesco Furini, *Allegory of Casa Salviati*, 1628. Collezione Salviati, Florence.

astonishing speed by Vasari and his workshop (Fig. 37). Cosimo's purpose was to illustrate the emblematic moments of his regime; and since almost all of them were acts of violence, the room is an oppressive melee of cavalry and infantry constantly refigured in scenes of combat. Massive hindquarters of horses loom in the foreground as their riders charge minuscule forts in the distance; the intervening spaces swarm with soldiers, forests of pikes and lances, exploding cannon, and capsizing boats. Soldiers fall from collapsing ladders and muskets bloom into coronas of flame, and everywhere bodies lie trampled in blood. Overhead Cosimo sits serenely on a cloud bank, crowned by angels and encircled by the escutcheons of Florence's twenty-four guilds.

Vasari boasts of the minute detail with which he has rendered the most complex battle scenes, researching sites and copying topographi-

Fig. 37. Giorgio Vasari, *The Sacking of Pisa*. Sala Grande, Palazzo della Signoria, Florence.

cal features directly from the landscape. He has conjured up every possible variation on death and disfigurement, with bodies falling in an infinite variety of positions. The artist quotes Francesco I as having exclaimed of one picture, 'questo ottangolo mi piace, perché si scorge in esso fierezza, e si vede la strage de' soldati che fa l'artiglieria, ed il combatter loro a piè e a cavallo; e n'avete messi morti assai in varie attitudini con gran maestria' (I like this octagon [panel] because it shows boldness, and the way artillery can massacre soldiers, and it shows men fighting both on foot and on horseback; and you put lots of dead bodies in a variety of positions with exceptional skill).[61] This resembles the enthusiasm of a child describing an especially inventive and violent video game. The sight of the Sala Grande must have been an adrenalin rush, especially for the duke in whose image it was created. Seated on his throne on its elevated dais, Cosimo had a uniquely privileged view of his audience hall and its spectacle of mayhem.

However disturbing this aestheticization of violence, it was exactly what the patron ordered. These paintings were political wallpaper designed to advertise the interests of his regime. They were produced rapidly and efficiently by a centralized committee: Vincenzo Borghini (program), Giovanni Caccini (finances), and Giorgio Vasari (design and execution). These three directed a workforce of architects, painters, masons, carpenters, gilders, and other artisans. However mediocre the result, it was a modern system of artistic production in which tasks were highly specialized and many individuals could work simultaneously – their activity coordinated and monitored by Vasari, the consummate bureaucrat.

The Sala Grande was modelled on the Venetian Sala del Maggior Consiglio, but on a larger scale and with a vastly more complicated program. The geometry of the coffered ceiling is scrupulously plotted; the surface has been articulated into twelve rectangular panels, four octagons, and two roundels (each framed by eight smaller square fields), all surrounding the image of Cosimo's apotheosis. The central axis of the ceiling traces a (highly subjective) history of Florence from its founding to the present, while the two outer rows illustrate Cosimo's dominions (six portraits of Florence and sixteen scenes of other cities and regions in Tuscany). Vasari has disposed of a curious leftover trapezoid (deriving from the irregular shape of the original room) by inserting a group portrait of his chief mason, carpenter, gilder, and grotesque maker peering over a trompe-l'œil balustrade.[62] The six frescoed battle scenes on the walls are complemented by four slate panels illustrating related

conquests. The huge paintings are framed by gilt stucco swags and the entire ensemble is gilded, festooned, and embellished with a multitude of decorative motifs.

Vasari found the program exhilarating and encyclopedic: 'Et insomma, ardirò dire, che ho avuto occasione di fare in detto palco quasi tutto quello che può credere pensiero e concetto d'uomo: varietà di corpi, visi, vestimenti, abigliamenti, celate, elmi, corazze, acconciature di capi diverse, cavalli, fornimenti, barde, artiglierie d'ogni sorte, navigazioni, tempeste, piogge, nevate, e tante altre cose che io non basto a ricordarmene' (I will venture to say that I had occasion to depict on that ceiling almost everything that human thought and imagination can conceive; all the varieties of bodies, faces, vestments, costumes, armour, helmets, cuirasses, headdresses, horses, harnesses, caparisons, artillery of every kind, navigations, tempests, storms of rain and snow, and so many other things that I am not able to remember them).[63] It is, he notes, a microcosm of human experience worthy of his patron (the cosmo/Cosimo pun was routine in Medici propaganda).[64]

The Sala Grande is a kaleidoscopic array of military imagery – a galaxy of trophies. But in this sprawl of armour, past and present don't seem to be conjugated in any consistent way. In the battle scenes, extreme topographical precision contrasts with free historical improvisation, particularly of armour types. The incongruities that result can be surreal: soldiers in Roman costume slash each other fiercely alongside mounted knights in plate armour as if they occupied parallel universes. Warriors in leather buskins are oblivious to the deafening cannon behind them.

But it is possible to detect some organizing principles. As Starn and Partridge have pointed out, the imagery of the Sala Grande is structured by a fundamental opposition between the republican conquest of Pisa (1496–1509) and the ducal conquest of Siena (1553–5).[65] In comparing the Battle of Stampace on the west wall to its pendant scene on the east wall, Starn notes that the scene from the Pisan war is fragmented and chaotic, while the view of Cosimo's own victory over Siena at Porta Camollia is tightly focused – the image of an orderly operation. The Florentine soldiers of 1499 are dressed in Roman costume, but only fifty years later the duke's army all wear contemporary armour.[66] What this seems to suggest is the modernity and superiority of the ducal regime. The classicizing armour of the republican army would signify their attachment to a political ideal that is obsolete. The contrast between these two scenes implies that the republic is ancient history; classical

armour belongs to the *passato remoto*, while sixteenth-century armour denotes the *passato prossimo* of ducal Florence. The return of the Medici has caused an absolute rupture with its republican past, which now appears antiquated and naive.

Yet this use of classicizing armour *in malo* is clearly inconsistent with Cosimo's appropriation of such imagery as an integral part of his own propaganda. The contradiction is symptomatic of his ambivalent relationship with the historical past: it is an essential part of his project of self-legitimation to claim continuity with Rome, but he also needs to radically differentiate ducal Florence from its republican traditions.[67] Cosimo's imitation of Rome is thus both selective and contradictory: he uses classical armour to fashion an imperial persona, presiding as Divus Augustus over the Sala Grande at the fulcrum of its iconographical scheme, but within the same program stigmatizes the Roman pretensions of the republic that preceded him. *All'antica* armour in one context can be a sign of supreme virtue, and in another a symptom of folly and delusion.

Henk Th. Van Veen has argued that during the course of his reign, Cosimo I evolved from an aggressive image politics of absolutism to a more conciliatory recuperation of the symbols and images of the republic.[68] He claims that it is possible to trace a coherent progression in Cosimo's cultural policy from the calculated image of the imperial autocrat toward the persona of the citizen prince in *abito civile*. While agreeing that Cosimo played an active role in dictating the programs of his artistic commissions, I believe that he was actually more flexible and pragmatic than Van Veen suggests. His alternating use of the imagery of classical armour *in bono* and *in malo* within a single iconographic scheme demonstrates a strategy of opportunistic hybridization rather than a clear evolution. Such hybridization is further complicated by a third element, the appropriation of Christian imagery in his dynastic propaganda. Cosimo's gesture of founding the military and pseudo-chivalric Order of the Knights of Santo Stefano in 1562 served to create (ex nihilo) a titled 'nobility' he could manipulate to consolidate his power.[69] The declared purpose of the order was to defend the church and protect Christian shipping routes in the Tyrrhenian sea, but it was actually a patronage mechanism that was entirely pragmatic. The imagery associated with armour alone illustrates that there is no consistent narrative in the propaganda of Cosimo's regime; throughout his reign he freely adapted available models and ideals in his self-representation.

Cosimo's most audacious move during the development of the pro-

gram of the Sala Grande was his invention of the scene of his own apotheosis (Fig. 38).[70] In the central *tondo*, where Borghini and Vasari had envisioned an allegorical figure of the city of Florence, the duke insisted they substitute his portrait. The image of the 'Divine Cosimo' not only becomes the focus of the entire program but also marks the endpoint of a process of rhetorical inflation that we have traced in his portraiture. Above the clouds Cosimo looks supremely confident in his classical thorax. More awkwardly, his Medici ancestors stand in Roman costume below in the Udienza.[71] Balanced uneasily in their niches, they line up like wallflowers at a crowded dance where there was some disagreement about the dress code.

Had it been installed, the most incongruous element of the Sala Grande might have been Ammannati's monumental fountain on the wall facing Cosimo's throne.[72] 'La femmina che si preme le poppe' (in Vasari's phrase) would have been an undignified addition to this hall of state. This voluptuous Ceres squeezing her breasts and the reclining nude spreading her legs over a jar were intended to celebrate the prosperity of Florence under Cosimo's rule. But the rare appearance of nude females in this monument to male belligerence and athleticism would have been a reminder that the arbiter of Medici destiny was now a seventeen-year-old girl. The Sala Grande was of course intended as a permanent record of the wedding festivities created for Giovanna d'Austria in 1565. As Starn and Partridge have shown, her father-in-law consistently upstaged her in her own wedding procession and her bridegroom was nowhere to be found; but the political designs of the Medici converged on this small person.[73] The edifice of masculine fantasy illustrated in the Sala Grande depended on Francesco's bride to deliver an heir. Cosimo's wife Eleonora had died in 1562 along with their sons Giovanni and Garcia, and Ferdinando had become a cardinal in 1563. Of their ten children, only Francesco was left to assure the future of the dynasty. The Sala Grande somewhat misleadingly celebrated Cosimo's transcendence; there was no transcending the deeply prosaic question of reproduction. Sexual fertility must be a central preoccupation of any hereditary regime, and having established their hereditary rule the Medici were beset by inevitable anxieties regarding dynastic continuity.[74]

Cosimo's ambitions for his family were thoroughly reactionary, but in retrospect we can characterize his political use of images as strikingly modern. Despite his youth and inexperience he established and main-

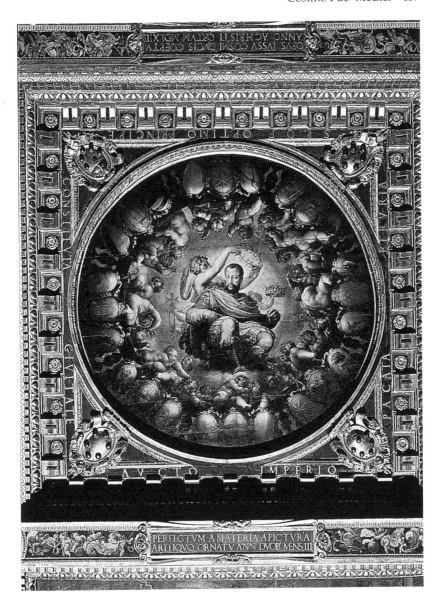

Fig. 38. Giorgio Vasari, *Apotheosis of Cosimo I de' Medici*. Sala Grande, Palazzo della Signoria, Florence.

tained control over Florence with the help of a highly organized image industry. With the customary thrift of the Florentines, he invested in art that was quick, easy, and cost-effective – both the ephemeral forms of festival and the mass-produced pictorial cycles that commemorated them (produced with strict deadlines and subcontracts negotiated in advance). Time and financial pressures left a limited margin for creativity; art by committee was a fully rationalized process. The artist was no longer a solitary genius on a scaffolding, but a project manager shuttling among worksites while developing a migraine.[75]

As we have seen, Cosimo also commissioned propaganda images in series by workshop and circulated them widely to reinforce his authority. He distributed portraits of *Cosimo armato* to political allies and prominent families with the understanding that they would be prominently displayed; this was both a mark of favour and free publicity. It also placed the recipient conveniently in his debt; a later law forbade the removal of Cosimo's portrait bust from palazzo facades without permission of the authorities.[76]

Media strategists and cultural bureaucrats like Vasari and Borghini produced vast decorative ensembles at Cosimo's direction. To a ruler provided with such an efficient *équipe*, images of armour were available in almost infinite supply. In fact we know that the thing itself was much harder to come by. Cosimo's difficulty in attracting a court armourer is repeatedly documented; it was a source of constant frustration and an unpleasant reminder of the gap between his imperial pretensions and actual status as the ruler of a small Italian state.

The most prestigious armourers were of course in Milan, but they were highly sought after by all the courts of Europe and had no interest in moving to Florence. This was probably due to a number of factors: their reliance on known conditions and materials, economic protectionism within the armour-making industry, and political calculation. But the dependence on Milan was both an embarrassment and an inconvenience. Cosimo had particular need to build his arms collection (both for field and parade use) because the Medici armouries had been confiscated and dispersed each time the family were driven from Florence. He had 'infinite' need of armour for his own protection; he required equipment for the order of the Cavalieri di Santo Stefano which he had created in 1561, and for all his other troops.[77] In numerous letters to Medici agents in Milan, Prince Francesco begged for a contract, but it was not until 1568 that Cosimo and Francesco managed to lure a member of the Piatti family to set up a permanent shop in Florence to supply the Medici family and the Tuscan military.

Cosimo's apotheosis in Roman armour at the centre of the Sala Grande belies his marginal and dependent position on the map of Europe. His control over a world of heroic simulations was clearly an illusion; outside of Florence he was just one of many potential clients for luxury goods. Due to the vicissitudes of the Medici armoury, we know relatively little about Cosimo's actual collection; one of the few surviving items he was believed to have owned (the Bargello 'Medici fragments') is now disputed. It is an ironic fact that the most valuable Medici armour was acquired much later through his grandson's marriage, when the contents of the della Rovere armouries in Urbino and Pesaro were transferred to Florence. In the last resort, a woman became the 'carrier' of armour: after the death of the last male heir to the dynasty, Vittoria della Rovere brought the priceless collection to Ferdinand II de' Medici in 1630 as part of her dowry. There it remained, a relic of dynastic ambition, till the extinction of the Medici line.

Conclusion

The fact that Cosimo I de' Medici had such difficulty in procuring an armoury says much about the position of parvenu Italian rulers in the early sixteenth century. These enterprising individuals struggled to assert and maintain their limited authority in a shifting landscape of centralizing nation-states, but their efforts at imperial self-fashioning were especially ironic in view of their ultimate subjugation to Spain (and in some cases, France). Although no longer functional in warfare, armour became an essential component of political theatre, especially to such petty peninsular leaders, for whom armour was an enabling fiction. Subordinated and marginalized at the macropolitical level, they appropriated the imagery of dominance to disguise the novelty and vulnerability of their regimes.

In the courts of Cinquecento Italy, armour contributed to a charade of mastery that masked a condition of political dependence. During the crisis of morale caused by repeated foreign invasions, armour was an icon of impenetrability that was especially poignant. In the face of anxieties regarding Italy's feminization, armour was a symbolic defence as well as a form of aggrandizement – a figuration of the self that exaggerated the stature of minor rulers, imparting *gravitas* and the illusion of autonomy.

It has often been observed that throughout the Italian wars, Italy continued to excel in the realm of the arts despite its military defeat and political humiliation.[1] In providing luxury arms to the rest of Europe (especially to royal clients and the Habsburg court), Italy produced objects that dramatized its own subjection. Unable to compete with more influential patrons for the arms they coveted, peninsular rulers often had to settle for virtual armour. We have seen that when he failed

to attract a master armourer to Florence, Cosimo de' Medici compensated by multiplying *images* of armour in his self-promotion and dynastic propaganda. His most efficient armour was two-dimensional: ephemeral, mass-produced, and cost-effective. It is a measure of his modernity that Cosimo was able in this way to exploit the functional equivalence between the object and its representation.

I have attempted in this book to map a semiotics of armour in early modern Italy by exploring a range of objects and images from court culture of the Cinquecento. I have suggested a number of contexts in which these objects may be viewed: first, as representations of the body (within the three-fold typology of classical/sacred/grotesque); and second, as items of costume – material signifiers of masculinity that contributed to the self-fashioning of individual patrons. Independently of historical context, armour inevitably suggests a hyperbolic assertion of self – a full-body inflation of the aggressive drama of the codpiece. It can be a vehicle for fantasy as well as the inscription of ideology, reflecting the dream of access to a second, incorruptible body impervious to injury, aging, and death. In this sense armour is fundamentally theatrical – implicated in the drama of self-presentation and self-concealment that informs all masquerade.

In purely imaginative terms, armour can be compelling, enigmatic, and even uncanny. In these pages, however, I have chosen to focus directly on armour as a historical phenomenon. Like other artifacts of material culture, armour is embedded in contingent historical events. In focusing on the period of the Italian wars (1494–1559), I have presented an array of objects that are products of a precise historical dynamic – the crisis of Italian states and the transformation of military technology and tactics in the first half of the sixteenth century. As I have noted, with the growing reliance on infantry and the eclipse of armoured cavalry, armour began to disappear from the battlefield. Body armour was not just inadequate as a protection against firearms: due to its increasing weight it became an actual encumbrance. Yet as field armour was retired, recycled, and discarded, parade and ceremonial armour became increasingly flamboyant. Displaced from its utilitarian function of defence and retained only for symbolic uses, armour evolved in a new direction as a medium of artistic expression. Working with this vestigial cultural form, armourers became artists – free to experiment with elaborate embossed ornament and three-dimensional modelling more appropriate to sculpture.

As real warfare diverged more decisively from the symbolic, armour

became pure theatre. A resulting irony was that those left wearing armour were the least likely to fight – Renaissance princes for whom it was a prop to political identity and public display. Such costume became a chief accessory in the performance of Renaissance masculinity by individuals with varying degrees of actual power; often, as we have seen, it was an aspirational costume, based on the emulation of figures with higher social and political status. For Cosimo I de' Medici, descended from a lateral branch of a family of merchant bankers anxious to sustain a recently conferred hereditary title, armour was part of a calculated imperial performance. For Guidobaldo II della Rovere, son of the adopted heir of the sterile descendant of the Montefeltro clan of *condottieri*, the symbolism of armour helped consolidate a vulnerable claim to the duchy of Urbino. In these and other courts throughout the Italian peninsula, costume armour continued to proliferate as subjects emulated the style of the prince. Even for the middle class, portraits in armour (sometimes rented for the occasion) served the purpose of social climbing; the painter and art theorist Giovanni Paolo Lomazzo complained in 1584 that 'merchants and bankers who have never seen a drawn sword and who should properly appear with quill pens behind their ears, their gowns about them and their day-books in front of them, have themselves painted in armour holding generals' batons' (i mercanti e banchieri che non mai videro spada ignuda, a quali propriamente si aspetta la penna nell'orecchia con la gonella intorno et il giornale davanti, si ritraggono armati con bastoni in mano da generali).[2]

Despite its many imitations the luxury armour I have examined in this book is, inescapably, an artifact of elite culture. As I have shown, it stages the anxieties and contradictions of that culture in a variety of ways. Through its iconography such armour not only signifies the wearer's masculinity in a generic fashion but also affirms his entry into a specific political hierarchy. Armour advertises lineage and thus inscribes the individual in a system of male power relations. A clear example we have considered here is that of Guidobaldo II della Rovere, where a father–son dialogue is articulated through armour and its representations. As I have suggested, in such cases armour can be an expression of adolescent rebellion or conversely (and finally) of the son's acceptance of his dynastic responsibilities. The *all'antica* ensemble made by Bartolomeo Campi for the thirty-two-year-old duke celebrates his integration into patriarchal culture and assent to the marriage alliance dictated by his father.

In the Western tradition, genealogical vaunting has been a critical

part of the warrior's self-presentation. In epic poetry this is conveyed by the literal recitation of the hero's paternal ancestry before entering battle. Inscribed with markers of rank and station, armour serves the same function by making that genealogy visible. By implying the gendered transmission of physical prowess along with name and property, armour marks the entry of the individual into a regime of masculinity defined by heredity. In this sense, armour is an imaginative as well as a physical prosthesis; it exceeds the limits of the body by evoking a past and future beyond the individual.

As Valeria Finucci has argued, the male masquerade of early modern Italy associates manhood not simply with sexual potency but specifically with paternity.[3] Armour produced by the unstable hereditary regimes of sixteenth-century Italy reflects this focus on the patrilineal transmission of power. Its elaborate genealogical imagery presents the political legitimacy of the prince as inseparable from his gender identity.

During the course of the Cinquecento, there was a shift in military practice toward long sieges, as new fortification techniques evolved to defend against artillery.[4] Increasingly, it was not the individual that was armoured but the fortress. There is an intimation of this shift in Vasari's portrait of Alessandro de' Medici, where the armoured duke appears in profile against a view of the Fortezza da Basso, newly built to shore up his unpopular regime (Fig. 35). In the changing landscape of early modern warfare, advances in military technology would work to secure not bodies but spaces.

In considering the role of armour in Cinquecento court culture, I have read across several registers of cultural expression. There is much room for further theoretical reflection on the subject of armour in the Renaissance, but in particular I hope this study will encourage more analyses that are historically and culturally specific. My goal has been to recover some of the stories associated with these objects and to open an interdisciplinary conversation. I hope this book is a useful point of departure for future study and that a range of scholars in early modern studies might contribute to the larger project of developing a historical anthropology of armour – a sustained critical attention to armour and its representations.

Glossary

Following is a bilingual list of the most frequently used terms denoting components of armour or related terms.

backplate (schienale): plate armour protecting the back.

bard (barda): horse armour.

basinet (bacinetto): light, pointed helmet often closed in front with a visor.

besague (rotellina): round spiked plate protecting the underarm area.

breastplate (petto): plate armour protecting the chest and abdomen.

buffe (buffa): lower face and throat defence.

burgonet (borgognotta): type of helmet that leaves the face uncovered and has hinged cheekpieces.

cap-a-pie harness: full-length armour (worn from head to foot).

chanfron or shaffron (frontale): head defence for a horse.

codpiece (braghetta): covering for genitals.

couter (cubitiera): elbow defence.

cuirass (corazza): combination of breastplate and backplate.

cuisse (cosciale): thigh defence.

damascene (damascena): an ornamental technique consisting of inlaying gold or silver into engraved grooves on an armour's (often darkened) surface.

fauld (falda): a metal band worn below a breastplate (corresponding to the culet in back) to protect the waist and hips.

garniture (guarnitura): an armour that consists of a customized set of interchangeable pieces for field and sporting uses.

gauntlet (manopola): armoured glove.

gorget (goletta): armour protecting the throat and upper torso.

greave (schiniera): lower leg defence.

harness (arnese): period term for an individual armour.

joust (*giostra*): sporting combat between two individuals.

lame (*lama*): narrow strip of steel plate.

mail (*maglia*): body armour composed of interlocking metal rings.

mascaron: ornamental motif representing a face, human or animal.

morion (*morione*): open helmet, generally with rounded skull, tall comb, and downward-curved brim.

pauldron (*spallaccio*): shoulder and upper arm defence.

peytral: the element of horse armour protecting the horse's chest.

poleyn (*ginocchiera*): knee defence.

pteruge: pendant strap.

rondel/roundel (*rondela*): armpit defence (also called besague).

sabaton (*scarpa*): foot armour.

sallet (*celata*): semi-open helmet with 'tail' and visor.

tasset (*scarsella*): upper thigh defence.

umbo: knob or boss at the centre of a shield.

vambrace (*avambraccio*): arm defence.

visor (*visiera*): part of helmet, movable or fixed, that protects the eyes.

Notes

Introduction

1 The study of armour has traditionally been associated with the academic
disciplines of military history and the decorative arts (itself a marginal
field of art history). Among the works of military history most helpful in
orienting me to the period were Charles Oman, *A History of the Art of War
in the Sixteenth Century* (London: Methuen, 1937); John Rigby Hale, *War
and Society in Renaissance Europe, 1450–1620* (New York: St Martin's Press,
1985); Michael Mallett, *Mercenaries and Their Masters: Warfare in Renais-
sance Italy* (Totowa, NJ: Rowman and Littlefield, 1974); and Malcolm Vale,
War and Chivalry (London: Duckworth, 1981). The classic introduction to
the history and iconography of Italian defensive armour is Bruno Thomas
and Ortwin Gamber, 'L'arte milanese dell'armatura,' in *Storia di Milano*,
vol. 11, *Il declino spagnolo, 1630–1706* (Milan: Treccani, 1958), 697–841.
Among the general works that have proved indispensable to this study
are Lionello Giorgio Boccia and E.T. Coelho, *L'arte dell'armatura in Italia*
(Milan: Bramante, 1967) and Lionello Giorgio Boccia, Francesco Rossi, and
Marco Morin, *Armi e armature lombarde* (Milan: Electa, 1980). Catalogues
of Italian collections of particular interest are Lionello Giorgio Boccia,
Giuseppe Cantelli, and Fosco Maraini, eds., *Il Museo Stibbert a Firenze*, vol.
4 (Milan: Electa, 1976) and Franco Mazzini, ed., *L'armeria reale di Torino*
(Varese: Bramante, 1982). Partway through this project my research was
greatly facilitated by the publication of the superb exhibition catalogue by
Stuart W. Pyhrr and José-A. Godoy, eds., *Heroic Armor of the Renaissance:
Filippo Negroli and His Contemporaries*, Exhibition catalogue (8 October
1998–17 January 1999) (New York: Metropolitan Museum of Art, 1998).
This has continued to be an indispensable iconographic and bibliographi-
cal resource. The most complete international glossary of terms relating

to armour is the *Glossarium armorum. Arma defensiva*, ed. Ortwin Gamber. (Graz, Austria: Akademische Druck-u. Verlaganstalt, 1972). The best terminological dictionary in Italian is Lionello Giorgio Boccia, ed., *Armi difensive dal medioevo all'età moderna* (Florence: Centro Di, 1982); it provides detailed diagrams and descriptions of individual components of armour and also includes an extensive critical bibliography. For an extended discussion of a single parade armour based on the theme of Hercules, see Amedeo Quondam, *Cavallo e cavaliere: L'armatura come seconda pelle del gentiluomo moderno* (Rome: Donzelli, 2003). Although his focus is on the 'Hercules armour' made by Eliseus Libaerts for Erik XIV of Sweden in 1562–4 (Dresden, Rüstkammer), Quondam offers many useful reflections on the more general semiotics of armour. More specialized essays and monographs will be cited in later notes.

2 To cite Stephen Greenblatt, such artifacts are 'complex symbolic and material articulations of the imaginative and ideological structures of the society that produced them.' *Learning to Curse: Essays in Early Modern Culture* (New York: Routledge, 1990), 169.

3 The classic structural analysis of armour in Italian epic is Daniela Delcorno Branca, *L'Orlando furioso e il romanzo cavalleresco medievale* (Florence: Olschki, 1973), especially 57–103. The pursuit of armour in chivalric texts may be considered a variant of the fundamental narrative motif of the search for a missing object; see Vladimir Propp, *Morphology of the Folktale*, trans. Laurence Scott (Bloomington: Indiana University Press, 1958). For a provocative psychoanalytic reading of the armour topos in epic, see Elizabeth J. Bellamy, *Translations of Power: Narcissism and the Unconscious in Epic History* (Ithaca, NY: Cornell University Press, 1992), especially chap. 3, '*Habendi Libido*: Ariosto's Armor of Narcissism,' 82–130. Bellamy asserts that 'armor (and anxiety over its dispersal) is what I would argue to be the privileged trope of the *Furioso*' (p. 89). My own very different approach derives from a sense that armour is not just a structural motif but a gesture toward a set of real objects in the world. Although based in a literary tradition, Ariosto's treatment of the armour motif is new because of cultural circumstances specific to the Cinquecento. In this sense armour is not inert; it is historically framed and inflected.

4 On the detachability and literal transference of armour, see Peter Stallybrass, 'Hauntings: The Materiality of Memory on the Renaissance Stage,' in *Generation and Degeneration: Tropes of Reproduction in Literature and History from Antiquity through Early Modern Europe*, ed. Valeria Finucci and Kevin Brownlee (Durham, NC: Duke University Press, 2001), 287–316. For a broader discussion of clothing and textiles and their relationship to

the construction of identity that I have found extremely valuable, see Ann Rosalind Jones and Peter Stallybrass, *Renaissance Clothing and the Materials of Memory* (Cambridge: Cambridge University Press, 2000); on armour, see especially pp. 246–68. On clothing and gender, I am indebted to the work of Margery Garber, *Vested Interests: Cross-Dressing and Cultural Anxiety* (New York: Routledge, 1992).

5 See Arjun Appadurai, ed., *The Social Life of Things: Commodities in Cultural Perspective* (Cambridge: Cambridge University Press, 1986).

6 I use these terms as defined by Stephen Greenblatt: 'By resonance I mean the power of the object displayed to reach out beyond its formal boundaries to a larger world, to evoke in the viewer the complex, dynamic cultural forces from which it has emerged and for which as metaphor or more simply as metonymy it may be taken by a viewer to stand. By wonder I mean the power of the object displayed to stop the viewer in his tracks, to convey an arresting sense of uniqueness, to evoke an exalted attention.' 'Resonance and Wonder,' in *Learning to Curse*, 170.

7 Dario Lanzardo's photographs in the exhibition catalogue *Il convitato di ferro* (Turin: Quadrante Edizioni, 1987) convey the uncanny, spectral quality of empty armour. The phrase *cavaliere inesistente*, of course, refers to Italo Calvino's novella of the same name (Milan: Garzanti, 1985).

8 For a more thorough explanation of these terms and an example of how they can be used to evaluate a fifteenth-century Italian specimen, see Lionello Giorgio Boccia, 'The Devil's Mask,' in *Art, Arms, and Armour: An International Anthology*, ed. Robert Held (Chiasso: Acquafresca, 1979).

9 On the debate regarding the usefulness of the term 'early modern,' see Randolph Starn, 'The Early Modern Muddle,' *Journal of Early Modern History* 6, no. 3 (2002): 296–307. In support of the term, Peter Erickson and Clark Hulse note that 'as a field descriptor, "early modern" displaces the progressive implications of "Renaissance," decentering its implicit claims to establish a normative or classical form of human subjectivity and the human body which can be seen as Italy's and Europe's benign gift to the world ... A more complex model of the underlying society in turn allows for a positive expansion both of the range of artifacts considered within "visual culture" and of the interpretive possibilities for those objects, especially with regard to issues of gender and race,' in *Early Modern Visual Culture: Representation, Race, and Empire in Renaissance England*, ed. Peter Erickson and Clark Hulse (Philadelphia: University of Pennsylvania Press, 2000), 8. I find 'early modern' an odd solution since it replicates the teleological implications of the older term. Given the problems with both, I have used them alternately in this book.

10 For a detailed history of the technology of armour production, see Alan Williams, *The Knight and the Blast Furnace: A History of the Metallurgy of Armour in the Middle Ages and the Early Modern Period* (Leiden and Boston: Brill, 2003). A brief social history of the craftsmen themselves (with a focus on Germany) is Matthias Pfaffenbichler, *Medieval Craftsmen: Armourers* (Toronto: University of Toronto Press, 1992).

11 '[T]he more glorious its ceremonial forms, the more pointless its promise of material preservation in the age of gunpowder.' Jones and Stallybrass, *Renaissance Clothing and the Materials of Memory*, 256.

12 A complete armour proofed against artillery had exceptionally thick plates and could be as heavy as forty kilos: an example is the very late specimen (1620) in the Vienna Kunsthistorisches Museum, inv. A 1530. For a recent discussion of the transformation in military practice in the early sixteenth century, see Michael Mallett, 'The Transformation of War, 1494–1530,' in *Italy and the European Powers: The Impact of War, 1500–1530*, ed. Christine Shaw (Leiden and Boston: Brill, 2006), 3–21. See also the classic account by Piero Pieri, *Il Rinascimento e la crisi militare italiana* (Turin: Einaudi, 1952).

13 On Machiavelli's underestimation of the future importance of artillery, see (among others) Oman, *A History of the Art of War in the Sixteenth Century*, 93ff. Christopher Lynch objects to 'nearly unanimous scholarly opinion' by insisting that Machiavelli supported technological innovation and gunpowder technology in particular, in Niccolò Machiavelli, *Art of War*, trans. Christopher Lynch (Chicago: University of Chicago Press, 2003), xxvii and 182ff. On the rhetorical dimension of war, see Barbara Spackman, 'Politics on the Warpath: Machiavelli's *Art of War*,' in *Machiavelli and the Discourse of Literature*, ed. Albert Russell Ascoli and Victoria Kahn (Ithaca, NY: Cornell University Press, 1993), 179–93. Spackman cites Kenneth Burke's assertion that 'military force can persuade by its sheer "meaning" as well as by its use in actual combat'; see '"Administrative" Rhetoric in Machiavelli,' in Burke, *A Rhetoric of Motives* (Berkeley: University of California Press, 1969), 161. Spackman also cites Felix Gilbert, 'Machiavelli: The Renaissance of the Art of War,' in *Makers of Modern Strategy: From Machiavelli to the Nuclear Age*, ed. Peter Paret (Princeton, NJ: Princeton University Press, 1986), 11–31.

14 For a detailed account see Gulru Necipoglu, 'Suleiman the Magnificent and the Representation of Power in the Context of Ottoman-Hapsburg-Papal Rivalry,' *Art Bulletin* 71 (1989): 401–27. Fundamental research on this helmet was published by O. Kurz in 'A Gold Helmet Made in Venice for Sultan Suleyman the Magnificent,' *Gazette des beaux-arts* 74 (1969): 249–58. See also the remarks of Lisa Jardine, *Worldly Goods: A New His-*

tory of the Renaissance (New York: Doubleday, 1996), 379–84, and Marina Belozerskaya, *Luxury Arts of the Renaissance* (London: Thames and Hudson, 2005), 144–7. For a historical overview of commercial, political, and diplomatic relations between Venice and the Islamic world, see Stefano Carboni, *Venice and the Islamic World, 828–1797* (New Haven, CT: Yale University Press, 2007).

15 Paolo Giovio credits Gritti with the design of the helmet in *Gli elogi vite brevemente scritte d'huomini illustri di guerra, antichi et moderni* (Florence, 1554), 345.

16 Notwithstanding the surviving Venetian woodcuts of the sultan wearing this helmet (which seem to have been derived from sketches of the object superimposed on an earlier profile portrait), at no point is he recorded to have worn the helmet during the campaign. Instead, in a deliberately theatrical way, he seems to have deployed it as a stage prop.

17 Marino Sanuto, *I diarii di Marino Sanuto*, ed. R. Fulin et al. (Venice, 1581). Francesco Sansovino describes its impact in similarly hyperbolic terms, noting that on receiving the object the Sultan himself was 'stupefied by a thing so remarkable.' Sansovino, *Venetia città nobilissima et singolare* (Venice, 1581), 134; cited in Necipoglu, 'Suleiman the Magnificent,' 402.

18 Necipoglu, 'Suleiman the Magnificent,' 417 n52.

19 Ibid., 409.

20 Necipoglu notes that the four detachable crowns were removed and probably melted down so their materials could be used elsewhere. The helmet itself, stripped to expose the more typically Ottoman ogival patterns on its surface, may have been donated to the Habsburgs to commemorate the truce of 1547; thus it found its way into the Schatzkammer of the Bavarian dukes (ibid., 416).

21 See Stephen Harold Riggins, ed., *The Socialness of Things: Essays on the Socio-Semiotics of Objects* (Berlin and New York: Mouton de Gruyter, 1994), 2; and especially the essay in the same volume by Peter Corrigan, 'Interpreted, Circulating, Interpreting: The Three Dimensions of the Clothing Object,' 435–50. Igor Kopytoff discusses the 'cultural biography' of artifacts in 'The Cultural Biography of Things: Commoditization as Process,' in Appadurai, *The Social Life of Things*, 64–91; and Nicholas Thomas writes of 'socially entangled objects' in *Entangled Objects: Exchange, Material Culture, and Colonialism in the Pacific* (Cambridge, MA: Harvard University Press, 1991). See also Stephen Harold Riggins, 'The Power of Things: The Role of Domestic Objects in the Presentation of Self,' in *Beyond Goffman: Studies on Communication, Institution, and Social Interaction*, ed. Stephen Harold Riggins (Berlin and New York: Mouton de Gruyter, 1990), 341–67.

22 Riggins, *The Socialness of Things*, 3.

23 Recent theoretical discussions of masculinity (or masculinities) are too numerous to cite individually. Use of the plural term stresses the fact that masculinity is not monolithic, but culturally and historically variable. For Judith Kegan Gardiner, 'Masculinity is ... the confluence of multiple processes and relationships with variable results for differing individuals, groups, institutions, and societies ... Although dominant or hegemonic forms of masculinity work constantly to maintain an appearance of permanence, stability, and naturalness, the numerous masculinities in every society are contingent, fluid, socially and historically constructed, changeable and constantly changing, variously institutionalized, and recreated through media representations and individual and collective performances.' *Masculinity Studies and Feminist Theory: New Directions* (New York: Columbia University Press, 2002), 11.

On the performativity of gender, the now-classic work is Judith Butler, *Gender Trouble: Feminism and the Subversion of Identity* (New York: Routledge, 1990). On the natural alliance between masculinity studies and feminist scholarship, see Judith Kegan Gardiner, ed., *Masculinity Studies and Feminist Theory*. For an early cross-cultural study of masculinity from an anthropological perspective, see David D. Gilmore, *Manhood in the Making: Cultural Concepts of Masculinity* (New Haven, CT: Yale University Press, 1990). Two pioneering volumes of collected essays on masculinity and premodern Europe were Claire Lees, Thelma Fenster, and Jo Ann McNamara, eds., *Medieval Masculinities: Regarding Men in the Middle Ages* (Minneapolis: University of Minnesota Press, 1994), and Jeffrey Jerome Cohen and Bonnie Wheeler, eds, *Becoming Male in the Middle Ages* (New York: Garland, 1997). More recently, see Ruth Mazo Karras, *From Boys to Men: Formations of Masculinity in Late Medieval Europe* (Philadelphia: University of Pennsylvania Press, 2003).

On the Italian sixteenth century, see especially Valeria Finucci, *The Manly Masquerade: Masculinity, Paternity, and Castration in the Italian Renaissance* (Durham, NC: Duke University Press, 2003). Other recent works on masculinity and the Cinquecento include Raymond B. Waddington, *Aretino's Satyr: Sexuality, Satire, and Self-Projection in Sixteenth-Century Literature and Art* (Toronto: University of Toronto Press, 2004); Allison Levy, *Remembering Masculinity in Early Modern Florence: Widowed Bodies, Mourning and Portraiture* (Aldershot, UK: Ashgate, 2006); and Margaret A. Gallucci, *Benvenuto Cellini: Sexuality, Masculinity, and Artistic Identity in Renaissance Italy* (New York: Palgrave Macmillan, 2003).

24 Filippo headed the family workshop, which included his three younger

brothers, Giovan Battista, Francesco, and Alessandro, and his cousin Giovan Paolo. For a comprehensive history of the Negroli workshop, see Silvio Leydi, 'A History of the Negroli Family,' in *Heroic Armor*, ed. Pyhrr and Godoy, 37–60. On the role of Milan in the sixteenth-century arms industry, see 25–35.

25 The 1550 edition of Vasari's *Lives* contains the first known reference to Filippo Negroli: 'Filippo Negrollo milanese, intagliatore di cesello in armi di ferro con fogliami e figure' (Filippo Negroli of Milan, chiseller of arms in iron with leaves and figures); see Giorgio Vasari, *Le vite de' più eccellenti architetti, pittori, et scultori italiani ... Firenze 1550*, modern annotated edition, ed. Luciano Bellosi and Aldo Rossi (Turin: Einaudi, 1986), 812. By the the the time of the 1568 edition, Negroli's reputation was evidently secure: 'Di Filippo Negrolo, milanese, intagliatore di cesello in arme di ferro con fogliami e figure, non mi distenderò, avendo operato, come si vede, in rame cose che si veddono fuor di suo, che gli hanno dato fama grandissima'; see Vasari, *Le vite de' più eccellenti pittori, scultori et architettori*, ed. Gaetano Milanesi (Sansoni, 1906), 5:389.

26 'Now, if it were not for the need to be brief, I would tell of the many Milanese who were inventors of outstanding and useful types of armor and who took this art to the kingdom of France and other kingdoms and who with this profession earned great riches. And in Milan there are those of this profession who, having gained much wealth, now live honorably and are considered to be of the nobility having married into the noble families of the city. There are those also who raised themselves and their families to the nobility by their great wealth just as many other artists and merchants have done.' Paolo Morigi, *La nobiltà di Milano divisa in sei libri* (Milan, 1615; facs. ed., Sala Bolognese: Arnaldo Forni Editore, 1979), 298; English translation from Pyhrr and Godoy, *Heroic Armor*, 31 and 32 n24.

27 See Erving Goffman, *The Presentation of Self in Everyday Life* (New York: Doubleday, 1959).

28 Erving Goffman, *Behavior in Public Places* (London: Collier-Macmillan, 1963), 34. On the semiotics of fashion see Roland Barthes, *The Fashion System*, trans. Matthew Ward and Richard Howard (Berkeley: University of California Press, 1983).

29 See also Marshall Sahlins, *Culture and Practical Reason* (Chicago: University of Chicago Press, 1976), 203: '"Mere appearance" must be one of the most important forms of symbolic statement in Western civilization. For it is by appearances that civilization turns the basic contradiction of its construction into a miracle of existence: a cohesive society of perfect strangers.'

30 Victor Turner, *The Anthropology of Performance* (New York: PAJ Publications, 1986), 99.

31 On such overcoding in sign production and interpretation, see Umberto
 Eco, *A Theory of Semiotics* (Bloomington: Indiana University Press, 1976),
 129–30. Appadurai argues that such heightened semiotic value is a defin-
 ing characteristic of luxury goods: 'I propose that we regard luxury goods
 not so much in contrast to necessities ... but as goods whose principal use
 is *rhetorical* and *social*, goods that are simply *incarnated signs*. The neces-
 sity to which they respond is fundamentally political,' in *The Social Life of
 Things*, 38.

32 Portraits in armour could serve the purpose of social climbing; the painter
 and art theorist Giovanni Paolo Lomazzo complained in 1584 that 'mer-
 chants and bankers who have never seen a drawn sword and who should
 properly appear with quill pens behind their ears, their gowns about them
 and the day-books in front of them, have themselves painted in armour
 holding generals' batons' ('i mercanti e banchieri che non mai videro
 spada ignuda, a quali propriamente si aspetta la penna nell'orecchia con
 la gonella intorno et il giornale davanti, si ritraggono armati con bastoni
 in mano da generali'). *Trattato dell'arte della pittura, scoltura e architettura*
 (Milan, 1584); excerpted in Paola Barocchi, ed., *Scritte d'arte del Cinquecento*,
 (Milan and Naples, 1971–7), 3:2743.

33 Like plate armour, the codpiece outgrew its pragmatic function (to conceal
 the genital area after the introduction of shorter doublets) and became a
 flamboyant accessory in its own right. On the codpiece as a materialization
 of competing ideologies of early modern masculinity ('scrotal' and 'phal-
 lic'), see Will Fisher, *Materializing Gender in Early Modern English Literature
 and Culture* (Cambridge: Cambridge University Press, 2006), 59–82. On the
 history of the codpiece, see Grace Vicary, 'Visual Art as Social Data: The
 Renaissance Codpiece,' *Cultural Anthropology* 4, no. 1 (1989): 3–25, and Jef-
 frey Persels, 'Bragueta Humanistica, or Humanism's Codpiece,' *Sixteenth
 Century Journal* 28 (1997): 79–99.

34 On the relationship between clothing and historically variable construc-
 tions of the nude, see Anne Hollander, *Seeing through Clothes* (New York:
 Viking Press, 1978). A typical fluted Maximilian armour is by Lorenz
 Helmschmid, ca 1480, in the Vienna Kunsthistorisches Museum. A prime
 example of the tonlet is the garniture of Charles V in the Madrid Real
 Armería, ca 1525, designed for foot tournament in a fenced enclosure
 (inv. A 93); the richly ornamented lower plate of the skirt was removable.
 An example of the convex peascod belly is the Brescian corselet made
 for Girolamo Martinengo ca 1540 (Turin, Armeria Reale, inv. C 11). Ewart
 Oakeshott notes that the oversize tassets of lobster armours (in Italian
 often referred to as 'crosta di gambero') conformed to the colossal baggy

breeches of seventeenth-century fashion as well as the need to counter the increasing brutality of firearms; see Oakeshott, *European Weapons and Armour from the Renaissance to the Industrial Revolution* (North Hollywood, CA: Beinfeld Publishing, 1980), 209. On the relationship between armour and civilian dress, see Stephen V. Grancsay, 'The Mutual Influence of Costume and Armor: A Study of Specimens in the Metropolitan Museum of Art,' *Metropolitan Museum Studies* 3, no. 2 (1931): 194–208.

35 For one such discussion, see Jones and Stallybrass, *Renaissance Clothing and the Materials of Memory*, 256. See also Harry J. Berger, Jr, *Fictions of the Pose: Rembrandt against the Italian Renaissance* (Stanford: Stanford University Press, 2000). The association with Lacan is central to Elizabeth Bellamy's reading of armour in Ariosto; she argues that 'Lacan's metaphor positions armor as both protection against bodily fragmentation and also a proleptic symbol of wholeness,' in *Translations of Power*, 94. Noting Bradamante's submission once divested of her armour, Deanna Shemek reiterates armour's 'integrating, even prosthetic function for the woman warrior as subject,' in *Ladies Errant: Wayward Women and the Social Order in Early Modern Italy* (Durham, NC: Duke University Press, 1998), 121.

36 Jacques Lacan, 'The Mirror Stage as Formative of the Function of the I as Revealed in Psychoanalytic Experience,' in *Écrits*, trans. Alan Sheridan (New York: Norton, 1977), 4. This 'orthopaedic totality' is, for Jones and Stallybrass, 'both a protective carapace and a worked and engraved mnemonic system'; see *Renaissance Clothing and the Materials of Memory*, 256.

37 The significance of armour in Hamlet is discussed in Stallybrass, 'Hauntings: The Materiality of Memory on the Renaissance Stage.' Not accidentally, Hamlet's father wears armour when he returns to confront the son and demand revenge for his murder. The king's armour is the most prestigious vehicle of his memory, 'the alienated but material ghost of the royal body' (p. 297).

38 E. Jane Burns describes a 'gendered sartorial continuum' in courtly ideology from armour to skin in *Courtly Love Undressed: Reading through Clothes in Medieval French Culture* (Philadelphia: University of Pennsylvania Press, 2002), 121–48. 'The properly socialized body in Arthurian romance results from encasing the male anatomy so fully in armor that no skin shows … The courtly lady, by contrast, gains social status "as a woman" to the extent that her flesh is exposed to view' (pp. 135–7). An early and now classic discussion of the symbolic role of armour in the construction of male identity is Klaus Theweleit, *Male Fantasies*, trans. Stephen Conway (Minneapolis: University of Minnesota Press, 1987), 1:302–31.

39 Cesare Ripa's *Iconologia* (Rome, 1603) is a gallery of such armoured women. On the 'odd trick' that language played on philosophical discourse by

gendering as feminine abstract nouns of virtue, knowledge, and spirituality in Greek and Latin as well as in the languages that derive from them, see Marina Warner, *Monuments and Maidens: The Allegory of the Female Form* (Berkeley: University of California Press, 1985), especially 63–87. 'Congruity with the female character was hardly ever adduced,' she notes. 'Rather, the oddness of language's alignments provoked comment' (p. 64). The other armoured women acknowledged by early modern Europe were, of course, the Amazons rumoured to have been sighted in the New World. If not purely fictional or allegorical, armed women were invariably associated with distant times and places. For a recent account of cultural fantasies of the Amazon, see Stefano Andres, *Le Amazzoni nell'immaginario occidentale* (Pisa: ETS, 2001).

40 'I know that I have the body of a weak and feeble woman, but I have the heart and stomach of a king ... Rather than any dishonour shall grow by me, I myself will take up arms, I myself will be your general.' Cited in Stephen Orgel, *Impersonations: The Performance of Gender in Shakespeare's England* (Cambridge: Cambridge University Press, 1996), 118.

41 Orgel notes that depictions of Elizabeth in armour were documents in a polemical 'politics of nostalgia.' The famous 1630 engraving by Thomas Cecil, for example, was 'an effective rebuke to the effeminate Charles I, who was felt by his critics to be controlled by his French Catholic wife'; ibid., 100. On the image of Elizabeth in armour, see Susan Frye, 'The Myth of Elizabeth I at Tilbury,' *Sixteenth Century Journal* 23 (1992): 95–114.

42 On Joan's transvestism, see Susan Crane, *The Performance of Self: Ritual, Clothing, and Identity during the Hundred Years War* (Philadelphia: University of Pennsylvania Press, 2002), 73–106. See also her earlier 'Clothing and Gender Definition: Joan of Arc,' *Journal of Medieval and Early Modern Studies* 26, no. 2 (Spring 1996): 297–320. For a history of the myth of Joan of Arc and an attempt to explain its imaginative force, see Marina Warner, *Joan of Arc: The Image of Female Heroism* (Berkeley: University of California Press, 1981). On Joan's armour, see Adrien Harmand, *Jeanne d'Arc: Ses costumes, son armure* (Paris: Leroux, 1929).

43 The term 'Italian wars' conventionally refers to the period from the 1494 invasion of Italy by Charles VIII to the 1559 Treaty of Cateau-Cambresi. For an especially vivid account of the crisis of morale in post–1494 Italy, see John Rigby Hale, 'War and Public Opinion in Renaissance Italy,' in *Renaissance War Studies* (London: Hambledon Press, 1983), 359–87. There is a growing bibliography on the Italian Wars, including Christine Shaw, ed., *Italy and the European Powers: The Impact of War, 1500–1530* (Leiden: Brill, 2006).

44 See Shemek, *Ladies Errant*, 31.

45 On Petrarch's use of the image, see Margaret Brose, 'Petrarch's Beloved Body: "Italia mia,"' in *Feminist Approaches to the Body in Medieval Literature*, ed. Linda Lomperis and Sarah Stanbury (Philadelphia: University of Pennsylvania Press, 1993), 1–20.

46 Niccolò Machiavelli, *Il principe*, ed. Federico Chabod (Turin: Einaudi, 1961), chap. 26, 125–6; English translation from *The Prince*, trans. Robert M. Adams (New York), chap. 26 Although never referred to explicitly as *donna*, Italy is clearly personified in this passage as female. The series of feminine adjectives, participles, and pronouns used to refer to *la Italia* reinforces its implied gender.

47 Machiavelli, *Il principe*, chap. 25; *The Prince*, chap. 25. Although it does not change my argument here, Freccero is right to clarify that *donna* would more accurately be translated as 'lady' in this context, given the distinction in Renaissance Italian between *femina* ('woman') and *donna* ('lady'). See John Freccero, 'Medusa and the Madonna of Forlì: Political Sexuality in Machiavelli,' in *Machiavelli and the Discourse of Literature*, ed. Albert Russell Ascoli and Victoria Kahn (Ithaca, NY: Cornell University Press, 1993), 161–78. For a broader discussion of gender and politics in Machiavelli's thought, see Hanna Fenichel Pitkin, *Fortune Is a Woman: Gender and Politics in the Thought of Niccolò Machiavelli* (Berkeley: University of California Press, 1984). Pitkin proposes that 'the focus of ambivalence in Machiavelli's texts … is manhood: anxiety about being sufficiently masculine and concern over what it means to be a man' (p. 5). On Machiavelli and gender, see also Maria J. Falco, ed., *Feminist Interpretations of Niccolò Machiavelli* (College Park: Penn State University Press, 2004); and most recently, Guido Ruggiero, *Machiavelli in Love: Sex, Self, and Society in the Italian Renaissance* (Baltimore: Johns Hopkins University Press, 2007).

48 In Machiavelli's *Discorsi supra la prima deca di Tito Livio*, ed. Francesco Bausi (Rome: Salerno, 2001), 3:36, he quotes this judgment of Titus Livius.

49 For a discussion of the trope of women as 'leaky vessels' in the Renaissance, see Gail Kern Paster, *The Body Embarrassed: Drama and the Disciplines of Shame in Early Modern England* (Ithaca, NY: Cornell University Press, 1993). See also Patricia A. Parker, *Literary Fat Ladies: Rhetoric, Gender, Property* (London and New York: Methuen, 1987).

50 Niccolò Macchiavelli, *L'arte della guerra: Scritti politici minori*, ed. Jean-Jacques Marchand, Denis Fachard, and Giorgio Masi (Rome: Salerno, 2001), 236, 287. Translations from *L'arte della guerra* are my own.

51 Ibid.

52 Ibid., 245–8. Machiavelli (b. 1469) was fifty-one when he wrote this passage; Lorenzo di Filippo Strozzi (b. 1482), his addressee, was thirty-eight.

53 Machiavelli notes that Cosimo Rucellai's only recorded accomplishments were some youthful verses, but even these were the products of literary imitation since he had never been in love. Machiavelli represents Cosimo (like himself) as frustrated by inactivity, waiting for an opportunity to enter public life.

54 Cited and translated in Hale, 'War and Public Opinion,' 365. The orations were collected and published by Francesco Sansovino, *Diverse orationi volgarmente scritte da molti huomini illustri di tempi* (Venice, 1561).

55 I have used the Italian edition of Guicciardini's *Storia d'Italia*, ed. Silvana Seidel Menchi (Turin: Einaudi, 1971); quoted material is from p. 78. The English translation is from Francesco Guicciardini, *The History of Italy*, trans. Sidney Alexander (Princeton, NJ: Princeton University Press, 1984), 48–9.

56 Guicciardini, *Storia d'Italia*, 78–9; *History of Italy*, 49. Guicciardini describes the French king's physical imperfections with unusual relish. In fact, Charles was a polydactyl; the duck-billed sabatons that replaced pointed poulaines as the new fashion in armour were designed to accommodate his extra toe. For an example of the most extreme form of poulaines – whose elongated toes were removable to enable the wearer to walk, see the Missaglia armour (ca 1450) made to commemorate the accession to power of Friedrich I, Elector of the Palatinate (Vienna Kunsthistorisches Museum, inv. A 2).

57 Though still cumbersome and unwieldy, the new technology was already incomparably deadly. Guicciardini was one of many to pronounce this diabolical weapon the death of chivalry. On the range of responses to fire-arms in the sixteenth century, see John Rigby Hale, 'Gunpowder and the Renaissance: An Essay in the History of Ideas,' in *Renaissance War Studies*, 389–420.

58 On the spread of syphilis during the Italian wars, see Jon Arrizabalanga, John Henderson, and Roger French, *The Great Pox: The French Disease in Renaissance Europe (1997)* (New Haven, CT: Yale University Press, 1997), and Sheldon Watts, *Epidemics and History: Disease, Power, and Imperialism* (New Haven, CT: Yale University Press, 1997). For a contemporary com-mentary, see Girolamo Fracastoro's Latin poem *Syphilis sive morbus gallicus* (1530), translated as *Fracastoro's Syphilis*, trans. Geoffrey Eatough (Liver-pool: Cairns, 1984). Given the mode of transmission for syphilis, it is ironic that Fracastoro dedicated his poem to Bembo, the theorist of Platonic love.

59 Among the characters in his dialogue Castiglione does, however, include a number of individuals who were active soldiers, such as Romano Ettore, Cesare Gonzaga, and Pietro Monte, and Morella da Ortona. On the gradual

demilitarization of the Italian aristocracy, see Gregory Hanlon, *The Twilight of a Military Tradition: Italian Aristocrats and European Conflicts, 1560–1800* (London: UCL Press, 1998).

60 Count Lodovico da Canossa famously pronounces arms to be the chief profession of the courtier: '[E]stimo che la principale e vera profession del cortegiano debba esser quella dell'arme, la qual sopra tutto voglio che egli faccia vivamente.' Baldassar Castiglione, *Il libro del cortegiano*, ed. Walter Barberis (Turin: Einaudi, 1998), I.17. For a subtle reading of the paradoxical debate regarding the primacy of arms vs letters, see John M. Najemy, 'Arms and Letters: The Crisis of Courtly Culture in the Wars of Italy,' in *Italy and the European Powers*, ed. Christine Shaw (Leiden: Brill, 2006), 207–38.

61 Castiglione, *Libro del cortegiano*, II.8. I cite the English translation of *The Book of the Courtier* by Charles Singleton, ed. Daniel Javitch (New York: Norton, 2002), 72–3. All further references are to this translation.

62 Ibid.

63 Torquato Accetto, *Della dissimulazione onesta* (1641), ed. Salvatore Nigro (Turin: Einaudi, 1997).

64 See Daniel Javitch, '*Il Cortegiano* and the Constraints of Despotism,' in *Castiglione: The Ideal and the Real in Renaissance Culture*, ed. Robert W. Hanning and David Rosand (New Haven, CT: Yale University Press, 1983), 17–28. On the Renaissance culture of dissimulation, I look forward to reading Jon Snyder's forthcoming book, *Dissimulation and the Culture of Secrecy in Early Modern Europe* (Berkeley: University of California Press, 2009). On gender and politics in Castiglione, see Carla Freccero, 'Politics and Aesthetics in Castiglione's *Il Cortegiano:* Book III and the Discourse on Women,' in *Creative Imitation: New Essays on Renaissance Literature*, ed. David Quint, Margaret W. Ferguson, G.W. Pigman III, and Wayne A. Rebhorn (Binghamton: Medieval and Renaissance Texts and Studies, 1992), 259–80; also Valeria Finucci, *The Lady Vanishes: Subjectivity and Representation in Castiglione and Ariosto* (Stanford: Stanford University Press, 1992).

65 This is precisely how the voice of the poet justifies Bradamante's betrayal of Brunello in *Orlando furioso* (4.1–3).

66 The trompe-l'œil cycle in Urbino's ducal palace features images of armour along with books, musical instruments, and other prized objects from the duke's collection. On the iconography of the studiolo, see Luciano Cheles, *The Studiolo of Urbino: An Iconographic Investigation* (Wiesbaden: L. Reichert, 1986).

67 Mikhail Bakhtin, *Rabelais and His World*, trans. Helen Iswolsky (Bloomington: Indiana University Press, 1984). In the years since this work first

appeared there has been considerable criticism of Bakhtin's belief in the emancipatory potential of carnival. Nonetheless, in my view his opposition between the classical and grotesque body remains a valid and suggestive point of departure for discussions of early modern imagery.

68 Patricia Fumerton describes three generations of new historicists: those representing the 'political' new historicism of the 1980s (Greenblatt, Montrose, Mullaney, Tennenhouse); its 'more "grounded" British counterpart, cultural materialism' (Stallybrass, Barker, Dollimore, Belsey); and a 'new new historicism' focused on the details of everyday life. See 'Introduction: A New New Historicism,' in Patricia Fumerton and Simon Hunt, eds., *Renaissance Culture and the Everyday* (Philadelphia: University of Pennsylvania Press, 1999), 1–17. As will be clear from my notes in this book, I have learned from all three. See also Catherine Gallagher and Stephen Greenblatt, *Practicing New Historicism* (Chicago: University of Chicago Press, 2000). For one recent discussion of these issues, see Sarah Maza, 'Stephen Greenblatt, New Historicism, and Cultural History, or, What We Talk about When We Talk about Interdisciplinarity,' *Modern Intellectual History* 1, no. 2 (2004): 249–65.

69 See Stephen Greenblatt, 'Towards a Poetics of Culture,' in *Learning to Curse*, 146–60.

1. The Classical Body

1 Mikhail Bakhtin, *Rabelais and His World*, trans. Helene Iswolsky (Bloomington: Indiana University Press, 1984), 322.

2 Mario Scalini has argued that the 'Medici fragments' in the Bargello could not have been originally commissioned by the Medici; it would have been inappropriate, he claims, for the sovereign of a small Italian state to appear in such an armour, or in the even finer *guarnitura della Fama* also preserved in the Bargello. For this and other reasons relating to iconographic details that I will discuss later, Scalini attributes the Bargello cuirass not to Filippo Negroli but to his cousin Giovanpaolo, and argues that it was made for Henry II of Valois in 1547 for the occasion of his accession to the throne of France. Mario Scalini, *Armature all'eroica dei Negroli* (Florence: Museo Nazionale del Bargello, 1987), 22. Other experts have attributed the torso to Filippo Negroli (as a commission for Cosimo I) and to Bartolomeo Campi (as a commission for Guidobaldo II della Rovere). The most recent scholarship, however, concludes that neither artist nor patron can be known with any certainty. See Stuart W. Pyhrr and José-A. Godoy, eds., *Heroic Armor of the Italian Renaissance: Filippo Negroli and His Contemporar-*

ies, exhibition cat. (New York: Metropolitan Museum of Art, 1998), 289. Because it is orphaned, I have chosen to adopt the cuirass in this chapter. Whatever its provenance, the armour is a valuable specimen of a distinctive armour type that articulated an important conception of the body in the Renaissance.

3 John F. Hayward, 'The Revival of Roman Armour in the Renaissance,' in *Art, Arms and Armour: An International Anthology*, ed. Robert Held (Chiasso: Acquafresca, 1979), 144–63.

4 Despite his passion for armour in the antique style, Cosimo I was not portrayed exclusively in Roman armour; the well-known portrait by Bronzino shows him in an armour of German manufacture, probably by Jörg Seusenhofer. See my chapter 6 for a more detailed discussion of Cosimo's use of martial imagery in portraiture and his actual patronage of contemporary armourers.

5 For a useful account of such Florentine festivals, see Mario Scalini, *Il Saracino e gli spettacoli cavallereschi nella Toscana granducale* (Florence: Museo Nazionale del Bargello, 1987). On Francesco I's wedding of 1579, see p. 40. For a more detailed description and illustrations of the event, see R. Gualterotti, *Feste nelle nozze del Serenissimo Don Francesco Medici, Gran Duca di Toscana, et della Serenissima sua consorte la Sig. Bianca Cappello* (Florence, 1579).

6 On Francesco's reign and particularly on his public relations problems with the Florentines, see Luciano Berti, *Il principe dello studiolo: Francesco I dei Medici e la fine del Rinascimento italiano* (Florence: Edam, 1967). There is some disagreement among historians in interpreting Francesco's conduct; I may be generous in attributing Francesco's behaviour here to a deliberate strategy of self-promotion meant to counter Florentine opposition to Bianca Cappello.

7 Mars, the ancient patron of Florence, was officially displaced in Christian times by John the Baptist but still respected as a symbol of the city's Roman origins. The mutilated statue of Mars that had guarded the city was left on the Ponte Vecchio until it was washed away by the disastrous flood of 1333, while the name of the heraldic lion of Florence, the Marzocco, was said to derive from a corruption of the diminutive of Mars (*Martocus*).

8 The child, Don Antonio, was actually born to a woman named Lucia. The nurse who had collaborated with Bianca in the hoax was murdered a year later. For a full chronology see Berti, *Il principe dello studiolo*, 257–316.

9 Scalini, *Saracino*, 40–4. See also two detailed contemporary accounts of Cosimo II's wedding: *Descrizione delle feste fatte nelle reali nozze de' serenissimi principi di Toscana D. Cosimo de' Medici e Maria Maddalena arciduchessa d'Austria* (Bologna, 1608), and C. Rinuccini, *Descrizione delle feste fatte nelle*

reali nozze de' serenissimi principi di Toscana D. Cosimo de' Medici e Maria Maddalena arciduchessa d'Austria (Florence, 1608).

10 Scalini, *Saracino*, 50–2.

11 Bakhtin, *Rabelais and His World*, 320.

12 Ibid., 26.

13 Peter Stallybrass, 'Patriarchal Territories: The Body Enclosed,' in *Rewriting the Renaissance: The Discourses of Sexual Difference in Early Modern Europe*, ed. Margaret W. Ferguson, Maureen Quilligan, and Nancy J. Vickers (Chicago: University of Chicago Press, 1986), 123–42.

14 Giorgio Dondi, 'Il guerriero è asimmetrico,' in *Il convitato di ferro*, exhibition cat. (Turin: Il Quadrante, 1987), 169–80.

15 For a more detailed discussion of these two specimens, see my chapter 5.

16 Bakhtin, *Rabelais and His World*, 26.

17 Ibid., 321.

18 Ibid., 30.

19 On the formation of this Order, see Franco Angiolini, *I cavalieri e il principe: L'Ordine di Santo Stefano e la società toscana in età moderna* (Florence: Edifir, 1996).

20 Bakhtin, *Rabelais and His World*, 320.

21 Anna Omodeo, 'Modelli e moduli per le decorazioni delle armature,' in *Il convitato di ferro*, 183.

22 On war games and their specialized armour, in addition to Scalini, *Saracino*, see the detailed descriptions and diagrams in Lionello Giorgio Boccia, *Armi difensive dal medioevo all'età moderna* (Florence: Centro Di, 1982).

23 Dondi, 'Il guerriero è asimmetrico,' 169–80.

24 See especially Jonathan Walters, 'Invading the Roman Body: Manliness and Impenetrability in Roman Thought,' in *Roman Sexualities*, ed. Judith P. Hallett and Marilyn B. Skinner (Princeton, NJ: Princeton University Press, 1997), 29–43. Walters contends that 'the Roman sexual protocol that defined men as impenetrable penetrators can most usefully be seen in the context of a wider conceptual pattern that characterized those of high social status as being able to defend the boundaries of their body from invasive assaults of all kinds' (p. 30).

2. The Sacred Body

1 Although a composite, this is one of the oldest surviving Italian body armours and is considered one of the most precious incunabula of the armourer's art. For a detailed technical description of the armour, see Lionello Giorgio Boccia and E.T. Coelho, *L'arte dell'armatura in Italia* (Milan: Bramante, 1967), 117–18 and 126–7.

2 Ibid., 126

3 See in particular John W. O'Malley, *Praise and Blame in Renaissance Rome: Rhetoric, Doctrine, and Reform in the Sacred Orators of the Papal Court, c. 1450–1521* (Durham, NC: Duke University Press, 1979). Leo Steinberg's thesis in *The Sexuality of Christ in Renaissance Art and in Modern Oblivion* (New York: Pantheon, 1983) is deeply influenced by O'Malley's argument.

4 Throughout this discussion I am using the term 'martyrdom' in the broader sense in which the late medieval world understood it. Although neither Jerome's trial in the desert nor Francis's receipt of the stigmata was literally a martyrdom, metaphorically both figures were regarded as martyrs; their 'white martyrdom' was characterized by severe and continual voluntary penance rather than by external persecution and violent death. The ascetic model of martyrdom was characterized in the twelfth century by Bernard of Clairvaux as martyrdom 'in will alone'; Francis of Assisi would provide a striking example. For a general discussion of the historical understanding of martyrdom, see R. Hedde, 'Martyre,' in *Dictionnaire de théologie catholique*, ed. A. Vacant, E. Mangenot, and E. Amann, 15 vols (1903–50). On pagan heroism and Christian martyrdom as opposing models of exemplarity, see Timothy Hampton, *Writing from History: The Rhetoric of Exemplarity in Renaissance Literature* (Ithaca, NY: Cornell University Press, 1990), especially 110–33. On the Christian discourse of martyrdom, see Daniel Boyarin, *Dying for God: Martyrdom and the Making of Christianity and Judaism* (Stanford: Stanford University Press, 1999), 93–126.

5 On the history of the cult of Saint Michael, see Carl Erdmann, *The Origin of the Idea of Crusade*, trans. M.W. Baldwin and W. Goffart (Princeton, NJ: Princeton University Press, 1977), 20–1; on Saint George, see 277–81. Saint George was particularly associated with armourers; Donatello's statue of Saint George at Orsanmichele (1416) was sponsored by the guild of Corazzai e Spadai.

6 Jacobus de Voragine, *The Golden Legend of Jacobus de Voragine*, trans. Grange Ryan and Helmut Ripperger (New York: Arno, 1968). On recent scholarship relating to the *Golden Legend*, see Caroline Walker Bynum, 'Material Continuity, Personal Survival, and the Resurrection of the Body: A Scholastic Discussion in Its Medieval and Modern Contexts,' reprinted in her volume of essays, *Fragmentation and Redemption: Essays on Gender and the Human Body in Medieval Religion* (New York: Zone Books, 1991), 239–97.

7 Jacopo's etymologies are ingenious and of course problematic; in this case he is correct, although the original connotation of Christopher's 'burden' was spiritual rather than physical.

8 For a secular version of this topos on armour, see the detail from the so-called Hercules Armour decorated by Eliseus Libaerts after designs

by Etienne Delaune, 1562–4 (Dresden, Historisches Museum). The medallion reproduced here depicts Hercules supporting the firmament. For an extended analysis of the Libaerts armour, see Amedeo Quondam, *Cavallo e cavaliere: L'armatura come seconda pelle del gentiluomo moderno* (Rome: Donzelli, 2003).

9 The physical discomfort and even danger of wearing armour into battle was a topos of the comic and anti-chivalric tradition. The heraldic surcoat was originally designed to protect knights of the First Crusade from the intolerable heat of their mail and helmets in the Holy Land. By the fifteenth century it was discarded for aesthetic reasons, to enhance the independent visual effect of the knight in full armour as an animated metal statue. Divested from its material origins in armour, heraldry or 'armory' survived as a largely autonomous semiotic system.

10 For a full description of this distinctive armour, see Lionello Giorgio Boccia, 'The Devil's Mask,' in *Art, Arms, and Armour: An International Anthology*, ed. Robert Held (Chiasso: Acquafresca, 1979). The crest is composed of a pair of chamois horns.

11 Peter Brown, *The Cult of the Saints: Its Rise and Function in Latin Christianity* (Chicago: University of Chicago Press, 1981), 50–68.

12 Brown (ibid., 78) cites the example of Felicitas from the *Passio perpetuae et felicitas* 15.5–6, ed. and trans. H. Musurillo, *The Acts of the Christian Martyrs* (Oxford: Clarendon Press, 1972), 123–5: 'One of the assistants of the prison guards said to her: "You suffer so much now – what will you do when you are tossed by the beasts?" "What I am suffering now," she replied, "I suffer by myself. But then Another will be inside me who will suffer for me, for I shall be suffering for him."'

13 Bynum, *Fragmentation and Redemption*, 267. As Bynum notes (p. 409 n90), Aquinas suggested that the martyrs were able to resist pain because the beatific vision flowed naturally into their body. This proleptic assimilation of the living holy to the glorified body in heaven also explained other miracles of bodily closure, such as catatonic trances and miraculous fasting (which arrested the normal processes of excretion and menstruation). For one theory of sacred fasting, see Rudolph Bell, *Holy Anorexia* (Chicago: University of Chicago Press, 1985). For a more convincing discussion, see Caroline Walker Bynum, *Holy Feast and Holy Fast: The Religious Significance of Food to Medieval Women* (Berkeley: University of California Press, 1987).

14 In pairing two paintings of the martyrdoms of Saints Agatha and Sebastian (*Fragmentation and Redemption*, figs. 6.14 and 6.15), Bynum is fair to point out that the representation of such graphic and sexually suggestive tortures was not limited to female saints, although 'the picture of Agatha

… can (and *should*) also be read as representing the sadism frequent in medieval depiction of the female nude' (p. 392 n158).

15 Sebastian's peculiar association with armour in the Renaissance may also derive from his fourteenth-century cult as protector against the plague. It was an ancient belief that the plague was caused by the arrows of Apollo, and Sebastian's miraculous healing from these wounds made him the natural patron of those in physical danger, either from disease or on the battlefield.

16 Bynum, *Fragmentation and Redemption*, 294.

17 John R. Hale notes that the church identified Saint Barbara as the patron saint of gunners to alleviate Christian guilt for using the new technology of firearms. On the role of Saint Barbara as patron saint of gunners, see Hale, 'Gunpowder and the Renaissance: An Essay in the History of Ideas,' in *Renaissance War Studies* (London: Hambledon Press, 1983), 402. As examples of the appearance of Saint Barbara on guns and armour, Hale cites a cannon of Ferdinand II of Tuscany in the arsenal at Venice and a horse armour in the Tower of London presented by Maximilian I to Henry VIII in 1509 (p. 416). He also notes that Palma il Vecchio's altarpiece in S. Maria Formosa in Venice portrayed her standing over a cannon; the painting was commissioned by the Venetian association of *bombardieri*. See also Hale, 'War and Public Opinion in Renaissance Italy,' in *Renaissance War Studies*, 359–87.

18 On Clorinda's association with towers as an emblem of masculine power and feminine enclosure, see John C. McLucas, 'Clorinda and Her Echoes in the Women's World,' *Stanford Italian Review* 10, no. 1 (1991): 81–92. On the imagery of towers in Ariosto, see also Albert Russell Ascoli, 'Body Politics in Ariosto's *Orlando furioso*,' in *Translating Desire in Medieval and Early Modern Literature*, ed. Craig A. Berry and Heather Richardson Hayton (Tempe, AZ: Arizona Center for Medieval and Renaissance Studies, 2005), 49–85.

19 Both *L'ordene de chevalerie* and the prose romance *Lancelot*, for example, catalogue the significance of each part of the knight's armour. Richard Barber summarizes the major topoi in this tradition: '[A]s the hauberk safeguards the body so the knight safeguards the Church; as the helm defends the head so the knight defends the Church; as the fear of the lance drives back the unarmed so the knight drives back the Church's enemies. The two edges of the sword show that the knight serves both God and the people, and its point shows that all people must obey him. The horse that carries him represents the people, whom the knight must lead, but who must support him and give him the wherewithal for an honorable life.' In *The Knight and Chivalry* (New York: Scribner's, 1970), 36. On the allegorization of armour, see also Louise

Olga Fradenburg, *City, Marriage, Tournament: Arts of Rule in Late Medieval Scotland* (Madison: University of Wisconsin Press, 1991): 202–4.

20 See in particular Erdmann, *The Origin of the Idea of Crusade*, 3–34.

21 For various attempts to trace a genealogy of the medieval topos of Christ as knight, see Wilbur Gaffney, 'The Allegory of the Christ-Knight in *Piers Plowman*,' *PMLA* 46 (1931): 155–68; Rosemary Woolf, 'The Theme of Christ the Lover-Knight in Medieval English Literature,' *Review of English Studies* 13 (1962): 1–16; and V.A. Kolve, *The Play Called Corpus Christi* (Stanford: Stanford University Press, 1966), 191–205.

22 On the psychological characterization of the *tortores* in the York cycle and the representation of Christ's 'joust' as a game, see Kolve, *The Play Called Corpus Christi*, 191–205.

23 Thomas Wright's paraphrase of Bozon is cited from Gaffney, 'The Allegory of the Christ-Knight,' 158–9.

24 The *arma Christi* were first used explicitly as symbols of the Passion in the ninth century but did not become common until the end of the twelfth century. On the historical development of the *arma Christi*, see Gertrud Schiller, *Iconography of Christian Art*, trans. Janet Seligman, (Greenwich, CT: New York Graphic Society, 1968), 2: 184–211.

25 The *crux invicta* first appeared as a symbol in Christian art in the fourth century after the legendary discovery of the True Cross by Helena, mother of the Emperor Constantine. Jacobus of Voragine writes that it was carried off by the Persian king Chosroes and eventually retrieved by the Emperor Heraclius in the seventh century; see *The Golden Legend*, 269–76. From this point, as Stephen Bann notes in a discussion of varying artistic treatments of the legends of the cross, 'its peregrinations and periods of latency being over, it became a relic, or rather the mythic source of an infinite number of fragmentary relics, diffused across the Eastern and Western worlds,' in *The True Vine: On Visual Representation and the Western Tradition* (Cambridge: Cambridge University Press, 1989), 226.

26 On the cult of relics in medieval Europe, see Patrick J. Geary, *Furta Sacra: Thefts of Relics in the Central Middle Ages* (Princeton, NJ: Princeton University Press, 1978). See also Sally J. Cornelison and Scott G. Montgomery, eds., *Images, Relics, and Devotional Practices in Medieval and Renaissance Italy* (Tempe, AZ: Arizona Center for Medieval and Renaissance Studies, 2006), and Jean-Luc Deuffic, *Reliques e sainteté dans l'espace médiéval* (Saint-Denis: Pecia, 2006).

27 The precise status of Christ's body was nonetheless a vexed question; apart from the issue of the Holy Foreskin, relics of Christ's blood, hair, and other body parts were variously sighted.

28 Bynum, *Fragmentation and Redemption*, 278, observes that 'the sexual over-
tones modern viewers find in such depictions may have been apparent
also to medieval viewers, who frequently spoke of entering into Christ's
side as into a womb.' In her reply to Leo Steinberg's *Sexuality of Christ in
Renaissance Art and in Modern Oblivion* (1983), which first appeared as 'The
Body of Christ in the Later Middle Ages: A Reply to Leo Steinberg' in *Ren-
aissance Quarterly* 39, no. 3 (Autumn 1986): 399–439, and is now reprinted
in *Fragmentation and Redemption*, 79–117, Bynum also suggests the parallel
between the side wound and the female breast.

29 The painting, by Daniel Mauch, is reproduced in both Schiller, *Iconography
of Christian Art* (fig. 668), and Bynum, *Fragmentation and Redemption*, (fig.
7.7). Schiller points out that the instruments in this composition are organ-
ized around three focal points: the crown of thorns, Sacred Heart, and
cross.

30 Bynum *Fragmentation and Redemption*, 262–80. For a photo of the hand
reliquary described below, see her fig. 7.3. On relics and their quality of
praesentia, see Brown, *The Cult of the Saints*, 86–105. On the translation of
relics, see Geary, *Furta Sacra*.

3. The Grotesque Body

1 Homer, *The Iliad*, trans. Richmond Lattimore (Chicago: University of Chi-
cago Press, 1951), 165.

2 The etymology of the word *grottesco* derives from the Italian *grotta* (cave).
The frescoes found on the walls and ceilings of Nero's palace inspired
many Italian artists of the Cinquecento; Raphael studied and copied them
in the Vatican Loggie. See Nicole Dacos, *La découverte de la Domus Aurea et
la formation des grotesques à la Renaissance*, Studies of the Warburg Institute
31 (Leiden: E.J. Brill, 1969).

3 For a detailed catalogue of mannerist armour whose design vocabulary is
grotesque in this sense, see José-A. Godoy and Silvio Leydi, *Parate trionfali:
Il manierismo nell'arte dell'armatura italiana* (Milan: 5 Continents, 2003).

4 For a rich anthology of references to Medusa in literature, philosophy,
advertising, and the arts, see Marjorie Garber and Nancy J. Vickers, *The
Medusa Reader* (New York and London: Routledge, 2003). As the editors
note in their introduction, 'both trope (a turn of phrase, a figure of speech)
and apotrope (a warning), the head of Medusa partakes of linguistic as
well as material culture, and has over time been seen as the epitome of the
apotropaic object,' (p. 2). On the motif of a woman's face on a shield, see
Nancy J. Vickers, '"This Heraldry in Lucrece' Face,"' in *The Female Body in*

Western Culture, ed. Susan Suleiman (Cambridge, MA: Harvard University Press, 1986), 209–22.

5 In addition to the shields described in this chapter, Medusa imagery appears on a variety of other pieces of sixteenth-century parade armour, including cuirasses, helmets, and horse bards. Some examples: the 1543 burgonet by Filippo Negroli (New York, Metropolitan Museum, inv. 17.190.1720), with a Medusa head over the peak; and the 'Farnese garniture,' attributed to Lucio Marliani (Milan ca 1576–80; Vienna, inv. A 1132, 1153 ff).

6 For Freud, Medusa's head symbolized the female genitals, which evoke in the young boy both a fear of castration and its simultaneous denial. Sigmund Freud, 'Medusa's Head,' in *The Standard Edition of the Complete Psychological Works of Sigmund Freud* (London: Hogarth, 1966), 18:273–4.

7 Medusa imagery was widely circulated in emblem books of the Cinquecento; see Giovanni Sambuco, *Emblemata* (Antwerp, 1564), 195, and Andrea Alciati, *Emblemata* (Antwerp, 1581), 425. Natale Conti allegorizes the story of Perseus and Medusa in his *Mythologiae* (1551). Cesare Ripa associates her with the victory of reason over the passions in the *Iconologia* (Rome, 1603).

8 'And now assuming the war tunic of Zeus who gathers / the clouds, she armed in her gear for the dismal fighting. / And across her shoulders she threw the betasselled, terrible / aegis, all about which Terror hangs like a garland, / and Hatred is there, and Battle Strength, and heart-freezing Onslaught / and thereon is set the head of the grim gigantic Gorgon, / a thing of fear and horror, portent of Zeus of the aegis.' Homer, *Iliad*, 5.736–42.

9 'He took up the man-enclosing elaborate stark shield, / a thing of splendour. There were ten circles of bronze upon it, / and set about it were twenty knobs of tin, pale-shining, / and in the very centre another knob of dark cobalt. / And circled in the midst of all was the blank-eyed face of the Gorgon / with her stare of horror, and Fear was inscribed upon it, and Terror.' Ibid., 11.32–7.

10 Garber and Vickers, *The Medusa Reader*, 4.

11 Ovid, *Metamorphoses*, 5.204.

12 Hélène Cixous, 'The Laugh of the Medusa,' trans. Keith Cohen and Paula Cohen, *Signs* 1, no. 4 (Summer 1976), 875–93.

13 For thorough documentation and bibliography pertaining to this shield, see Stuart W. Pyhrr and José-A. Godoy, *Heroic Armor of the Italian Renaissance: Filippo Negroli and His Contemporaries*, exhibition cat. (New York: Metropolitan Museum of Art, 1998), 177–9. See also Antonio Domínguez

Ortiz, Concha Herrero Carretero, and José-A. Godoy, *Resplendence of the Spanish Monarchy: Renaissance Tapestries and Armor from the Patrimonio Nacional*, exhibition cat. (New York: Metropolitan Museum of Art, 1991), 149.

14 PHILPP' IACOBI ET F NEGROLI FACIEBANT M D XXXXI (Made by Filippo Negroli, son of Giacomo, and F in 1541). Pyhrr and Godoy, *Heroic Armor*, 177, note that F refers to *Franciscus, frater*, or *fratres*; they attribute the damascene work to Filippo's younger brother Francesco, adding that a second brother, Giovan Battista, may have collaborated as well.

15 Pyhrr and Godoy, *Heroic Armor*, 177.

16 Ibid., 216–24; Godoy and Leydi, *Parate trionfali*, 412–13. The shield was first attributed to the Milanese armourer Lucio Piccinino as a commission for Charles V and dated ca 1550–2. Rejecting this attribution for its improbable chronology, Bruno Thomas suggested that the work was commissioned from Filippo Negroli in 1541 by Ferdinand I, as a gift to his brother Charles V on the eve of his Algerian campaign; see Thomas, *Gesammelte Schriften* (Graz, 1977), 182. Pyhrr and Godoy object to this theory for a variety of reasons, both historical and stylistic. Mario Scalini is alone in attributing the shield to Leone and Pompeo Leoni, in 'Mecenatismo artistico far-nesiano ed armature istoriate nella seconda metà del Cinquecento,' *Waffen-und Kostümkunde* 32, nos 1–2 (1990): 1–34.

17 Illustrated in Pyhrr and Godoy, *Heroic Armor*, 331–5.

18 The shield is now at the Staatliche Kunstsammlungen, Dresden. Cellini composed many variations on the Medusa theme; one of his most signifi-cant works was, of course, the bronze *Perseus* (1545–54) created for Cosimo I, now in the Bargello (with a copy in the Loggia dei Lanzi).

19 On this shield, see Godoy and Leydi, *Parate trionfali*, 499.

20 Another parade shield now in the Museo Bagatti Valsecchi, Milan (inv. 940), condenses these two passages from the *Iliad* as its principal subject.

21 *La Medusa del Caravaggio restaurata*, ed. Caterina Caneva (Rome: Retablo, 2002). See also the catalogue of an exhibition held at the Museo Bagatti Valsecchi edited by Micol Fontana, *Caravaggio, la Medusa: Lo splendore degli scudi da parata del Cinquecento* (Milan: Silvana, 2004).

22 Louis Marin, *Détruire la peinture* (Paris: Editions Galilee, 1977); trans. by Mette Hjort as *To Destroy Painting* (Chicago: University of Chicago Press, 1995).

23 See Filippo Fineschi and Roberto Mancini, 'La maschera della morte: Esecuzioni capitali a Roma in età moderna,' in *La Medusa del Caravaggio res-taurata*, ed. Caterina Caneva (Roma: Retablo, 2002), 73–83. On the 'bio-thanatology' of decapitation, see also Emiliano Panconesi, 'La perturbante

testa di Medusa fra mito, psicologia e medicina,' in the same volume, 85–97. The 'Medusa effect' attributed to the dying man's gaze was its lethal power to 'petrify' the beholder.

24 Luigi Spezzaferro argues that this tableau was a belated arrangement (probably dating from the 1630s), based on a misunderstanding of the work's original context and significance; see his 'La Medusa del Caravaggio,' in *Caravaggio, la Medusa*, ed. Micol Fontana, 19–27. In any case it is an important dimension of the object's material history.

25 Detlef Heikamp, 'La Medusa del Caravaggio e l'armatura dello Scià Abbas di Persia,' *Paragone* 17, no. 199 (1966): 62–76.

26 Giambattista Marino, *La galeria* (1620), ed. Marzio Pieri (Padua: Liviana, 1979); Gaspare Murtola, *Rime* (Venice: Neglietti, 1603), Madrigale 473, 'Per lo scudo di Medusa. Pittura del medesimo [Caravaggio].'

27 On the 'Medusa effect' of the painting, see Maurizio Marini, *Caravaggio: Michelangelo Merisi da Caravaggio 'pictor praestentissimus'* (Rome: Newton Compton, 1987), 403–5; also Michael Fried, 'Thoughts on Caravaggio,' *Critical Inquiry* 24 (1997): 13–56.

28 Roger Caillois, *The Mask of Medusa*, trans. George Ordish (New York: Potter, 1964), 104.

29 Giorgio Vasari, *Lives of the Artists*, trans. George Bull (New York: Penguin, 1965), 1:258–60; cited in Garber and Vickers, *The Medusa Reader*, 60–1. A Medusa still life in the Uffizi gallery was also long attributed to Leonardo. This painting, described in Shelley's poem, 'On the Medusa of Leonardo da Vinci in the Florentine Gallery' (1819), is now associated with the Flemish school and postdated to Rubens's 1618 treatment of the subject (Kunsthistorisches Museum, Vienna). According to Vasari, Leonardo was distracted by other projects and never completed the painting; appropriately, Shelley's ekphrasis was also incomplete and only published posthumously.

30 On the medieval antecedents of such crests, see Michel Pastoureau, 'Désigner ou dissimuler? Le rôle du cimier dans l'imaginaire médiéval,' in *Masques et déguisements dans la litterature médiévale*, ed. Marie-Louise Ollier (Montreal: Les Presses de l'Université de Montréal, 1988), 127–40.

31 Illustrated in John F. Hayward, 'The Revival of Roman Armour in the Renaissance,' in *Art, Arms, and Armour: An International Anthology*, ed. Robert Held (Chiasso: Acquafresca, 1979), 152.

32 Illustrated in ibid., 153.

33 Stuart W. Pyhrr, Donald J. LaRocca, and Dirk H. Breiding, *The Armored Horse in Europe, 1480–1620*, exhibition cat. (New Haven, CT: Yale University Press, 2005), 35–8. The shaffron, ca 1490–1500, has been attributed to

the Milanese armourer Roman des Ursins; it was redecorated in 1539 for use by Dauphin Henry of France. A similar piece, in the Musée de l'Armée, Paris (inv. G 587), has fluted shell-shaped ears.

34 On the composite identity of man and horse in the cultural system of chivalry, see Jeffrey J. Cohen, *Medieval Identity Machines* (Minneapolis: University of Minnesota Press, 2003), 35–77. For a more conventional account of their interdependence, see Amedeo Quondam, *Cavallo e cavaliere: L'armatura come seconda pelle del gentiluomo moderno* (Rome: Donzelli, 2003).

35 Caillois, *The Mask of Medusa*, 102.

36 The burgonet was transferred from the armoury of the dukes of Urbino to the Medici armoury in 1631. The peak remains in the Bargello in Florence (inv. M 771), while the buffe and cheekpieces were dispersed. The peak was eventually acquired by the Royal Armouries in Leeds (inv. IV 477). The cheekpieces are in the Wallace Collection in London (inv. A 206–7). See Pyhrr and Godoy, *Heroic Armor*, 155–9.

37 For a discussion of this bearded buffe, see my chapter 5. In his treatise 'Arte fabrile overo armeria universale dove si contengano, tutte, le qualità, e natura del ferro con varie impronte che si trovano in diversi arme così antiche come moderne e vari segreti e tempere' (Florence, Biblioteca Nazionale Centrale, 1642), Antonio Petrini identifies the helmet as a relic of Aeneas, made by the (fictitious) armourer Ripa, son of Numa Babilonico. Such attributions were intended to provoke curiosity about the Medici collections.

38 The Anglo-Florentine collector Frederick Stibbert (1838–1906) had a special passion for Japanese armour and helmets. The Stibbert Museum remains one of the most important collections of Japanese armour in Europe. See especially Kristen Aschengreen Piacenti, *Draghi e peonie, Capolavori della collezione giapponese* (Florence: Edizioni Polistampa, 1999), and Henry Russell Robinson, series ed., *Il Museo Stibbert a Firenze* (Milan: Electa, 1973–6).

39 Pyhrr and Godoy, *Heroic Armor*, 159 n5. On Japanese armour, see Henry Russell Robinson, *Japanese Arms and Armor* (New York: Crown, 1969). Most of the works illustrated and discussed in this book are from the Stibbert Museum and Museo Orientale in Venice.

40 On the history of this collection, eventually moved from the Castle of Ambras to Vienna, see the introductory essay by Christian Beaufort-Spontin to the beautifully illustrated edition of Calvino's *Cavaliere inesistente* (Milan: Franco Maria Ricci, 1994).

41 Ewart Oakeshott, *European Weapons and Armor from the Renaissance to the Industrial Revolution* (North Hollywood, CA: Beinfeld Publishing, 1980), 123.

4. Guidobaldo II della Rovere

1 Konrad Eisenbichler, 'Bronzino's Portrait of Guidobaldo II della Rovere,' *Renaissance and Reformation* 12 (Winter 1988): 21–33. I am indebted to Eisenbichler's new classic analysis, summarized in the following pages.

2 On the historical circumstances around the absence of Francesco Maria della Rovere and his wife, see Dennis Dennistoun of Dennistoun, *Memoirs of the Dukes of Urbino Illustrating the Arms, Arts and Literature of Italy, 1440–1630*, ed. Edward Hutton (London: John Lane, 1909), 3:58–9.

3 Eisenbichler, 'Bronzino's Portrait,' remarks that earlier comments on the *Guidobaldo* 'serve very well as an example of how the most obvious can also be the most conscientiously ignored element of a painting' (p. 25).

4 For the Greek transcription, see Andrea Emiliani, *Il Bronzino* (Milan: Bramante, 1960), plate 12.

5 Baldassar Castiglione, *Il libro del cortegiano*, ed. Walter Barberis (Turin: Einaudi, 1998), 20; *The Book of the Courtier*, trans. Charles Singleton and ed. Daniel Javitch (New York: Norton, 2002), 11.

6 Castiglione, *Il libro*, 320; *Book of the Courtier*, 186.

7 'But because he wished it done with certain armour that he was waiting to receive from Lombardy, Bronzino was forced to stay longer than he would have liked with that prince,' Giorgio Vasari, *Le vite de' più eccellenti pittori scultori ed architettori*, ed. Gaetano Milanesi (Florence: Sansoni, 1906) 6:173; translation mine.

8 Francesco Maria della Rovere served for many years as captain general of the church and in 1538 (the year of his death) was appointed commander of land forces for the Holy League against the Turks.

9 On the imitation of textiles in armour, see Lionello Giorgio Boccia and E.T. Coelho, 'I motivi a tessuto (1540–1620),' in *L'arte dell'armatura* (Milan: Bramante, 1967), 375–482; see also Anna Omodeo, 'Modelli e moduli per le decorazioni delle armature,' in *Il convitato di ferro*, exhibition cat. (Turin: Quadrante, 1987), 181–6; and Anna Omodeo, *Grafica per orafi* (Bologna: Tip. Labanti e Nanni, 1975).

10 Eisenbichler reviews this correspondence in 'Bronzino's Portrait,' 27–8.

11 Cited in Filippo Ugolini, *Storia dei conti e duchi d'Urbino* (Florence: Grazzini, Giannini, 1859), 2:248.

12 Eisenbichler, 'Bronzino's Portrait,' 28.

13 Francesco Maria II (d. 1631) had one son, Federico Ubaldo, who died in 1623.

14 Patricia Simons, 'Alert and Erect: Masculinity in Some Italian Renaissance Portraits of Fathers and Sons,' in *Gender Rhetorics: Postures of Dominance and*

Submission in History, ed. Richard C. Trexler (Binghamton, NY: Medieval and Renaissance Texts and Studies, 1994), 163–75.

15 Ibid., 172.

16 Ibid., 173.

17 Georg Gronau, *Documenti artistici urbinati: Raccolta di fonti per la storia dell'arte* (Florence: Sansoni, 1936), 1:92. Mario Scalini, in his *Armature all'eroica dei Negroli* (Florence: Museo Nazionale del Bargello, 1987), 17, suggests that the armour was of German manufacture, and that it was produced by the workshop of Lorenz and Kolman Helmschmid.

18 In my view, Simons, 'Alert and Erect,' 174, misses the point of this contrast when she implies that the two codpieces equally suggest phallic virility.

19 Gronau, *Documenti artistici urbinati*, 1:92.

20 Harry Berger, Jr, *Fictions of the Pose: Rembrandt against the Italian Renaissance* (Stanford: Stanford University Press, 2000), 206. Berger is citing Lorne Campbell, *Renaissance Portraits: European Portrait-Painting in the 14th, 15th, and 16th Centuries* (New Haven, CT: Yale University Press, 1990), 107. For Berger's analysis of the Titian portrait, see *Fictions of the Pose*, 213–15.

21 Marjorie Garber, *Vested Interests: Cross-Dressing and Cultural Anxiety* (New York and London: Routledge, 1992), 122.

22 Pietro Aretino, *Poesie varie*, ed. Giovanni Aquilecchia and Angelo Romano (Rome: Salerno, 1992), 259–60; translation mine.

23 Deborah Parker comments briefly on this sonnet in *Bronzino: Renaissance Painter as Poet* (Cambridge: Cambridge University Press, 2000), 85–7. On Aretino's ekphrastic poetry, see Raymond Waddington, *Aretino's Satyr: Sexuality, Satire, and Self-Projection in Sixteenth-Century Literature and Art* (Toronto: University of Toronto Press, 2004), 20–31. As Waddington points out, Aretino's ekphrases were not always so edifying; his most famous were the *Sonetti lussuriosi*, devoted to the erotic engravings of Marcantonio Raimondi (from drawings by Giulio Romano).

24 Eisenbichler, 'Bronzino's Portrait,' accepts the Berruguete attribution; Simons, 'Alert and Erect,' acknowledges both possibilities.

25 Two classic studies are Enrico Castelnuovo, 'Il significato del ritratto pittorico nella societa', *Storia d'Italia* (Turin: Einaudi, 1973), 5:1033–94, and Peter Burke, 'The Presentation of Self in the Renaissance Portrait,' in *The Historical Anthropology of Early Modern Italy* (Cambridge: Cambridge University Press, 1987), 150–67.

26 Real Armería, Patrimonio Nacional, Madrid (inv. A 188). The harness is considered complete even though it is missing several minor ornaments: a brass chain that would have been worn as a belt (which passed through rings that are still extant on the cuirass), three small detachable rings (indi-

cated by mounting holes), and a crest (which would have been inserted into the plume holder at the base of the burgonet).

27 Both the helmet and its accompanying lion shield are in the Real Armería in Madrid (inv. D 1 and D 2). On this ensemble, see Stuart W. Pyhrr and José-A. Godoy, *Heroic Armor of the Italian Renaissance: Filippo Negroli and His Contemporaries*, exhibition cat. (New York: Metropolitan Museum of Art, 1998), 278–84. Other discussions include Bruno Thomas and Ortwin Gamber, 'L'arte milanese dell'armatura,' in *Storia di Milano*, vol. 11, *Il declino spagnolo (1630–1706)* (Milan: Fondazione Treccani, 1957), 704–5, 764, 777; John F. Hayward, 'The Revival of Roman Armour in the Renaissance,' in *Art, Arms, and Armour: An International Anthology*, ed. Robert Held (Chiasso, Switzerland: Acquafresca Editrice, 1979), 144–63; Lionello Giorgio Boccia and José-A. Godoy, eds., *Museo Poldi Pezzoli: Armeria* (Milan: Electa, 1985–86), 1:92; Matthias Pfaffenbichler, *Medieval Craftsmen: Armourers* (Toronto: University of Toronto Press, 1992), 38–40; Lionello Giorgio Boccia, 'Le armature dei Negroli,' *Poiein/Quaderni di cultura artistica del Ministero della Pubblica Istruzione* 6 (1993): 24.

28 Angelo Angelucci, *Documenti inediti per la storia delle armi da fuoco italiane* (Turin: G. Cassone, 1869), vol. 1, pt. 1, 330. Cited in Pyhrr and Godoy, *Heroic Armor*, 283

29 Pyhrr and Godoy, *Heroic Armor*, 112–14.

30 This was the theory of Valencia de Don Juan, in his *Catalogo historico-descriptivo de la Real Armería de Madrid* (Madrid: Real Casa, 1898), 64–8.

31 The 'portrait' mannequin is of course an idealized image of the emperor. Ironically, it seems to be modelled on the Negroli anatomical helmet that Charles V had commissioned; see chapter 5.

32 The earliest and probably most accurate of these paintings is the set painted ca 1561 for Francesco Ferdinando d'Avalos, Marchese di Pescara and governor of Milan. These copies are now in the Museo e Galleria Nazionale di Capodimonte.

33 For a detailed discussion of this issue, see Pyhrr and Godoy, *Heroic Armor*, 149–52.

34 Ibid., 136–46.

35 A number of important pieces of the original harness are still missing, including the backplate, browband, and several lames. Ibid., 139.

36 Lionello Giorgio Boccia and E.T. Coelho, *L'arte dell'armatura in Italia*, 327–8. The confusion arises partially from the fact that the armour is listed as having belonged to Francesco Maria I in the 1630 inventory of the della Rovere armoury. The entire della Rovere collection was being packed for shipment to Florence as part of the inheritance of Vittoria della Rovere, betrothed to

Ferdinando II dei' Medici. Pyhrr and Godoy, *Heroic Armor*, 141, suggest that the compiler may have been mistaken in his attribution.

37 This painting, now lost, is known through a copy in the Kunsthistoriches Museum in Vienna. Ibid., 146–7.

38 Scalini, *Armature all'eroica dei Negroli*, 17ff.

39 Ibid., 21.

40 Pyhrr and Godoy, *Heroic Armor*, 288.

41 See Goran V. Stanivukovic, ed., *Ovid and the Renaissance Body* (Toronto: University of Toronto Press, 2001), 7; and Jonathan Sawday, *The Body Emblazoned: Dissection and the Human Body in Renaissance Culture* (New York and London: Routledge, 1996), 23.

42 Pyhrr and Godoy, *Heroic Armor*, 144, also point out this detail.

43 On the success of Ariosto's poem, see Daniel Javitch, *Proclaiming a Classic: The Canonization of 'Orlando furioso'* (Princeton, NJ: Princeton University Press, 1991).

44 Lionello Giorgio Boccia makes this suggestion in 'Curiosa di armamentaria ariostea,' in *Signore cortese e umanissimo: Viaggio intorno a Ludovico Ariosto*, exhibition cat., ed. Jadranka Bentini (Venice: Marsilio, 1994), 59.

45 Translation mine. The motif of Rodomonte's armour is derived from Matteo Maria Boiardo, *Orlando innamorato*, ed. Aldo Scaglione (Turin: UTET, 1963), 2:14.32–4.

46 Ariosto alludes to Orlando's physical invulnerability at several points in the poem: *Orlando furioso*, 11.50, 12.49, 24.10, and 29.52. On this point, see especially Albert Russell Ascoli, 'Like a Virgin: Fantasies of the Male Body in *Orlando furioso*,' in *The Body in Early Modern Italy*, ed. Walter Stephens and Julia Hairston (Baltimore: Johns Hopkins University Press, forthcoming).

47 Mario Scalini, 'Il poema epico cinquecentesco, armi all'eroica e da pompa,' in *Armi e armati: Arte e cultura delle armi nella Toscana e nell'Italia del tardo Rinascimento dal Museo Bardini e dalla Collezione Corsi*, ed. Mario Scalini (Florence: Centro Di, 1988), 14.

48 Thomas and Gamber, 'L'arte milanese dell'armatura,' 764.

49 The original painting is lost; the best extant copy is a miniature in the Gemäldegalerie, Kunsthistoriches Museum in Vienna; see Pyhrr and Godoy, *Heroic Armor*, 146–7.

50 'I will not dwell on Filippo Negrolo from Milan, chiseller of arms in iron with foliage and figures, except to say that as we can see, he created such unusual works in copper that he achieved very great fame.' Vasari, *Vite*, ed. Milanesi, 5:389; translation mine.

51 Paolo Morigi, *La nobiltà di Milano divisa in sei libri* (Milan, 1615; facs. ed. Sala Bolognese: Arnaldo Forni Editore, 1979), 297–8; translation mine.

52 Antonio Petrini, 'Arte fabrile overo armeria universale dove si contengano, tutte, le qualità, e natura del ferro con varie impronte che si trovano in diversi arme così antiche come moderne e vari segreti e tempere' (Florence, Biblioteca Nazionale Centrale, 1642,); reprinted in A. Gaibi, 'Un manoscritto del '600: L'arte fabrile, di Antonio Petrini,' *Armi antiche* (1962): 111–39.

53 Pyhrr and Godoy, *Heroic Armor*, 142.

54 The helmet is now dismembered: the peak is in the Bargello (inv. M 771), the cheekpieces are in the Wallace Collection in London (inv. A 206–7), and the bottom plate or buffe is in the Royal Armouries at Leeds (inv. IV.477). See Pyhrr and Godoy, *Heroic Armor*, 155–9.

55 Ariosto writes that the pagan knight Mandricardo won Hector's thousand-year-old armour in a battle in Syria (Canto 14.31) and finally lost it to Ruggiero, who wore it in his victory over Rodomonte (Canto 26.109–40).

5. Charles V Habsburg

1 Frances Yates, 'Charles V and the Idea of the Empire,' in *Astraea: The Imperial Theme in the Sixteenth Century* (London and Boston: Routledge, 1975), 1–28. Biographies of Charles V include the classic by Karl Brandi, *Emperor Charles V: The Growth and Destiny of a Man and of a World-Empire*, trans. C.V. Wedgwood (London: Jonathan Cape, 1965); among the most recent is by Willem Blockmans, *Emperor Charles V, 1500–1558* (New York: Oxford University Press, 2002). For a recent study of his campaign strategy and domestic politics, see James D. Tracy, *Emperor Charles V, Impresario of War* (Cambridge: Cambridge University Press, 2002).

2 Apart from Milan, Augsburg and Nuremberg were the most important capitals of the sixteenth-century arms industry. The Helmschmid (or Helmschmied) family produced several generations of highly skilled armourers: Lorenz (1445–1516) was principal armourer to Maximilian I; Colman (1471–1532) created a number of armours for Charles V; and Desiderius (1513–78) produced the famed garniture that Charles V wore at the Battle of Mühlberg. The family's original surname was Kolman; they changed it to Helmschmied to refer to their profession as 'helmet makers.'

3 The inventory identifies the armour in the following entry: 'una Armatura del Ser.mo Sig.r Duca Francesco Mario Po. fatta à scaglie, e occhio di pescie con l'elmo à foggia d'Aquila con una serpa in cima, con i suoi gambali senza schiena ma con la Croce, con scarpe scimitarra, e mazza, *la quale fù da Carlo quinto addimandata per farne fare una simile*, con la spada,' cited in Pyhrr and Godoy, *Heroic Armour of the Italian Renaissance: Filippo Negroli*

and His Contemporaries, exhibition cat. (New York: Metropolitan Museum of Art, 1998), 145 n2; my emphasis.

4 'In proposito di questa armatura io dissi a sua Maestà delle due celate che ha V. Ex. laudandoglile summamente, massimamente quella rizza, di modo che l'è venuta in desiderio di vederle, et per questo mando il presente mio cavallaro. La Ex.tia vostra sarà contenta mandarle subito, et serà bene che la faccia venir insieme l'armarolo suo, che se gli faranno veder dette armature, et spero che vi trovarà delle cose che molto gli piacerano.' The letter was first published in Carlo d'Arco, *Delle arti e degli artefici di Mantova: Notizie raccolte ed illustrate con disegni e con documenti* (Mantua: Tipografia Ditta Giovanni Agazzi, 1857), 2:118–19, and again by Alessandro Luzio, *Un pronostico satirico di Pietro Aretino (MDXXXIIII)* (Bergamo: Istituto Italiano d'Arti Grafiche, 1900): 98–9. Cited in Silvio Leydi, 'A History of the Negroli Family,' in Pyhrr and Godoy, *Heroic Armor*, 41 and 56 n26.

5 Pyhrr and Godoy, *Heroic Armor*, 131, cite several examples of similar anthropomorphic helmets, including two that probably belonged to either Francesco Maria della Rovere or his son Guidobaldo II: New York, Metropolitan Museum (inv. 04.3.202); Saint Petersburg, Hermitage (inv. 3.0.3414).

6 Both the helmet and its accompanying lion shield are in the Real Armería in Madrid (inv. D 1 and D 2). On this helmet and its accompanying lion shield, see ibid., 125–31. Other discussions include Bruno Thomas and Ortwin Gamber, 'L'arte milanese dell'armatura,' in *Storia di Milano*, vol. 11, *Il declino spagnolo (1630–1706)* (Milan: Fondazione Treccani, 1958), 760–3; Stephen V. Grancsay, 'The Illustrated Inventory of the Arms and Armor of Emperor Charles V,' in *Homenaje a Rodríguez-Monino* (Madrid: Editorial Castalia, 1966), 1:205–12; Mario Scalini, *Armature all'eroica dei Negroli* (Florence: Museo Nazionale del Bargello, 1987), 13–14; Antonio Domínguez Ortiz, Concha Herrero Carretero, and José-A. Godoy, eds., *Resplendence of the Spanish Monarchy: Renaissance Tapestries and Armor from the Patrimonio Nacional*, exhibition cat. (New York: Metropolitan Museum of Art, 1991), 144–8; J. De Geest, Juan Hernández Ferrero, Concha Herrero Carretero, and José-A. Godoy, eds., *Charles Quint: Tapisseries et armures des collections royales d'Espagne*, exhibition cat. (Brussels: Musées Royaux d'Art e d'Histoire, 1994), 168–71; Fernando Checa Cremades, *Carlos V: La imagen del poder en el Renacimiento* (Madrid: Ediciones El Viso, 1999), 199–200; Alvaro Soler de Campo, *Real Armería: Palacio Real* (Madrid: Patrimonio Nacional, 2000), 53–4.

7 The exacerbation of such physical features was one result of the systematic use of intermarriage by the Habsburg family to extend and consolidate

its global empire. The anomaly is clearly visible in many of the family portraits; they provide an unusually detailed series of medical illustrations of interest to specialists in genetics and plastic surgery. See for example W.C. Grabb, G.P. Hodge, R.O. Dingman, and R.M. O'Neal, 'The Hapsburg Jaw,' *Plastic and Reconstructive Surgery* 42 (1968): 442–5; G.P. Hodge, 'A Medical History of the Spanish Habsburgs as Traced in Portraits,' *Journal of the American Medical Association* 238 (1977): 1169–74; G. Wolff, T.F. Wienker, and H. Sander, 'On the Genetics of Mandibular Prognathism: Analysis of Large European Noble Families,' *Journal of Medical Genetics* 30 (1993): 112–16.

8 In a 1525 report to the Senate, the Venetian ambassador Gaspare Contarini gave an unsparing physical description of the Emperor: 'né in lui altra parte del corpo si può incolpare, eccetto il mento, anzi tutta la mascella inferiore, la quale è tanto larga e tanto lunga, che non pare naturale di quel corpo, ma pare posticcia, onde avviene che non può, chiudendo la bocca, congiungere li denti inferiori con li superiori, ma gli rimane spazio della grossezza d'un dente, onde nel parlare, massime nel finire della clausula, balbutisce qualche parola, la quale spesso non s'intende molto bene' (nor can one fault any other part of his body, apart from the chin, indeed the entire lower jaw, which is so wide and so long that it doesn't seem to belong to the body, but rather seems to be a subsequent addition. Therefore when closing his mouth he can't join his upper and lower teeth; instead there is a gap the size of a tooth, causing him to stammer occasionally, especially at the end of a phrase, so he can't easily be understood). Giovanni Comisso, *Gli ambasciatori veneti (1525–1792): Relazioni di viaggio e di missione* (Milan: Longanesi, 1960), 203–4; translation mine.

9 Most telling is the absence of such a visor from the extensive illustrations of the Spanish collection in the *Inventario ilustrado* by Valencia de San Juan in 1544–58.

10 See my earlier discussion in chapter 4.

11 Filippo Negroli's name is inscribed in a banderole at the base of the neck: PHILIPPI NIGROLI IAC F. / MEDIOLANENSIS OPUS / M D XXXII. The helmet is his earliest signed work.

12 Ovid again tells the story of Jason and the Argonauts in *Metamorphoses* 7. On the Golden Fleece as a topical political reference in Renaissance epic, see David Quint, *Epic and Empire: Politics and Generic Form from Virgil to Milton* (Princeton, NJ: Princeton University Press, 1993), 259. On the history of the Order of the Golden Fleece, see D'Arcy J.D. Boulton, *The Knights of the Crown: The Monarchical Orders of Knighthood in Later Medieval Europe, 1325–1520*, 2nd ed. (Woodbridge: Boydell, 2000), 356–96.

13 Like many other examples of Renaissance armour, the originally blackened surface of this shield was removed by excessive cleaning. The black coating served to protect the metal from corrosion. In this case, the chromatic contrast between gold figure and black ground also made the image more visible, particularly at a distance.

14 On this device, see the two articles by Earl Rosenthal, '"Plus ultra," "Non plus ultra", and the Columnar Device of the Emperor Charles V,' *Journal of the Warburg and Courtauld Institutes* 34 (1971): 204–28; and 'The Invention of the Columnar Device of Emperor Charles V at the Court of Burgundy in Flanders in 1516,' *Journal of the Warburg and Courtauld Institutes* 36 (1973): 198–230. For a sixteenth-century commentary on the device, see G. Ruscelli, *Le imprese illustri* (Venice, 1572), 20. Yates notes that the twin-column device was repeatedly copied and adapted in both England and France, most memorably in the 'Sieve' portrait of Elizabeth I (*Astraea*, 117 and 57–8). Stephen Orgel points out that 'the adaptation of Roman Catholic imperial iconography was an increasingly visible element in the creation of a British royal self,' in 'Gendering the Crown,' in *Subject and Object in Renaissance Culture*, ed. Margreta De Grazia, Maureen Quilligan, and Peter Stallybrass (Cambridge: Cambridge University Press, 1996), 155.

15 An important example of a lion's-head sallet from the Quattrocento is in the Metropolitan Museum in New York (inv. 23.141). This is considered the only surviving *all'antica* parade helmet from the Quattrocento (see Pyhrr and Godoy, *Heroic Armor*, 92–4).

16 Guillaume Du Choul, *Discours sur la castramentation et discipline militaire des Romains* (Lyon: Guillaume Rouille, 1555), 152. Cited in Pyhrr and Godoy, *Heroic Armor*, 94.

17 For an extended discussion of a single parade armour based on the theme of Hercules, see Amedeo Quondam, *Cavallo e cavaliere: L'armatura come seconda pelle del gentiluomo moderno* (Rome: Donzelli, 2003). Although his focus is on the 'Hercules armour' made by Eliseus Libaerts for Erik XIV of Sweden in 1562–4 (Dresden, Rüstkammer), Quondam offers many useful reflections on the more general semiotics of armour. The primary monograph on the Libaerts armour is Johannes Schoebel, *Ein Prunk-harnisch: Der Herakles-Harnisch aus dem Historischen Museum der Staatlichen Kunstsammlunger Dresden* (Lipsia: Prisma-Verlag, 1966); see also J. Schoebel, *Princely Arms and Armor: A Selection from the Dresden Collection*, trans. M.O.A. Stanton (New York: Barrie and Jenkins, 1975).

18 Stanzas 18–36 of Canto 15, which were probably written between 1526 and 1532, were added to the third edition of *Orlando furioso*. In his *Vita di Ludovico Ariosto, ricostruita su nuovi documenti* (Geneva: Olschki, 1930–1),

Michele Catalano remarks that Ariosto received 'un diploma di poeta laureato' from the emperor in exchange for this encomium (1:608).

19 See my earlier discussion, chapter 4.

20 On the Habsburg emperor's complicated relationship with Italy, see the volume of essays edited by Marcello Fantoni, *Carlo V e l'Italia* (Rome: Bulzoni, 2000). For recent perspectives on the relationship between Spain and the Italian states, see Thomas J. Dandelet and John Marino, eds., *Spain in Italy: Politics, Society, and Religion 1500–1700*, The Medieval and Early Modern Iberian World 32 (Leiden: Brill, 2007).

21 Apart from Tanner's work on the role of Virgilian themes in Habsburg propaganda, there is an enormous bibliography on the pageantry associated with Charles V. Of particular interest to me for this study have been the studies focusing on his ceremonies and processions in Italy. On this subject, Bonner Mitchell is a fundamental resource; see *The Majesty of the State: Triumphal Progresses of Foreign Sovereigns in Renaissance Italy, 1494–1600* (Florence: Olschki, 1986). An important earlier study is Roy Strong, *Art and Power: Renaissance Festivals, 1450–1650* (Berkeley: University of California Press, 1984) (an expanded and revised version of his 1973 *Splendour at Court*); see especially 'Images of Empire: Charles V and the Imperial Progress,' 75–97. There are several useful case studies of the emperor's visits to individual Italian cities in Marcello Fagiolo, ed., *La città effimera e l'universo artificiale del giardino: La Firenze dei Medici e l'Italia del '500* (Rome: Officina Edizioni, 1980). Much recent scholarship on festival culture of the Renaissance was stimulated by the three international congresses whose acts were published in the three-volume series *Les fêtes de la renaissance*, ed. Jean Jacquot; volume 2, *Fêtes et cérémonies au temps de Charles Quint* (Paris: Centre National de la Recherche Scientifique, 1960) is dedicated to festivals and ceremonies at the time of Charles V.

22 An excellent study of this ceremony is Tiziana Bernardi's 'Analisi di una cerimonia pubblica: L'incoronazione di Carlo V a Bologna,' *Quaderni storici* 61 (1986): 171–99. For an earlier discussion see Giordano Conti's 'L'incoronazione di Carlo V a Bologna,' in *La città effimera*, ed. Marcello Fagiolo, 38–45; see also Marcello Fantoni, 'Carlo V e l'immagine dell'*Imperator*,' in *Carlo V e l'Italia*, 101–18.

23 Pyhrr and Godoy, *Heroic Armor*, 160–70. See also Thomas and Gamber, 'L'arte milanese dell'armatura, 760–5; Lionello Giorgio Boccia and E. T. Coelho, *L'arte dell'armatura in Italia* (Milan: Bramante, 1967), 322, 331, figs 256–8; Matthias Pfaffenbichler, *Medieval Craftsmen: Armourers* (Toronto: University of Toronto Press, 1992), 41.

24 Soler del Campo, *Real Armería. Palacio Real*, 44. Santa Barbara was associated with protection against firearms (see above, chapter 2).

25 Ironically, the images most frequently erased from Renaissance armours are the ones with Christian reference. In the life span of the armour, figural medallions like the Virgin and Santa Barbara – rendered in precious metals – were frequently detached. Another example is the Damascened Garniture of Charles V, divided among the Real Armería (inv. A 159), Museo Stibbert (inv. 3190). Hermitage Museum (inv. 6141) and Metropolitan Museum (inv. 04.3.21). The garniture includes two breastplates and two backplates that bore appliqués of the Virgin and Santa Barbara: all four ornaments have now disappeared. Their ghosts are visible in the outlines on the steel and the holes created for attachment of the figures.

26 Pyhrr and Godoy, *Heroic Armor*, 186–8. See also Domínguez Ortiz, Herrero Carretero, and Godoy, *Resplendence of the Spanish Monarchy*, 152–4; Lionello Giorgio Boccia, 'Le armature dei Negroli,' *Poiein / Quaderni di cultura artistica del Ministero della Pubblica Istruzione* no. 6 (1993): 17–21.

27 Two burgonets with an analogous program are in Paris (Musée de l'Armée, inv. H 253) and New York (Metropolitan Museum, acc. no. 49.163.3).

28 Francesco Sansovino, *Il simulacro di Carlo V imperadore* […] (Venice: F. Franceschini et I. Mantelli, 1567), 51; cited in Fantoni, 'Carlo V e l'immagine dell'*Imperator*,' 113.

29 Nicolai Vernulaei, *Virtutem augustissimae gentis Austriacae* (Louvain, 1640), 33; cited in Marie Tanner, *The Last Descendent of Aeneas: The Hapsburgs and the Mythic Image of the Emperor* (New Haven, CT: Yale University Press, 1993), 191.

30 The ceremony is described in Strong, *Art and Power*, 82.

31 Erwin Panofsky, *Problems in Titian: Mostly Iconographic* (New York: New York University Press, 1969), 84. See also Yates, *Astraea*, 22.

32 The equestrian statue of Marcus Aurelius had been moved in 1538 from the Lateran to the Capitoline; Michelangelo redesigned the piazza to accommodate the statue. See Lucilla De Lachenal, 'Il gruppo equestre di Marco Aurelio e il Laterano: Ricerche per una storia della fortuna del monumento dall'età medievale sino al 1538,' *Bollettino d'arte* 74 (1990): 1–52.

33 Guevara's *Relox de principes* (1529), dedicated to Charles V, explicitly proposes Marcus Aurelius as a moral exemplum; see Michael P. Mezzatesta, 'Imperial Themes in the Sculpture of Leone Leoni' (PhD diss., New York University, 1980), 209–17. On the life and works of Antonio de Guevara, see Augustin Redondo, *Antonio de Guevara (1480?–1545) et l'Espagne de son temps, de la carrière officielle aux œvres politico-morales* (Geneva: Droz, 1976).

34 The armour, made by Desiderius Helmschmidt, appears in two sculptures by Leone Leoni now in the Prado Museum: *Charles V and Fury* (E 273) and *Bust of Charles V* (E 271). See my discussion later in this chapter. The armour is also portrayed in a painting by Pantoja de la Cruz in the Real Monasterio de San Lorenzo de El Escorial. It appears again in a tapestry from the famous *Tunis* series woven in Brussels between 1548 and 1554. The Real Armería displays the armour together with an eighteenth-century copy of this tapestry commissioned by Philip V.

35 See the recent English edition of Erasmus, *The Education of a Christian Prince*, ed. Lisa Jardine (Cambridge: Cambridge University Press, 1997).

36 See especially chapter 3, 'Concerning the Weapons of Christian Soldiering," in Desiderius Erasmus, *The Enchiridion*, trans. and ed. Raymond Himelick (Gloucester, MA: Peter Smith, 1970), 46–58. On p. 57 the author cites the famous passage from Ephesians 6:13–17.

37 An essential resource on Leoni's work for Charles V is Mezzatesta, 'Imperial Themes.' On *Charles V and Fury Restrained*, see pp. 1–68; see also *Los Leoni (1509–1608): Escultores del Renacimiento italiano al servicio de la corte de Espana*, exhibition cat. (Madrid: Museo del Prado, 1994), 102–9. Commissioned in 1549, the sculpture was not completed until 1564, nine years after Charles V had abdicated to his son Philip II. Warehoused and largely forgotten until the nineteenth century, it is now prominently displayed in the rotunda of the Prado. It remains without question the most ingenious and memorable image of Charles V ever created.

38 'dirae ferro et compagibus artis / claudentur Belli portae; Furor impius intus / saeva sedens super arma et centum vinctus aenis / post tergum nodis fremet horridus ore cruento.' (The gates of war, grim with iron and close-fitting bars, shall be closed; within, impious Rage, sitting on savage arms, his hands fast bound behind with a hundred brazen knots, shall roar in the ghastliness of blood-stained lips). *Aeneid* 1.293–6; trans. H. Rushton Fairclough (London: Putnam's, 1916).

39 vertù contra furore
 prenderà l'arme, et fia 'l combatter corto:
 ché l'antiquo valore
 ne l'italici cor' non è anchor morto.
 Francesco Petrarca, *Canzoniere*, ed. Gianfranco Coutini (Turin: Einaudi, 1964), Canzone 128, 93–6. (Virtue will take up arms against Fury, and the battle will be brief: for ancient valour is not yet dead in Italian hearts.) Translation mine.

40 Written in 1513, Machiavelli's *Principe* was published posthumously in 1532.

41 Earlier in the speech that culminates in the reference to 'Furor impius,' Jupiter encourages the exhausted Trojans and promises them, 'his ego nec metas rerum nec tempora pono; imperium since fine dedi' (*Aeneid* 1.278–9).

42 In his autobiography, Cellini makes the entertaining claim that Leoni took part in a conspiracy to kill him by sprinkling a ground diamond in his salad. See Benvenuto Cellini, *La vita di Benvenuto Cellini*, ed. Orazio Bacci (Florence: Sansoni, 1961), 200ff; cited in Mezzatesta, 'Imperial Themes,' xv.

43 Although unsuccessful in his bid for a commission from Francesco Maria della Rovere, Leoni apparently made a parade helmet for Pierluigi Farnese in 1546. It has been suggested that this was the model for a helmet at the base of the *Fury* sculptural group.

44 Cellini, *Vita*, 281ff. Cited in Mezzatesta, 'Imperial Themes,' 12.

45 'Because I desire it very, very much, I beg [Your Majesty] to let me know [if this is acceptable]'; translation mine. Mezzatesta includes the text of this letter in 'Imperial Themes, Appendix 3, 66.

46 Giorgio Vasari, *Le vite de' più eccellenti pittori, scultori ed architettori*, ed. Gaetano Milanesi (Florence: Sansoni, 1906), 7:536; translation mine.

47 For a discussion and illustrated catalogue of these armours, see Lionello Giorgio Boccia, *Le armature di Santa Maria delle Grazie di Curtatone di Mantova e l'armatura lombarda del '400* (Milan: Bramante Editrice, 1982). The two figures on pp. 14–15 illlustrate the unusual iconography of the niches containing the armoured mannequins (in reality wooden frames with papier maché heads): the effigies are surrounded by elaborate constellations of ex-voto images – eyes, breasts, hands, and hearts – arranged in geometrical patterns. Earlier sources include the volume by Renzo Margonari and Attilio Zanca, *Il Santuario della Madonna delle Grazie presso Mantova* (Mantua: Gizeta, 1973).

48 Mezzatesta, 'Imperial Themes,' 21 n45, speculates that the statue might have been intended to be armed in a ceremony inspired by the literary topos of the 'arming of the hero' (see *Iliad* 19.367–91 and *Aeneid* 12.430–55).

49 Leoni's particular admiration for Michelangelo's Minerva Christ is evident from the great care and expense with which he later obtained a plaster cast of the statue to add to his collection in Milan; Mezzatesta, 'Imperial Themes,' 238.

50 Marie Tanner discusses the Habsburg cult of the Eucharist in *The Last Descendant of Aeneas*, 207–22. In St Gudule, Charles restored the chapel that celebrated a fourteenth-century miracle on which the family's particular devotion to the Sacrament was based.

51 See Irving Lavin, 'Bernini's Death,' *The Art Bulletin* 54 (1972): 177.

52 The official chronicle of the tour was written by Juan Cristobal Calvete de Estrella, *El felicíssimo viaje del muy alto y muy poderoso Príncipe Don Phelippe,*

hijo del Emperador Don Carlos Quinto Maximo, desde España a sus tierras de la baxa Alemaña: con la descripción de todos los estados de Brabante y Flandes (Antwerp: Martin Nucio, 1552, repr. Madrid: López de Toro, 1950, 2 vols). On the iconography of the armour worn by Philip II on this tour, see the dissertation by Braden K. Frieder, 'The Perfect Prince: Tournaments, Armor, and the Iconography of Succession on the Grand Tour of Philip of Spain, 1548–1551' (PhD diss., University of Wisconsin–Madison, 1997). Classic biographies of the prince include Edward Grierson, *King of Two Worlds: Philip II of Spain* (London: Collins, 1974) and Geoffrey Parker, *Philip II* (Boston: Little, Brown, 1978). More recently, see Henry Kamen, *Philip of Spain* (New Haven, CT: Yale University Press, 1997); see also Fernando Checa Cremades, *Felipe II, Mecenas de las artes* (Madrid: Editorial Nerea, 1992) and the beautifully illustrated volume edited by Pedro Navascués Palacio, *Philippus II Rex* (Barcelona: Lunwerg, 1998).

53 Five separate payments to Desiderius Colman during Philip's stays in Brussels and Augsburg seem to apply to this garniture (Real Armería, inv. A 239–42). For details, see Frieder, 'The Perfect Prince,' 176, n63.

54 For further examples, see Strong, *Art and Power*, 88; and Tanner, *The Last Descendant of Aeneas*, 131–45.

55 Frieder, 'The Perfect Prince.'

56 Frieder notes that an early inventory of the prince's possessions mentions a toy knight made of silver with a complete suit of armour and a miniature horse and lance; ibid., 22.

57 Soler del Campo, *Real Armería*, 62.

58 Such gauntlets were banned from some tournaments, and often known as 'forbidden' gauntlets; Frieder, 'The Perfect Prince,' 99.

59 Federigo Badovaro (1557); cited in Grierson, *King of Two Worlds*, 53.

60 Ibid., 31.

61 Many years later, Philip chose to wear this armour for a state portrait by Sanchez Coello.

62 During this early stage Philip complied with his father's tastes in armour, although later in life he shifted his patronage to Wolfgang Grossschedel in Landshut. Since the king set the style for most nobles at the Spanish and Austrian courts, Philip's decision proved detrimental to the armour business at Ausburg, causing many of its workshops to close; Soler del Campo, *Real Armería*, 62.

63 On the ideal symbiosis of knight and horse, see Quondam, *Cavallo e cavaliere*.

64 José-A. Godoy, 'Renaissance Arms and Armor from the Patrimonio Nacional,' in *Resplendence of the Spanish Monarchy*, 155.

65 Less felicitous was Jörg Sigman's relationship with the Augsburg gold-smith's guild, which (despite his skill) long denied him a license as master craftsman. This conflict was eventually resolved by Colman's intervention.

66 Frieder, 'The Perfect Prince,' speculates that these scenes, based on Petrarch's *Trionfi*, may have been adapted from illustrations in Philip's own boyhood copy of the book (p. 182).

67 See ibid., 180. Philip's first wife, Maria of Portugal, had died in childbirth just eighteen months after their marriage.

68 When Ferdinand I died in 1564, the electors gave the imperial title to his son, who became Maximilian II.

69 Frieder, 'The Perfect Prince,' 183.

70 Mezzatesta, 'Imperial Themes,' 170.

71 For a similar juxtaposition of Virgin and Medusa (to great rhetorical effect), see Petrarca, *Canzoniere*, 366.

72 Mary was educated by humanists at her grandfather's court in Vienna. In 1528 her court preacher Johannes Henckel wrote to Erasmus, '[I]f you could see the Queen at home, you would think yourself not in a woman's apartment but in a school. She is always surrounded by books' (Mezzatesta, 'Imperial Themes,' 165). By portraying Mary with a book, Leoni may have intended to illustrate the topos of arms and letters as the twin attributes of a prince. Mary herself insisted that martial skill was a necessary quality for strong leadership; as a woman (however learned), she felt limited by her lack of military *virtù*.

73 Ibid., 167.

74 Don Carlos was mentally unstable and would eventually be barred from the succession before dying at twenty-three. Philip did commission an armour for the thirteen-year-old boy to match his own Cloud Bands Garniture (Real Armería, inv. A 274–6). Its irregular shape reveals some of the child's physical handicaps.

75 Grierson, *King of Two Worlds*, 22.

76 The *Flores* Garniture by Desiderius Helmschmid is ensemble A 217–30 in the Real Armería. Philip wears it in several state portraits, including the famous painting by Titian (1551) and another by Rubens (both in the Prado). The *Ondas* or Cloud Bands Garniture by Wolfgang and Franz Grosschedel (inv. A 243–62) is exhibited next to the *Flores* armour. For a lively discussion of the English marriage, see ibid., 34–49.

77 On Philip's construction of a radically different royal persona from that of his father and deliberate practice of withdrawal and concealment, see Fernando Checa Cremades, 'Monarchic Liturgies and the "Hidden King": The Function and Meaning of Spanish Royal Portraiture in the Sixteenth

and Seventeenth Centuries,' in *Iconography, Propaganda, and Legitimation*, ed. Allan Ellenius (Oxford: Clarendon Press, 1998), 89–104. In contrast to Charles's peripatetic existence, Cremades notes that 'Philip II advised his son to travel round his kingdom as little as possible, since the constant exhibition of the monarch was seen as detrimental to his prestige, authority, and majesty' (p. 98).

6. Cosimo I de' Medici

1 Benedetto Varchi, Cosimo's official historian, established this topos in his *Storia fiorentina*, ed. Lelio Arbib (Florence: Società Editoriale delle Storie dei Nardi e dei Varchi, 1843), 3:278.

2 On Medici genealogy, see Gaetano Pieraccini, *La stirpe de' Medici di Cafaggiolo* (Florence: Vallecchi, 1924).

3 Alessandro had been the first Medici to be formally invested with an hereditary title. This step was critical to the family's attempt to distance itself from its bourgeois origins.

4 Alessandro did have one son, but he was illegitimate and just five years old at his father's death. Alessandro's minister, Cardinal Cybo, promoted the boy's candidacy as figurehead successor in the hope of gaining effective power as his regent, but Guicciardini and Vettori opposed this attempt. For a fuller account of the choice of Cosimo (initially elected 'capo and primario' of the Florentine government) and his subsequent accession to the title of duke, see John M. Najemy, *A History of Florence 1200–1575* (Malden, MA: Blackwell, 2006), 466–73.

5 For their detailed and imaginative analysis, see Randolph Starn and Loren Partridge, *Arts of Power: Three Halls of State in Italy, 1300–1600* (Berkeley: University of California Press, 1992), 151–212.

6 There is still disagreement on which portrait of Cosimo served as the prototype. For a systematic review of the portrait's many variants, see Robert Barry Simon, 'Bronzino's Portraits of Cosimo I de' Medici,' (PhD diss., Columbia University, 1982), which is briefly excerpted and updated in 'Bronzino's Portrait of Cosimo I in Armour,' *The Burlington Magazine* 125 (1983): 527–39. The painting's date is contested; it has generally been considered to be 1545, but Simon makes a convincing case for the earlier date of 1543.

 Indispensable studies of Medici portraiture include Karla Langedijk, *The Portraits of the Medici from the Fifteenth to the Eighteenth Century*, 3 vols (Florence: Studio per edizioni scelte, 1981–7); and Janet Cox-Rearick, *Dynasty and Destiny in Medici Art: Pontormo, Leo X, and the Two Cosimos* (Princeton,

NJ: Princeton University Press, 1984). On Cosimo's iconography, see Kurt Forster, 'Metaphors of Rule: Political Ideology and History in the Portraits of Cosimo I de' Medici,' *Mitteilungen des Kunsthistorischen Institutes in Florenz* 15 (1971): 65–104. Also see Paul Richelson's *Studies in the Personal Imagery of Cosimo I de' Medici, Duke of Florence* (New York: Garland, 1978). For more recent perspectives, see the volume of essays edited by Konrad Eisenbichler, *The Cultural Politics of Duke Cosimo I de' Medici* (Aldershot, UK and Burlington, VT: Ashgate, 2001) and its sequel, *The Cultural World of Eleanora da Toledo, Duchess of Florence and Siena* (Burlington, VT: Ashgate, 2004). Most recently, see Henk Th. Van Veen, *Cosimo I de' Medici and His Self-Representation in Florentine Art and Culture*, trans. Andrew P. McCormick (Cambridge: Cambridge University Press, 2006) and Allison Levy, *Re-membering Masculinity in Early Modern Florence: Widowed Bodies, Mourning and Portraiture* (Aldershot, UK: Ashgate, 2006), especially 119–39. On the relationship between Bronzino's poetry and painting, see Deborah Parker, *Bronzino: Renaissance Painter as Poet* (Cambridge: Cambridge University Press, 2000).

7 Giorgio Vasari, *Le vite de' più eccellenti pittori scultori ed architettori*, ed. Gaetano Milanesi (Florence: Sansoni, 1906), 7:597–8. All translations from the Milanesi edition are mine. Vasari's 'arme bianche' refers not to the colour but to the composition of the armour; the expression was commonly used to denote arms of polished steel.

8 Bruno Thomas, 'Die Innsbrucker Plattnerkunst; ein Nachtrag,' *Jahrbuch der Kunsthistorischen Sammlungen in Wien* 70 (1974): 194–6.

9 Simon, 'Bronzino's Portraits,' 136, notes that Thomas, 'Die Innsbrucker Plattnerkunst' and Lionello Giorgio Boccia, 'Le armi medicee negli inventari del Cinquecento,' in *Le arti del principato mediceo* (Florence: Studio per Edizioni Scelte, 1980), 383–405, agree on this point, while Eric Cochrane, *Florence in the Forgotten Centuries, 1527–1800: A History of Florence and Florentines in the Age of the Grand Dukes* (Chicago: University of Chicago Press, 1973) seems to take it for granted. He points out, however, that no records or documentation have been found regarding the acquisition of the armour.

10 The work was painted in Bologna in 1530 and was apparently known to Bronzino through a woodcut by Giovanni Britto. The painting was lost some time after 1636; see Langedijk, *Portraits of the Medici*, 2:86.

11 Inventories of the Medici Guardaroba show that replicas of the portrait were sent to scores of prominent individuals throughout the courts of Europe. On the economy of gift exchange in the Medici court, see Marcello Fantoni, 'Il dono: Liberalità e potere,' in *La corte del granduca: Forma e simboli del potere mediceo fra Cinque e Seicento* (Rome: Bulzoni, 1994), 97–137.

12 Pius V crowned him Grand Duke of Tuscany in a 1570 ceremony in the Sistine Chapel, although Emperor Maximilian II did not officially recognize the title until 1575, a year after Cosimo's death.

13 See Langedijk, *Portraits of the Medici*, 2:427.

14 Simon, 'Bronzino's Portraits,' 165–7, cites the case of the disappearing mole on Cosimo's left cheek.

15 Cited in Lorne Campbell, *Renaissance Portraits: European Portrait-Painting in the 14th, 15th, and 16th Centuries* (New Haven, CT: Yale University Press, 1990), 3 and 247 n10.

16 John Pope-Hennessy, *The Portrait in the Renaissance* (New York: Bollingen Foundation, distrib. Pantheon Books, 1963), 183.

17 Cox-Rearick is one of several to reject the theory that this was a portrait of Cosimo; see *The Drawings of Pontormo* (Cambridge, MA: Harvard University Press, 1964), 276ff. Pope-Hennessy and Forster are among the many who disagree. On the controversy, see Forster, 'Metaphors of Rule,' 72–4.

18 On the ambiguous eroticism of the Bronzino portrait of Cosimo as Orpheus, see Patricia Simons, 'Homosociality and Erotics in Italian Renaissance Portraiture,' in *Portraiture: Facing the Subject*, ed. Joanna Woodall (Manchester: Manchester University Press, 1997), 29–51. This unusual portrait was one of two featured in a 2004 exhibition at the Philadelphia Museum of Art; see the catalogue edited by Carlo Brandon Strehlke, *Pontormo, Bronzino, and the Medici: The Transformation of the Renaisssance Portrait in Florence* (University Park: Pennsylvania State University Press, 2004). In particular, see the discussion by Elizabeth Cropper, 'Pontormo and Bronzino in Philadelphia: A Double Portrait, in *Pontormo, Bronzino, and the Medici*, ed. Carl Brandon Strehlke, 1–33. See also Robert B. Simon, 'Bronzino's *Cosimo I de' Medici* as Orpheus,' *Philadelphia Museum of Art Bulletin* 81, no. 348 (1985): 17–27.

19 Vasari, *Vite*, ed. Milanesi, 8:16; cited in Forster, 'Metaphors of Rule,' 100.

20 For details of this story, see Robert Simon, 'Bronzino's Portraits,' 50–2.

21 Pope-Hennessy, *The Portrait in the Renaissance,* 182.

22 Langedijk, *Portraits of the Medici*, 2:86–8, was apparently the first to note the relationship between the two portraits.

23 Harry Berger, Jr, *Fictions of the Pose: Rembrandt against the Italian Renaissance* (Stanford: Stanford University Press, 2000), 199.

24 Cited in Simon, 'Bronzino's Portraits,' 109–10; emphasis mine. I have slightly adapted his translation.

25 Vulcan's finest piece of metalwork was the gossamer net he used to capture Mars and Venus *in flagrante*.

26 The text of the poem is as follows:

> Te duce, mortales quae dedignata scelestos
>> Extulerat niveos aurea ad astra pedes,
> aurea nunc Astrea redit, Venus ante recessit
>> Sacrilega, Etruscae Cosme decus patriae,
> Per quem parta quies, & pax & copia rerum est,
>> Et Sophiae, Aonidumque artibus ortus honos.
> In falcem, duce te, galeae conflantur & enses
>> Nec lethale sonant classica, nec litiui.
> Marte satus, Ianum claudis, quis claudere Ianum
>> Mavortis prolem te potuisse putet?

[With you as duke, she who, unworthy of wicked mortals, had borne away her snowy white feet to the golden stars, golden Astraea now returns, profane Venus has withdrawn before, O Cosimo, glory of the Etruscan fatherland, through whom quiet, and peace, and abundance of things are acquired, and the honor of Wisdom and the Muses' arts has arisen. With you as duke, swords and helmets are melted into scythes and neither the trumpet calls nor the bugles lethally sound. O son of Mars, you close the gates of war: who would have thought you, descendant of Mars, could have closed war's doors?] Paolo Giovio, *Elogia virorum bellica virtute illustrium* (Basel: Petri Pernae, 1575), 339–40; translation from Simon, 'Bronzino's Portraits.'

27 Simon, 'Bronzino's Portrait of Cosimo I,' 528, maintains that the painting owned by Giovio (which appeared at auction in 1971 and remains in a private collection) is not a workshop variant but by Bronzino himself. In his reconstruction of a hypothetical sequence for the entire group of portraits, Simon argues that this expanded (three-quarter-length) version of *Cosimo armato* was directly commissioned by the duke and went on to serve as prototype for a second 'family' of portraits.

28 Cardinal Cybo is said to have cited the line from Virgil when he introduced Cosimo to the Senate: 'primo avulso non deficit alter [aureus], et simili frondescit virga metallo' (*Aeneid* 6.143–4); this according to Varchi, *Storia fiorentina*, 251.

29 Giovio provides the following explanation of the *broncone* in his *Dialogo dell'imprese*: 'Cosimo ebbe un'altra impresa nel principio del suo principato ... e fu quel che dice Vergilio nell'Eneide del ramo d'oro, col motto: Uno avulso non deficet alter, figurando un ramo svelto dall'albero in luogo del quale ne succede subito un altro, volendo intendere che, se bene era stata

levata la vita al duca Alessandro, non mancava un altro ramo d'oro nella medesima stirpe.'

[Cosimo had another emblem at the beginning of his reign ... and it was Virgil's image of the golden bough, with the motto: 'When the first is torn away, the second fails not,' portraying a branch torn from a tree followed immediately by another, signifying that although Alessandro's life had been taken, there remained another golden bough from the same tree.] Paolo Giovio, *Dialogo dell'imprese militari e amorose*, ed. Maria Luisa Giovio (Rome, 1978), 72–3; translation from Simon, 'Bronzino's Portraits,' 118.

30 Another early example of Cosimo's use of the *broncone* is a medal by Domenico di Polo; it shows the young duke dressed in armour with (on the reverse) a broken branch and the motto *Uno avvulso non deficit alter*. On Cosimo's use of the *broncone*, see Simon, 'Bronzino's Portraits,' 117–34.

31 The bust was placed over the entrance of a fortress in Cosmopoli (now Portoferraio). It did not return to Florence until 1781 and is now in the Bargello. It is said that Bandinelli challenged Cellini to reproduce the bust in marble; this less successful version found its way to the De Young Memorial Museum in San Francisco (Langedijk, *Portraits of the Medici*, 1:472–4). For Cellini's story, see *La vita di Benvenuto Cellini*, ed. Orazio Bacci (Florence: Sansoni, 1961), 2:71.

32 Langedijk notes diplomatically, 'Cosimo's preference for Bandinelli's work is remarkable. It is difficult to imagine that he can have been insensitive to Cellini's far higher artistic achievement' (*Portraits of the Medici*, 1:90). Pope-Hennessy puts it more bluntly: 'Cellini's bust of Cosimo I, which seems to our eyes much superior to the generality of Medicean portraits, was disavowed because it was animated and unorthodox' (*The Portrait in the Renaissance*, 181).

33 Pope-Hennessy, *The Portrait in the Renaissance*, 180; also cited in Berger, *Fictions of the Pose*, 199.

34 Examples include the tombstones in the pavement of the Florentine Duomo to his fourteenth-century ancestors Salvestro and Vieri de' Medici, the tomb of his fifteenth-century ancestor Provost Carlo in the Prato cathedral, and the tomb of Piero de' Medici in the abbey of Monte Cassino; see Langedijk, *Portraits of the Medici*, 1:111–12.

35 On the art of *pietre dure* (polychrome hardstone marquetry, or 'Florentine inlay') and its sponsorship by the Medici, see Wolfram Koeppe and Annamaria Giusti, eds., *Art of the Royal Court: Treasures in Pietre Dure from the Palaces of Europe*, exhibition cat. (New York: Metropolitan Museum of

Art, 2008); see also Annamaria Giusti, *Pietre Dure: The Art of Semiprecious Stonework* (Oxford: Oxford University Press, 2006).

36 According to Langedijk, *Portraits of the Medici*, 1:111, Aretino lent the mask (made by Giulio Romano) to the sculptor Alfonso Lombardi to make a portrait bust; after Lombardi's death he eventually reclaimed the mask and loaned it to Titian. He sent the resulting portrait, accompanied by the mask, to Cosimo as a gift; lest the transaction seem uncharacteristically straightforward for Aretino, the portrait he presented as Titian's work had actually been painted by a lesser artist, Giovanni Paolo Pace.

37 When the figure was unveiled in 1850 the Florentines commented, 'Messer Giovanni delle Bande Nere / Del lungo cavalcar noiato e stanco / Scese di sella e si pose a sedere.' Ibid., 2:1034–5.

38 The painting (ca 1545), by an anonymous Florentine artist, is now in the Galleria Sabauda in Turin. Charles Buttin was the first to notice the presence of the son's armour in the father's portrait; see 'Un portrait de Jean des Bandes Noires à la Pinacothèque de Turin, *Gazette des beaux-arts*, 67 (1925): 1–8. In her recent book, *Re-membering Masculinity in Early Modern Florence*, Allison Levy is right to point out the identical armour in these two 1545 paintings (p. 123). But she has it backwards: it is not Cosimo who poses in his father's armour, but the reverse. The posthumous portrait of Giovanni delle Bande Nere makes the bold gesture of retrofitting the father in the armour of the son; see my discussion of this armour (attributed to Seusenhofer) earlier in this chapter. Similarly, Levy mistakes the father–son dynamic in another portrait pair: Alessandro Allori's *Cosimo I* (Palazzo Vecchio, Florence) and Carlo Portelli's *Giovanni delle Bande Nere, 1565–70* (Minneapolis Institute of Arts). It is true that 'the sharing of armor re-connects the two separated bodies' of father and son, but in a deliberate reversal of patriarchal transmission, it is the son who bequeathes his armour to the father.

39 For a discussion of this unusual painting, see Simon, 'Bronzino's Portraits,' 137–44. Simon seems interested primarily in what the contrast between the two paintings reveals of Bronzino's superior artistic skill. More intriguing to me is the son's gesture of retrofitting his father in his own favourite armour.

40 Giangirolamo Rossi di San Secondo, *Vita di Giovanni de' Medici, celebre capitano delle bande nere* (Milan: Fergario, 1833), 46; translation mine.

41 Lionello Giorgio Boccia's opinion that the funerary armour, now in the Museo Stibbert (inv. 16721), was a composite of Italian and German pieces from a Gonzaga storeroom has been accepted by most scholars; see his 'Le armi medicee negli inventari del Cinquecento.' Most recently, as a result

of its restoration, Mario Scalini contends that the armour was indeed Giovanni's own, in 'I resti dell'armatura funebre di Giovanni delle Bande Nere e alcuni oggetti a lui legati,' in *Giovanni delle Bande Nere*, ed. Mario Scalini (Florence: Banca Toscana, 2001), 223–9.

42 Boccia, 'Le armi medicee negli inventari del Cinquecento,' 390 n15.

43 Three fragments have been identified as belonging to the armour: two knee defences and the bottom lame from the fauld. These are faint traces indeed of the armour painted by Bronzino; because these parts of the body are excluded from the portrait format, none of the surviving pieces is visible in the Bronzino portrait series.

44 Florence, Uffizi, inv. 1890. For details on the portrait, see Langedijk, *Portraits of the Medici*, 1:70–5 and 226–7. On the iconography of this painting, see Malcolm Campbell, 'Il ritratto del Duca Alessandro de' Medici di Giorgio Vasari: Contesto e significato,' in *Giorgio Vasari tra decorazione ambientale e storiografia artistica*, ed. Gian Carlo Garfagnini (Florence: Olschki, 1985), 339–61. See also Cox-Rearick, *Dynasty and Destiny in Medici Art*, 234–6; Forster, 'Metaphors of Rule,' 69–70; Lorne Campbell, *Renaissance Portraits*, 129–32; and Pope-Hennessy, *The Portrait in the Renaissance*, 180–1 and 236–8.

45 Vasari, *Vite*, ed. Milanesi, 7:42.

46 Malcolm Campbell points out that Pontormo was more of an ally than a competitor during Vasari's work on the portrait, despite the widespread assumption that they were rivals in constructing Alessandro's image; 'Il ritratto del duca,' 339–41.

47 For a discussion of such virtuoso lighting effects, see ibid., 347–8.

48 Campbell briefly notes this incongruity (ibid., 349) but does not comment on its implications.

49 Domenico di Polo's 1534 portrait medal of Alessandro has been proposed as an explicit model for the painting; there are many parallels, including the allegory of Peace burning weapons on the reverse (another figure seated in profile to the right). Vasari's 1533–4 portrait of Lorenzo de' Medici shares this orientation. For details on the posthumous Lorenzo portrait, see Langedijk, *Portraits of the Medici*, 1:67–8 and 3:1144–6. On Domenico di Polo's medal, see ibid., 70 and 234. Cox-Rearick, *Dynasty and Destiny in Medici Art*, 234, and Forster, 'Metaphors of Rule,' 69, attribute the medal to Francesco del Prato.

50 Vasari, *Vite*, ed. Milanesi, 8:16.

51 I cite the remaining portion of the letter that explains its iconography:

 Il [Duca] siede, mostrando la possessione presa et havendo in

mano il bastone del dominio, tutto d'oro, per reggere et coman-
dare da principe et capitano. Ha dreto alle spalle, per esser passata,
una rouina di colonne et di edifitij, figurati per l'assedio della città
l'anno 1530; il quale per lo straforo d'una rottura di quello, vede
una Firenze, che guardandola intentamente con gl'occhi, fa' seg-
nio del suo riposo, sendoli sopra l'aria tutta serena. La sieda tonda,
doue siede sopra, non hauendo principio né fine, mostra il suo reg-
nare perpetuo. Que' tre corpi tronchi per più di detta sedia, in tre
per piede, sendo numero perfetto, sono i sua popoli, che guidandosi
secondo il uolere di chi sopra li comanda, non hanno né braccia né
gambe. Conuertesi il fine di queste figure in una zampa di leone,
per esser parte del segno della città di Firenze. Euui una maschera,
imbrigliata da certe fascie, la quale è figurata per la volubilità, uolen-
do mostrare che que' popoli instabili sono legati et fermi per il cas-
tello fatto et per l'amore che portano i sudditi à Sua Eccellenza. Quel
panno rosso che è mezzo in sul sedere, dove sono i corpi tronchi,
mostra il sangue che s'è sparso sopra di quelli che hanno repugnato
contro la grandezza della Illustrissima casa de' Medici; ed un lembo
di quello coprendo una coscia dell'armato, mostra che anche questi
di casa Medici sono stati percossi nel sangue nella morte di Giuliano
et ferite di Lorenzo uecchio. Quel tronco secco di lauro che manda
fuori quella uermena diritta et fresca di fronde è la casa de' Medici,
già spenta, che per la persona del duca Alessandro deve crescer di
prole infinitamente. Lo elmetto che non tiene in capo, ma in terra
abbrusciando, è la eterna pace, che procedendo dal capo del princ-
ipe per il suo buon gouerno, fa stare i popoli suoi colmi di letitia et
d'amore. (Ibid., 8:16–17)

52 On Vasari and allegory, see Marco Ruffini, 'Art without Author: The Death
of Michelangelo and Vasari's *Lives*' (PhD diss., University of California,
Berkeley, 2004).

53 Langedijk, *Portraits of the Medici*, 1:72–5.

54 Vasari concludes his explanatory letter to Ottaviano de' Medici with the
Latin inscription intended for the (lost) picture frame:
Arma quid? Urbis amor, per quem alta ruina per ostes.
Sella rotunda quid hec? Res sine fine notat.
Copora trunca monent tripodi quid vincta? Triunfum.
Hec tegit unde femur purpura? Sanguis erat.
Quid quoque sicca virens? Medicum genus indicat arbos.
Casside ab ardenti quid fluit? Alma quies.

Vasari clearly distinguishes between this 'public' gloss on the picture that will be visible on its frame and the more detailed explication he has given his patron in private: 'Et perché molti per l'oscurità della cosa non l'intenderebbono, uno amico mio et seruitore loro ha stretto in questi pochi versi quel ch'io ui ho detto in tante righe di parole, che, come uedrete, uanno nell'ornamento in quello epitaffio.' Vasari, *Vite*, ed. Milanesi, 8:17.

55 In this portrait, only the Marzocco and *broncone* were established motifs carried over from earlier Medici iconography. The *broncone* was first used by Piero il Gottoso in 1513 (Langedijk, *Portraits of the Medici*, 1:40). Malcolm Campbell argues that Vasari's redeployment of the symbol in the Alessandro portrait was an ingenious response to changing historical circumstances ('Il ritratto del duca,' 355–7). ·

56 See J.R. Hale, 'The End of Florentine Liberty: The Fortezza da Basso,' in *Renaissance War Studies* (London: Hambledon Press, 1983), 501–32.

57 Malcolm Campbell, 'Il ritratto del duca,' 344–50, and Langedijk, *Portraits of the Medici*, 1:233.

58 Vasari, *Vite*, ed. Milanesi, 3:374. Cited in Malcolm Campbell, 'Il ritratto del duca,' 346–7.

59 On Vasari's posthumous portrait of Lorenzo, see Langedijk, *Portraits of the Medici*, 1:67–8 and 3:1144; also Forster, 'Metaphors of Rule,' 66–8. In a letter to his patron, Vasari explains that he depicted Lorenzo 'in abito come egli stava positivamente a casa.' Even the ex-voto effigies of earlier Medici showed them in *abito civile*. To mark Lorenzo's recovery from his attempted assassination in the Pazzi conspiracy, Verrocchio created at least three ex-voto portraits of Lorenzo for Florentine churches, including SS. Annunziata. All portrayed him in typical merchant dress.

60 On the Furini allegory, see Langedijk, *Portraits of the Medici*, 1:194 and 428. See also Hans Keutner, 'Francesco Furini: La gloria di Casa Salviati,' *Mitteilungen des Kunsthistorischen Institutes in Florenz* 18, no. 3 (1974): 393–6; and Elena Toesca, *Francesco Furini* (Rome: Tuminelli, 1950), 14–16.

61 Vasari, *Vite*, ed. Milanesi, 7:702.

62 The panel is illustrated and the individuals are identified in Muccini, *Il Salone dei Cinquecento in Palazzo Vecchio* (Florence: Le Lettere, 1990), 99.

63 Vasari, *Vite*, ed. Milanesi, 7:702.

64 On the uses of astrology in Medici propaganda, see especially Cox-Rearick, *Dynasty and Destiny in Medici Art*.

65 Randolph Starn and Loren Partridge, *Arts of Power*, 176.

66 Strangely, the Florentine commander at Stampace wears sixteenth-century armour although his troops are dressed *all'antica*. This may indicate the lack of unity within the republic.

67 On Cosimo's paradoxical relationship with the historical memory of the
Florentine republic, see Najemy, *History of Florence*, 490: 'Cosimo regarded
the republican past ambivalently: on the one hand, he needed it to bolster
a legitimacy weakened not only by his state's violent origins but also by
his status as a creature, indeed a vassal, of the emperor; on the other, he
was wary of it because he feared its resurrection.'

68 Van Veen, *Cosimo I de' Medici and His Self-Representation*.

69 On the creation of this order, see Najemy, *A History of Florence*, 479–82.
The bifurcated red cross of the Order of Santo Stefano (which imitates
the bifurcated white cross of the Knights of Malta) appears frequently in
Medici dynastic portraits of the late sixteenth and seventeenth century. For
a more extensive discussion of the order, see Franco Angiolini, *I cavalieri e il
principe: L'Ordine di Santo Stefano e la società toscana in età moderna* (Florence:
Edifir, 1996). On the crusading orders, see Gregory Hanlon, *The Twilight of
a Military Tradition: Italian Aristocrats and Euopean Conflicts, 1560–1800* (Lon-
don: UCL Press,1998), 30–46; on the Order of Santo Stefano, see pp. 37–43.
For further background on the role of the chivalric orders in medieval
Europe, see D'Arcy J.D. Boulton, *The Knights of the Crown: The Monarchical
Orders of Knighthood in Later Medieval Europe, 1325–1520*, 2nd. ed. (Wood-
bridge: Boydell, 2000).

70 Van Veen, *Cosimo I de' Medici and His Self-Representation*, 78–9, finds a veiled
allusion to Cosimo's 1564 abdication in the central *tondo* that 'perfectly
suited [his] strategy' of 'seeming to surrender power while actually retain-
ing and even increasing it.

71 Bandinelli sculpted the figures of Alessandro de' Medici and Giovanni
delle Bande Nere. Cosimo's own portrait statue (begun by Bandinelli and
finished by Vincenzo de' Rossi) and the statue of his son Francesco (by
Giovanni Caccini) were added later.

72 On the Ammannati fountain, see Muccini, *Il Salone dei Cinquecento*, 42–5.

73 On Giovanna's triumphal entry of 1565, see Starn and Partridge, *Arts of
Power*, 168–80.

74 In fact, Francesco died in 1587 without a legitimate heir. His brother Ferdi-
nando at this point renounced his cardinalate and married to continue the
dynasty. See my earlier discussion in this chapter.

75 Starn and Partridge remark, 'To oversee and make arrangements for this
vast army Vasari often made his rounds on horseback for much of the day,
encountering so many difficulties that he often complained of severe head-
aches, and said that he felt half dead with fatigue,' *Arts of Power*, 203.

76 Langedijk, *Portraits of the Medici*, 1:91.

77 Suzanne Butters, *The Triumph of Vulcan: Sculptors' Tools, Porphyry, and the*

Prince in Ducal Florence (Florence: Olschki, 1996), 1:254–5. For a group of letters from the Medici court documenting its attempts to establish a permanent armourer in Florence, see her vol. 2, appendix 16, 475–87. On the curious intersection between Medici interests in armour-making and alchemy, see especially vol. 1, 241–69. Both Cosimo and Francesco collected and were fascinated by recipes for quenchants (used in hardening steel).

Conclusion

1 See, for example, J.R. Hale, 'War and Public Opinion in Renaissance Italy,' in *Renaissance War Studies* (London: Hambledon Press, 1983), 359–87.
2 Giovan Paolo Lomazzo, *Trattato dell'arte della pittura, scoltura e architettura* (Milan, 1584); excerpted in Paola Barocchi, ed., *Scritti d'arte del Cinquecento* (Milan and Naples: 1971–7), 3:2743.
3 Valeria Finucci, *The Manly Masquerade: Masculinity, Paternity, and Castration in the Italian Renaissance* (Durham, NC: Duke University Press, 2003).
4 The immense bibliography on the subject includes J.R. Hale, *Renaissance Fortification: Art or Engineering?* (London: Thames and Hudson, 1977); Simon Pepper and Nicholas Adams, *Firearms and Fortifications: Military Architecture and Siege Warfare in Sixteenth-Century Siena* (Chicago: University of Chicago Press, 1986); and Geoffrey Parker, *The Military Revolution: Military Innovation and the Rise of the West, 1500–1800* (Cambridge: Cambridge University Press, 1988).

Bibliography

Accetto, Torquato. *Della dissimulazione onesta* (1641). Edited by Salvatore Nigro. Turin: Einaudi, 1997.

Alciati, Andrea. *Emblemata*. Antwerp, 1581.

Andres, Stefano. *Le Amazzoni nell'immaginario occidentale*. Pisa: ETS, 2001.

Angelucci, Angelo. *Documenti inediti per la storia delle armi da fuoco italiane*. Vol. 1, pt. 1. Turin: G. Cassone, 1869.

Angiolini, Franco. *I cavalieri e il principe: L'Ordine di Santo Stefano e la società toscana in età moderna*. Florence: Edifir, 1996.

Appadurai, Arjun, ed. *The Social Life of Things: Commodities in Cultural Perspective*. Cambridge: Cambridge University Press, 1986.

Arco, Carlo d'. *Delle arti e degli artefici di Mantova: Notizie raccolte ed illustrate con disegni e con documentti*. Vol. 2. Mantua: Tipografia Ditta Giovanni Agazzi, 1857.

Aretino, Pietro. *Poesie varie*. Edited by Giovanni Aquilecchia and Angelo Romano. Rome: Salerno, 1992.

Ariosto, Ludovico. *Orlando furioso*. Edited by Marcello Turchi. Milan: Garzanti, 1974.

Armi del Museo Stibbert. Florence: Opera Museo Stibbert, 2000.

Arrizabalanga, Jon, John Henderson, and Roger French. *The Great Pox: The French Disease in Renaissance Europe*. New Haven, CT: Yale University Press, 1997.

Ascoli, Albert Russell. 'Body Politics in Ariosto's *Orlando furioso*.' In *Translating Desire in Medieval and Early Modern Literature*, edited by Craig A. Berry and Heather Richardson Hayton, 49–85. Tempe, AZ: Arizona Center for Medieval and Renaissance Studies, 2005.

– 'Like a Virgin: Fantasies of the Male Body in *Orlando furioso*.' In *The Body in*

Early Modern Italy, edited by Walter Stephens and Julia Hairston. Baltimore: The Johns Hopkins University Press, forthcoming.

– and Victoria Kahn, eds. *Machiavelli and the Discourse of Literature*. Ithaca, NY: Cornell University Press, 1993.

Bakhtin, Mikhail. *Rabelais and His World*. Translated by Helene Iswolsky. Bloomington: Indiana University Press, 1984.

Bann, Stephen. *The True Vine: On Visual Representation and the Western Tradition*. Cambridge: Cambridge University Press, 1989.

Barber, Richard. *The Knight and Chivalry*. New York: Scribner's, 1970.

Barocchi, Paola. *Scritti d'arte del Cinquecento*. 3 vols. Milan and Naples: Ricciardi, 1971–7.

Barthes, Roland. *The Fashion System*. Translated by Matthew Ward and Richard Howard. Berkeley: University of California Press, 1983.

Bell, Rudolph. *Holy Anorexia*. Chicago: University of Chicago Press, 1985.

Bellamy, Elizabeth J. *Translations of Power: Narcissism and the Unconscious in Epic History*. Ithaca, NY: Cornell University Press, 1992.

Belozerskaya, Marina. *Luxury Arts of the Renaissance*. London: Thames and Hudson, 2005.

Bentini, Jadranka, ed. *Signore cortese e umanissimo: Viaggio intorno a Ludovico Ariosto*. Exhibition catalogue, Reggio Emilia, Sala delle Esposizioni dell'Antico Foco Boario. Venice: Marsilio, 1994.

Berger, Harry, Jr. *Fictions of the Pose: Rembrandt against the Italian Renaissance*. Stanford: Stanford University Press, 2000.

Bernardi, Tiziana. 'Analisi di una cerimonia pubblica: L'incoronazione di Carlo V a Bologna.' *Quaderni storici* 61 (1986): 171–99.

Berti, Luciano. *Il principe dello studiolo: Francesco I dei Medici e la fine del Rinascimento italiano*. Florence: Edam, 1967.

Blockmans, Willem. *Emperor Charles V, 1500–1558*. New York: Oxford University Press, 2002.

Boccia, Lionello Giorgio. 'Le armature dei Negroli.' *Poiein / Quaderni di cultura artistca del Ministero dell Pubblica Istruzione* 6 (1993): 5–26.

– *Le armature di Santa Maria delle Grazie di Curtatone e Mantova e l'armatura del '400*. Milan: Bramante Editrice, 1982.

– ed. *Armi difensive dal medioevo all'età moderna*. Florence: Centro Di, 1982.

– 'Le armi medicee negli inventari del Cinquecento.' In *Le arti del principato mediceo*, 383–405. Florence: Studio per Edizioni Scelte, 1980.

– 'Curiosa di armamentaria ariostea.' In *Signore cortese e umanissimo: Viaggio intorno a Ludovico Ariosto*, edited by Jadranka Bentini, 48–59. Venice: Marsilio, 1994.

– 'The Devil's Mask.' In *Art, Arms, and Armour: An International Anthology*, edited by Robert Held. Chiasso: Acquafresca, 1979.

– 'Firenze e la Toscana dei Medici nell' Europa del Cinquecento.' In *Forte di Belvedere and Palazzo Medici-Riccardi*. Exhibition catalogue. Milan: Electa Editrice, 1980.

– Giuseppe Cantelli, and Fosco Maraini, eds. *Il Museo Stibbert a Firenze*. Vol. 4. Milan: Electa, 1976.

– and E.T. Coelho. *L'arte dell'armatura in Italia*. Milan: Bramante, 1967.

– and José-A. Godoy, eds. *Museo Poldi Pezzoli: Armeria*. 2 vols. Milan: Electa, 1985–6.

– Francesco Rossi, and Marco Morin. *Armi e armature lombarde*. Milan: Electa, 1980.

Boiardo, Matteo Maria. *Orlando innamorato*. Edited by Aldo Scaglione. 2 vols. Turin: UTET, 1963.

Boulton, D'Arcy J.D. *The Knights of the Crown: The Monarchical Orders of Knighthood in Later Medieval Europe, 1325–1520*. 2nd ed. Woodbridge: Boydell, 2000.

Boyarin, Daniel. *Dying for God: Martyrdom and the Making of Christianity and Judaism*. Stanford: Stanford University Press, 1999.

Brandi, Karl. *The Emperor Charles V: The Growth and Destiny of a Man and of a World-Empire*. Translated by C.V. Wedgwood. London: Jonathan Cape, 1965.

Brose, Margaret. 'Petrarch's Beloved Body: "Italia mia."' In *Feminist Approaches to the Body in Medieval Literature*, edited by Linda Lomperis and Sarah Stanbury, 1–20. Philadelphia: University of Pennsylvania Press, 1993.

Brown, Peter. *The Cult of the Saints: Its Rise and Function in Latin Christianity*. Chicago: University of Chicago Press, 1981.

Burke, Kenneth. *A Rhetoric of Motives*. Berkeley: University of California Press, 1969.

Burke, Peter. *The Historical Anthropology of Early Modern Italy*. Cambridge: Cambridge University Press, 1987.

Burns, E. Jane. *Courtly Love Undressed: Reading through Clothes in Medieval French Culture*. Philadelphia: University of Pennsylvania Press, 2002.

Butler, Judith. *Gender Trouble: Feminism and the Subversion of Identity*. New York: Routledge, 1990.

Butters, Suzanne. *The Triumph of Vulcan: Sculptors' Tools, Porphyry, and the Prince in Ducal Florence*. 2 vols. Florence: Olschki, 1996.

Buttin, Charles. 'Un portrait de Jean des Bandes Noires à la Pinacothèque de Turin.' *Gazette des beaux-arts* 67 (1925): 1–8.

Bynum, Caroline Walker. 'The Body of Christ in the Later Middle Ages: A

Reply to Leo Steinberg.' *Renaissance Quarterly* 39, no. 3 (Autumn 1986): 399–439; reprinted in Bynum, *Fragmentation and Redemption*, 79–117.

– *Fragmentation and Redemption: Essays on Gender and the Human Body in Medieval Religion*. New York: Zone, 1991.

– *Holy Feast and Holy Fast: The Religious Significance of Food to Medieval Women*. Berkeley: University of California Press, 1987.

Caillois, Roger. *The Mask of Medusa*. Translated by George Ordish. New York: Potter, 1964.

Calvino, Italo. *Il cavaliere inesistente*. Milan: Garzanti, 1985. Translated by Archibald Colquhoun as *The Nonexistent Knight and the Cloven Viscount*. New York: Harcourt Brace Jovanovich, 1977.

– *Il cavaliere inesistente*. Introduction by Cristian Beaufort-Spontin. Milan: Franco Maria Ricci, 1994.

Campbell, Lorne. *Renaissance Portraits: European Portrait-Painting in the 14th, 15th, and 16th Centuries*. New Haven, CT: Yale University Press, 1990.

Campbell, Malcolm. 'Il ritratto del duca Alessandro de' Medici di Giorgio Vasari.' In *Giorgio Vasari: Tra decorazione ambientale e storiografia artistica. Convegno di studi*, edited by Gian Carlo Garfagnini, 339–61. Florence: Olschki, 1985.

Caneva, Caterina, ed. *La Medusa del Caravaggio restaurata*. Rome: Retablo, 2002.

Carboni, Stefano. *Venice and the Islamic World, 828–1797*. New Haven, CT: Yale University Press, 2007.

Castelnuovo, Enrico. 'Il significato del ritratto pittorico nella societa.' In *Storia d'Italia*. Vol. 5, *Documenti*, 1033–94. Turin: Einaudi, 1973.

Castiglione, Baldesar. *The Book of the Courtier*. Translated by Charles Singleton. Edited by Daniel Javitch. New York: Norton, 2002.

– *Il libro del cortegiano*. Edited by Walter Barberis. Turin: Einaudi, 1998.

Catalano, Michele. *Vita di Ludovico Ariosto, ricostruita su nuovi documenti*. 2 vols. Geneva: Olschki, 1930–1.

Cellini, Benvenuto. *The Autobiography of Benvenuto Cellini*. Translated by George Bull. London: Penguin, 1966.

– *My Life*. Translated by Julia Conaway Bondanella and Peter Bondanella. New York: Oxford University Press, 2002.

– *La vita di Benvenuto Cellini*. Edited by Orazio Bacci. Florence: Sansoni, 1961.

Cheles, Luciano. *The Studiolo of Urbino: An Iconographic Investigation*. Wiesbaden: L. Reichert, 1986.

Cixous, Hélène. 'The Laugh of the Medusa.' Translated by Keith Cohen and Paula Cohen. *Signs* 1, no. 4 (Summer 1976), 875–93.

Cochrane, Eric. *Florence in the Forgotten Centuries, 1527–1800: A History of*

Florence and Florentines in the Age of the Grand Dukes. Chicago: University of Chicago Press, 1973.

Cohen, Jeffrey J. *Medieval Identity Machines*. Minneapolis: University of Minnesota Press, 2003.

– and Bonnie Wheeler, eds. *Becoming Male in the Middle Ages*. New York: Garland, 1997.

Comisso, Giovanni. *Gli ambasciatori veneti (1525–1792): Relazioni di viaggio e di missione*. Milan: Longanesi, 1960.

Conti, Giordano. 'L'incoronazione di Carlo V a Bologna.' In *La città effimera e l'universo artificiale del giardino: La Firenze dei Medici e l'Italia del '500*, edited by Marcello Fagiolo, 38–45. Rome: Bulzoni, 1980.

Conti, Natale. *Mythologiae*. 1551.

Il convitato di ferro. Exhibition catalogue. Turin: Quadrante Edizioni, 1987.

Cornelison, Sally J., and Scott G. Montgomery, eds. *Images, Relics, and Devotional Practices in Medieval and Renaissance Italy*. Tempe, AZ: Arizona Center for Medieval and Renaissance Studies, 2006.

Corrigan, Peter. 'Interpreted, Circulating, Interpreting: The Three Dimensions of the Clothing Object.' In *The Socialness of Things: Essays on the Socio-Semiotics of Objects*, edited by Stephen Harold Riggins, 435–50. Berlin and New York: Mouton de Gruyter, 1994.

Cox-Rearick, Janet. *The Drawings of Pontormo*. Cambridge, MA: Harvard University Press, 1964.

– *Dynasty and Destiny in Medici Art: Pontormo, Leo X, and the Two Cosimos*. Princeton, NJ: Princeton University Press, 1984.

Crane, Susan. 'Clothing and Gender Definition: Joan of Arc.' *The Journal of Medieval and Early Modern Studies* 26, no. 2 (Spring 1996): 297–320.

– *The Performance of Self: Ritual, Clothing, and Identity during the Hundred Years War*. Philadelphia: University of Pennsylvania Press, 2002.

Cremades, Fernando Checa. *Carlos V: La imagen del poder en el Renacimiento*. Madrid: Ediciones El Viso, 1999.

– *Felipe II, Mecenas de las artes*. Madrid: Editorial Nerea, 1992.

– 'Monarchic Liturgies and the "Hidden King": The Function and Meaning of Spanish Royal Portraiture in the Sixteenth and Seventeenth Centuries.' In *Iconography, Propaganda, and Legitimation*, edited by Allan Ellenius, 89–104. Oxford: Clarendon Press, 1998.

Cropper, Elizabeth. 'Pontormo and Bronzino in Philadelphia: A Double Portrait.' In *Pontormo, Bronzino, and the Medici: The Transformation of the Renaissance Portrait in Florence*, edited by Carl Brandon Strehlke, 1–33. University Park: Pennsylvania State University Press, 2004.

Dacos, Nicole. *La découverte de la Domus Aurea et la formation des grotesques à la Renaissance.* Studies of the Warburg Institute 31. Leiden: E.J. Brill, 1969.

Dandelet, Thomas J., and John A. Marino, eds. *Spain in Italy: Politics, Society, and Religion 1500–1700.* The Medieval and Early Modern Iberian World 32. Leiden: Brill, 2007.

De Geest, J., Juan Hernandez Ferrero, Concha Herrero Carretero, and José-A. Godoy, eds. *Charles Quint: Tapisseries et armures des collections royales d'Espagne.* Exhibition catalogue. Brussels: Musées Royaux d'Art e d'Histoire, 1994.

De Lachenal, Lucilla. 'Il gruppo equestre di Marco Aurelio e il Laterano: Ricerche per una storia della fortuna del monumento dall'età medievale sino al 1538.' *Bollettino d'arte* 74 (1990): 1–52.

Delcorno Branca, Daniela. *L'Orlando furioso e il romanzo cavalleresco medievale.* Florence: Olschki, 1973.

Dennistoun of Dennistoun, James. *Memoirs of the Dukes of Urbino Illustrating the Arms, Arts and Literature of Italy, 1440–1630.* 1851. New edition with notes by Edward Hutton. 3 vols. London: John Lane, 1909.

Descrizione delle feste fatte nelle reali nozze de' serenissimi principi di Toscana D. Cosimo de' Medici e Maria Maddalena arciduchessa d'Austria. Bologna, 1608; also Firenze, 1608.

Deuffic, Jean-Luc. *Reliques et sainteté dans l'espace médiéval.* Saint-Denis: Pecia, 2006.

Dominguez Ortiz, Antonio, Concha Herrero Carretero, and José-A. Godoy, eds. *Resplendence of the Spanish Monarchy: Renaissance Tapestries and Armor from the Patrimonio Nacional.* Exhibition catalogue. New York: Metropolitan Museum of Art, 1991.

Dondi, Giorgio. 'Il guerriero è asimmetrico.' In *Il convitato di ferro*, 169–80. Exhibition catalogue. Turin: Il Quadrante, 1987.

Du Choul, Guillaume. *Discours sur la castramentation et discipline militaire des Romains.* Lyon: Guillaume Rouille, 1555.

Eco, Umberto. *A Theory of Semiotics.* Bloomington: Indiana University Press, 1976.

Eisenbichler, Konrad. 'Bronzino's Portrait of Guidobaldo II della Rovere.' *Renaissance and Reformation* 12 (Winter 1988): 21–33.

– ed. *The Cultural Politics of Duke Cosimo I de' Medici.* Aldershot, UK and Burlington, VT: Ashgate, 2001.

– ed. *The Cultural World of Eleanora da Toledo, Duchess of Florence and Siena.* Burlington, VT: Ashgate, 2004.

Emiliani, Andrea. *Il Bronzino.* Milan: Bramante, 1960.

Erasmus, Desiderius. *The Education of a Christian Prince.* Edited by Lisa Jardine. Cambridge: Cambridge University Press, 1997.

– *The Enchiridion*. Translated by Raymond Himelick. Gloucester, MA: Peter Smith, 1970.

Erdmann, Carl. *The Origin of the Idea of Crusade*. Translated by M.W. Baldwin and W. Goffart. Princeton, NJ: Princeton University Press, 1977.

Erickson, Peter, and Clark Hulse, eds. *Early Modern Visual Culture: Representation, Race, and Empire in Renaissance England*. Philadelphia: University of Pennsylvania Press, 2000.

Estrella, Juan Cristobal Calvete de. *El felicisimo viaje del muy alto y muy poderoso Principe Don Phelippe, hijo del Emperador Don Carlos Quinto Maximo, desde Espana a sus tierras de la baxa Alemana: con la description de todos los estados de Brabante y Flandes*. Antwerp: Martin Nucio, 1552. Reprint, Madrid: Lòpez de Toro, 1950, 2 vols.

Fagiolo, Marcello, ed. *La città effimera e l'universo artificiale del giardino: La Firenze dei Medici e l'Italia del '500*. Rome: Officina Edizioni, 1980.

Falco, Maria J., ed. *Feminist Interpretations of Niccolò Machiavelli*. College Park: Penn State University Press, 2004.

Fantoni, Marcello, ed. *Carlo V e l'Italia*. Rome: Bulzoni, 2000.

– *La corte del granduca: Forma e simboli del potere mediceo fra Cinque e Seicento*. Rome: Bulzoni, 1994.

Fineschi, Filippo, and Roberto Mancini. 'La maschera della morte: Esecuzioni capitali a Roma in età moderna.' In *La Medusa del Caravaggio restaurata*, edited by Caterina Caneva, 73–83. Rome: Retablo, 2002.

Finucci, Valeria. *The Lady Vanishes: Subjectivity and Representation in Castiglione and Ariosto*. Stanford: Stanford University Press, 1992.

– *The Manly Masquerade: Masculinity, Paternity, and Castration in the Italian Renaissance*. Durham, NC: Duke University Press, 2003.

– and Kevin Brownlee, eds. *Generation and Degeneration: Tropes of Reproduction in Literature and History from Antiquity through Early Modern Europe*. Durham, NC: Duke University Press, 2001.

Fisher, Will. *Materializing Gender in Early Modern English Literature and Culture*. Cambridge: Cambridge University Press, 2006.

Fontana, Micol, ed. *Caravaggio, la Medusa: Lo splendore degli scudi da parata del Cinquecento*. Exhibition catalogue. Milan: Silvana, 2004.

Forster, Kurt. 'Metaphors of Rule: Political Ideology and History in the Portraits of Cosimo I de' Medici.' *Mitteilungen des Kunsthistorischen Institutes in Florenz* 15 (1971): 65–104.

Fracastoro, Girolamo. *Fracastoro's Syphilis*. Translated by Geoffrey Eatough. Liverpool: Cairns, 1984.

Fradenburg, Louise Olga. *City, Marriage, Tournament: Arts of Rule in Late Medieval Scotland*. Madison: University of Wisconsin Press, 1991.

Freccero, Carla. 'Politics and Aesthetics in Castiglione's *Il Cortegiano:* Book III and the Discourse on Women.' In *Creative Imitation: New Essays on Renaissance Literature*, edited by David Quint, Margaret W. Ferguson, G.W. Pigman III, and Wayne A. Rebhorn, 259-80. Binghamton: Medieval and Renaissance Texts and Studies, 1992.

Freccero, John. 'Medusa and the Madonna of Forlì: Political Sexuality in Machiavelli.' In *Machiavelli and the Discourse of Literature*, edited by Albert Russell Ascoli and Victoria Kahn, 161–78. Ithaca, NY: Cornell University Press, 1993.

Freud, Sigmund. 'Medusa's Head.' In *The Standard Edition of the Complete Psychological Works of Sigmund Freud*, translated by James Strachey, 18:273–4. London: Hogarth, 1966.

Fried, Michael. 'Thoughts on Caravaggio.' *Critical Inquiry* 24 (1997): 13–56.

Frieder, Braden K. 'The Perfect Prince: Tournaments, Armor and the Iconography of Succession on the Grand Tour of Philip of Spain, 1548–1551.' PhD diss., University of Wisconsin-Madison, 1997.

Frye, Susan. 'The Myth of Elizabeth I at Tilbury.' *Sixteenth Century Journal* 23 (1992): 95–114.

Fumerton, Patricia, and Simon Hunt, eds. *Renaissance Culture and the Everyday.* Philadelphia: University of Pennsylvania Press, 1999.

Gaffney, Wilbur. 'The Allegory of the Christ-Knight in *Piers Plowman*.' *PMLA* 46 (1931): 155–68.

Gaibi, A. 'Un manoscritto del '600: L'arte fabrile, di Antonio Petrini.' *Armi antiche* (1962): 111–39.

Gallagher, Catherine, and Stephen Greenblatt. *Practicing New Historicism.* Chicago: University of Chicago Press, 2000.

Gallucci, Margaret A., and Paolo L. Rossi, eds. *Benvenuto Cellini: Sculptor, Goldsmith, Writer.* Cambridge: Cambridge University Press, 2004.

Garber, Marjorie. *Vested Interests: Cross-Dressing and Cultural Anxiety.* New York: Routledge, 1992.

– and Nancy J. Vickers, eds. *The Medusa Reader.* New York and London: Routledge, 2003.

Gardiner, Judith Kegan, ed. *Masculinity Studies and Feminist Theory: New Directions.* New York: Columbia University Press, 2002.

Garfagnini, G.C., ed. *Giorgio Vasari: Tra decorazione ambientale e storiografia artistica. Convegno di studi Arezzo, 8–10 ottobre 1981.* Florence: Istituto nazionale di studi sul rinascimento, 1985.

Geary, Patrick. *Furta Sacra: Thefts of Relics in the Central Middle Ages.* Princeton, NJ: Princeton University Press, 1978.

Gilbert, Felix. 'Machiavelli: The Renaissance of the Art of War.' In *Makers of*

Modern Strategy: From Machiavelli to the Nuclear Age, edited by Peter Paret, 11–31. Princeton, NJ: Princeton University Press.

Gilmore, David D. *Manhood in the Making: Cultural Concepts of Masculinity.* New Haven CT: Yale University Press, 1990.

Giovio, Paolo. *Dialogo dell'imprese militari e amorose.* Edited by Maria Luisa Doglio. Rome, 1978.

– *Elogia virorum bellica virtute illustrium.* Basel: Petri Pernae, 1575.

– *Gli elogi vite brevemente scritte d'huomini illustri di guerra, antichi et moderni.* Florence, 1554.

Giusti, Annamaria. *Pietre Dure: The Art of Semiprecious Stonework.* Oxford: Oxford University Press, 2006.

Glossarium Armorum. Arma Defensiva. Edited by Ortwin Gamber. Graz, Austria: Akademische Druck-u. Verlaganstalt, 1972.

Godoy, José-A. 'Renaissance Arms and Armor from the Patrimonio Nacional.' In *Resplendence of the Spanish Monarchy: Renaissance Tapestries and Armor from the Patrimonio Nacional,* edited by Antonio Dominguez Ortiz, Concha Herrero Carretero, and José-A. Godoy, 95–164. New York: Metropolitan Museum of Art, 1991.

– and Silvio Leydi. *Parate trionfali: Il manierismo nell'arte dell'armatura italiana.* Milan: 5 Continents, 2003.

Goffman, Erving. *Behavior in Public Places.* London: Collier-Macmillan, 1963.

– *The Presentation of Self in Everyday Life.* New York: Doubleday, 1959.

Grabb, W.C., G.P. Hodge, R.O. Dingman, and R.M. O'Neal. 'The Hapsburg Jaw.' *Plastic and Reconstructive Surgery* 42 (1968): 442–5.

Grancsay, Stephen V. 'The Illustrated Inventory of the Arms and Armor of Emperor Charles V.' In *Homenaje a Rodriguez-Monino,* 1:205–12. Madrid: Editorial, 1966.

– 'The Mutual Influence of Costume and Armor: A Study of Specimens in the Metropolitan Museum of Art.' *Metropolitan Museum Studies* 3, no. 2 (1931): 194–208.

Greenblatt, Stephen J. *Learning to Curse: Essays in Early Modern Culture.* New York: Routledge, 1990.

– *Renaissance Self-Fashioning: From More to Shakespeare.* Chicago: University of Chicago Press, 1980.

Grierson, Edward. *King of Two Worlds: Philip II of Spain.* London: Collins, 1974.

Gronau, Georg. *Documenti artistici urbinati: Raccolta di fonti per la storia dell'arte.* Vol. 1. Florence: Sansoni, 1936.

Gualterotti, R. *Feste nelle nozze del Serenissimo Don Francesco Medici, Gran Duca di Toscana, et della Serenissima sua consorte la Sig. Bianca Cappello.* Florence, 1579.

Guicciardini, Francesco. *The History of Italy*. Translated by Sidney Alexander. Princeton, NJ: Princeton University Press, 1984.

– *Storia d'Italia*. Edited by Silvana Seidel Menchi. Turin: Einaudi, 1971.

Hale, John Rigby. *Artists and Warfare in the Renaissance*. New Haven, CT: Yale University Press, 1990.

– *Renaissance Fortification: Art or Engineering?* London: Thames and Hudson, 1977.

– *Renaissance War Studies*. London, Hambledon Press, 1983.

– *War and Society in Renaissance Europe*. New York: St. Martin's Press, 1985.

Hampton, Timothy. *Writing from History: The Rhetoric of Exemplarity in Renaissance Literature*. Ithaca, NY: Cornell University Press, 1990.

Hanlon, Gregory. *The Twilight of a Military Tradition: Italian Aristocrats and European Conflicts, 1560–1800*. London: UCL Press, 1998.

Harmand, Adrien. *Jeanne d'Arc: Ses costumes, son armure*. Paris: Leroux, 1929.

Hayward, John F. 'The Revival of Roman Armour in the Renaissance.' In *Art, Arms, and Armour: An International Anthology*, edited by Robert Held, 144–63. Chiasso: Acquafresca, 1979.

Heikamp, Detlef. 'La Medusa del Caravaggio e l'armatura dello Scià Abbas di Persia.' *Paragone* 17, no. 199 (1966): 62–76.

Hodge, G.P. 'A Medical History of the Spanish Habsburgs as Traced in Portraits.' *Journal of the American Medical Association* 238 (1977): 1169–74.

Hollander, Anne. *Seeing through Clothes*. New York: Viking Press, 1978.

Homer. *The Iliad*. Translated by Richmond Lattimore. Chicago: University of Chicago Press, 1951.

Jacobus de Voragine. *The Golden Legend of Jacobus de Voragine*. Translated by Grange Ryan and Helmut Ripperger. New York: Arno, 1968.

Jacquot, Jean, ed. *Les fêtes de la renaissance*. Vol. 2, *Fêtes et cérémonies au temps de Charles Quint*. Paris: Centre National de la Recherche Scientifique, 1960.

Jardine, Lisa. *Worldly Goods: A New History of the Renaissance*. New York: Doubleday, 1996.

Javitch, Daniel. '*Il Cortegiano* and the Constraints of Despotism.' In *Castiglione: The Ideal and the Real in Renaissance Culture*, edited by Robert W. Hanning and David Rosand, 17–28. New Haven, CT: Yale University Press, 1983.

– *Proclaiming a Classic: The Canonization of 'Orlando furioso'*. Princeton, NJ: Princeton University Press, 1991.

Jones, Ann Rosalind, and Peter Stallybrass. *Renaissance Clothing and the Materials of Memory*. Cambridge: Cambridge University Press, 2000.

Kamen, Henry. *Philip of Spain*. New Haven, CT: Yale University Press, 1997.

Karras, Ruth Mazo. *From Boys to Men: Formations of Masculinity in Late Medieval Europe*. Philadelphia: University of Pennsylvania Press, 2003.

Keutner, Hans. 'Francesco Furini: La gloria di Casa Salviati.' *Mitteilungen des Kunsthistorischen Institutes in Florenz* 18, no. 3 (1974): 393–6.

Koeppe, Wolfram, and Annamaria Giusti, eds. *Art of the Royal Court: Treasures in Pietre Dure from the Palaces of Europe.* Exhibition catalogue. New York: Metropolitan Museum of Art, 2008.

Kolve, V.A. *The Play Called Corpus Christi.* Stanford: Stanford University Press, 1966.

Kopytoff, Igor. 'The Cultural Biography of Things: Commoditization as Process.' In *The Social Life of Things: Commodities in Cultural Perspective,* edited by Arjun Appadurai, 64–91. Cambridge: Cambridge University Press, 1986.

Kurz, O. 'A Gold Helmet Made in Venice for Sultan Suleyman the Magnificent.' *Gazette des beaux-arts* 74 (1969): 249–58.

Lacan, Jacques. 'The Mirror Stage as Formative of the Function of the I as Revealed in Psychoanalytic Experience.' In Écrits, translated by Alan Sheridan. New York: Norton, 1977.

Langedijk, Karla. *The Portraits of the Medici from the Fifteenth to the Eighteenth Century.* 3 vols. Florence: Studio per edizioni scelte, 1981–7.

Lavin, Irving. 'Bernini's Death.' *The Art Bulletin* 54 (1972): 159–86.

Lees, Claire, Thelma Fenster, and Jo Ann McNamara, eds. *Medieval Masculinities: Regarding Men in the Middle Ages.* Minneapolis: University of Minnesota Press, 1994.

Levy, Allison. *Re-membering Masculinity in Early Modern Florence: Widowed Bodies, Mourning and Portraiture.* Aldershot, UK: Ashgate, 2006.

Leydi, Silvio. 'A History of the Negroli Family'. In *Heroic Armor of the Italian Renaissance: Filippo Negroli and His Contemporaries,* edited by Stuart W. Pyhrr and José-A. Godoy, 37–60. Exhibition catalogue. New York: Metropolitan Museum of Art, 1998.

Lomazzo, Giovan Paolo. *Trattato dell'arte della pittura, scoltura e architettura.* Milan, 1584.

Los Leoni (1509–1608): Escultores del Renacimiento italiano al servicio de la corte de España. Exhibition catalogue. Madrid: Museo del Prado, 1994.

Luzio, Alessandro. *Un pronostico satirico di Pietro Aretino (MDXXXIIII).* Bergamo: Istituto Italiano d'Arti Grafiche, 1900.

Machiavelli, Niccolò. *The Art of War.* Translated by Christopher Lynch. Chicago: University of Chicago Press, 2003.

– *L'arte della guerra: Scritti politici minori,* edited by Jean-Jacques Marchand, Denis Fachard, and Giorgio Masi. Rome: Salerno, 2001.

– *Discorsi sopra la prima deca di Tito Livio.* Edited by Francesco Bausi. Rome: Salerno, 2001.

– *The Prince.* Translated by Robert M. Adams. New York, 1977.

- *Il principe.* Turin: Einaud, 1961.

Mallett, Michael. *Mercenaries and Their Masters: Warfare in Renaissance Italy.* Totowa, NJ.: Rowman and Littlefield, 1974.

- 'The Transformation of War, 1494–1530.' In *Italy and the European Powers: The Impact of War, 1500–1530,* edited by Christine Shaw, 3–21. Leiden and Boston: Brill, 2006.

Margonari, Renzo, and Attilio Zanca. *Il Santuario della Madonna delle Grazie presso Mantova.* Mantua: Gizeta, 1973.

Marin, Louis. *Détruire la peinture.* Paris: Editions Galilee, 1977. Translated by Mette Hjort as *To Destroy Painting* (Chicago: University of Chicago Press, 1995).

Marini, Maurizio. *Caravaggio: Michelangelo Merisi da Caravaggio 'pictor praesten-tissimus.'* Rome: Newton Compton, 1987.

Marino, Giambattista. *La galeria.* (1620). Edited by Marzio Pieri. Padua: Liviana, 1979.

Maza, Sarah. 'Stephen Greenblatt, New Historicism, and Cultural History, or, What We Talk about When We Talk about Interdisciplinarity.' *Modern Intellectual History* 1, no. 2 (2004): 249–65.

Mazzini, Franco, ed. *L'armeria reale di Torino.* Varese: Bramante, 1982.

McCracken, Grant. 'Clothing as Language: An Object Lesson in the Study of the Expressive Properties of Material Culture.' In *Material Anthropology: Contemporary Approaches to Material Culture,* edited by Barrie Reynolds and Margaret A. Stotto, 57–70. Lanham, MD: University Press of America, 1987.

McLucas, John C. 'Clorinda and Her Echoes in the Women's World.' *Stanford Italian Review* 10, no. 1 (Fall 1991): 81–92.

Mezzatesta, Michael P. 'Imperial Themes in the Sculpture of Leone Leoni.' PhD diss., New York University, 1980.

Mitchell, Bonner. *Italian Civic Pageantry in the High Renaissance: A Descriptive Bibliography of Triumphal Entries and Selected Other Festivals for State Occasions.* Florence: Olschki, 1979.

- *The Majesty of the State: Triumphal Progresses of Foreign Sovereigns in Renaissance Italy, 1494–1600.* Florence: Olschki, 1986.

Morigi, Paolo. *La nobiltà di Milano divisa in sei libri.* Milan, 1615. Facsimile edition, Sala Bolognese: Arnaldo Forni Editore, 1979.

Muccini, Ugo. *Il Salone dei Cinquecento in Palazzo Vecchio.* Florence: Le Lettere, 1990.

- and Alessandro Cecchi. *The Apartments of Cosimo in Palazzo Vecchio.* Florence: Le Lettere, 1991.

Murtola, Gaspare. *Rime.* Venice: Neglietti, 1603.

Najemy, John M. 'Arms and Letters: The Crisis of Courtly Culture in the

Wars of Italy.' In *Italy and the European Powers: The Impact of War, 1500–1530*, edited by Christine Shaw, 207–38. Leiden: Brill, 2006.

- *A History of Florence 1200–1575*. Malden, MA: Blackwell, 2006.

Necipoglu, Gulru. 'Suleiman the Magnificent and the Representation of Power in the Context of Ottoman-Hapsburg-Papal Rivalry.' *Art Bulletin* 71 (1989): 401–27.

Oakeshott, Ewart. *European Weapons and Armour from the Renaissance to the Industrial Revolution*. North Hollywood, CA: Beinfeld Publishing, 1980.

O'Malley, John W. *Praise and Blame in Renaissance Rome: Rhetoric, Doctrine, and Reform in the Sacred Orators of the Papal Court, c. 1450–1521*. Durham, NC: Duke University Press, 1979.

Oman, Charles. *A History of the Art of War in the Sixteenth Century*. London: Methuen, 1937.

Omodeo, Anna. *Grafica per orafi*. Bologna: Tip. Labanti e Nanni, 1975.

- 'Modelli e moduli per le decorazioni delle armature.' In *Il convitato di ferro*, 181–6. Exhibition catalogue. Turin: Quadrante Edizioni, 1987.

Orgel, Stephen. 'Gendering the Crown.' In *Subject and Object in Renaissance Culture*, edited by Margreta De Grazia, Maureen Quilligan, and Peter Stallybrass, 133–65. Cambridge: Cambridge University Press, 1996.

- *Impersonations: The Performance of Gender in Shakespeare's England*. Cambridge: Cambridge University Press, 1996.

Palacio, Pedro Navascués, ed. *Philippus II Rex*. Barcelona: Lunwerg, 1998.

Panconesi, Emiliano. 'La perturbante testa di Medusa fra mito, psicologia e medicina.' In *La Medusa del Caravaggio restaurata*, edited by Caterina Caneva, 85–97. Rome: Retablo, 2002.

Panofsky, Erwin. *Problems in Titian: Mostly Iconographic*. New York: New York University Press, 1969.

Parker, Deborah. *Bronzino: Renaissance Painter as Poet*. Cambridge: Cambridge University Press, 2000.

Parker, Geoffrey. *The Military Revolution: Military Innovation and the Rise of the West, 1500–1800*. Cambridge: Cambridge University Press, 1988.

- *Philip II*. Boston: Little, Brown, 1978.

Parker, Patricia A. *Literary Fat Ladies: Rhetoric, Gender, Property*. London and New York: Methuen, 1987.

Passio perpetuae et felicitas. Edited and translated by H. Musurillo as *The Acts of the Christian Martyrs*. Oxford: Clarendon Press, 1972.

Paster, Gail Kern. *The Body Embarrassed: Drama and the Disciplines of Shame in Early Modern England*. Ithaca, NY: Cornell University Press, 1993.

Pastoureau, Michel. 'Désigner ou dissimuler? Le rôle du cimier dans

l'imaginaire médiéval.' In *Masques et déguisements dans la litterature médiévale*, edited by Marie-Louise Ollier, 127–40. Montreal: University of Montreal Press, 1988.

Pepper, Simon, and Nicholas Adams. *Firearms and Fortifications: Military Architecture and Siege Warfare in Sixteenth-Century Siena*. Chicago: University of Chicago Press, 1986.

Persels, Jeffrey. 'Bragueta Humanistica, or Humanism's Codpiece.' *Sixteenth Century Journal* 28 (1997): 79–99.

Petrarca, Francesco. *Canzoniere*. Edited by Gianfranco Contini. Turin: Einaudi, 1964.

Petrini, Antonio. 'Arte fabrile overo armeria universale dove si contengano, tutte, le qualità, e natura del ferro con varie impronte che si trovano in diversi arme così antiche come moderne e vari segreti e tempere.' Florence, Biblioteca Nazionale Centrale, 1642.

Pfaffenbichler, Matthias. *Medieval Craftsmen: Armourers*. Toronto: University of Toronto Press, 1992.

Piacenti, Kristen Achengreen. *Draghi e peoni: Capolavori della collezione giapponese*. Florence: Edizioni Polistampa, 1999.

Pieraccini, Gaetano. *La stirpe de' Medici di Cafaggiolo*. Florence: Vallecchi, 1924.

Pieri, Piero. *Il Rinascimento e la crisi militare italiana*. Turin: Einaudi, 1952.

Pitkin, Hanna Fenichel. *Fortune Is a Woman: Gender and Politics in the Thought of Niccolò Machiavelli*. Berkeley: University of California Press, 1984.

Pope-Hennessy, John. *The Portrait in the Renaissance*. New York: Bollingen Foundation, distributed by Pantheon, 1966.

Propp, Vladimir. *Morphology of the Folktale*. Translated by Laurence Scott. Bloomington: Indiana University Press, 1958.

Pyhrr, Stuart W. and José-A. Godoy, eds. *Heroic Armor of the Italian Renaissance: Filippo Negroli and His Contemporaries*. Exhibition catalogue (8 October 1998–17 January 1999). New York: Metropolitan Museum of Art, 1998.

– Donald J. LaRocca, and Dirk H. Breiding. *The Armored Horse in Europe, 1480–1620*. Exhibition catalogue, Metropolitan Museum of Art (15 February 2005–15 January 2006). New Haven, CT: Yale University Press, 2005.

Quint, David. *Epic and Empire: Politics and Generic Form from Virgil to Milton*. Princeton, NJ: Princeton University Press, 1993.

Quondam, Amedeo. *Cavallo e cavaliere: L'armatura come seconda pelle del gentiluomo moderno*. Rome: Donzelli, 2003.

Redondo, Augustin. *Antonio de Guevara (1480?–1545) et l'Espagne de son temps, de la carrière officielle aux œvres politico-morales*. Geneva: Droz, 1976.

Richelson, Paul. *Studies in the Personal Imagery of Cosimo I de' Medici, Duke of Florence*. New York: Garland, 1978.

Riggins, Stephen Harold. 'The Power of Things: The Role of Domestic Objects in the Presentation of Self.' In *Beyond Goffman: Studies on Communication, Institution, and Social Interaction*, edited by Stephen Harold Riggins, 341–67. Berlin and New York: Mouton de Gruyter, 1990.

– 'The Semiotics of Things: Towards a Sociology of Human-Object Interaction.' *Recherches Sémiotiques/Semiotic Inquiry* 5 (1985): 69–77.

– *The Socialness of Things: Essays on the Socio-Semiotics of Objects*. Berlin and New York: Mouton de Gruyter, 1994.

Rinuccini, C. *Descrizione delle feste fatte nelle reali nozze de' serenissimi principi di Toscana D. Cosimo de' Medici e Maria Maddalena arciduchessa d'Austria*. Florence, 1608.

Ripa, Cesare. *Iconologia*. Rome, 1603.

Robinson, Henry Russell. *The Armour of Imperial Rome*. New York: Scribner's, 1975.

– *Japanese Arms and Armor*. New York: Crown, 1969.

– series editor. *Il Museo Stibbert a Firenze*. Milan: Electa, 1973–6.

Rosenthal, Earl. 'The Invention of the Columnar Device of the Emperor Charles V at the Court of Burgundy in Flanders in 1516.' *Journal of the Warburg and Courtauld Institutes* 36 (1973): 198–230.

– '"Plus ultra," "Non plus ultra," and the Columnar Device of the Emperor Charles V." *Journal of the Warburg and Courtauld Institutes* 34 (1971): 204–28.

Rossi di San Secondo. *Vita di Giovanni de' Medici, celebre capitano delle bande nere*. Milan: Fergario, 1833.

Ruffini, Marco. 'Art without Author: The Death of Michelangelo and Vasari's Lives.' PhD diss., University of California, Berkeley, 2004.

Ruggiero, Guido. *Machiavelli in Love: Sex, Self, and Society in the Italian Renaissance*. Baltimore: The Johns Hopkins University Press, 2007.

Ruscelli, G. *Le imprese illustri*. Venice, 1572.

Sahlins, Marshall. *Culture and Practical Reason*. Chicago: University of Chicago Press, 1976.

Sambuco, Giovanni. *Emblemata*. Antwerp, 1564.

Sansovino, Francesco. *Diverse orationi volgarmente scritte da molti huomini illustri di tempi nostri*. Venice: 1561.

– *Il simulacro di Carlo V imperadore* [...] Venice: F. Franceschini et I. Mantelli, 1567.

– *Venetia città nobilissima et singolare*. Venice, 1581.

Sanuto, Marino. *I diarii di Marino Sanuto*. Venice, 1581. Edited by R. Fulin et al. Venice: F. Visentini, 1879–1903.

Sawday, Jonathan. *The Body Emblazoned: Dissection and the Human Body in Renaissance Culture*. New York and London: Routledge, 1996.

Scalini, Mario. *Armature all'eroica dei Negroli*. Florence: Museo Nazionale del Bargello, 1987.

– ed. *Giovanni delle Bande Nere*. Florence: Banca Toscana, 2001.

– 'Mecenatismo artistico farnesiano ed armature istoriate nella seconda metà del Cinquecento.' *Waffen- und Kostümkunde* 32, nos 1–2 (1990): 1–34.

– 'Il poema epico cinquecentesco, armi all'eroica e da pompa.' In *Armi e armati: Arte e cultura delle armi nella Toscana e nell'Italia del tardo Rinascimento dal Museo Bardini e dalla Collezione Corsi*, edited by Mario Scalini, 13–27. Florence: Centro Di, 1988.

– *Il Saracino e gli spettacoli cavallereschi nella Toscana granducale*. Florence: Museo Nazionale del Bargello, 1987.

Schiller, Gertrud. *Iconography of Christian Art*. Translated by Janet Seligman. 2 vols. Greenwich, CT: New York Graphic Society, 1968.

Schnapp, Jeffrey. 'Machiavellian Foundlings: Castruccio Castracani and the Aphorism.' *Renaissance Quarterly* 45, no. 4 (Winter 1991): 653–75.

Schoebel, Johannes. *Princely Arms and Armour: A Selection from the Dresden Collection*. Translated by M.O.A. Stanton. London: Barrie and Jenkins, 1975.

– *Ein Prunk-harnisch: Der Herakles-Harnisch aus dem Historischen Museum der Staatlichen Kunstsammlunger Dresden*. Lipsia: Prisma-Verlag, 1966.

Shaw, Christine, ed. *Italy and the European Powers: The Impact of War, 1500–1530*. Leiden: Brill, 2006.

Shemek, Deanna. *Ladies Errant: Wayward Women and Social Order in Early Modern Italy*. Durham, NC: Duke University Press, 1998.

Simon, Robert Barry. 'Bronzino's *Cosimo I de' Medici* as Orpheus.' *Philadelphia Museum of Art Bulletin* 81, no. 348 (1985): 17–27.

– 'Bronzino's Portrait of Cosimo I in Armour.' *The Burlington Magazine* 125 (1983): 527–39.

– 'Bronzino's Portraits of Cosimo I de' Medici.' PhD diss., Columbia University, 1982.

Simons, Patricia. 'Alert and Erect: Masculinity in Some Italian Renaissance Portraits of Fathers and Sons.' In *Gender Rhetorics: Postures of Dominance and Submission in History*, edited by Richard C. Trexler, 163–75. Binghamton, NY: Medieval and Renaissance Texts and Studies, 1994.

– 'Homosociality and Erotics in Italian Renaissance Portraiture.' In *Portraiture: Facing the Subject*, edited by Joanna Woodall, 29–51. Manchester: Manchester University Press, 1997.

Snyder, Jon. *Dissimulation and the Culture of Secrecy in Early Modern Europe*. Berkeley: University of California, 2009.

Soler de Campo, Alvaro. *Real Armeria: Palacio Real*. Madrid: Patrimonio Nacional, 2000.

Spackman, Barbara. 'Politics on the Warpath: Machiavelli's *Art of War*.' In

Machiavelli and the Discourse of Literature, edited by Albert Russell Ascoli and Victoria Kahn, 179–93. Ithaca, NY: Cornell University Press, 1993.

Spezzaferro, Luigi. 'La Medusa del Caravaggio.' In *Caravaggio, la Medusa: Lo splendore degli scudi da parata del Cinquecento,* edited by Micol Fontana, 19–27. Milan: Silvana, 2004.

Stallybrass, Peter. 'Hauntings: The Materiality of Memory on the Renaissance Stage.' In *Generation and Degeneration: Tropes of Reproduction in Literature and History from Antiquity through Early Modern Europe,* edited by Valeria Finucci and Kevin Brownlee, 287–316. Durham, NC: Duke University Press, 2001.

– 'Patriarchal Territories: The Body Enclosed.' In *Rewriting the Renaissance: The Discourses of Sexual Difference in Early Modern Europe,* edited by Margaret W. Ferguson, Maureen Quilligan, and Nancy J. Vickers, 123–42. Chicago: University of Chicago Press, 1986.

Stanivukovic, Goran, ed. *Ovid and the Renaissance Body.* Toronto: University of Toronto Press, 2001.

Starn, Randolph. 'The Early Modern Muddle.' *Journal of Early Modern History* 6, no. 3 (2002): 296–307.

– and Loren Partridge. *Arts of Power: Three Halls of State in Italy, 1300–1600.* Berkeley: University of California Press, 1992.

Steinberg, Leo. *The Sexuality of Christ in Renaissance Art and in Modern Oblivion.* New York: Pantheon, 1983.

Strehlke, Carl Brandon, ed. *Pontormo, Bronzino, and the Medici: The Transformation of the Renaissance Portrait in Florence.* University Park: The Pennsylvania State University Press, 2004.

Strong, Roy. *Art and Power: Renaissance Festivals 1450–1650.* Berkeley: University of California Press, 1984.

Tanner, Marie. *The Last Descendant of Aeneas: The Hapsburgs and the Mythic Image of the Emperor.* New Haven, CT: Yale University Press, 1993.

Theweleit, Klaus. *Male Fantasies.* Translated by Stephen Conway. 2 vols. Minneapolis: University of Minnesota Press, 1987.

Thomas, Bruno. *Gesammelte Schriften.* Graz, 1977.

– 'Die Innsbrucker Plattnerkunst: Ein Nachtrag.' *Jahrbuch der Kunsthistorischen Sammlungen in Wien* 70 (1974): 179–220.

– and Lionello G. Boccia. *Armi storiche del Museo Nazionale di Firenze, Palazzo del Bargello, restaurate dall'aiuto Austriaco per Firenze.* Exhibition catalogue. Florence, 1971.

– and Ortwin Gamber. 'L'arte milanese dell'armatura.' In *Storia di Milano.* Vol. 11, *Il declino spagnolo 1630–1706,* 697–841. Milan: Fondazione Treccani, 1958.

Thomas, Nicholas. *Entangled Objects: Exchange, Material Culture, and Colonialism in the Pacific.* Cambridge, MA: Harvard University Press, 1991.

Toesca, Elena. *Francesco Furini*. Rome: Tumminelli, 1950.

Tracy, James D. *Emperor Charles V, Impresario of War*. Cambridge: Cambridge University Press, 2002.

Trexler, Richard, ed. *Public Life in Renaissance Florence*. New York: Academic Press, 1980.

Trivero, Gianluca. 'Le narrazioni dell'armatura.' In *Il convitato di ferro*, 219–25. Exhibition catalogue. Turin: Quadrante Edizioni 1987.

Turner, Victor. *The Anthropology of Performance*. New York: PAJ Publications, 1986.

Ugolini, Filippo. *Storia dei conti e duchi d'Urbino*. Florence: Grazzini, Giannini, 1859.

Vale, Malcolm. *War and Chivalry*. London: Duckworth, 1981.

Valencia de Don Juan. *Catalogo historico-descriptivo de la Real Armeria de Madrid*. Madrid: Real Casa, 1898.

Valencia de San Juan. *Inventario ilustrado*. 1544–58.

Van Veen, Henk Th. *Cosimo I de' Medici and His Self-Representation in Florentine Art and Culture*. Translated by Andrew P. McCormick. Cambridge: Cambridge University Press, 2006. This is a revised version of the original Dutch edition of 1998.

Varchi, Benedetto. *Storia fiorentina*. Edited by Lelio Arbib. Florence: Società Editoriale delle Storie dei Nardi e dei Varchi, 1843.

Vasari, Giorgio. *Lives of the Artists* (selection). 2 vols. Translated by George Bull. Middlesex: Penguin, 1965.

– *The Lives of the Painters, Sculptors and Architects*. Translated by A.B. William Gaunt. London: Dutton, 1963.

– *Ragionamenti sopra le invenzioni da lui dipinte*. Edited by C.L. Ragghianti. Milan, 1949.

– *Le vite de' più eccellenti architetti, pittori, et scultori italiani, da Cimabue insino a' tempi nostri nell' edizione per tipi di Lorenzo Torrentino, Firenze 1550*. Modern annotated edition, edited by Luciano Bellosi and Aldo Rossi. Turin: Einaudi, 1986.

– *Le vite de' più eccellenti pittori, scultori ed architettori*. Edited by Gaetano Milanesi. 9 vols. Florence: Sansoni, 1906.

Vernulaei, Nicolai. *Virtutem augustissimae gentis Austriacae*. Louvain, 1640.

Vicary, Grace. 'Visual Art as Social Data: The Renaissance Codpiece.' *Cultural Anthropology* 4, no. 1 (1989): 3–25.

Vickers, Nancy J. '"This Heraldry in Lucrece' Face."' In *The Female Body in Western Culture*, edited by Susan Suleiman, 209–22. Cambridge, MA: Harvard University Press, 1986.

Virgil. *The Aeneid*. Translated by H. Rushton Fairclough. London: Putnam's, 1916.

Waddington, Raymond B. *Aretino's Satyr: Sexuality, Satire, and Self-Projection in Sixteenth-Century Literature and Art*. Toronto: University of Toronto Press, 2004.

Walters, Jonathan. 'Invading the Roman Body: Manliness and Impenetrability in Roman Thought.' In *Roman Sexualities*, edited by Judith P. Hallett and Marilyn B. Skinner, 29–43. Princeton, NJ: Princeton University Press, 1997.

Warner, Marina. *Joan of Arc: The Image of Female Heroism*. Berkeley: University of California Press, 1981.

– *Monuments and Maidens: The Allegory of the Female Form*. Berkeley: University of California Press, 1985.

Watts, Sheldon. *Epidemics and History: Disease, Power and Imperialism*. New Haven, CT: Yale University Press, 1997.

Williams, Alan. *The Knight and the Blast Furnace: A History of the Metallurgy of Armour in the Middle Ages and the Early Modern Period*. Leiden and Boston: Brill, 2003.

Wolff, G., T.F. Wienker, and H. Sander. 'On the Genetics of Mandibular Prognathism: Analysis of Large European Noble Families.' *Journal of Medical Genetics* 30 (1993): 112–16.

Woolf, Rosemary. 'The Theme of Christ the Lover-Knight in Medieval English Literature.' *Review of English Studies* 13 (1962): 1–16.

Yates, Frances A. *Astraea: The Imperial Theme in the Sixteenth Century*. London: Routledge, 1975.

Index